故宫博物院藏品大系

Compendium of Collections
in the Palace Museum

故宫博物院藏品大系

雕塑编

4

宋元明俑及明器模型

故宫博物院 编

紫 禁 城 出 版 社

时代出版传媒股份有限公司

安 徽 美 术 出 版 社

图书在版编目（ＣＩＰ）数据

故宫博物院藏品大系．雕塑编．4，宋元明俑及明器模型：汉英对照／故宫博物院编．—北京：紫禁城出版社，2009.9
ISBN 978-7-80047-850-5

Ⅰ．故… Ⅱ．故… Ⅲ．①故宫博物院—历史文物—北京市—图集②俑—中国—宋元时期—图集③俑—中国—明代—图集 Ⅳ．K870.2 K878.92

中国版本图书馆 CIP 数据核字（2009）第 144011 号

故宫博物院藏品大系

雕塑编 4 宋元明俑及明器模型

故宫博物院 编 ｜ 出版领导小组

主 编：王全利 ｜ 主 任：王亚非 王亚民

编 委：冯贺军 胡国强 田 军 ｜ 副主任：田海明 林清发
　　　　王殿英 何 欣 ｜ 委 员：郑 可 赵国英 唐元明

摄影统筹：胡 锤 ｜ 　　　　丁怀超 贾兴权

摄 影：赵 山 胡 锤 冯 辉

翻 译：张 彦 ｜ 项目实施小组

编辑统筹：陈丽华 王亚民 赵国英 ｜ 主 任：林清发

责任编辑：冯印淙 赵启芳 ｜ 副主任：武忠平

装帧设计：赵 谦 ｜ 成 员：谢育智 陈 涛 马晓芸

责任校对：司开江 史春霖 ｜ 　　　　黄 伟 姚 健 刘 辉

责任印制：马静波 李建森 徐海燕 ｜ 　　　　陈连营

出 版：紫 禁 城 出 版 社

　　　 时代出版传媒股份有限公司

　　　 安 徽 美 术 出 版 社

发 行：安徽美术出版社总经销

社 址：合肥市政务文化新区翡翠路 1118 号出版传媒广场 14 层

邮 编：230071

营 销 部：0551-3533604 0551-3533607

印 刷：北京圣彩虹制版印刷技术有限公司

开 本：787 毫米 ×1092 毫米 1/8

印 张：39.5

版 次：2011 年 1 月第 1 版第 1 次印刷

印 数：1~1,500 册

书 号：ISBN 978-7-80047-850-5

定 价：600.00 元

COMPENDIUM OF COLLECTIONS
IN THE PALACE MUSEUM

SCULPTURE

4

Funereal Figures and Molds of the Song, Yuan and Ming Dynasties

Edited by the Palace Museum

The Forbidden City Publishing House

Time Publishing and Media Co., Ltd.
Anhui Fine Arts Publishing House

总目

Contents

图版目录

List of Plates

图版

Plates

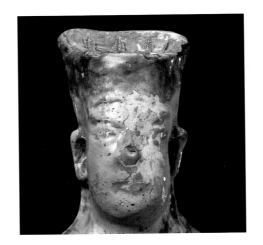

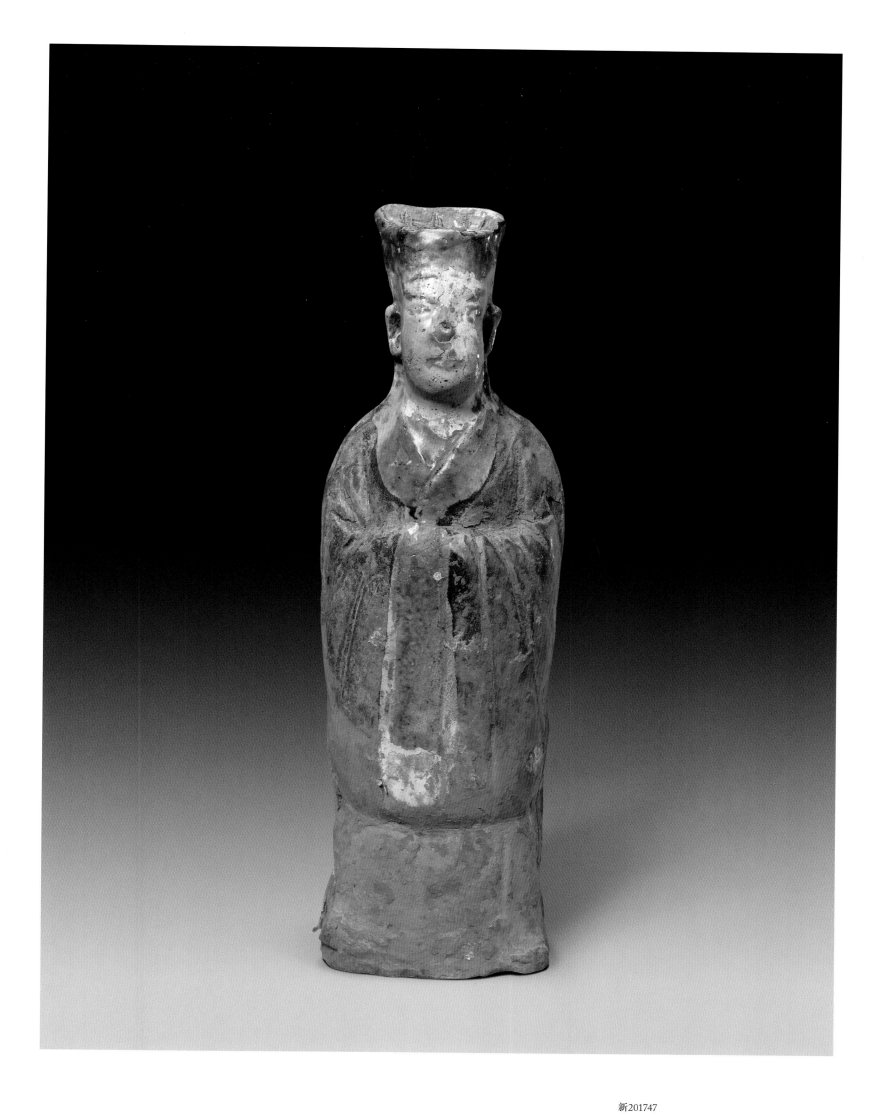

新201747
三彩男俑
宋
高22厘米　底宽6.3厘米

I Xin 201747
Tricolor Male Figure
Song Dynasty (960-1279)
Height 22 cm
Bottom width 6.3 cm

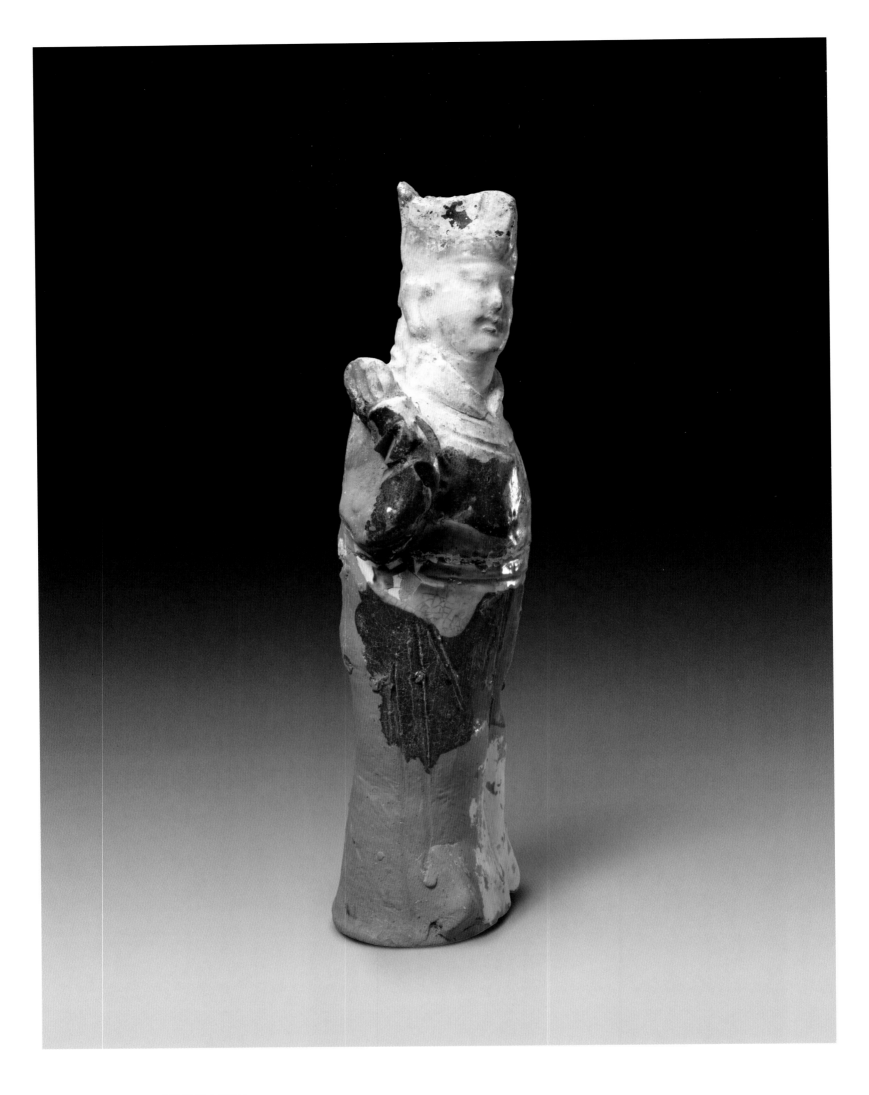

三彩男俑（側面）
Tricolor Male Figure（side）

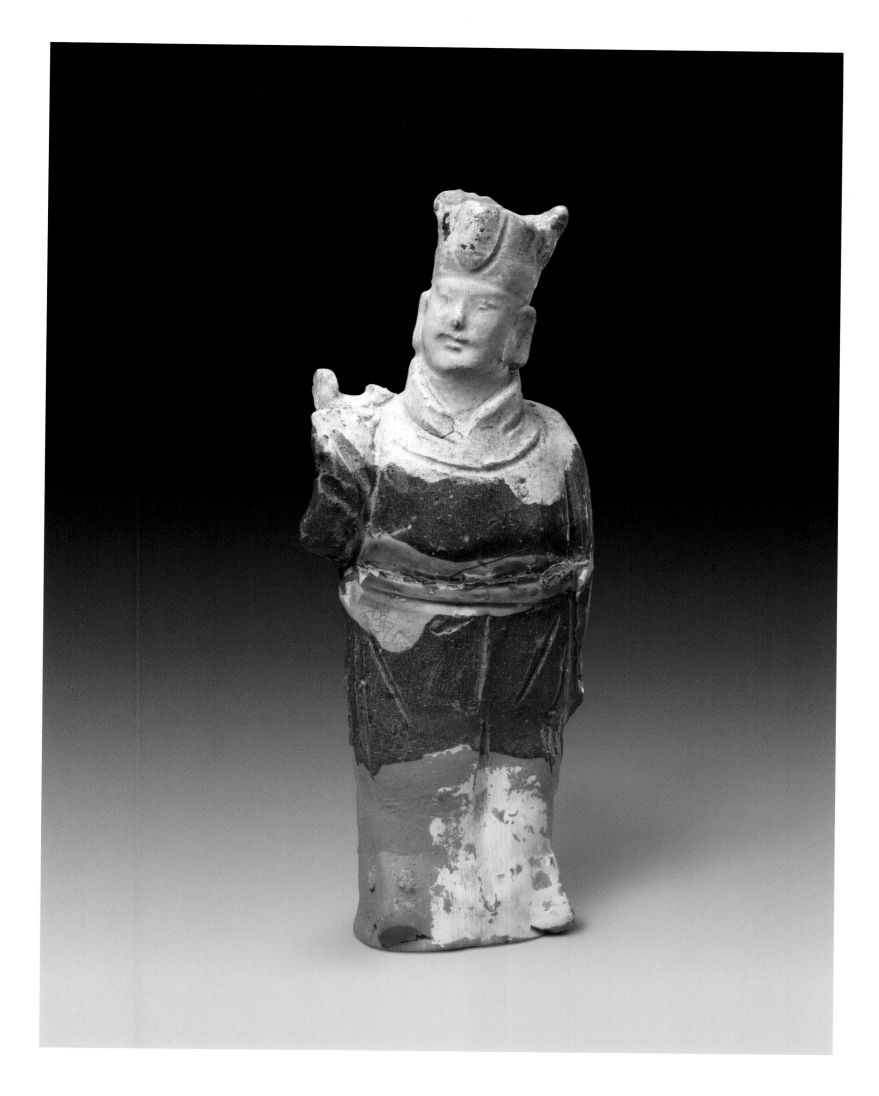

新201731
三彩男俑
宋
高21厘米 底宽5.7厘米

2 Xin 201731
Tricolor Male Figure
Song Dynasty (960-1279)
Height 21 cm
Bottom width 5.7 cm

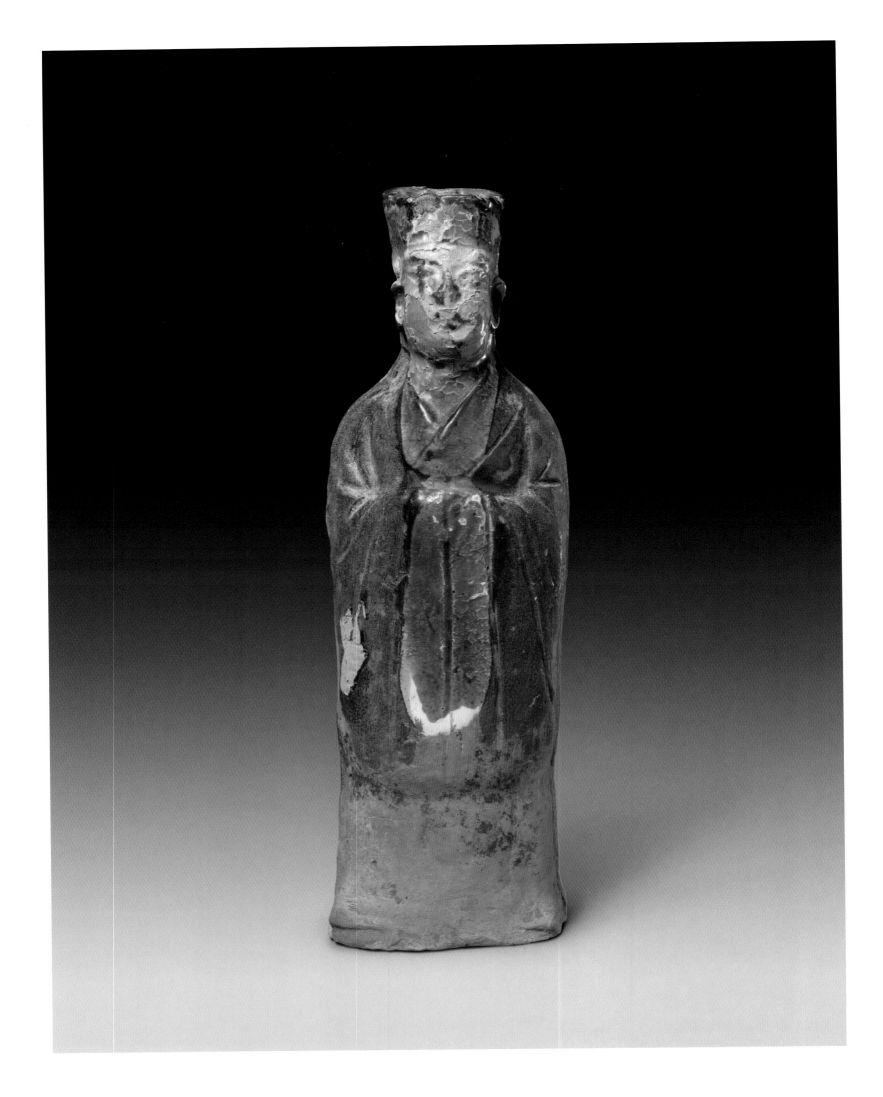

新201742

三彩男俑

宋

高21厘米 底宽6.3厘米

3 | Xin 201742

Tricolor Male Figure

Song Dynasty (960-1279)

Height 21 cm

Bottom width 6.3 cm

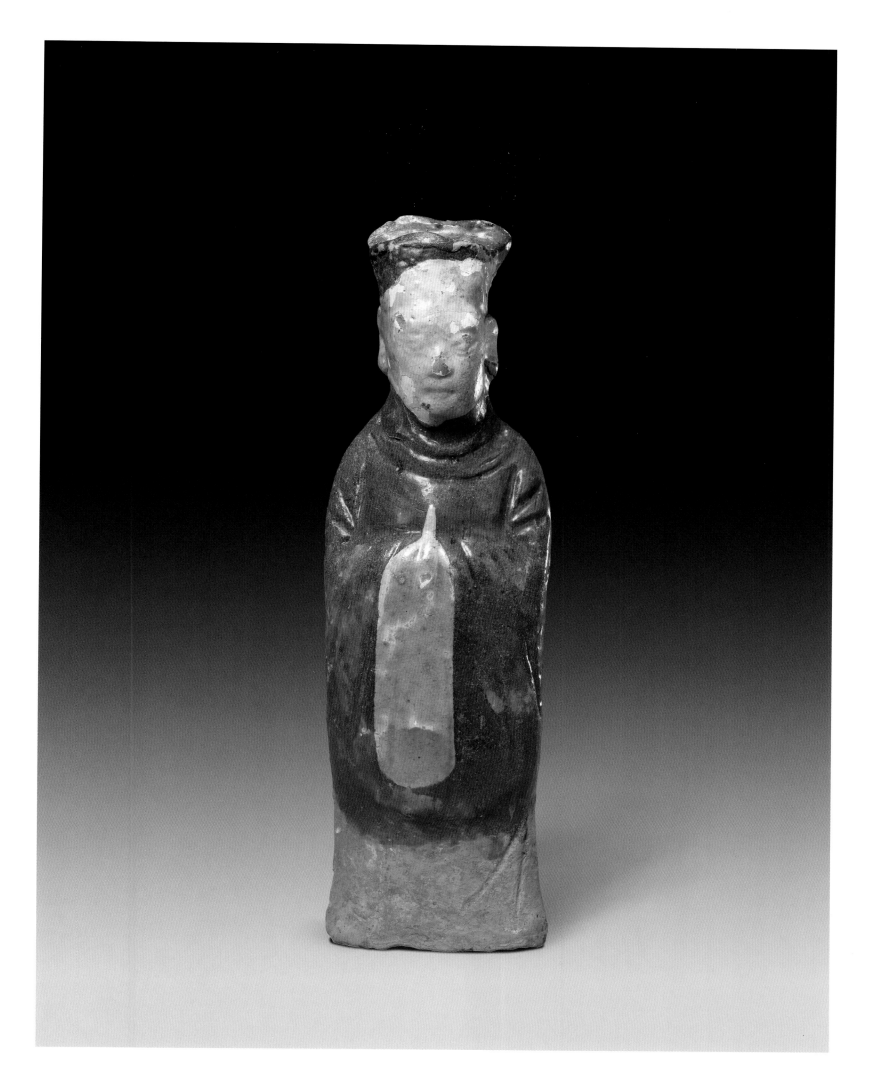

新201748

三彩男俑

宋

高20厘米 底宽6厘米

4 | Xin 201748

Tricolor Male Figure
Song Dynasty (960-1279)
Height 20 cm
Bottom width 6 cm

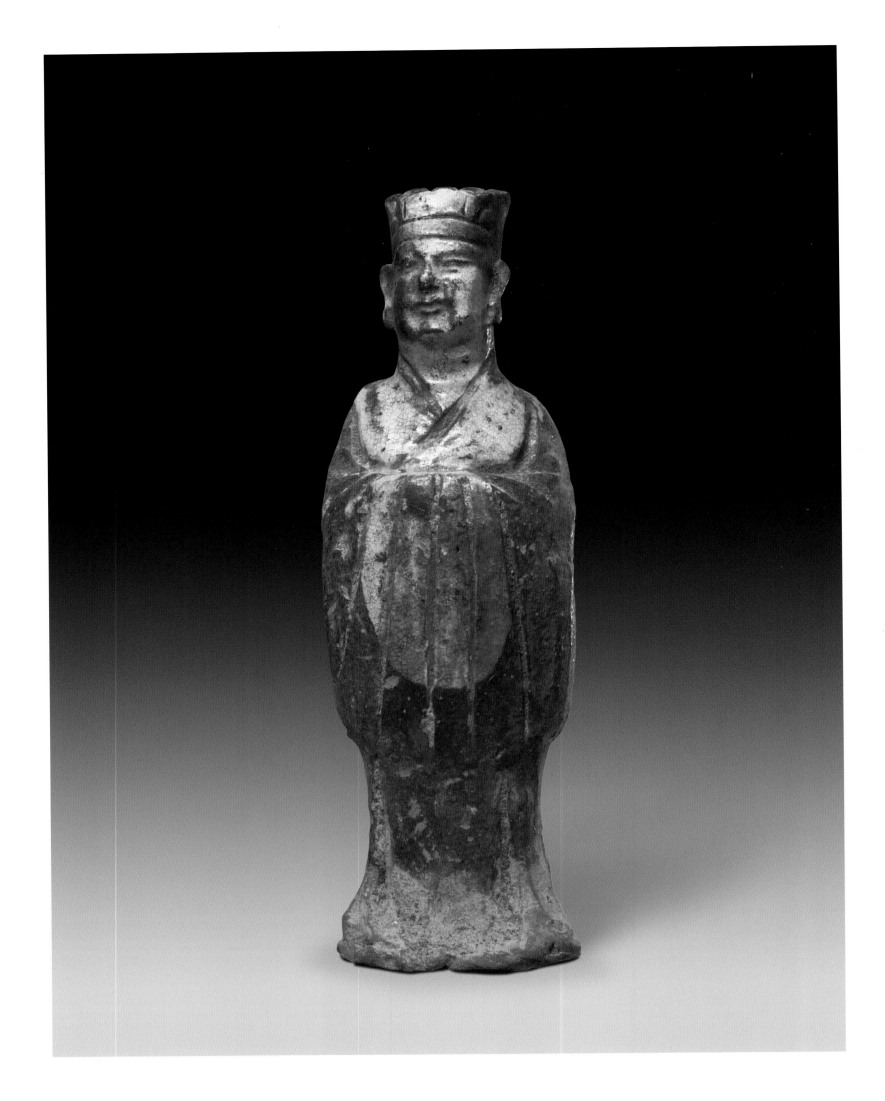

新 93103

三彩男俑

宋

高23厘米 底宽6.5厘米

5

Xin 93103

Tricolor Male Figure

Song Dynasty (960-1279)

Height 23 cm

Bottom width 6.5 cm

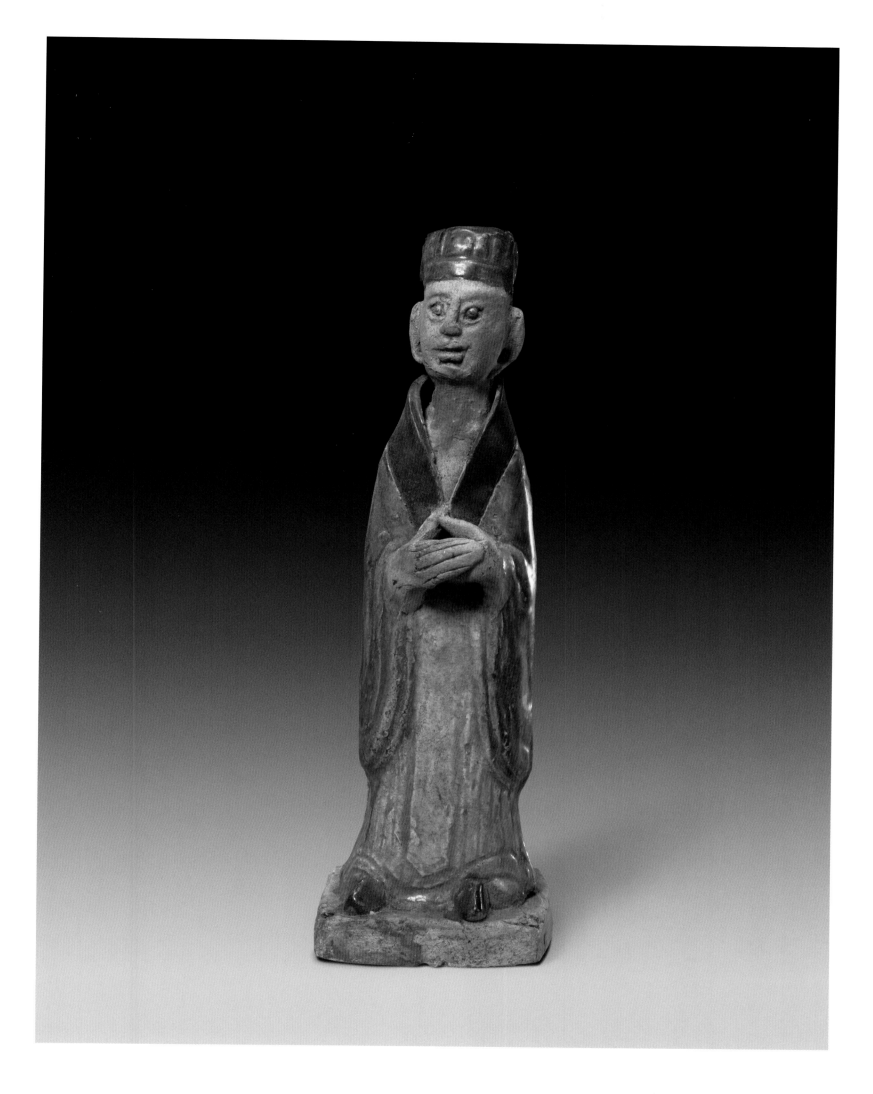

新137029
三彩男俑
宋

6 高21厘米 底宽6.5厘米

Xin 137029
Tricolor Male Figure
Song Dynasty (960-1279)
Height 21 cm
Bottom width 6.5 cm

25

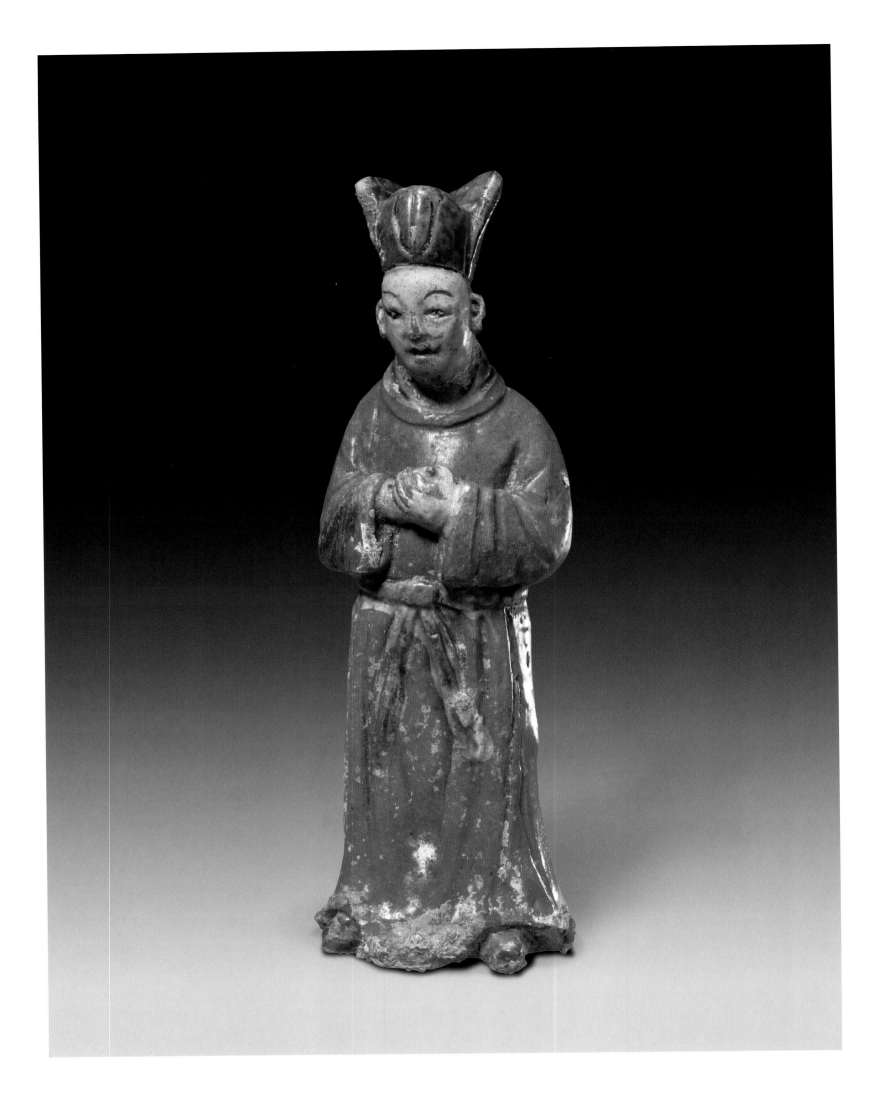

新82593

三彩男俑

宋

高23厘米 底宽7.3厘米

7 | Xin 82593

Tricolor Male Figure

Song Dynasty (960-1279)

Height 23 cm

Bottom width 7.3 cm

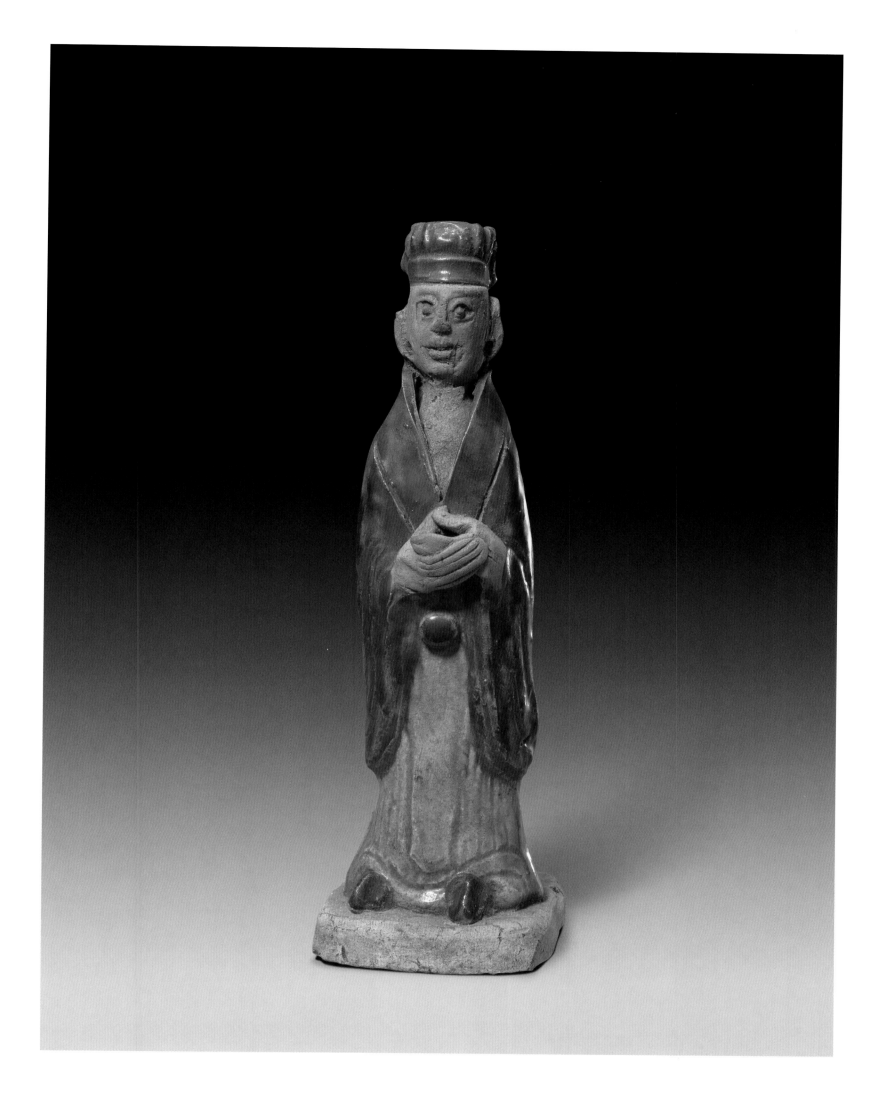

新137030

三彩男俑

宋

高20厘米 底宽6.2厘米

8

Xin 137030

Tricolor Male Figure

Song Dynasty (960-1279)

Height 20 cm

Bottom width 6.2 cm

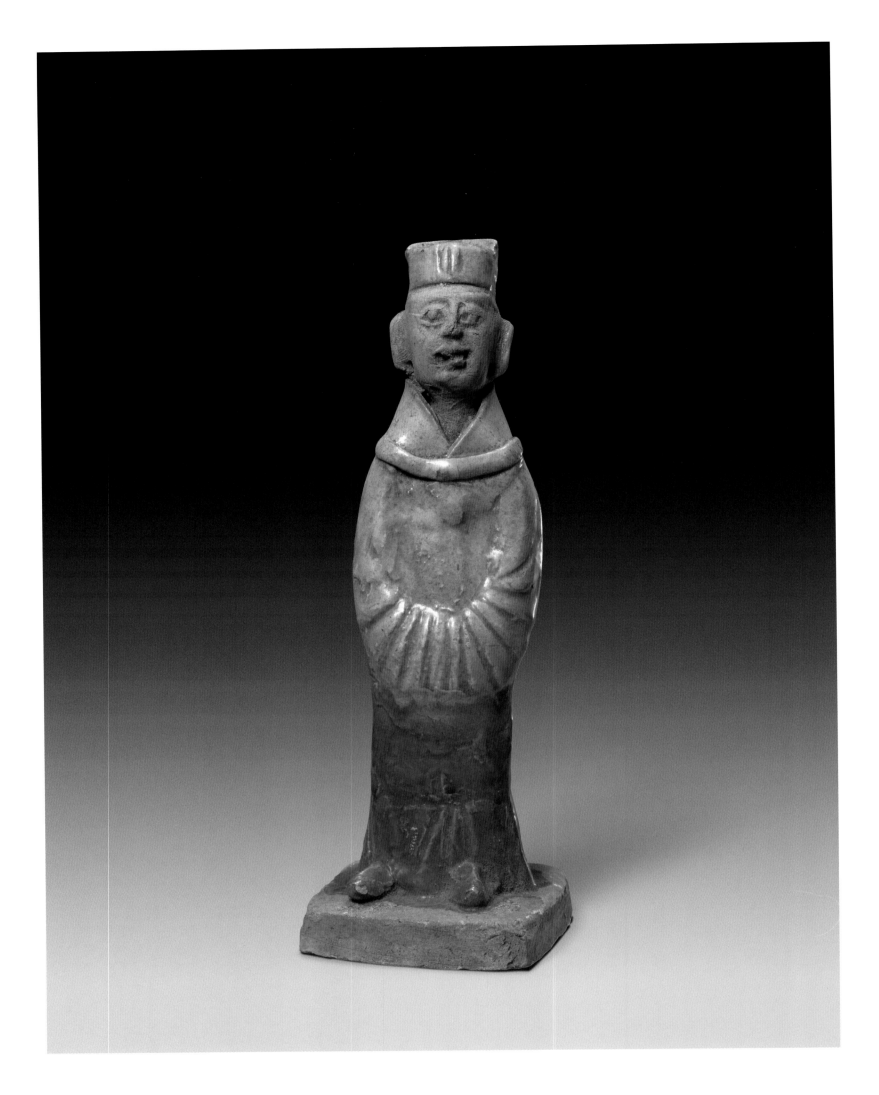

新137028

三彩男俑

宋

高20厘米 底宽6.5厘米

9 | Xin 137028
Tricolor Male Figure
Song Dynasty (960-1279)
Height 20 cm
Bottom width 6.5 cm

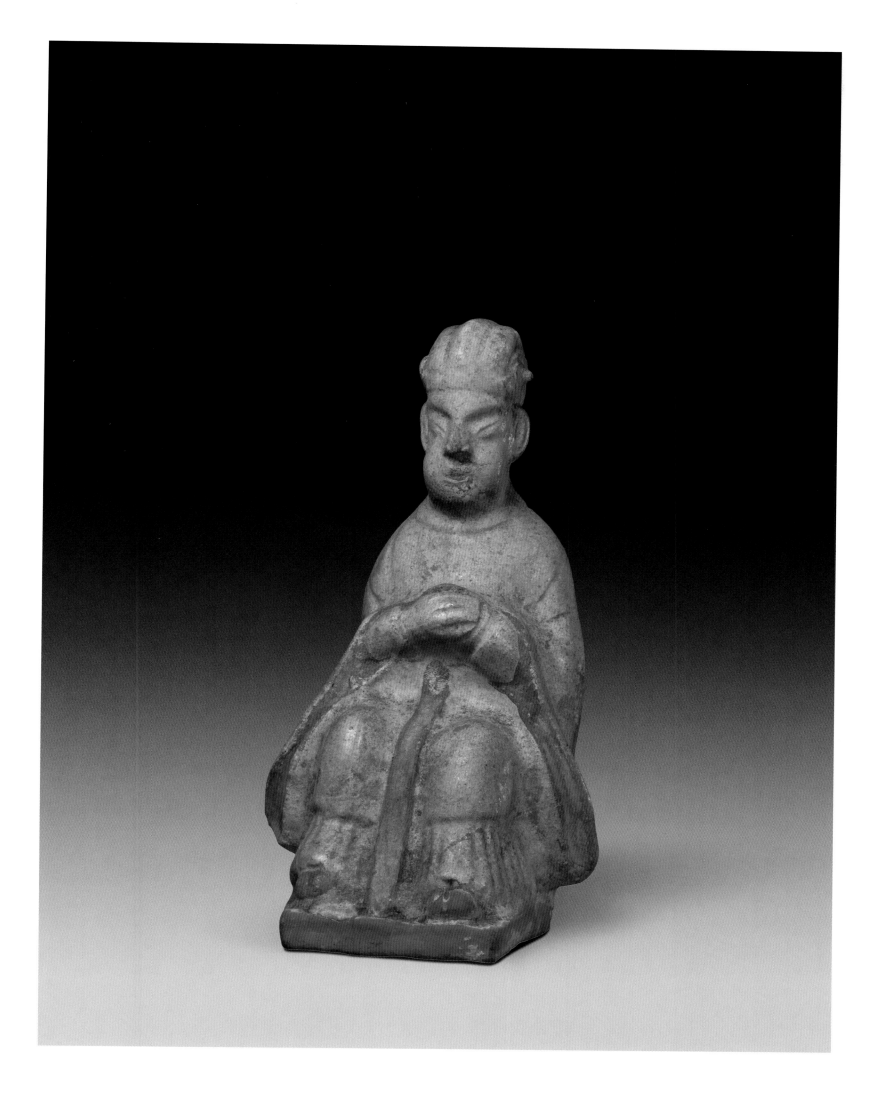

新142336
陶绿釉男俑
宋

高17.5厘米 底宽5.5厘米

10

Xin 142336
Green Glazed Pottery Male Figure
Song Dynasty (960-1279)
Height 17.5 cm
Bottom width 5.5 cm

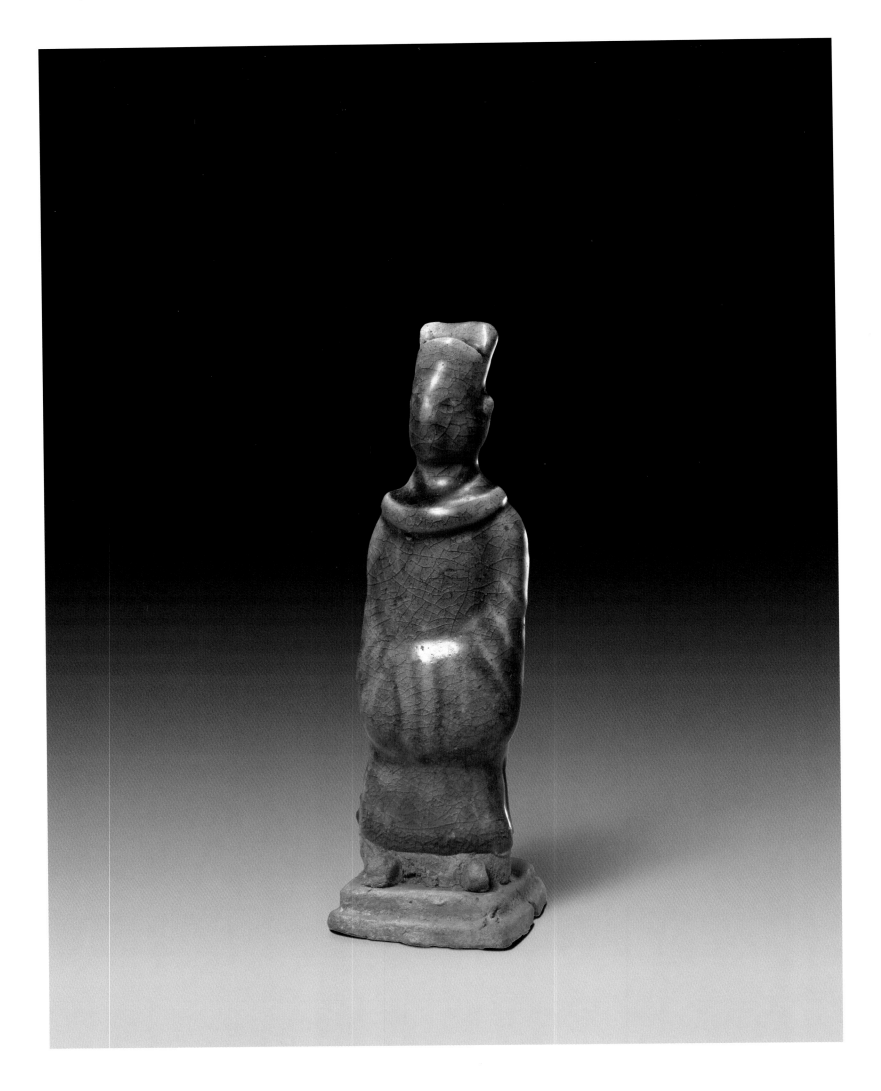

新137031
陶蓝釉男俑
宋

高17厘米 底宽5厘米

11

Xin 137031
Blue Glazed Pottery Male Figure
Song Dynasty (960-1279)
Height 17 cm
Bottom width 5 cm

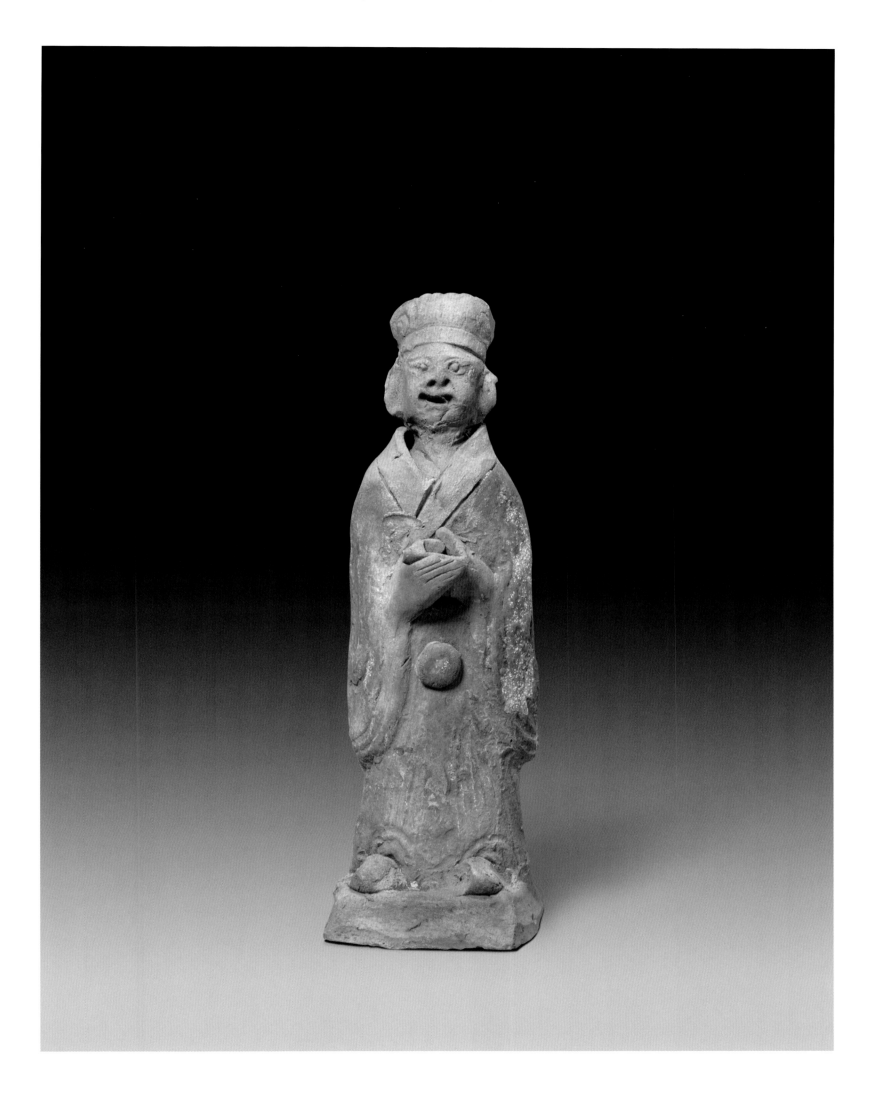

新54986

陶男俑

宋

高18厘米 底宽5.2厘米

12

Xin 54986

Pottery Male Figure

Song Dynasty (960-1279)

Height 18 cm

Bottom width 5.2 cm

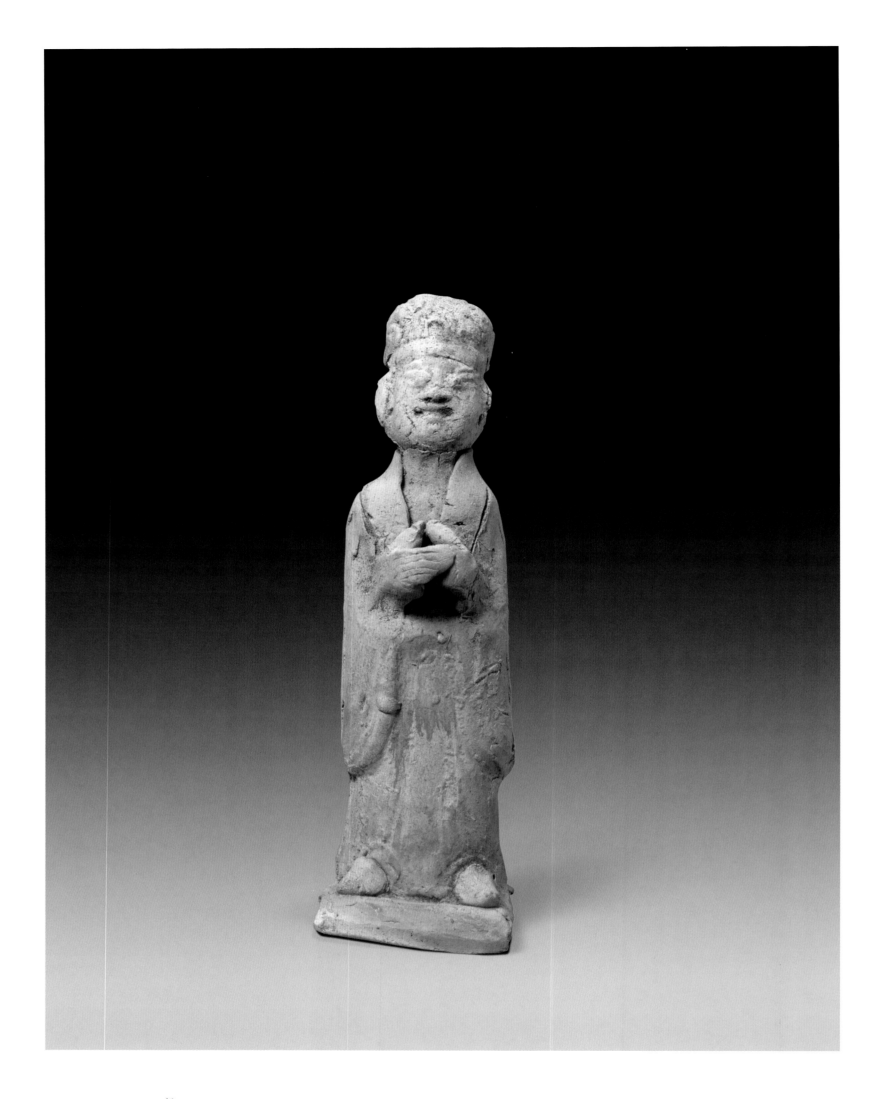

新124447

陶男俑

宋

高18厘米 底宽5厘米

13

Xin 124447

Pottery Male Figure

Song Dynasty (960-1279)

Height 18 cm

Bottom width 5 cm

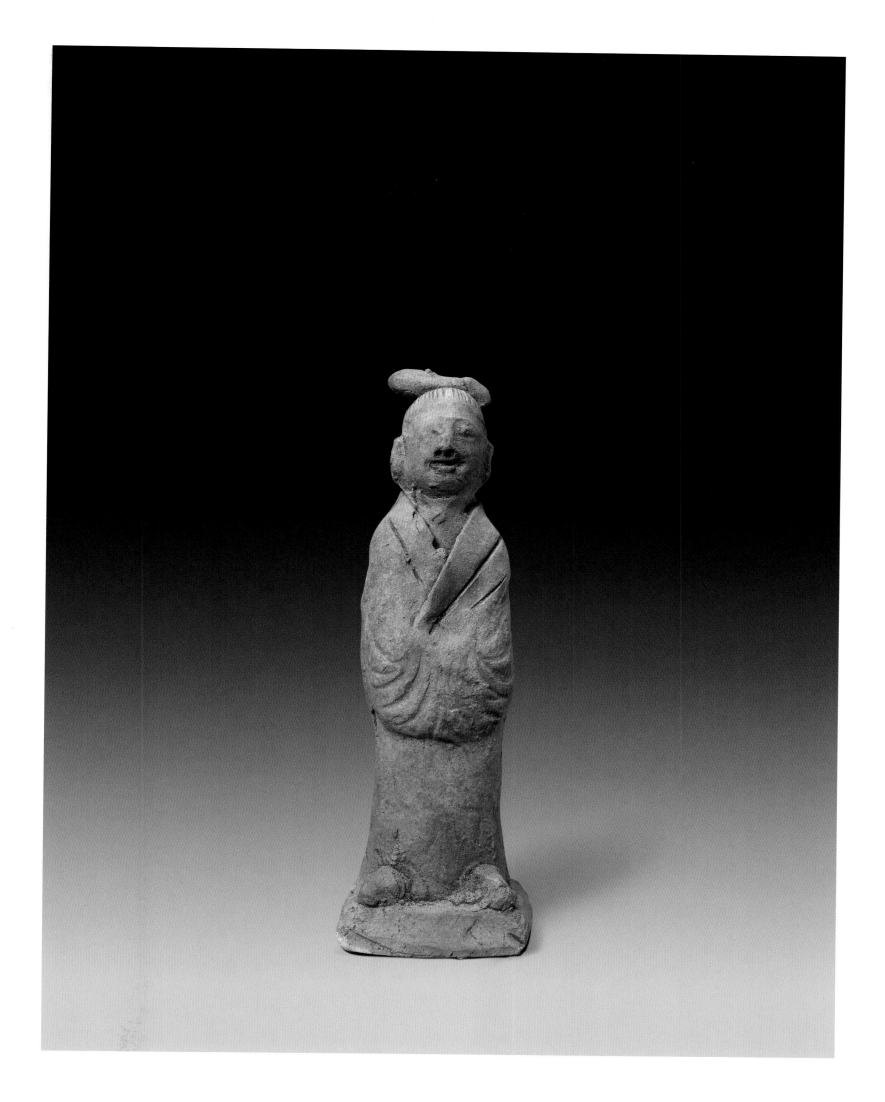

新85295
陶男俑
宋

高16厘米　底宽5厘米

14

Xin 85295

Pottery Male Figure
Song Dynasty (960-1279)
Height　16 cm
Bottom width　5 cm

陶男俑（背面）
Pottery Male Figure（back）

新54994

陶男俑

宋

高16厘米 底宽4.7厘米

15

Xin 54994

Pottery Male Figure

Song Dynasty (960-1279)

Height 16 cm

Bottom width 4.7 cm

陶男俑（侧面）
Pottery Male Figure（side）

新85292

陶男俑

宋

高27.5厘米 底宽5厘米

16

Xin 85292

Pottery Male Figure

Song Dynasty (960-1279)

Height 27.5 cm

Bottom width 5 cm

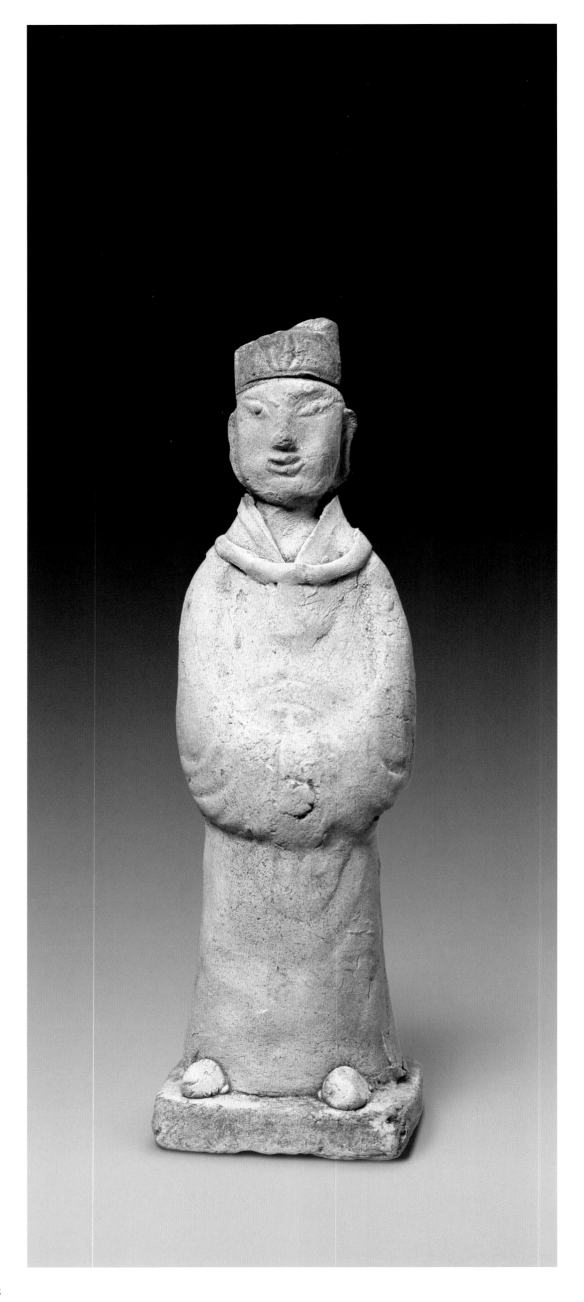

新124450
陶男俑
宋

高23厘米　底宽6.5厘米

17

Xin 124450
Pottery Male Figure
Song Dynasty (960-1279)
Height　23 cm
Bottom width　6.5 cm

新87089

陶男俑

宋

高31厘米　底宽9厘米

18

Xin 87089

Pottery Male Figure
Song Dynasty (960-1279)

Height 31 cm
Bottom width 9 cm

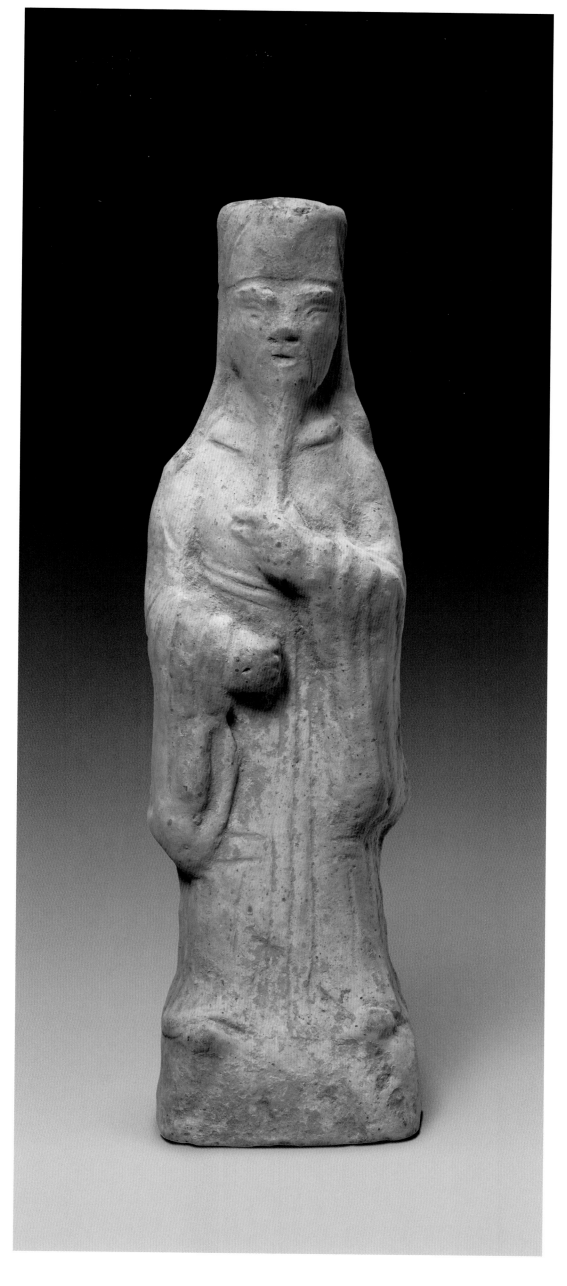

新59015
陶彩绘男俑
宋

高4.5厘米　底宽2.5厘米

19 Xin 59015

Painted Pottery Male Figure
Song Dynasty (960-1279)
Height 4.5 cm
Bottom width 2.5 cm

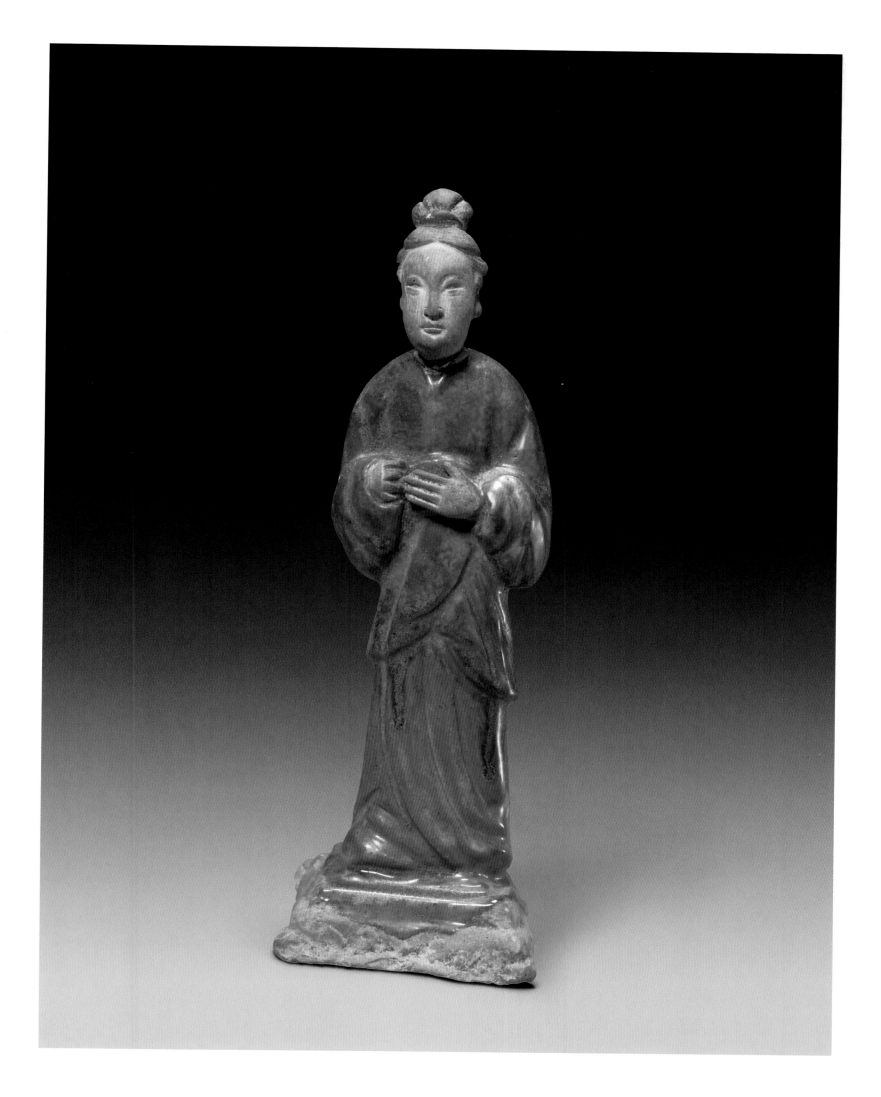

新180543
三彩女俑
宋

高23厘米 底宽7厘米

20

Xin 180543
Tricolor Female Figure
Song Dynasty (960-1279)
Height 23 cm
Bottom width 7 cm

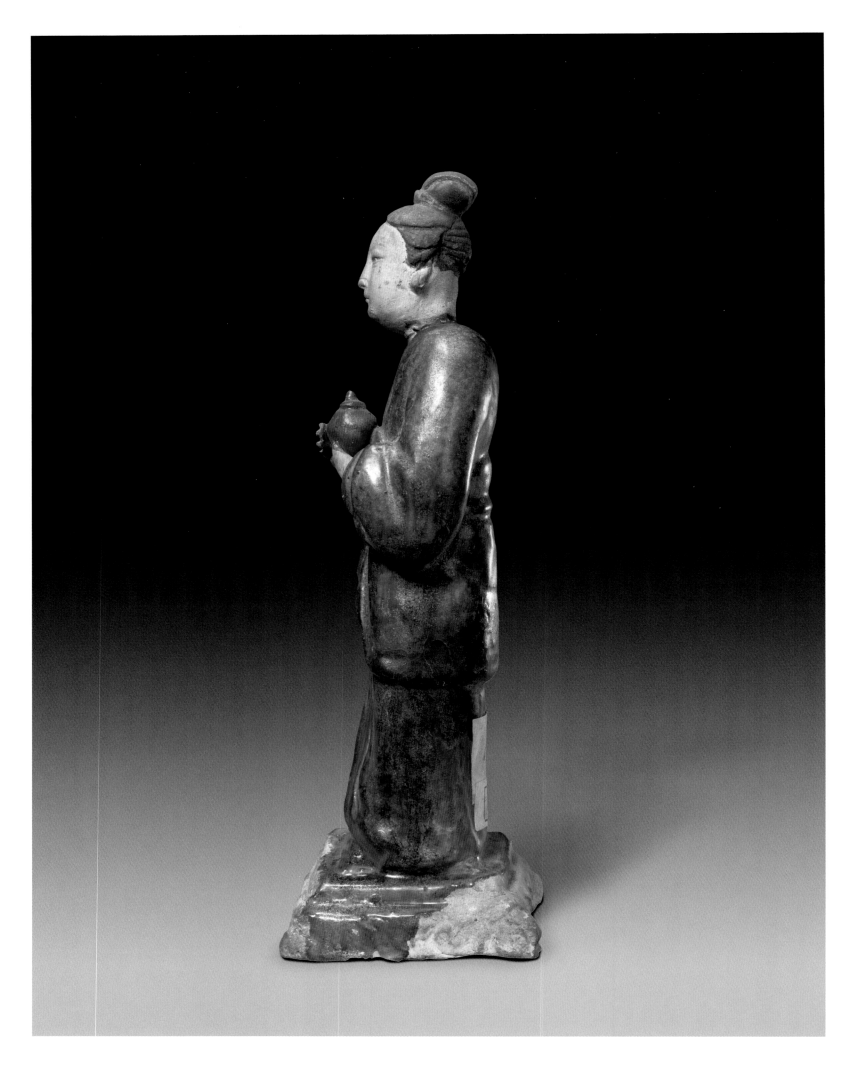

三彩女俑（侧面）
Tricolor Female Figure（side）

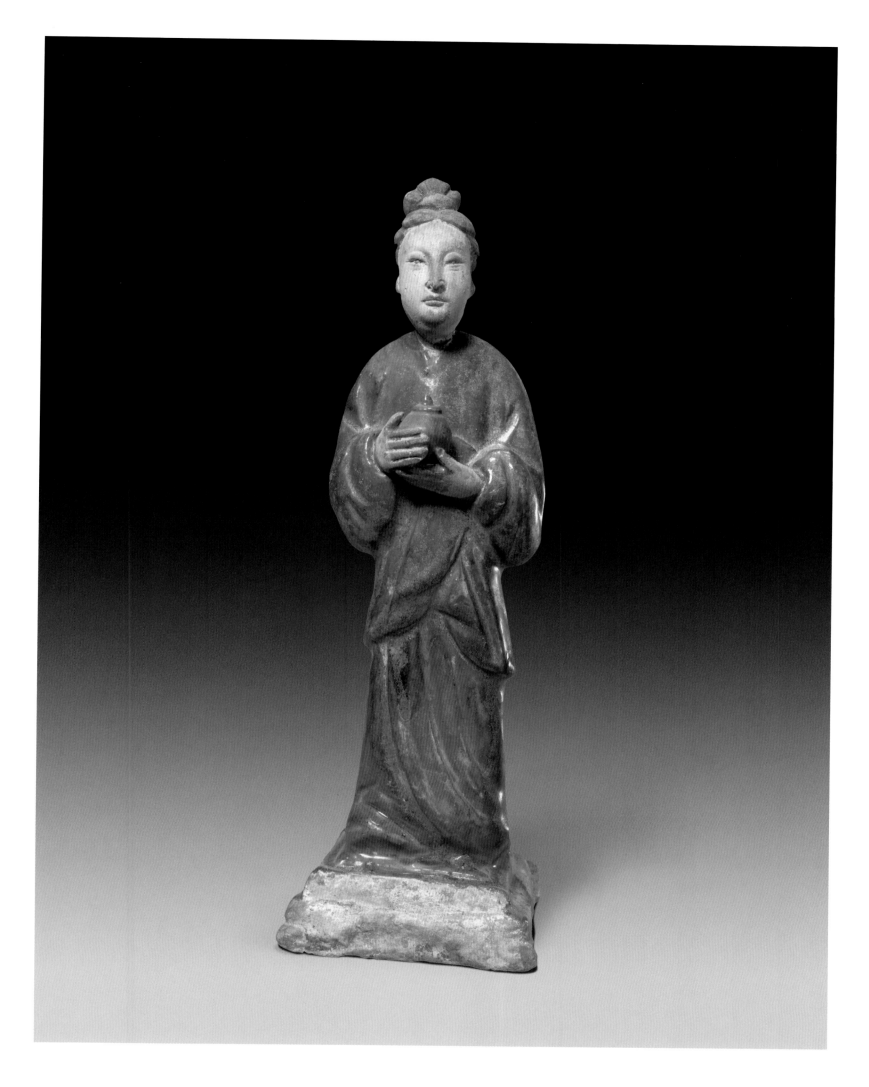

新180546

三彩女俑

宋

高24厘米　底宽7厘米

Xin 180546

Tricolor Female Figure

Song Dynasty (960-1279)

Height　24 cm

Bottom width　7 cm

21

新180544

三彩女俑

宋

高23.5厘米 底宽7厘米

22

Xin 180544

Tricolor Female Figure

Song Dynasty (960-1279)

Height 23.5 cm

Bottom width 7 cm

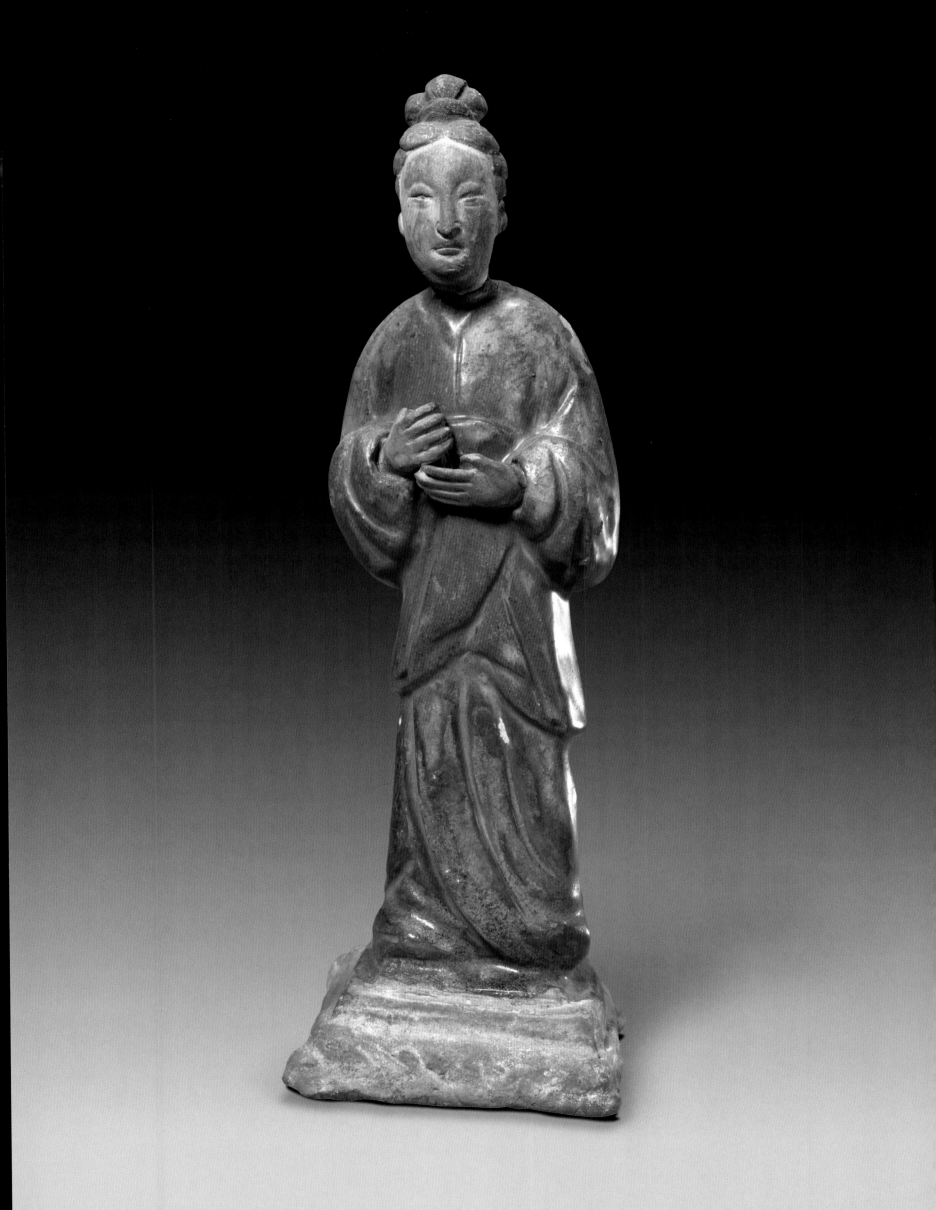

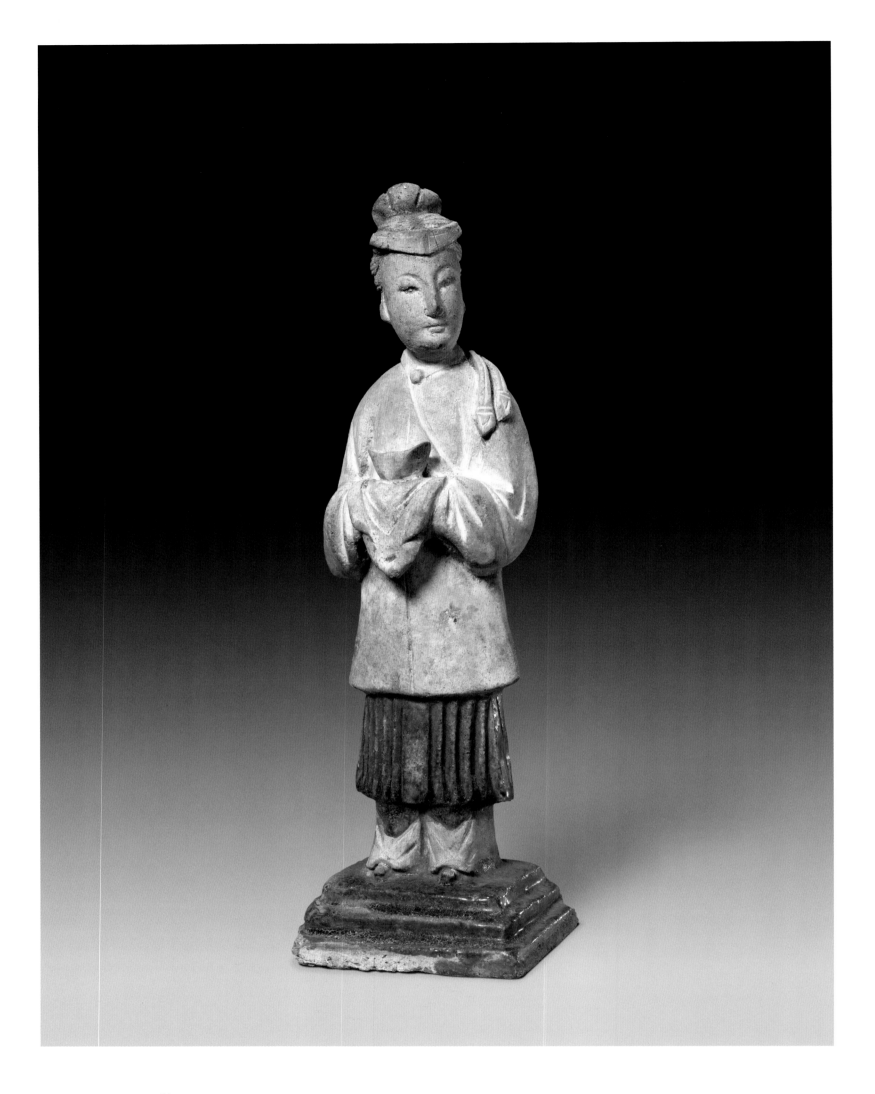

新135534
陶绿釉女俑
宋
高23.5厘米 底宽7.5厘米

23
Xin 135534
Green Glazed Pottery Female Figure
Song Dynasty (960-1279)
Height 23.5 cm
Bottom width 7.5 cm

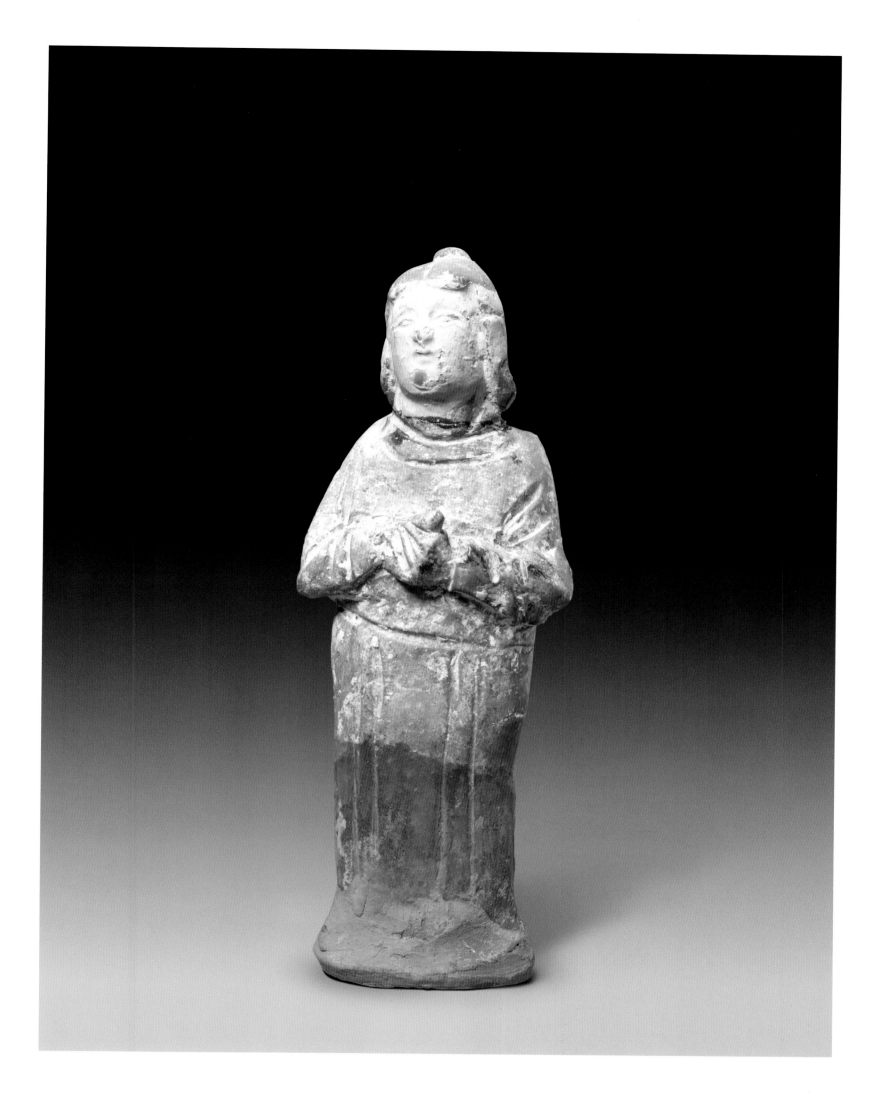

新201737

陶女俑

宋

高21厘米　底宽6厘米

24

Xin 201737

Pottery Female Figure

Song Dynasty (960-1279)

Height　21 cm

Bottom width　6 cm

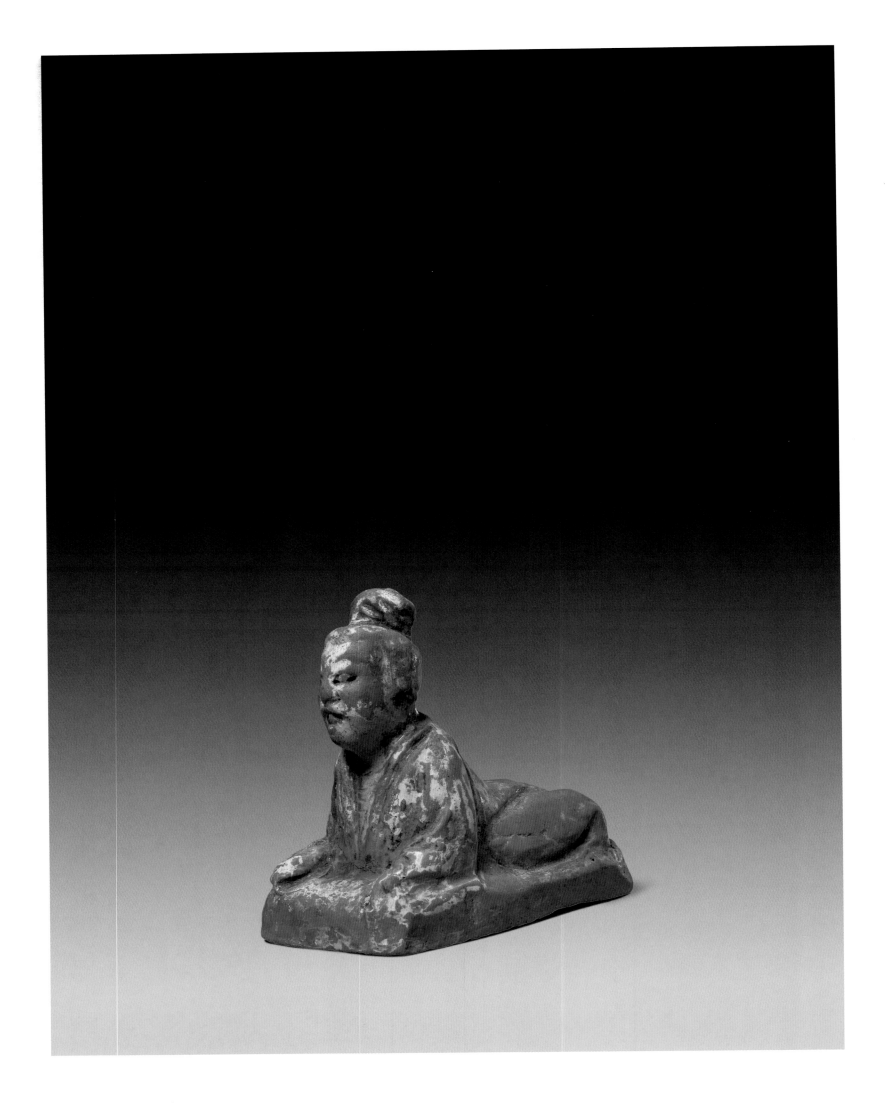

新57546

三彩女俑

宋

高10厘米 底宽5厘米

25

Xin 57546

Tricolor Female Figure

Song Dynasty (960-1279)

Height 10 cm

Bottom width 5 cm

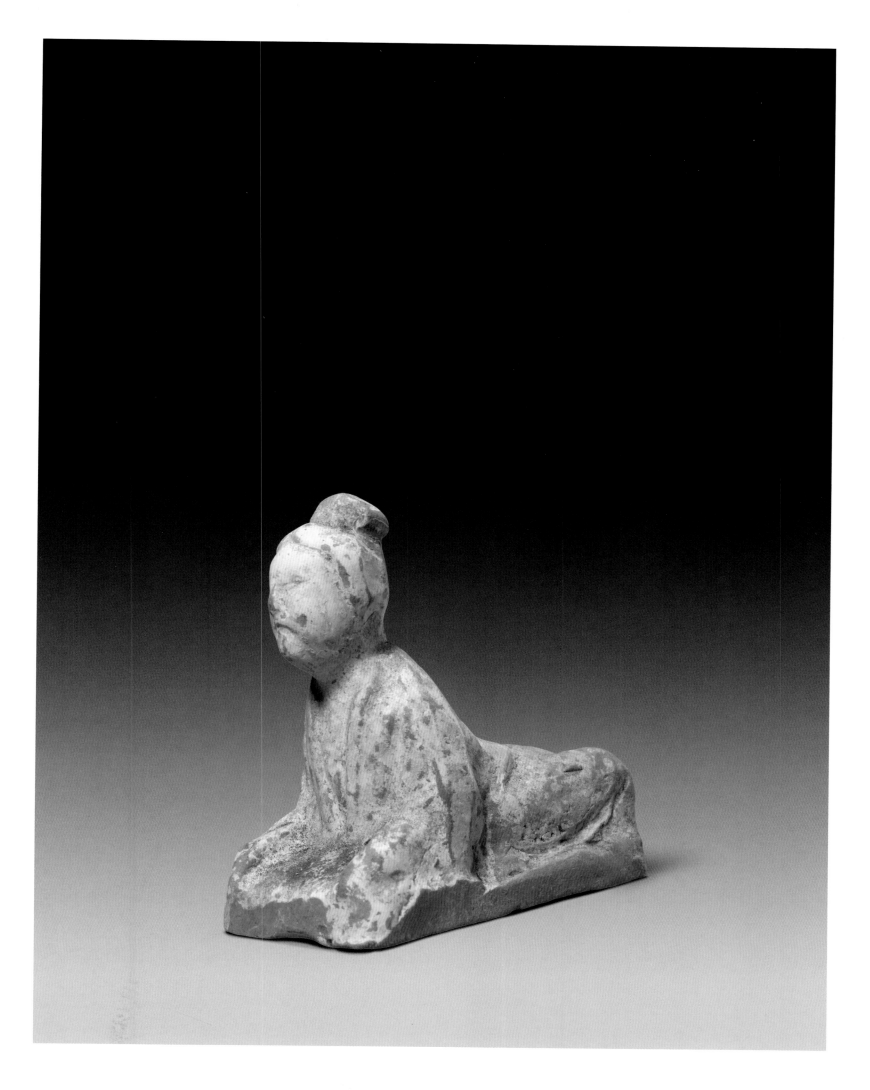

新124441
陶彩绘女俑
宋

高12.5厘米 底宽6.5厘米

26

Xin 124441
Painted Pottery Female Figure
Song Dynasty (960-1279)
Height 12.5 cm
Bottom width 6.5 cm

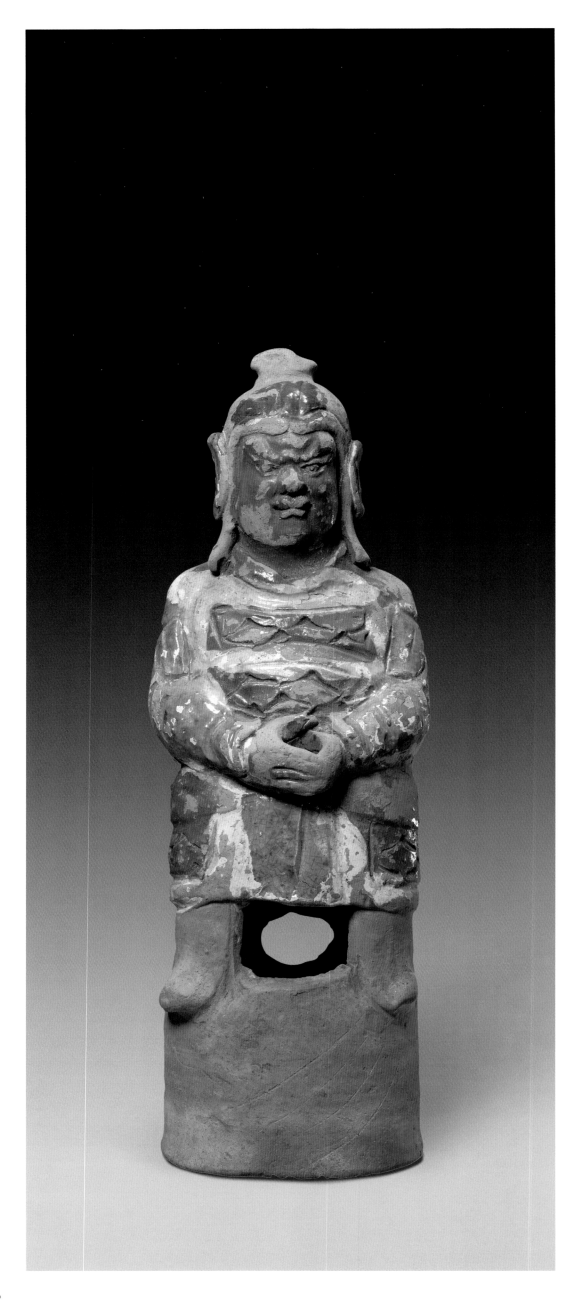

新82591

三彩武士俑
宋

高33.5厘米　底宽10厘米

Xin 82591

Tricolor Figure of a Warrior
Song Dynasty (960-1279)
Height 33.5 cm
Bottom width 10 cm

27

新93114
三彩武士俑
宋

28 | 高51厘米 底宽12.5厘米

Xin 93114
Tricolor Figure of a Warrior
Song Dynasty (960-1279)
Height 51 cm
Bottom width 12.5 cm

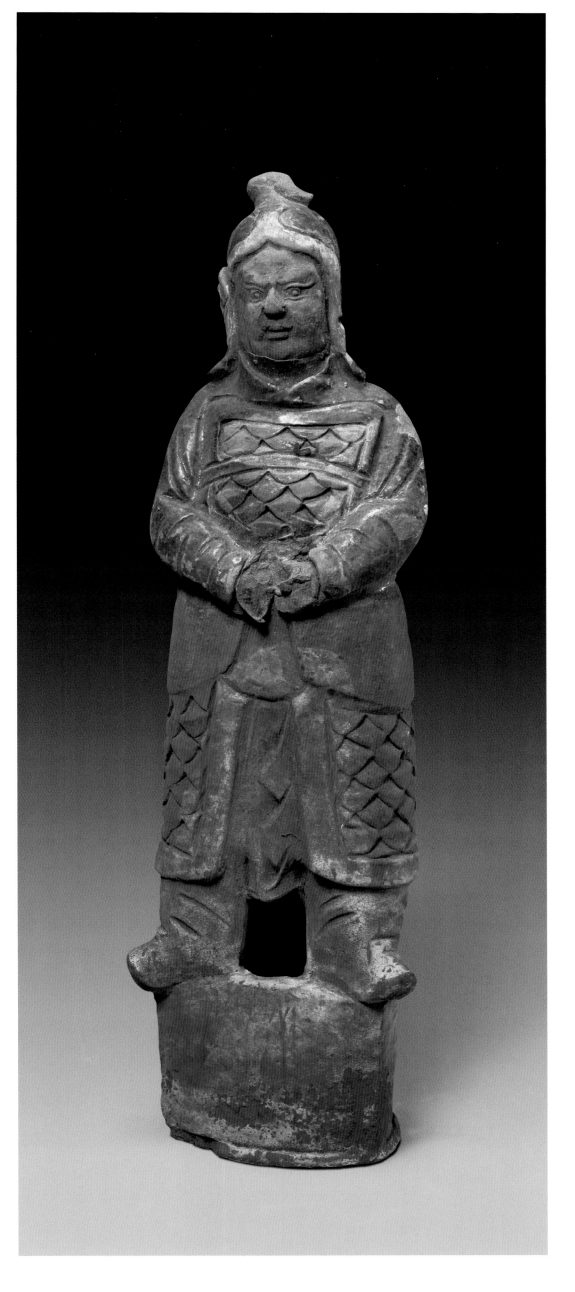

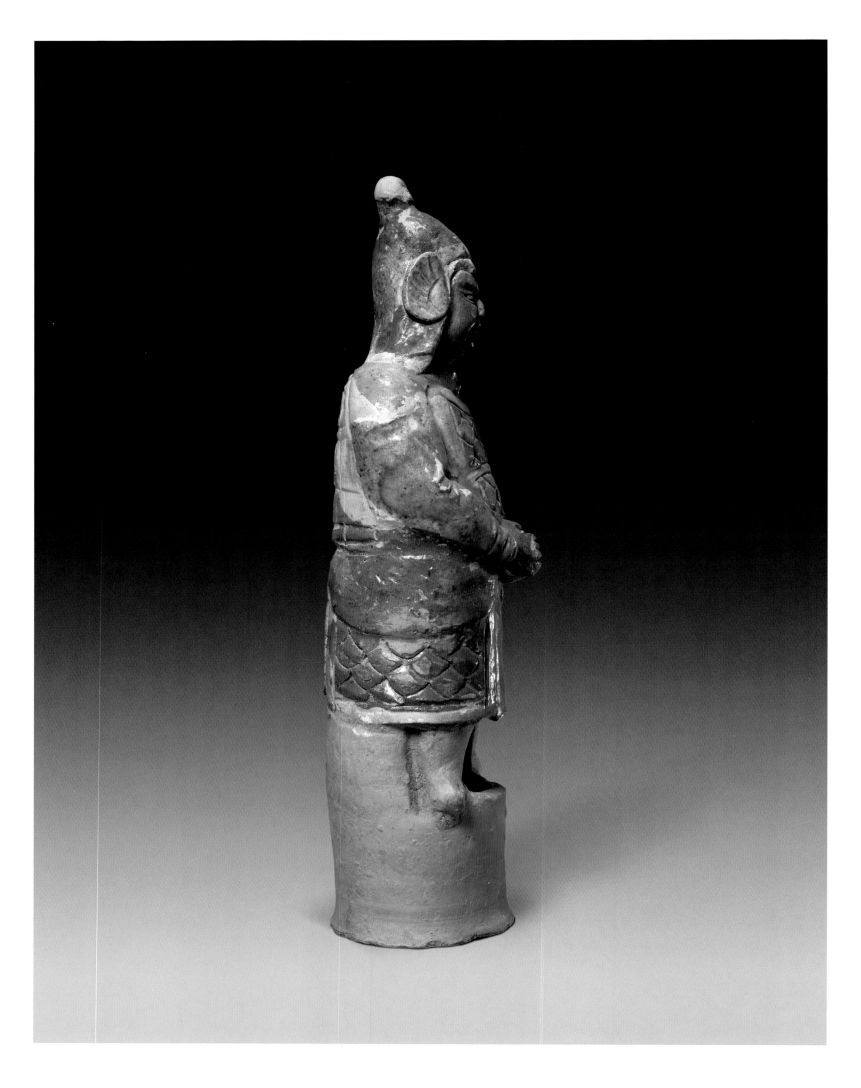

三彩武士俑（侧面）
Tricolor Figure of a Warrior（side）

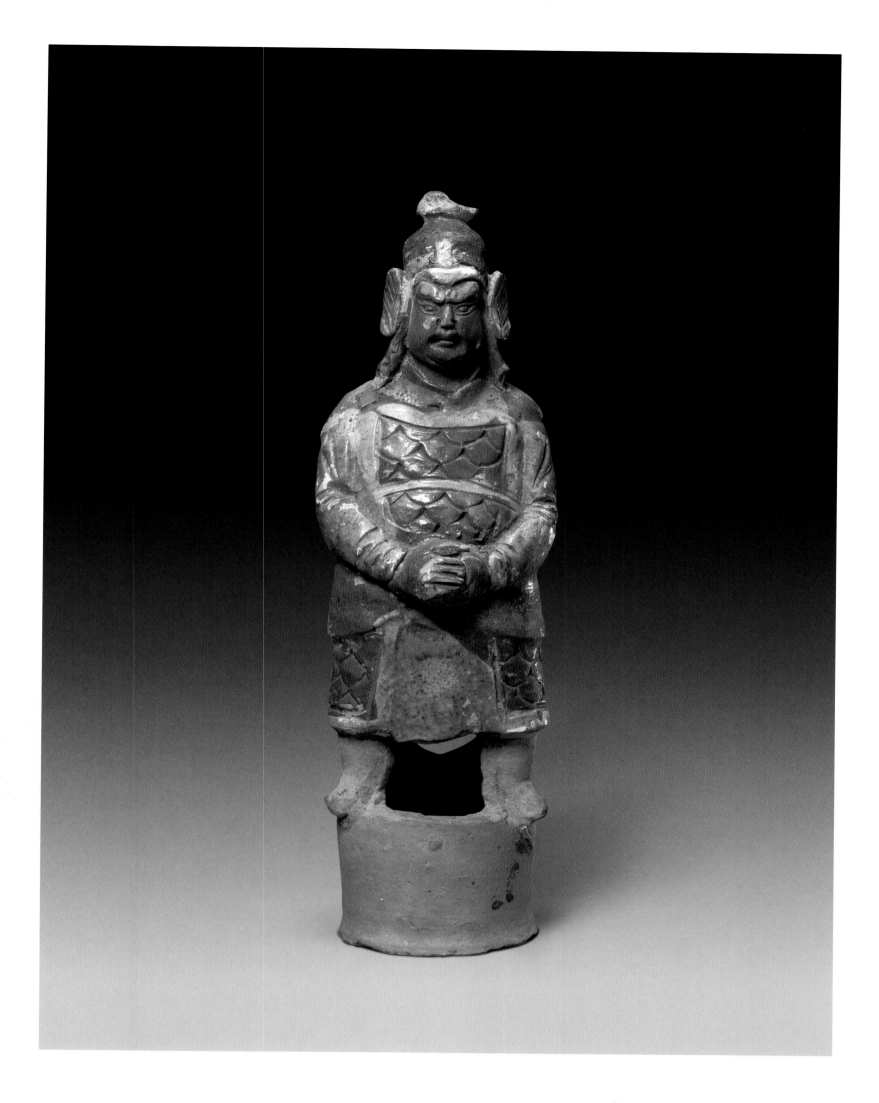

新82383

三彩武士俑

宋

高40厘米　底宽10.3厘米

29 | Xin 82383

Tricolor Figure of a Warrior

Song Dynasty (960-1279)

Height 40 cm

Bottom width 10.3 cm

新93115

三彩武士俑

宋

高48厘米　底宽12厘米

30

Xin 93115

Tricolor Figure of a Warrior

Song Dynasty (960-1279)

Height　48 cm

Bottom width　12 cm

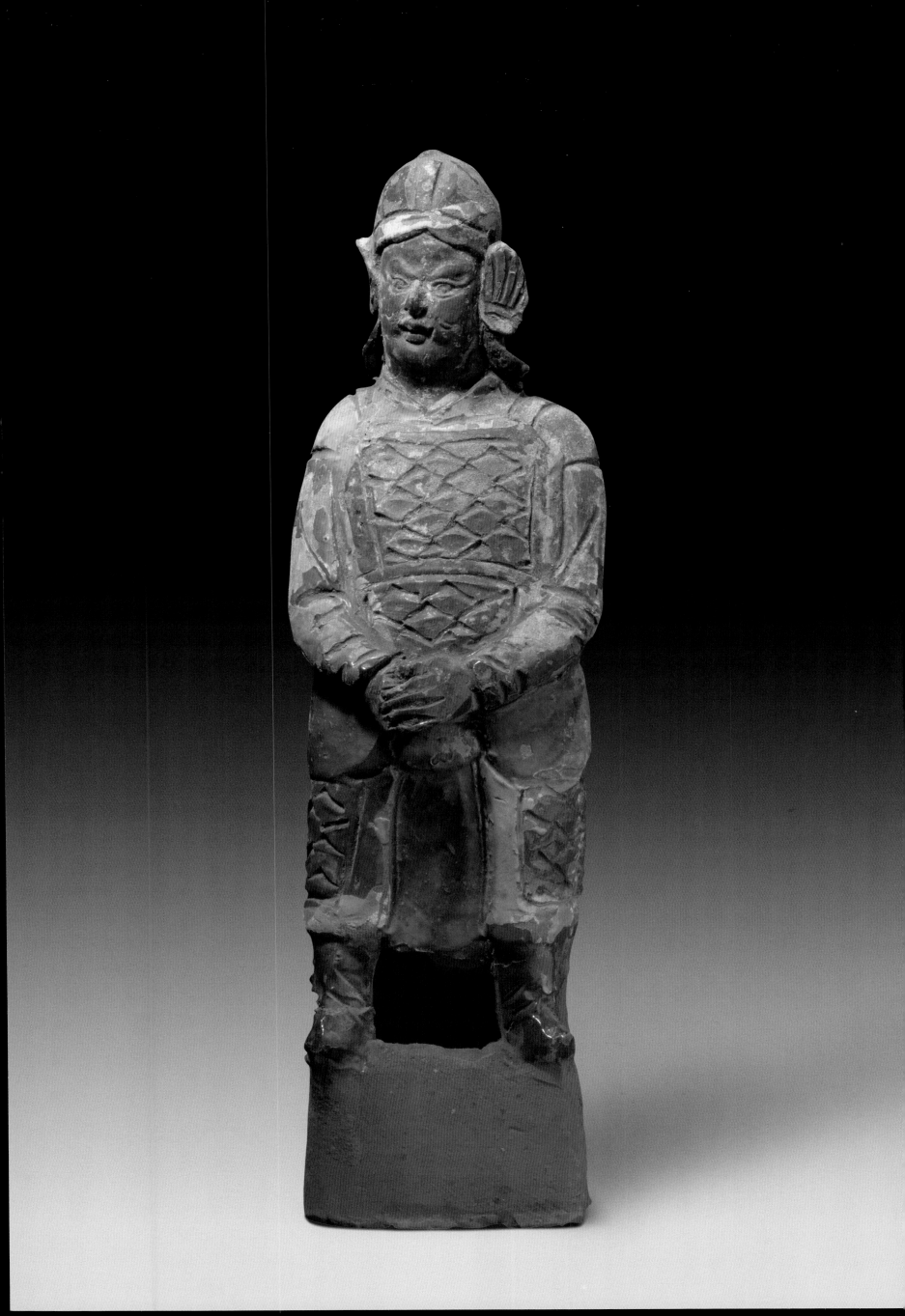

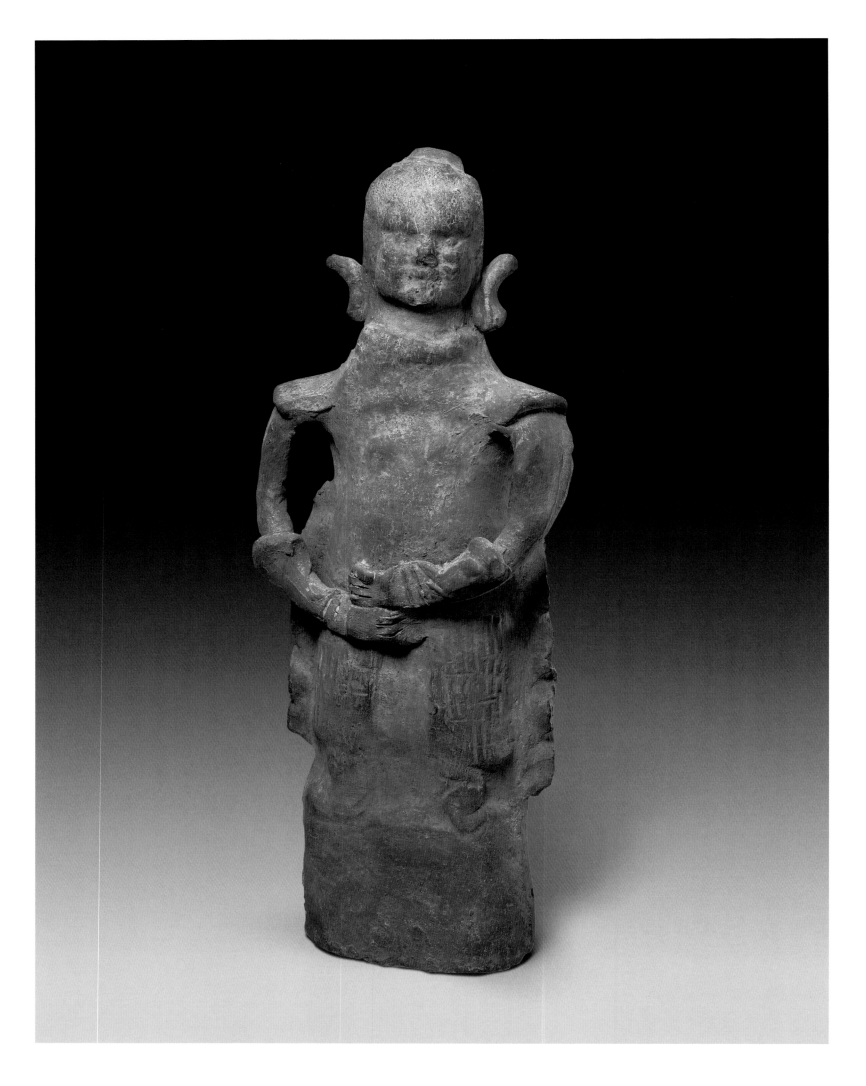

新86823
陶彩绘武士俑
宋

高41厘米 底宽12厘米

31

Xin 86823

Painted Pottery Figure of a Warrior
Song Dynasty (960-1279)
Height 41 cm
Bottom width 12 cm

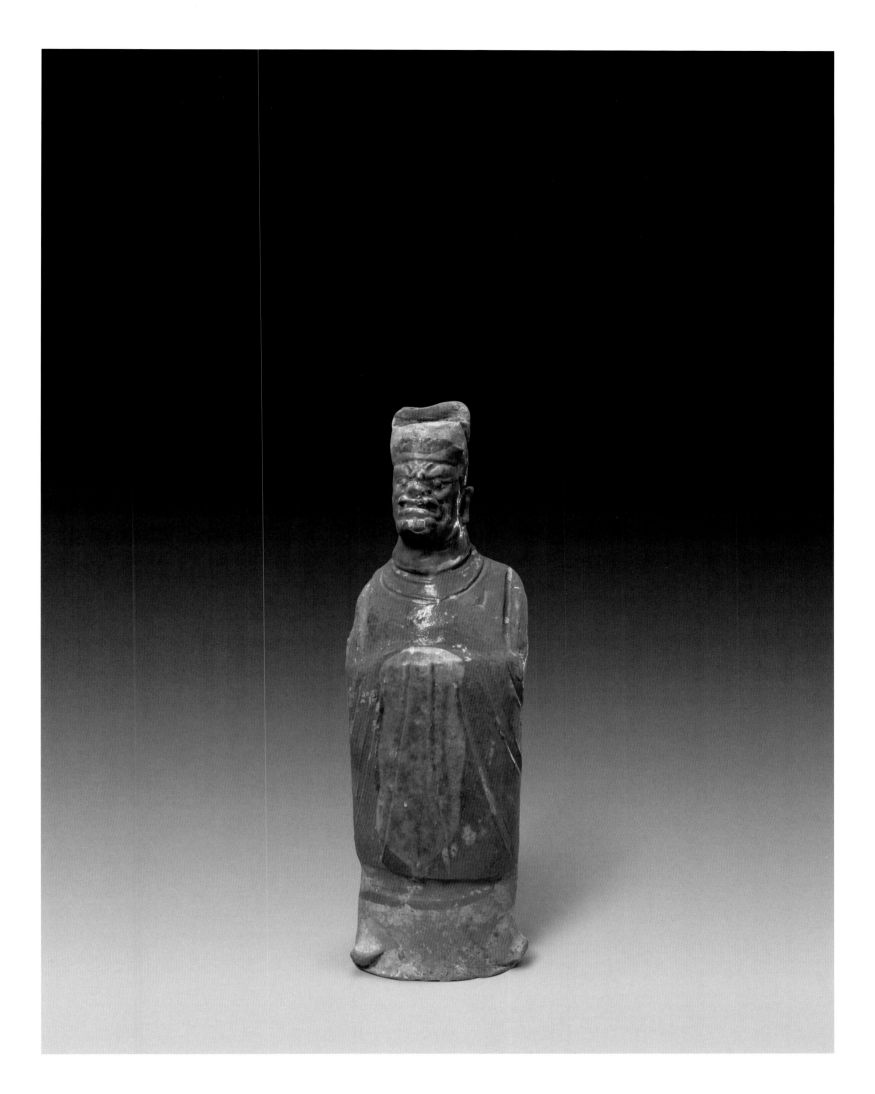

新99644
三彩猪首俑
宋
高22厘米　底宽6.5厘米

32

Xin 99644
Tricolor Figure with Pig's Head
Song Dynasty (960-1279)
Height 22 cm
Bottom width 6.5 cm

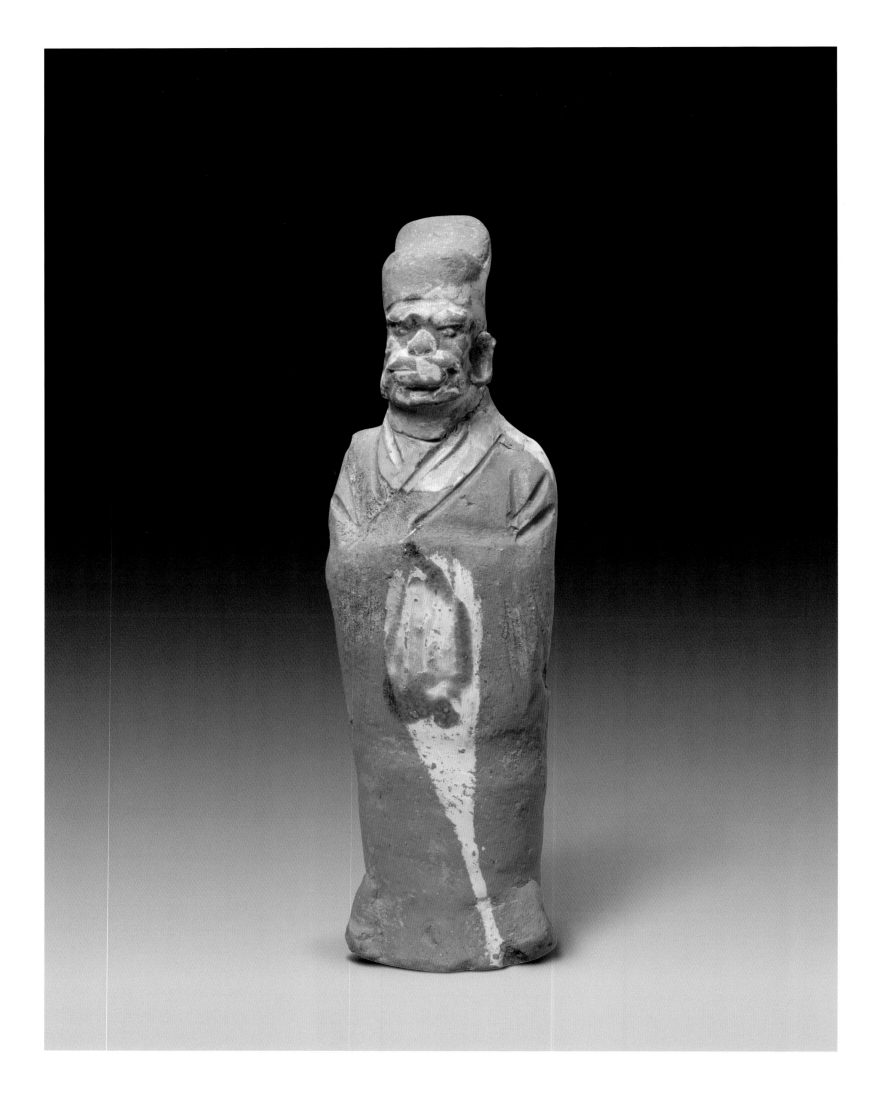

新201739

三彩猪首俑

宋

高21厘米　底宽5.5厘米

33 | Xin 201739

Tricolor Figure with Pig's Head

Song Dynasty (960-1279)

Height　21 cm

Bottom width　5.5 cm

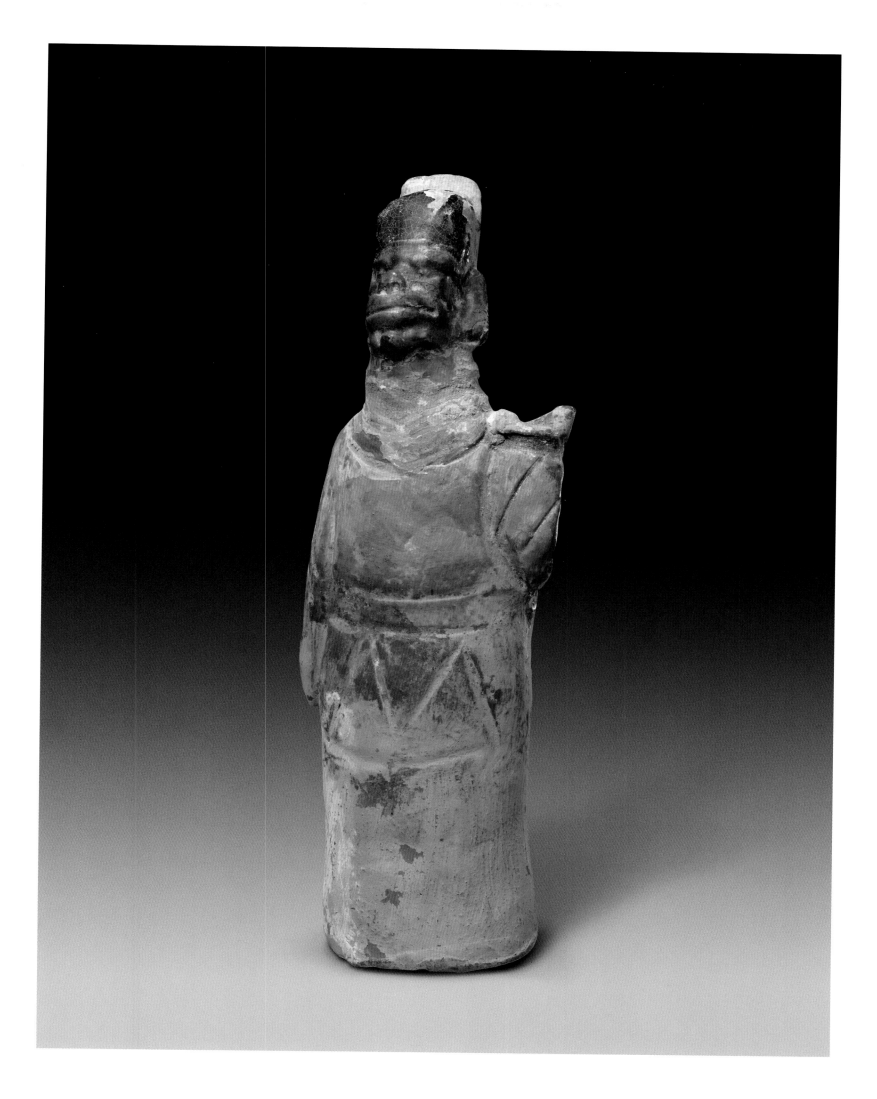

新201738

三彩猪首俑

宋

高22厘米 底宽5.5厘米

备注: 头身非原配

34 | Xin 201738

Tricolor Figure with Pig's Head

Song Dynasty (960-1279)

Height 22 cm

Bottom width 5.5 cm

The head and body was not of one piece originally

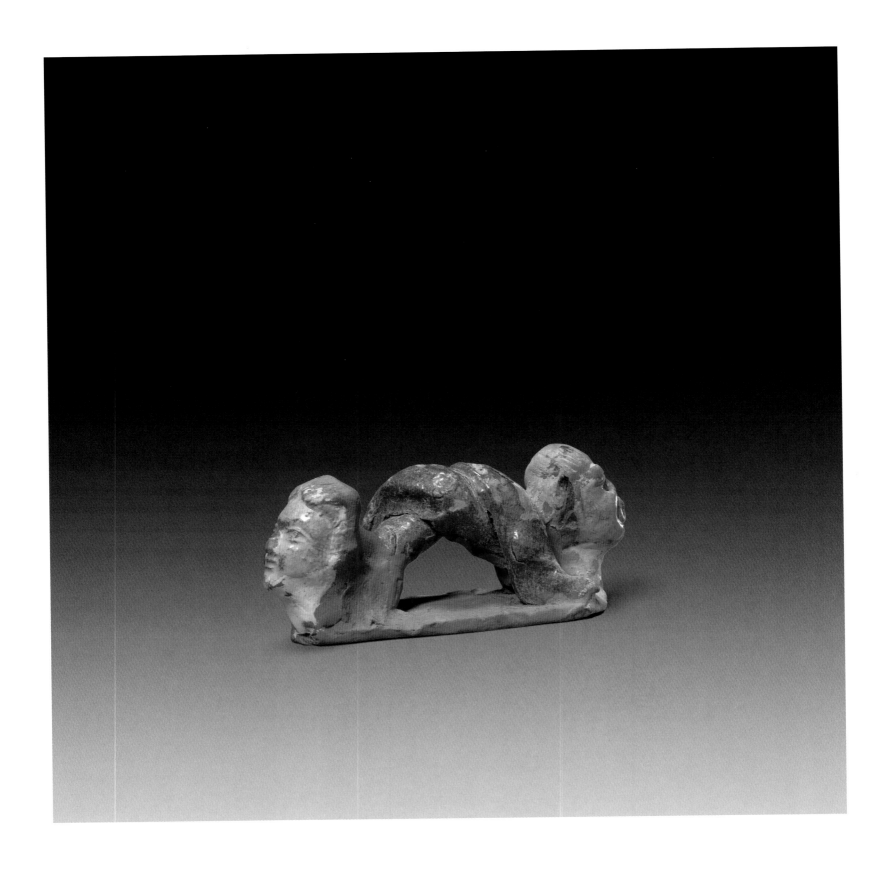

新201754
三彩蛇身双头俑
宋
高5.5厘米 底宽12厘米

35

Xin 201754
Tricolor Two-headed Figure with Snake Body
Song Dynasty (960-1279)
Height 5.5 cm
Bottom width 12 cm

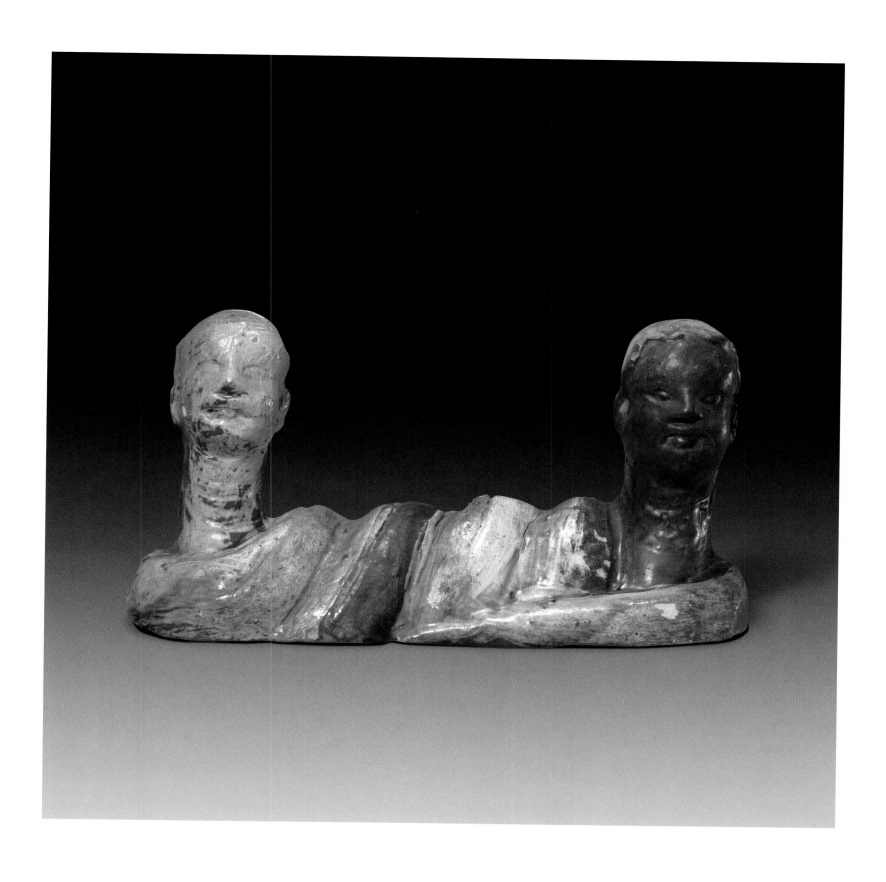

新82380
三彩蛇身双头俑
宋
高11.5厘米　底宽22厘米

36 Xin 82380
Tricolor Two-headed Figure with Snake Body
Song Dynasty (960-1279)
Height 11.5 cm
Bottom width 22 cm

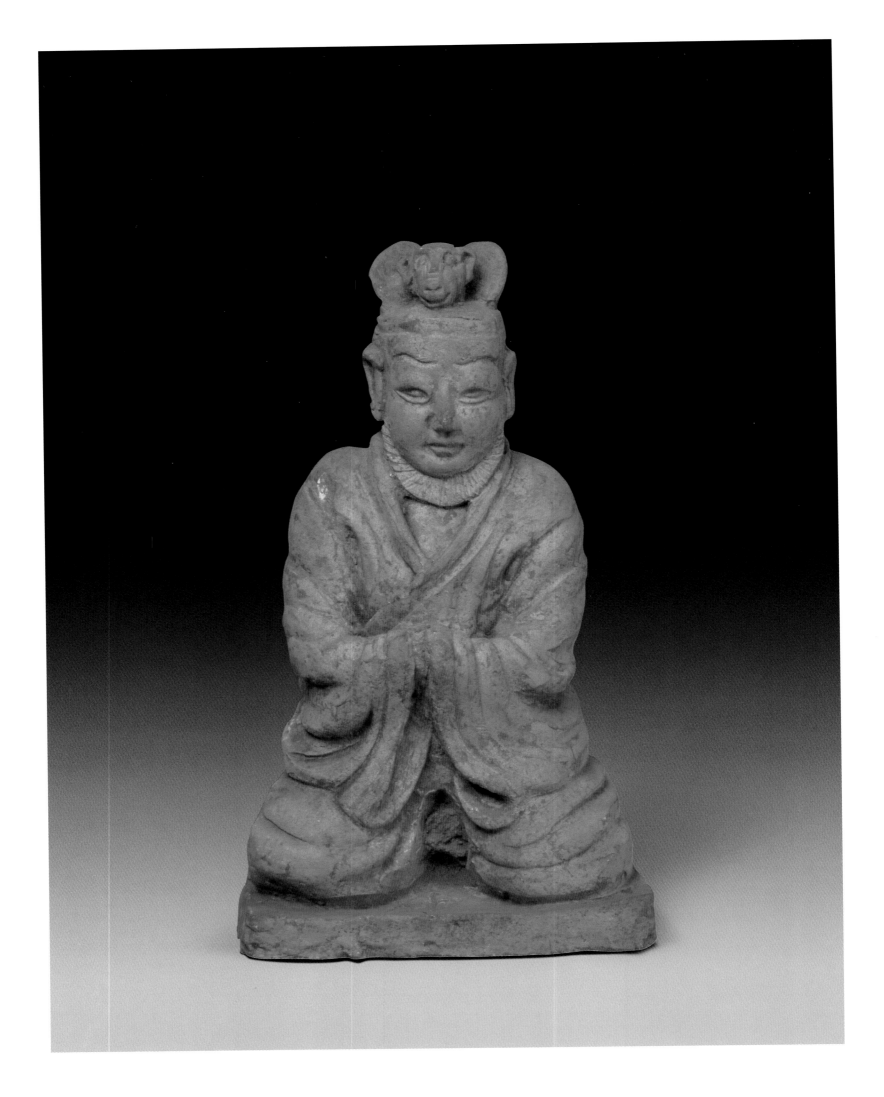

新142339
陶彩绘生肖俑
宋

高21厘米 底宽12厘米

37

Xin 142339
Painted Pottery Figure with Animal Zodiac Sign
Song Dynasty (960-1279)
Height 21 cm
Bottom width 12 cm

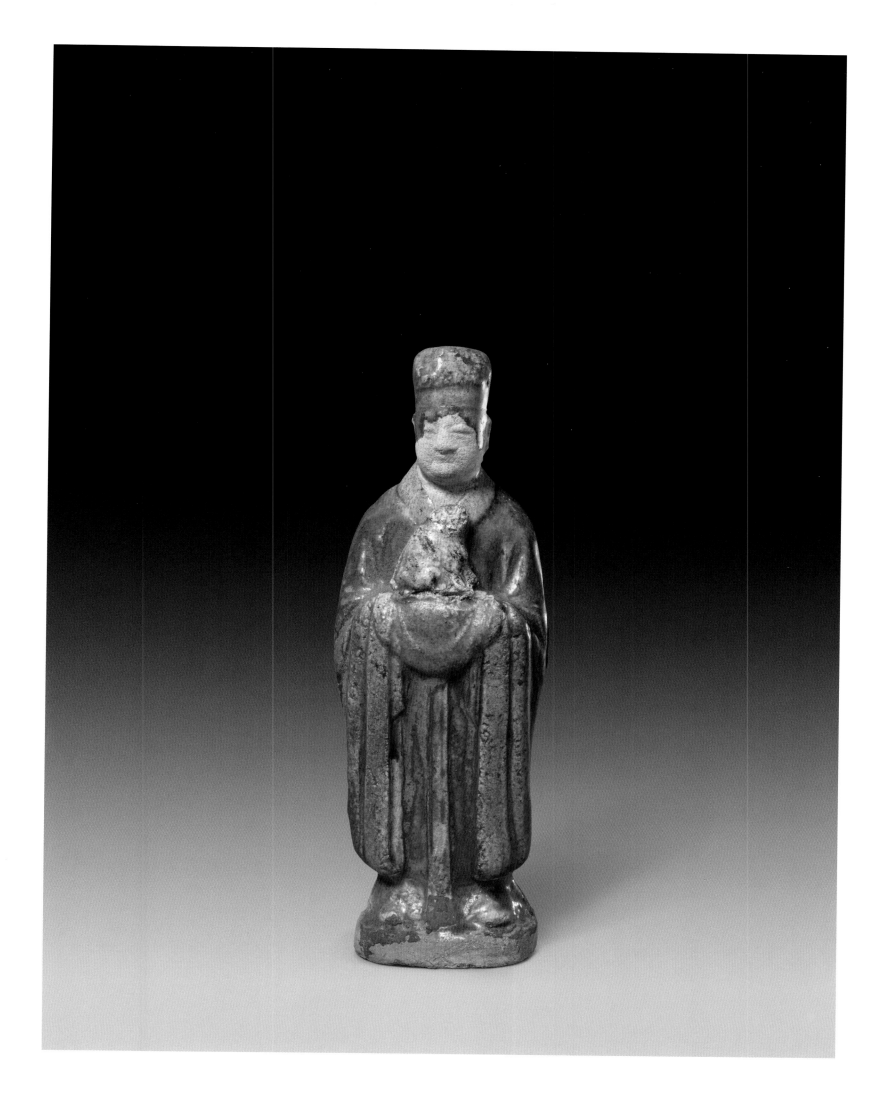

新135520

三彩生肖俑

宋

高17厘米　底宽5厘米

38

Xin 135520

Tricolor Figure with Animal Zodiac Sign

Song Dynasty (960-1279)

Height　17 cm

Bottom width　5 cm

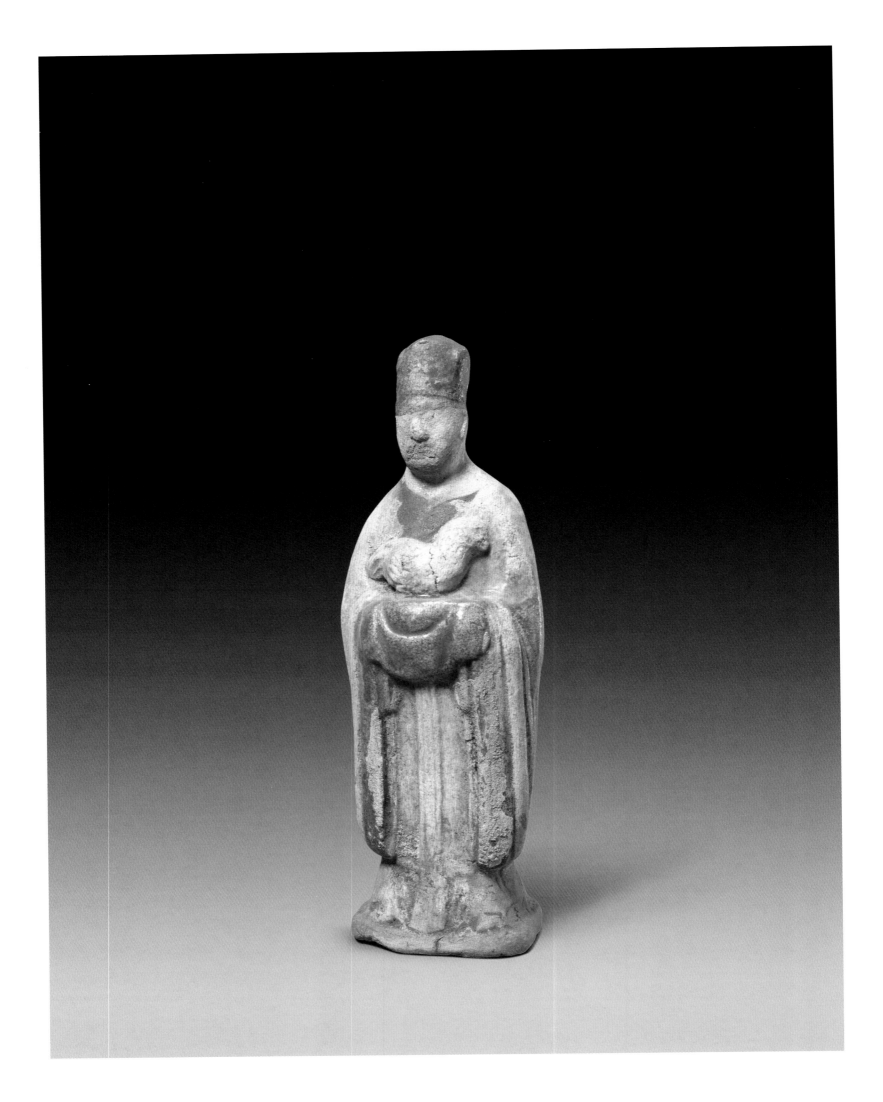

新135516
三彩生肖俑
宋
高17厘米 底宽4.8厘米

39 Xin 135516
Tricolor Figure with Animal Zodiac Sign
Song Dynasty (960-1279)
Height 17 cm
Bottom width 4.8 cm

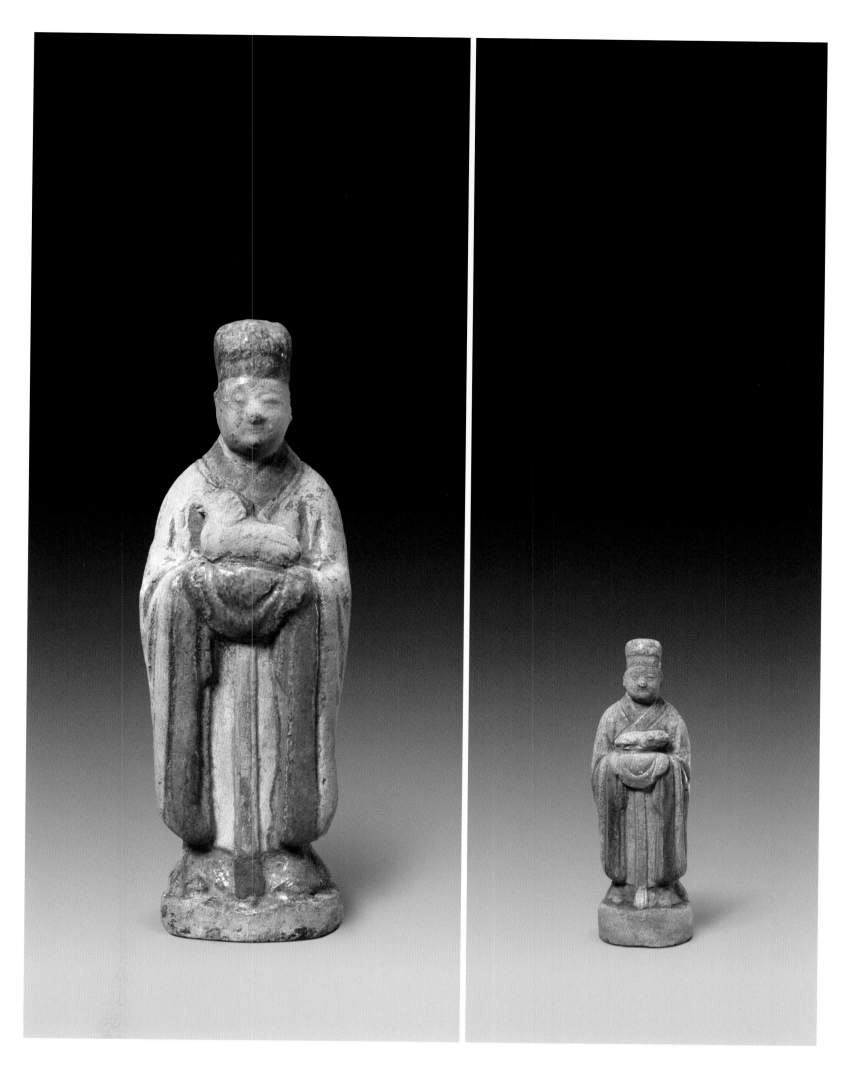

新135522

三彩生肖俑

宋

高17厘米 底宽5厘米

40 | Xin 135522

Tricolor Figure with Animal Zodiac Sign

Song Dynasty (960-1279)

Height 17 cm

Bottom width 5 cm

新60598

三彩生肖俑

宋

高8.5厘米 底宽3.7厘米

41 | Xin 60598

Tricolor Figure with Animal Zodiac Sign

Song Dynasty (960-1279)

Height 8.5 cm

Bottom width 3.7 cm

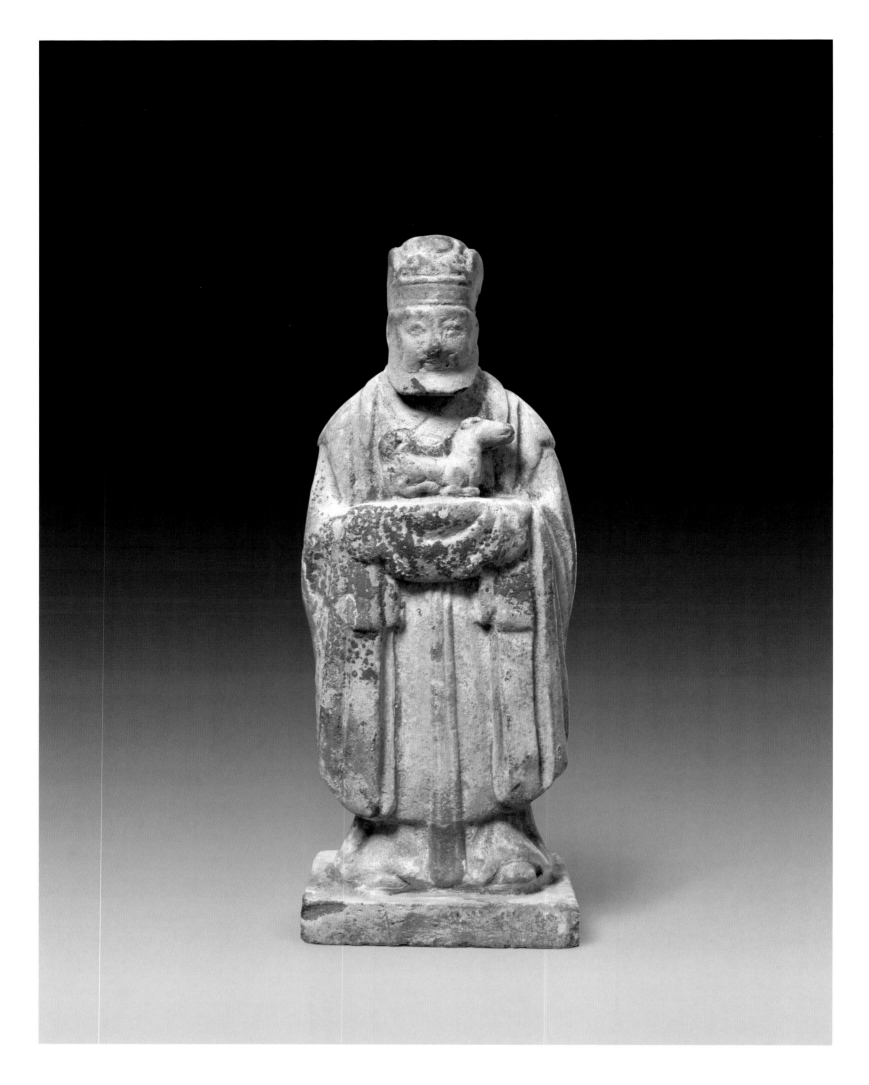

新135523
陶彩绘生肖俑
宋

高19.5厘米　底宽7.5厘米

42 | Xin 135523
Painted Pottery Figure with Animal Zodiac Sign
Song Dynasty (960-1279)
Height 19.5 cm
Bottom width 7.5 cm

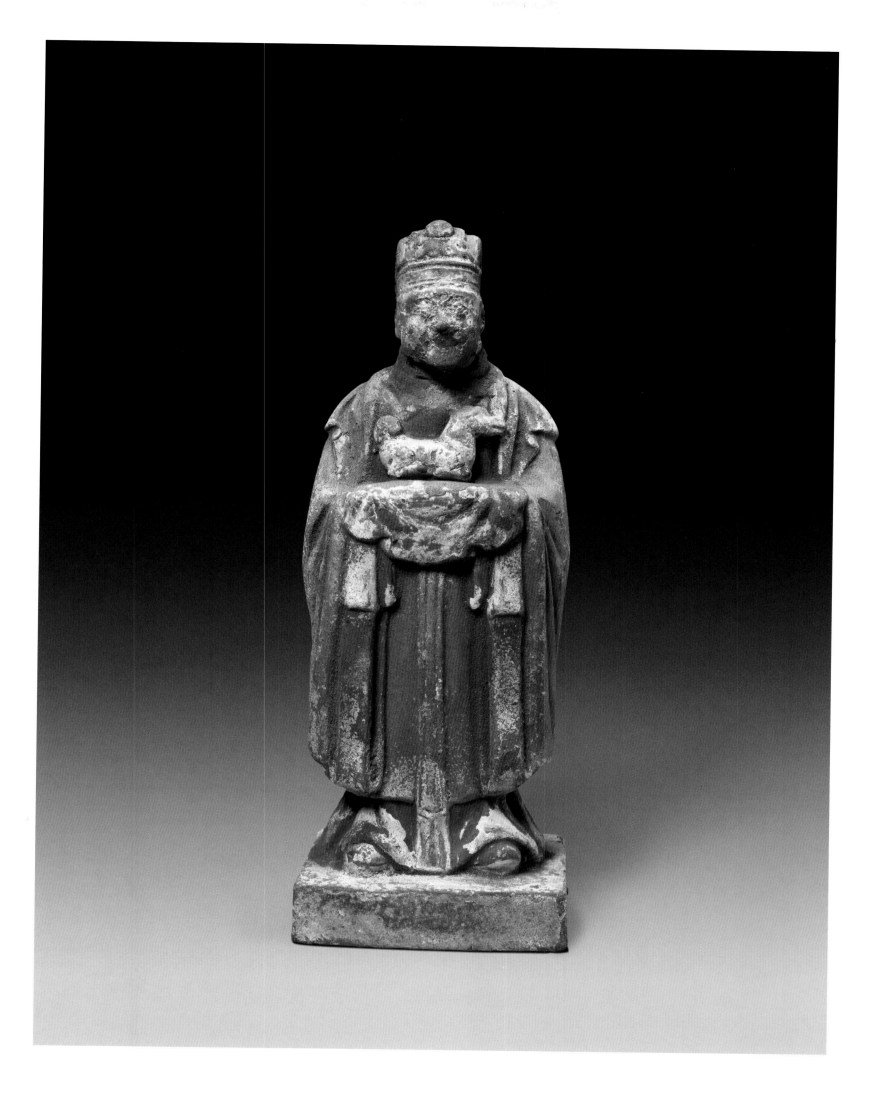

新112073
陶彩绘生肖俑
宋

43 | 高20厘米　底宽7.4厘米

Xin 112073
Painted Pottery Figure with Animal Zodiac Sign
Song Dynasty (960-1279)
Height　20 cm
Bottom width　7.4 cm

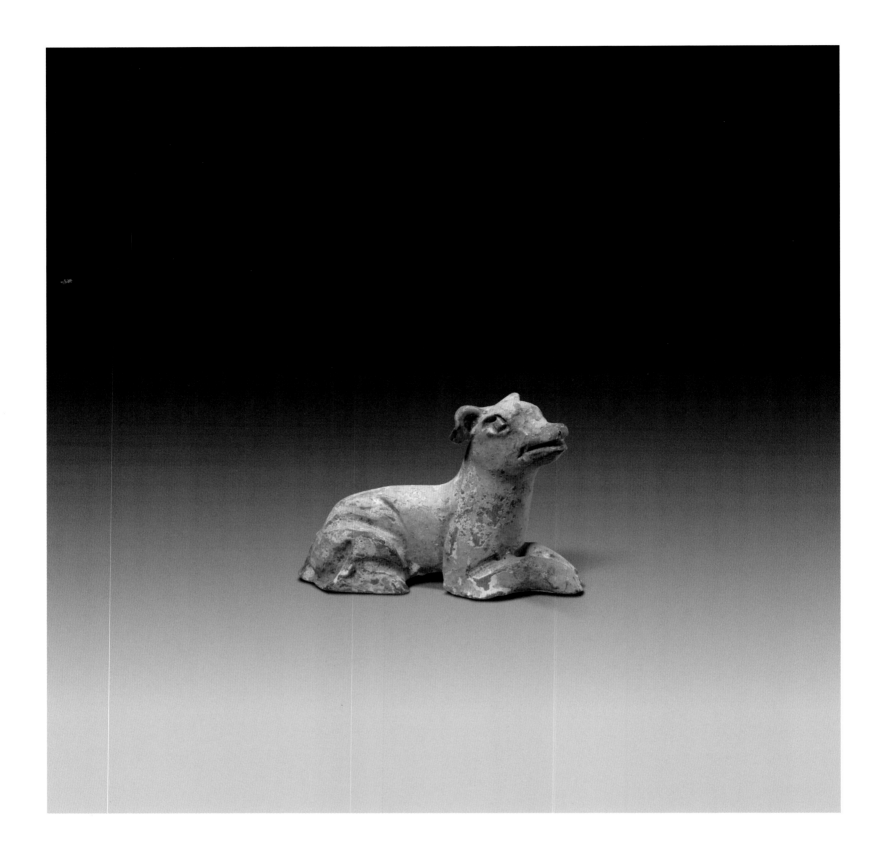

新134942

陶黄釉狗

宋

高5.7厘米　长16厘米

44 | Xin 134942

Yellow Glazed Pottery Dog

Song Dynasty (960-1279)

Height　5.7 cm

Length　16 cm

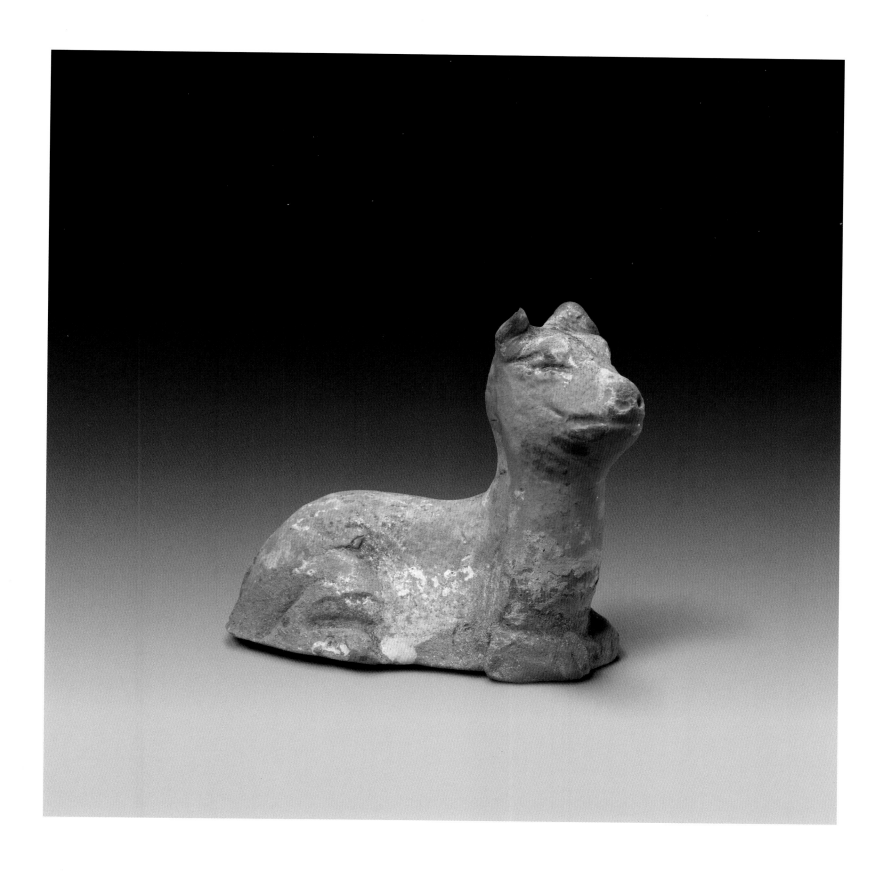

新82597

陶黄釉狗

宋

高10.5厘米　长9.6厘米

45

Xin 82597

Yellow Glazed Pottery Dog

Song Dynasty (960-1279)

Height 10.5 cm

Length 9.6 cm

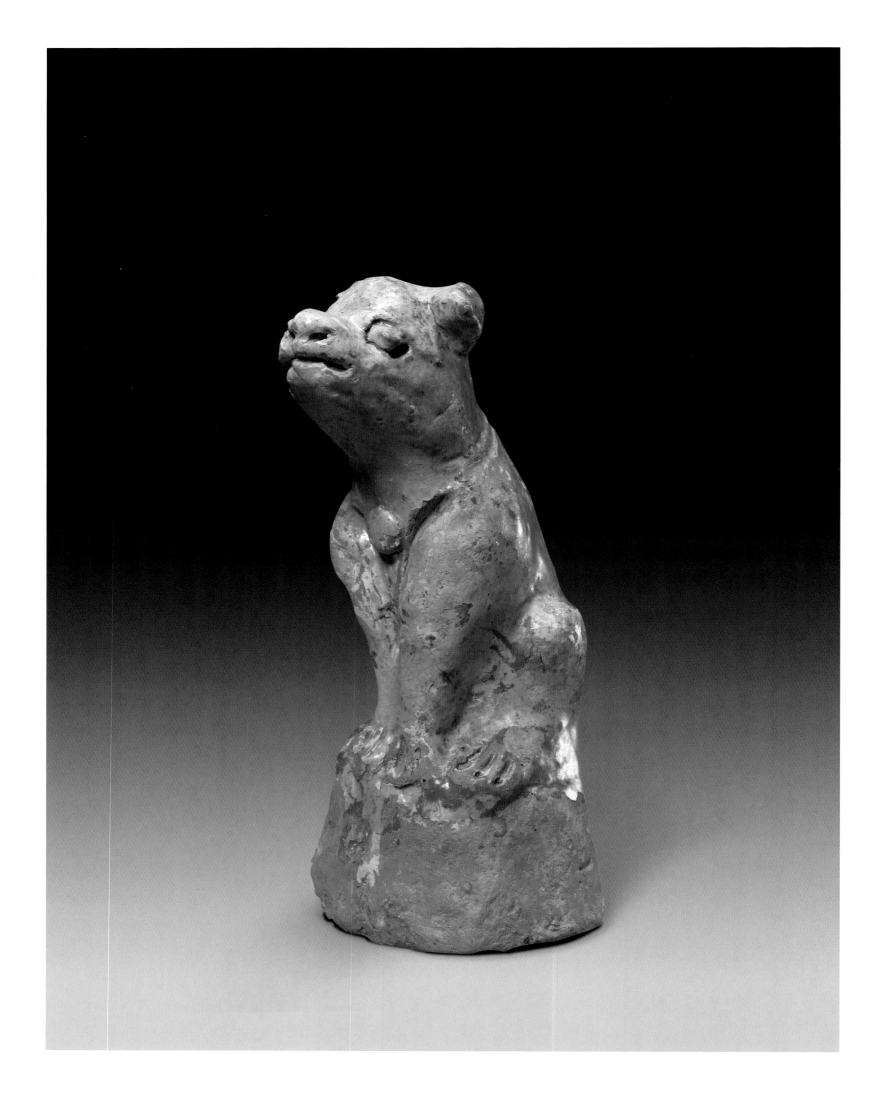

新109119
陶黄釉狗
宋
高18.5厘米 长7厘米

46

Xin 109119
Yellow Glazed Pottery Dog
Song Dynasty (960-1279)
Height 18.5 cm
Length 7 cm

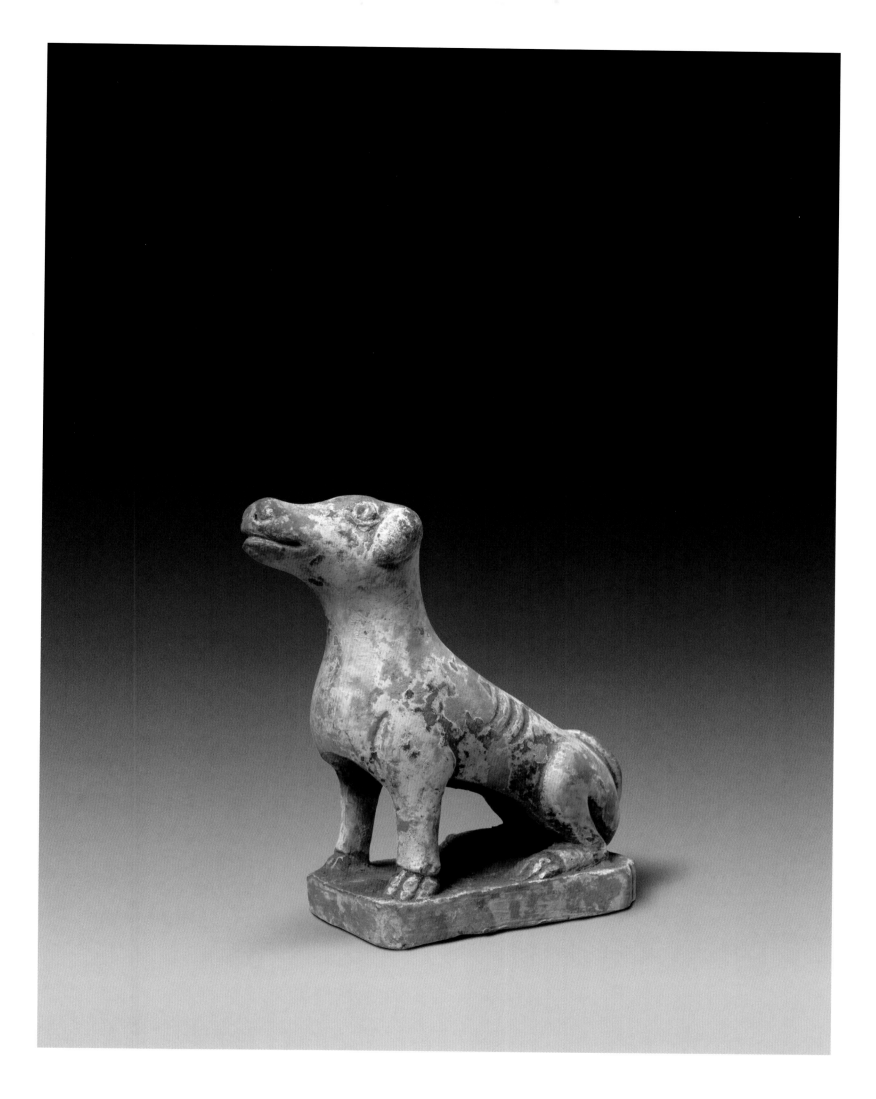

新135542
陶狗
宋
高12.5厘米　长6.8厘米

47

Xin 135542
Pottery Dog
Song Dynasty (960-1279)
Height　12.5 cm
Length　6.8 cm

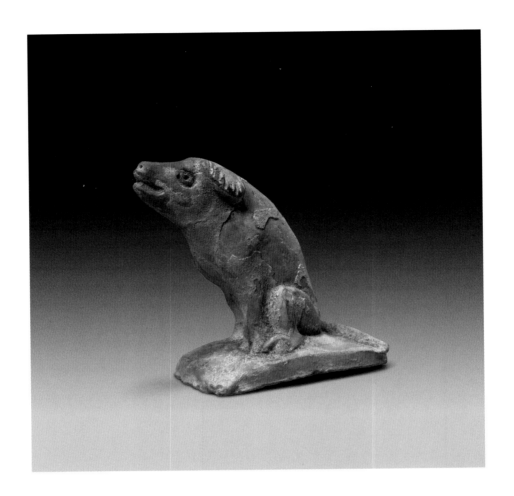

新135543
陶狗
宋
高6.7厘米 长5.4厘米

48 Xin 135543
Pottery Dog
Song Dynasty (960-1279)
Height 6.7 cm
Length 5.4 cm

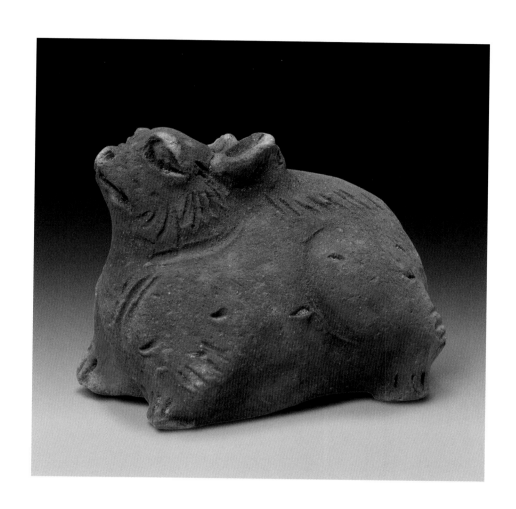

新180268
黑陶兔
宋

高8.5厘米　长10厘米

49 | Xin 180268
Black Pottery Hare
Song Dynasty (960-1279)
Height　8.5 cm
Length　10 cm

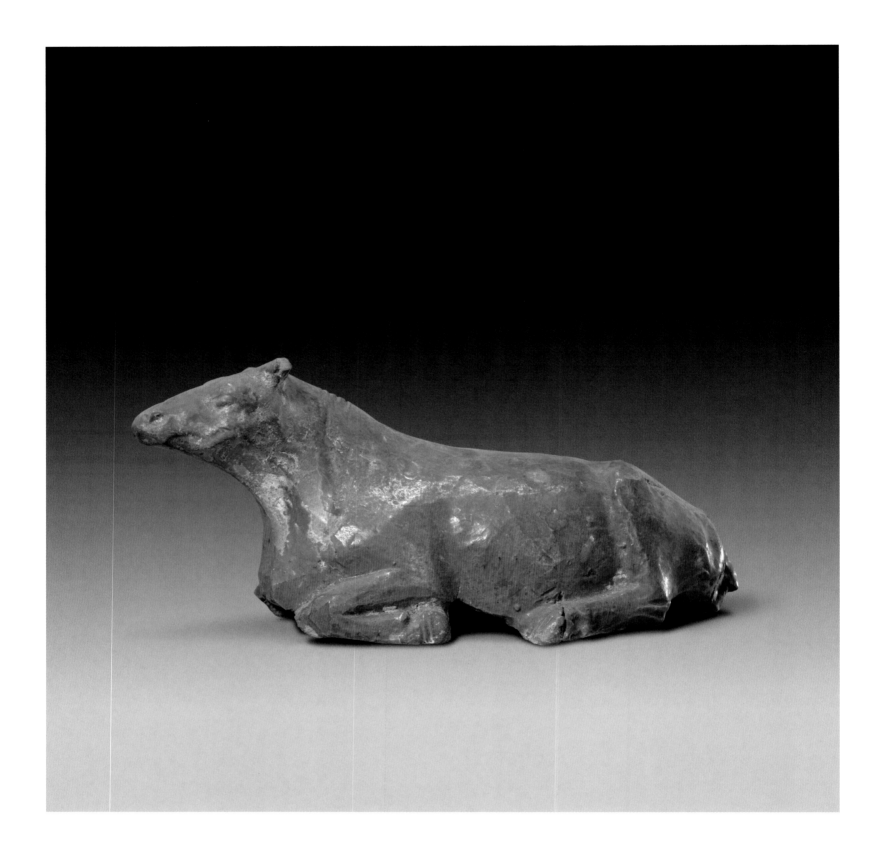

新121612
三彩牛
宋

高8厘米　长19厘米

50　Xin 121612
Tricolor Ox
Song Dynasty (960-1279)
Height　8 cm
Length　19 cm

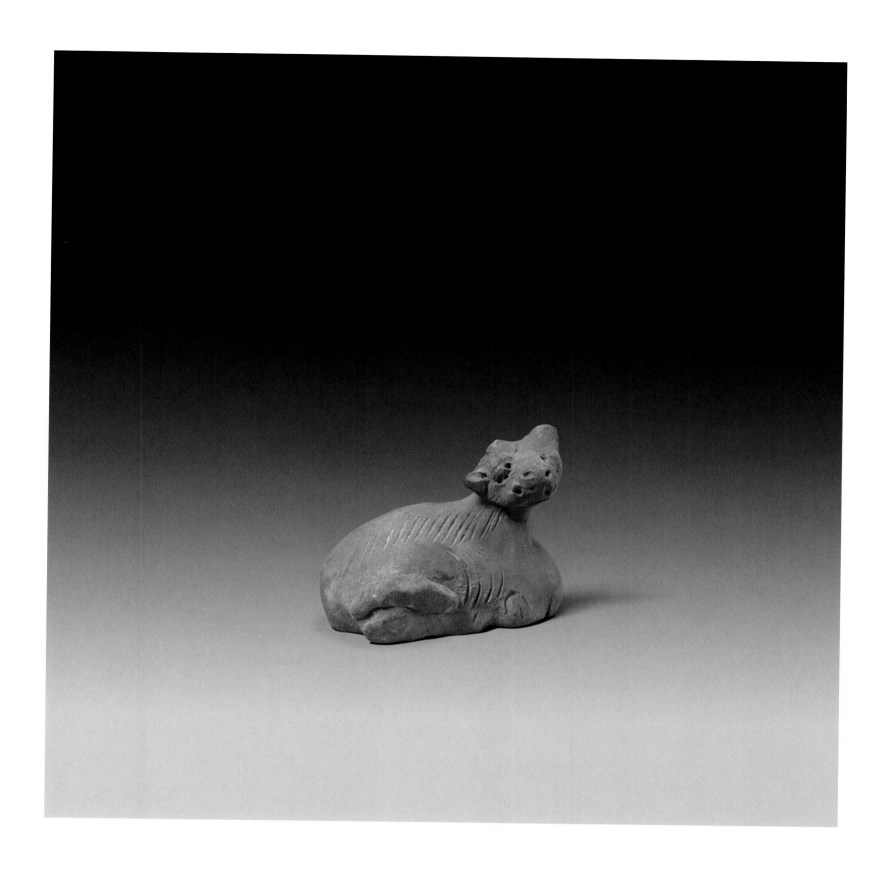

新180267
黑陶牛
宋

高6厘米　长9厘米

51

Xin 180267
Black Pottery Ox
Song Dynasty (960-1279)
Height 6 cm
Length 9 cm

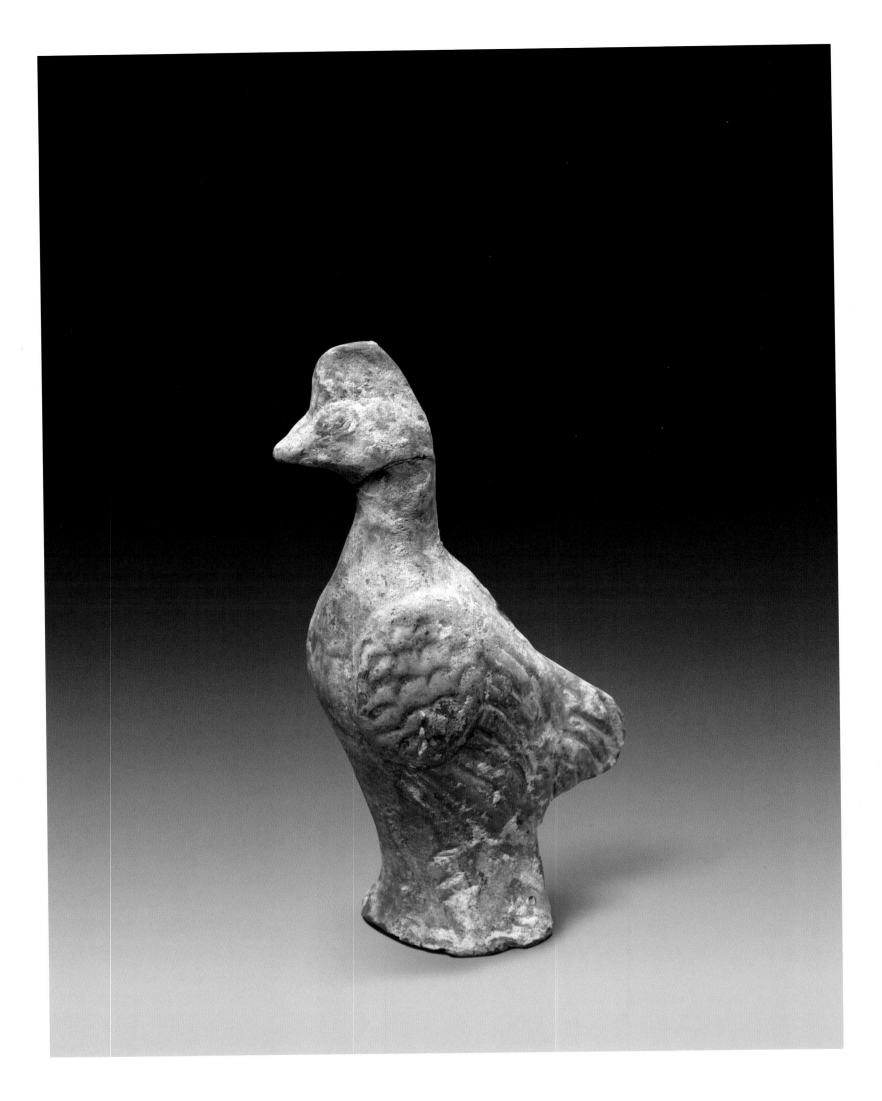

新201752
三彩鸡
宋
高17厘米　长7.6厘米
52 | Xin 201752
Tricolor Chicken
Song Dynasty (960-1279)
Height 17 cm
Length 7.6 cm

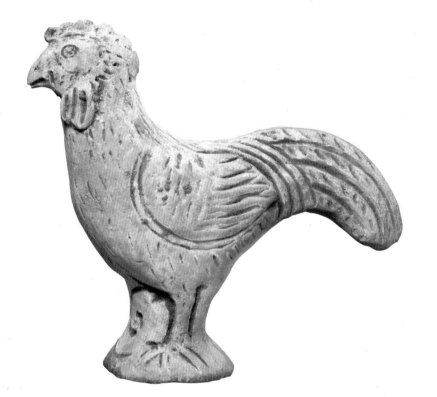

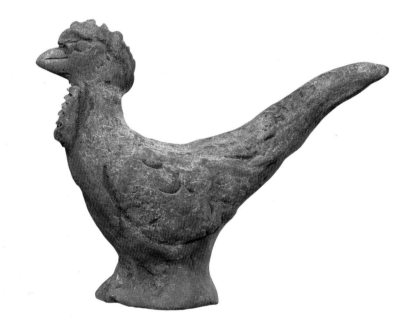

新135545
陶鸡
宋

高10厘米 长9厘米

53 | Xin 135545

Pottery Chicken
Song Dynasty (960-1279)
Height 10 cm
Length 9 cm

新54984
陶鸡
宋

高8厘米 长8.8厘米

54 | Xin 54984

Pottery Chicken
Song Dynasty (960-1279)
Height 8 cm
Length 8.8 cm

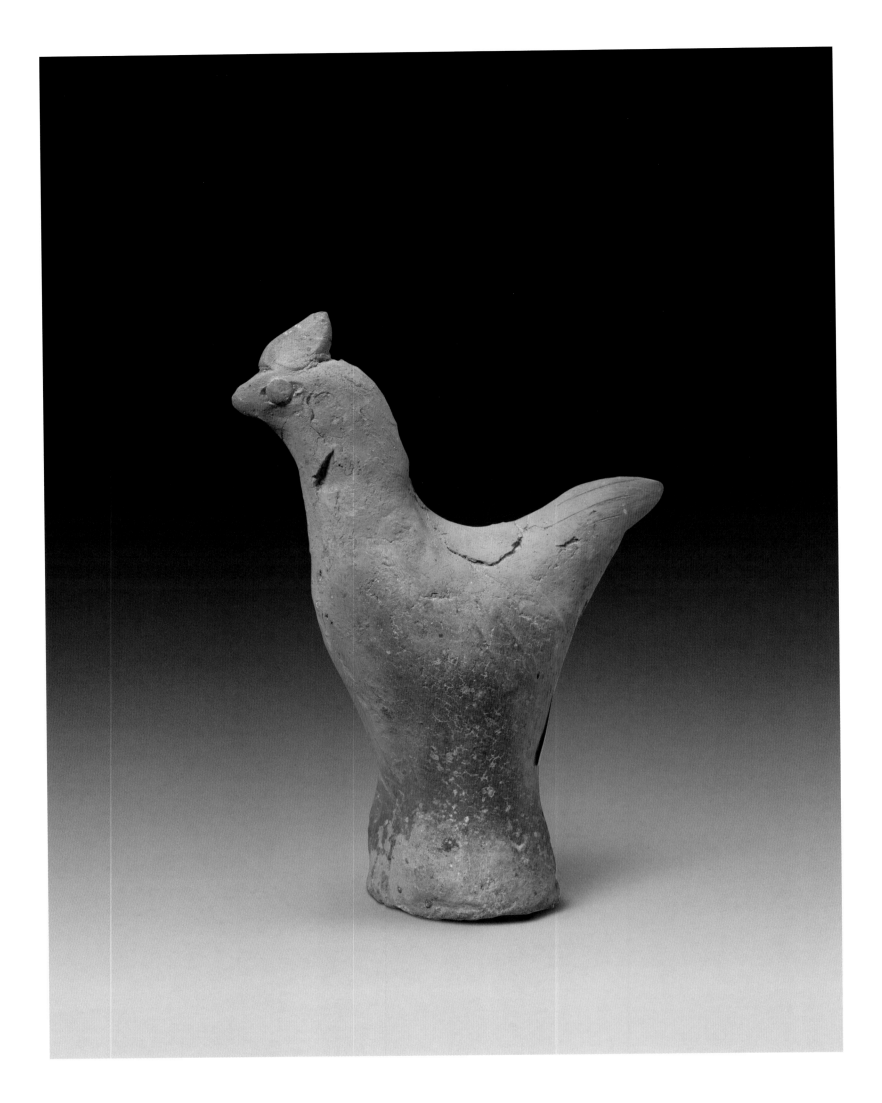

新135544
陶鸡
宋
高17厘米　长8.8厘米

55 | Xin 135544
Pottery Chicken
Song Dynasty (960-1279)
Height 17 cm
Length 8.8 cm

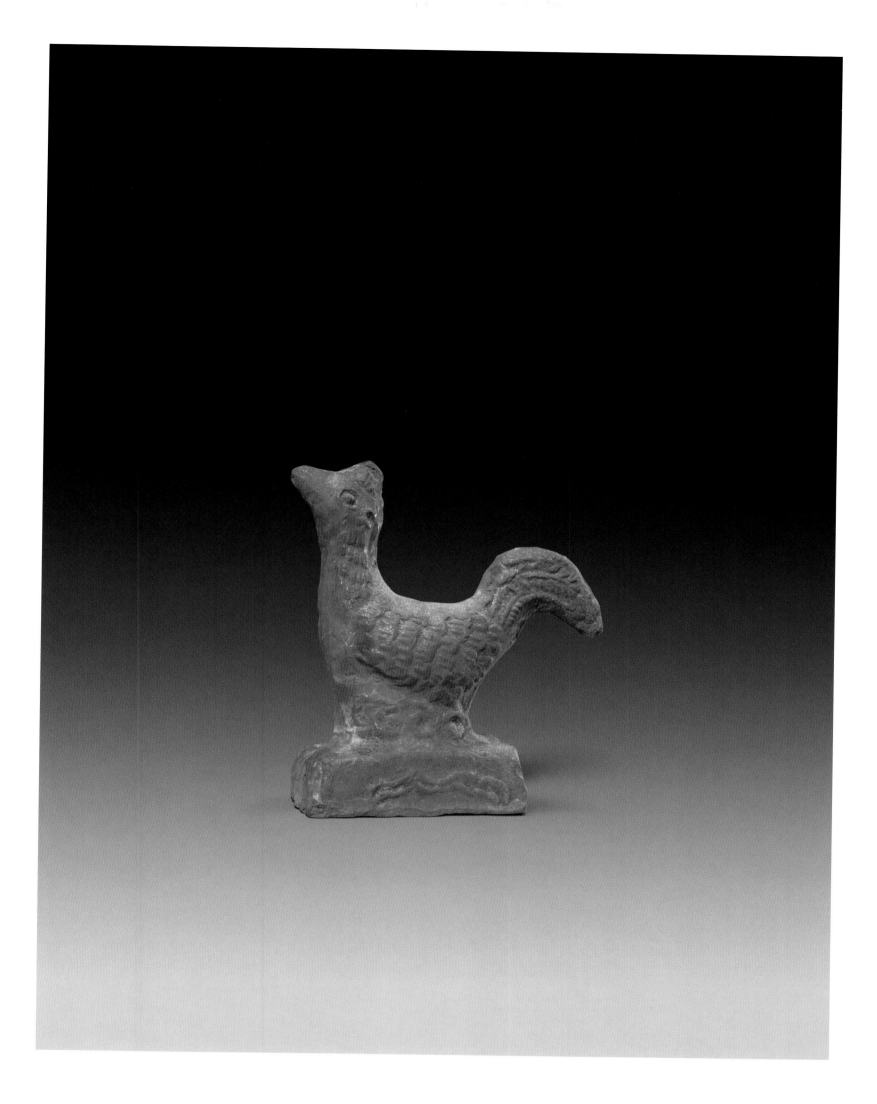

新135546
陶鸡
宋
高8.7厘米　长6厘米

56 Xin 135546
Pottery Chicken
Song Dynasty (960-1279)
Height　8.7 cm
Length　6 cm

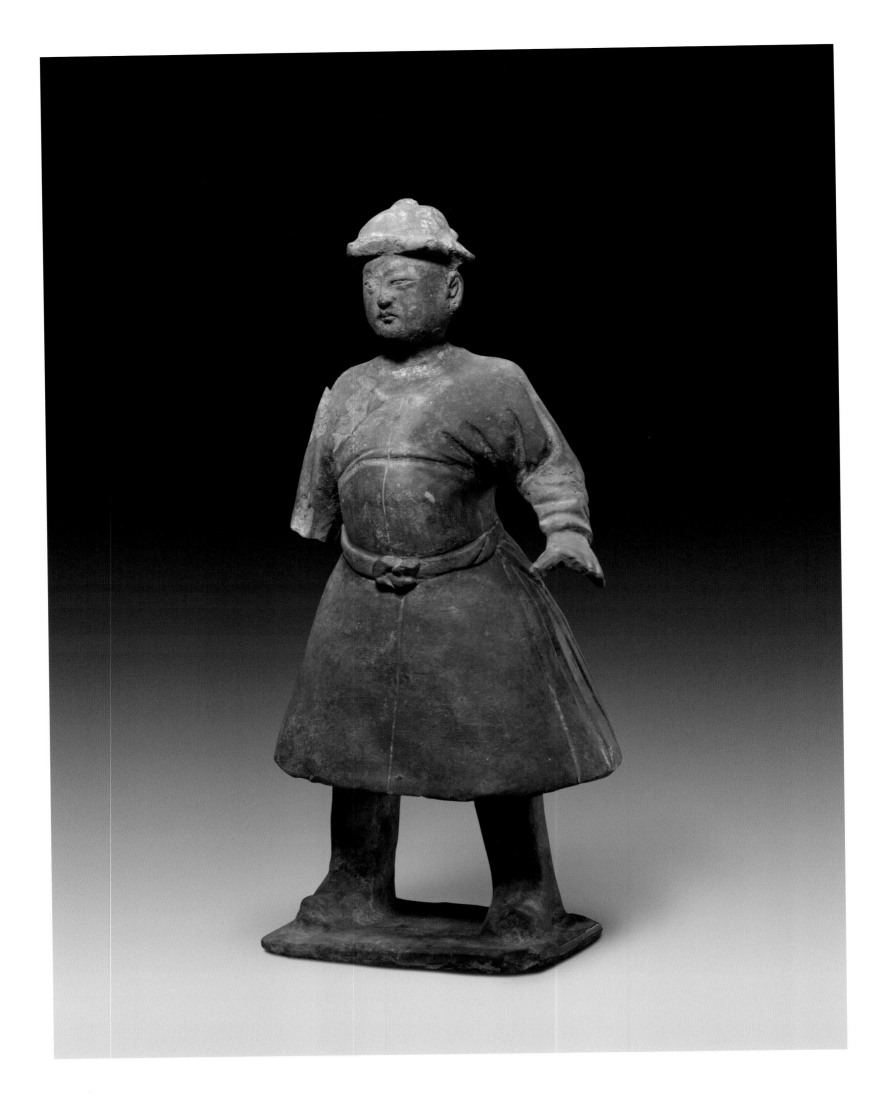

新93110
黑陶男俑
元

高24厘米 底宽9厘米

57 | Xin 93110

Black Pottery Male Figure
Yuan Dynasty (1271-1368)
Height 24 cm
Bottom width 9 cm

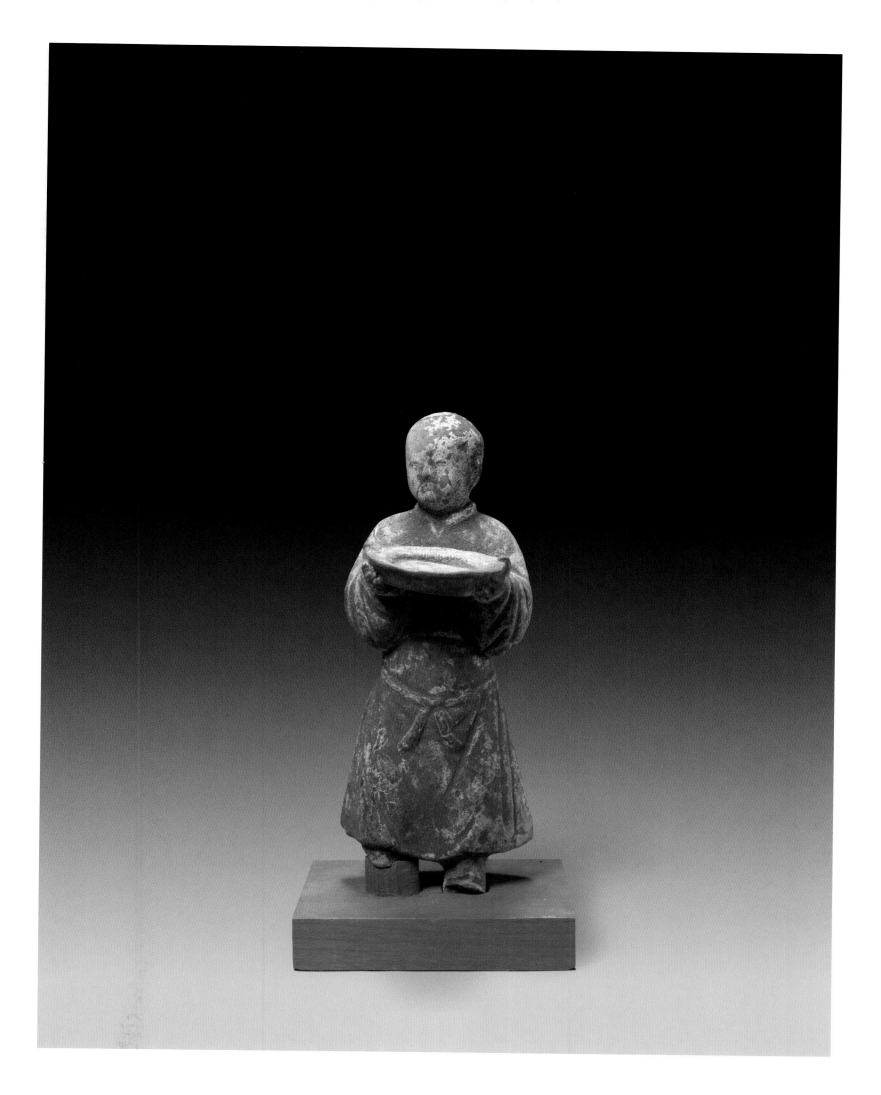

新124452
陶彩绘男俑
元
高15.5厘米 底宽5厘米

58

Xin 124452
Painted Pottery Male Figure
Yuan Dynasty (1271-1368)
Height 15.5 cm
Bottom width 5 cm

新93111

黑陶女俑

元

高28厘米　底宽9.2厘米

59

Xin 93111

Black Pottery Female Figure

Yuan Dynasty (1271-1368)

Height 28 cm

Bottom width 9.2 cm

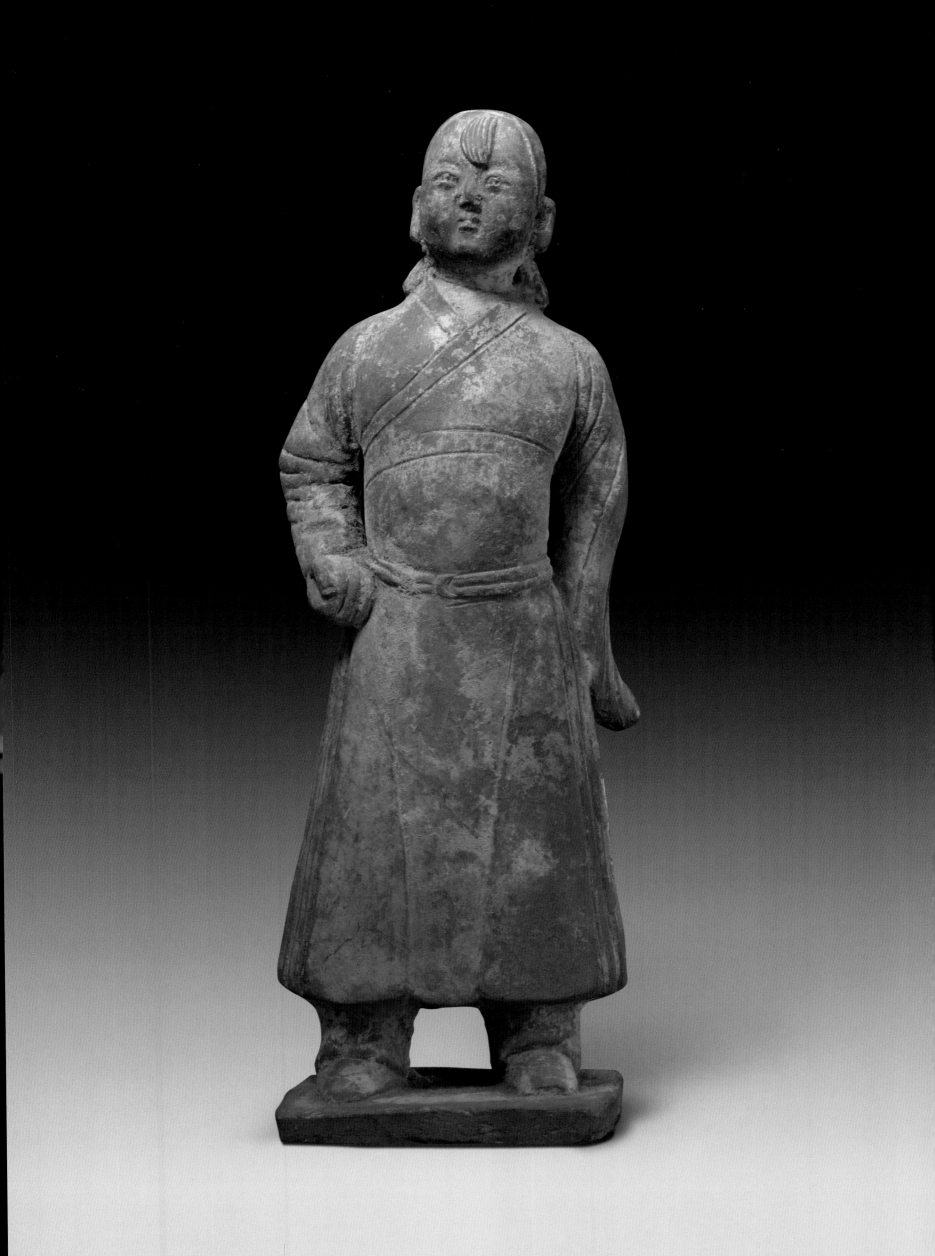

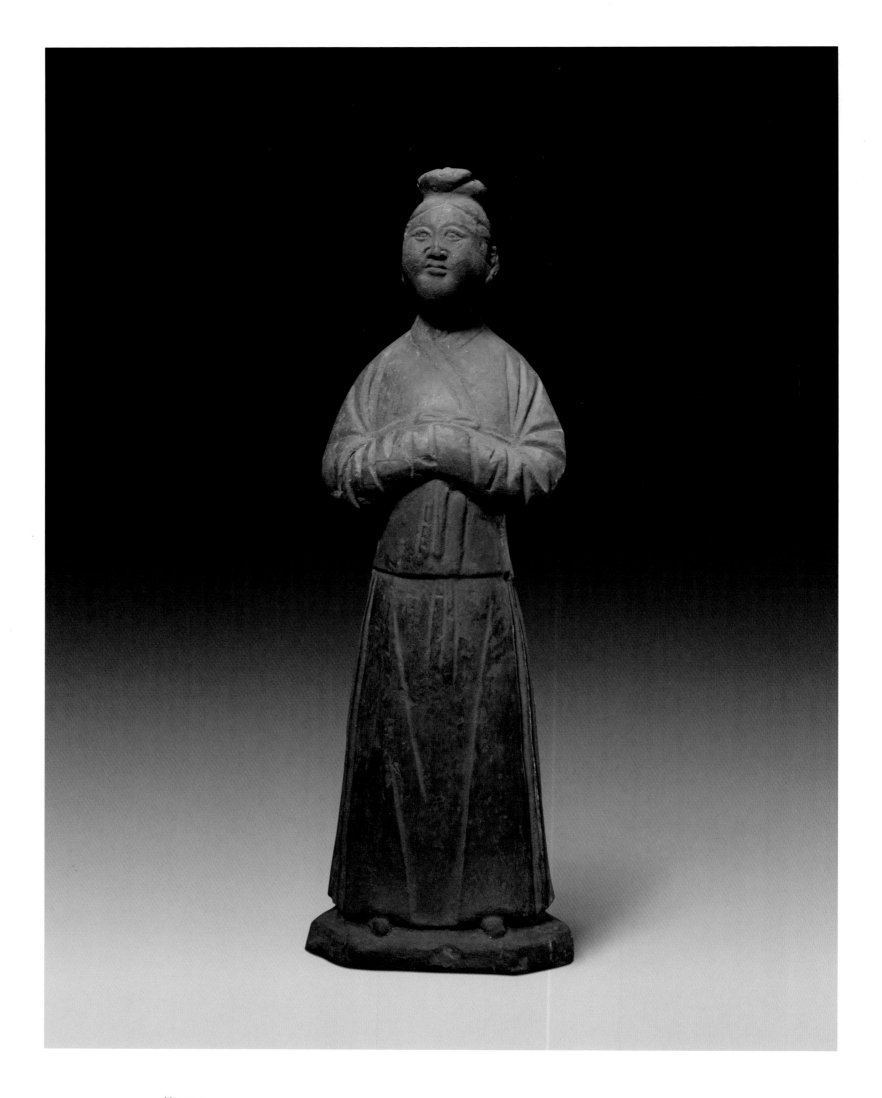

新122312

黑陶女俑

元

高25厘米 底宽8厘米

60

Xin 122312

Black Pottery Female Figure

Yuan Dynasty (1271-1368)

Height 25 cm

Bottom width 8 cm

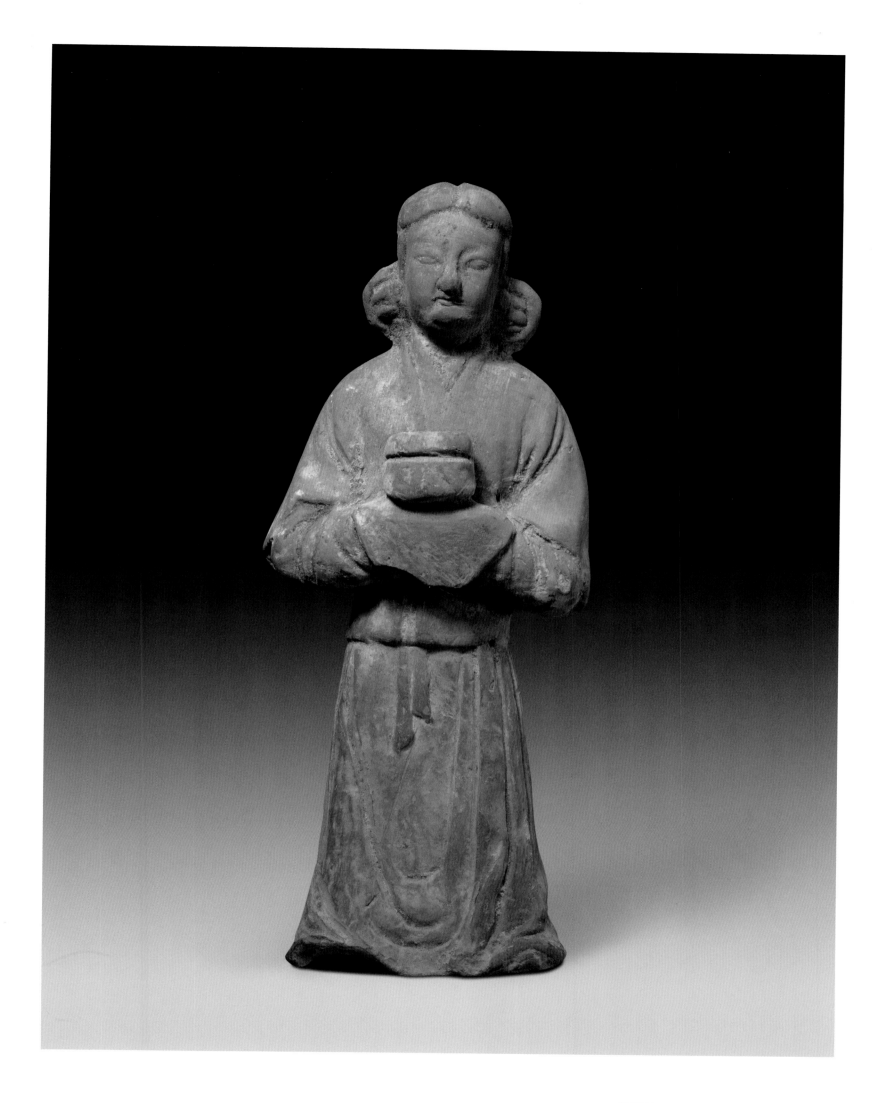

新122330
灰陶女俑
元
高23厘米 底宽7.3厘米

61

Xin 122330
Grey Pottery Female Figure
Yuan Dynasty (1271-1368)
Height 23 cm
Bottom width 7.3 cm

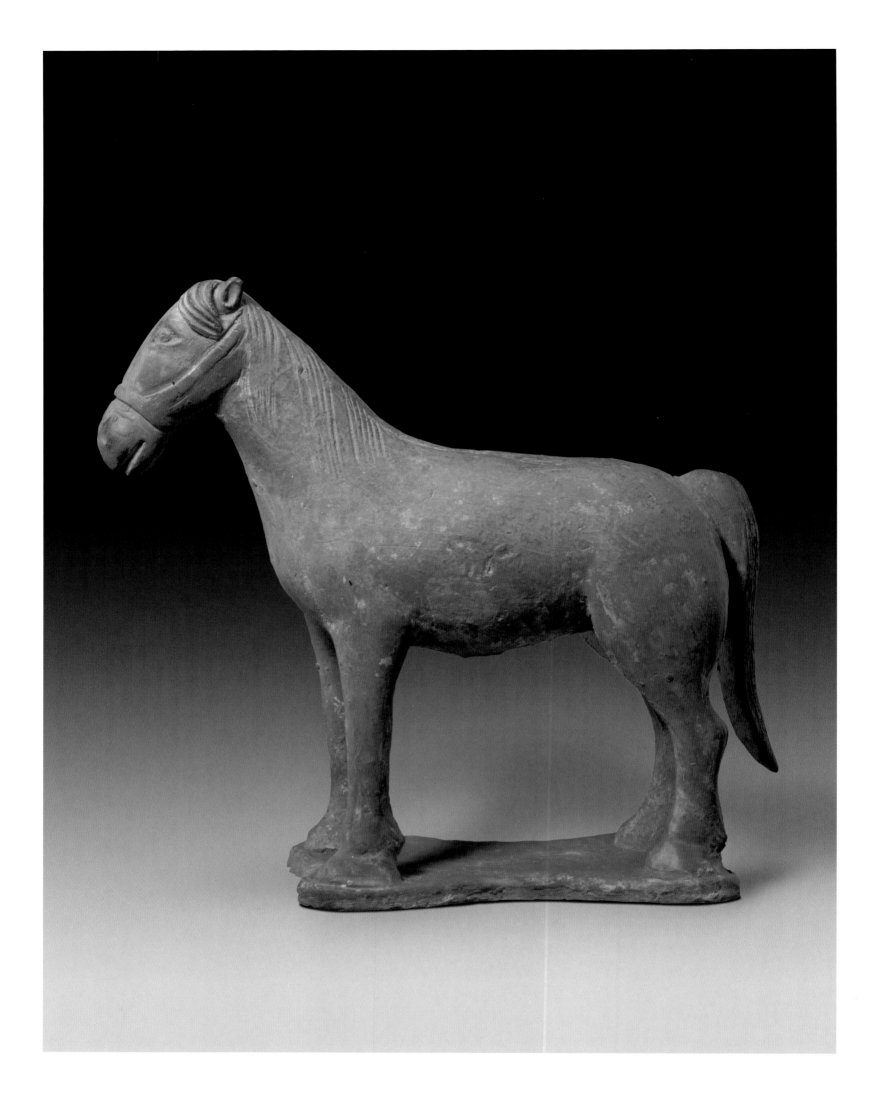

新129256
黑陶马
元

62 高19.5厘米 长21厘米

Xin 129256

Black Pottery Horse
Yuan Dynasty (1271-1368)
Height 19.5 cm
Length 21 cm

新129255
陶马
元

高20厘米 长17厘米

63

Xin 129255
Pottery Horse
Yuan Dynasty (1271-1368)
Height 20 cm
Length 17 cm

新135548

黑陶牛

元

高5.7厘米　长17厘米

64

Xin 135548

Black Pottery Ox

Yuan Dynasty (1271-1368)

Height　5.7 cm

Length　17 cm

新93112
黑陶羊
元
高5.2厘米 长13厘米

65 | Xin 93112
Black Pottery Sheep
Yuan Dynasty (1271-1368)
Height 5.2 cm
Length 13 cm

新107437

陶兽

元

高27厘米　长30厘米

66

Xin 107437

Pottery Beast

Yuan Dynasty (1271-1368)

Height　27 cm
Length　30 cm

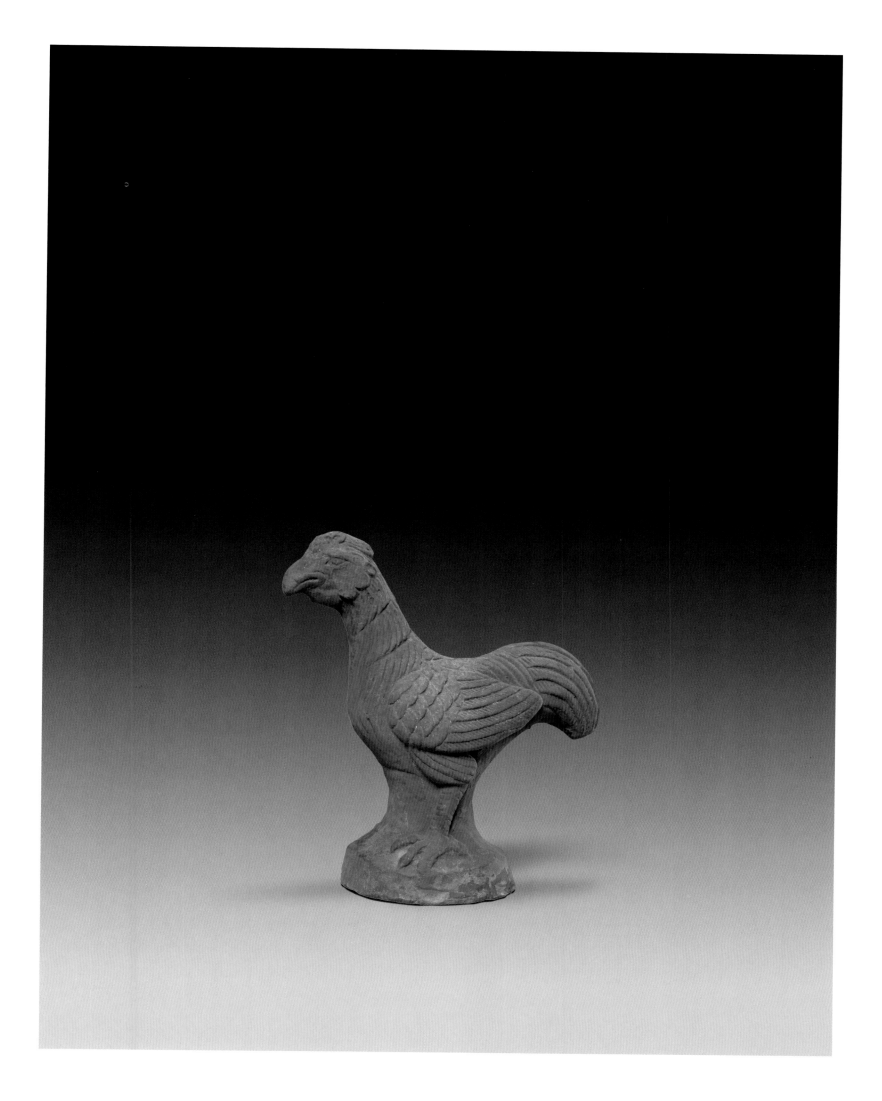

新154722
陶鸡
元
高13厘米 长9.5厘米

67

Xin 154722
Pottery Chicken
Yuan Dynasty (1271-1368)
Height 13 cm
Length 9.5 cm

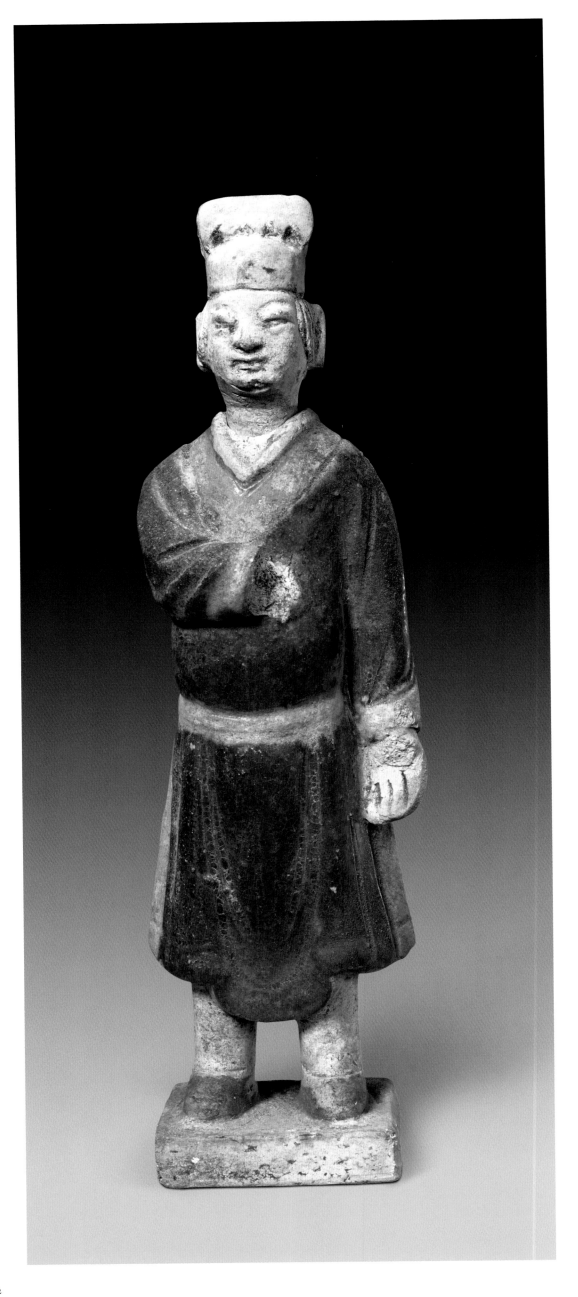

新135528
陶紫绿釉男俑
明

68

高30厘米　底宽7厘米

Xin 135528
Purple-green Glazed Pottery
Male Figure
Ming Dynasty (1368-1644)
Height　30 cm
Bottom width　7 cm

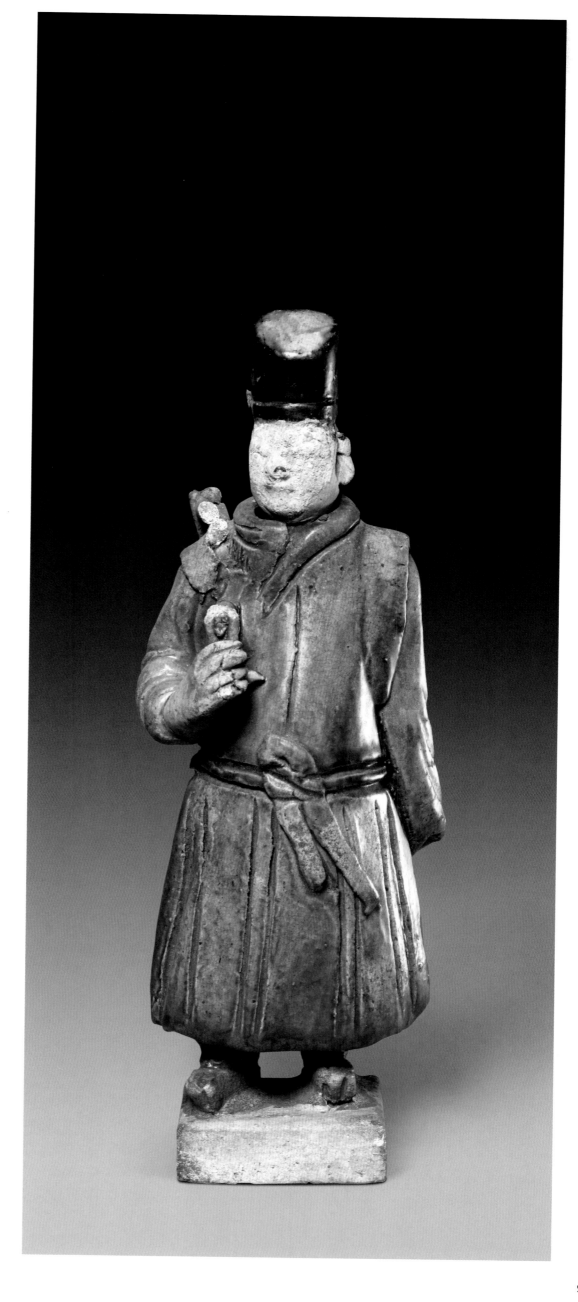

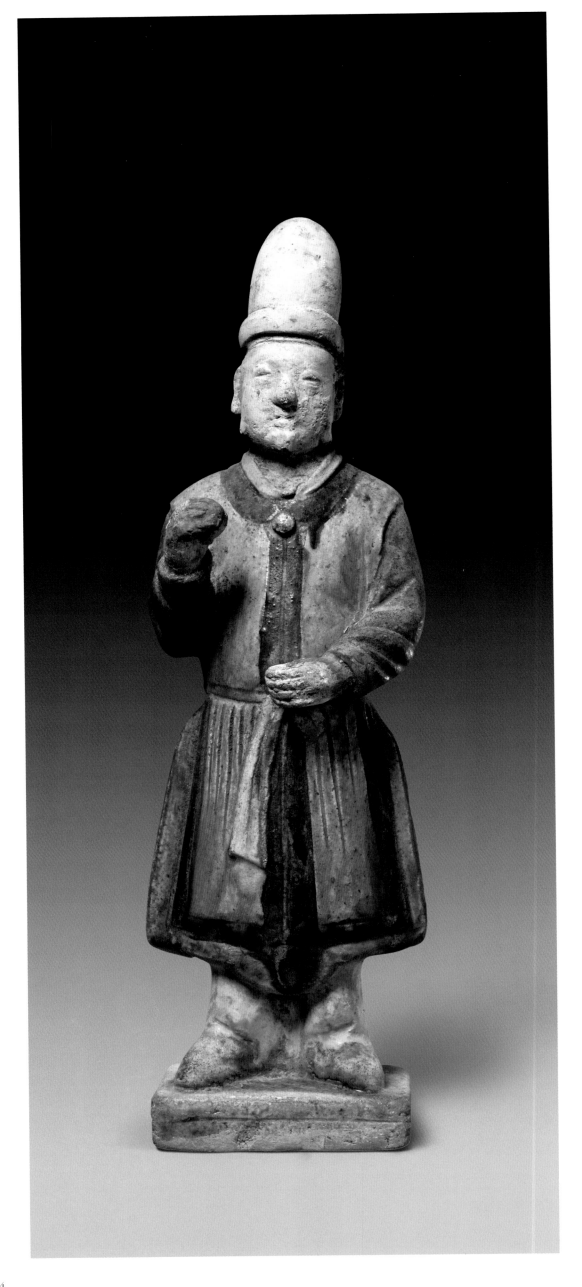

新112469

陶黄绿釉男俑

明

高29厘米 底宽7.8厘米

70

Xin 112469

Yellow-green Glazed Pottery Male Figure

Ming Dynasty (1368-1644)

Height 29 cm

Bottom width 7.8 cm

新135535
陶绿釉男俑
明

高25厘米　底宽7.5厘米

71

Xin 135535
Green Glazed Pottery Male Figure
Ming Dynasty (1368-1644)
Height　25 cm
Bottom width　7.5 cm

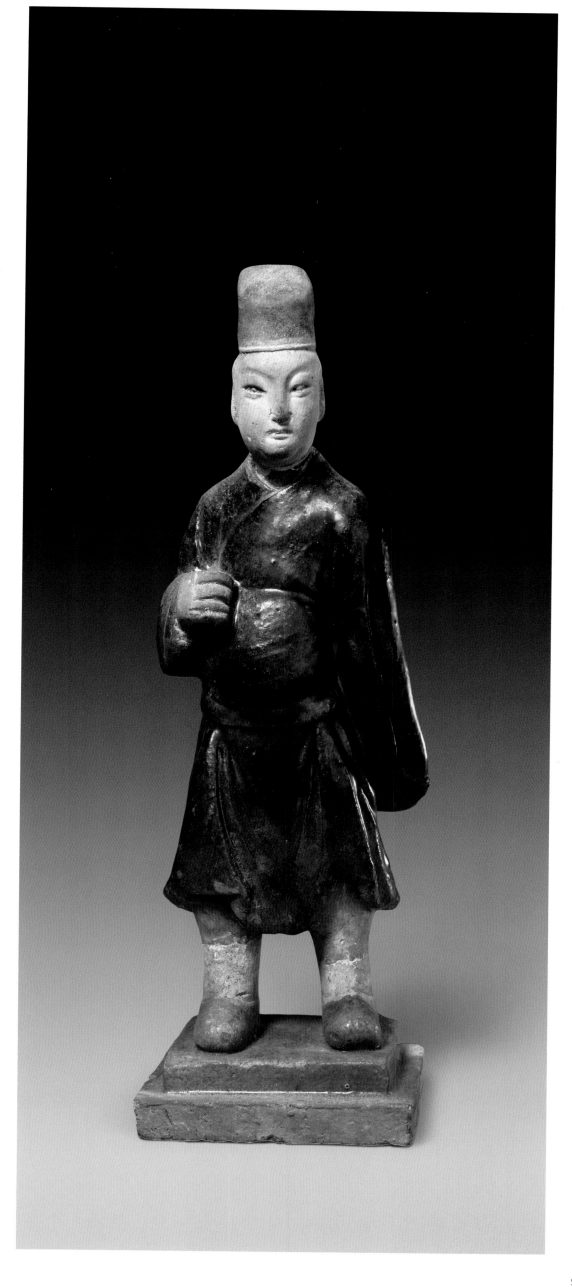

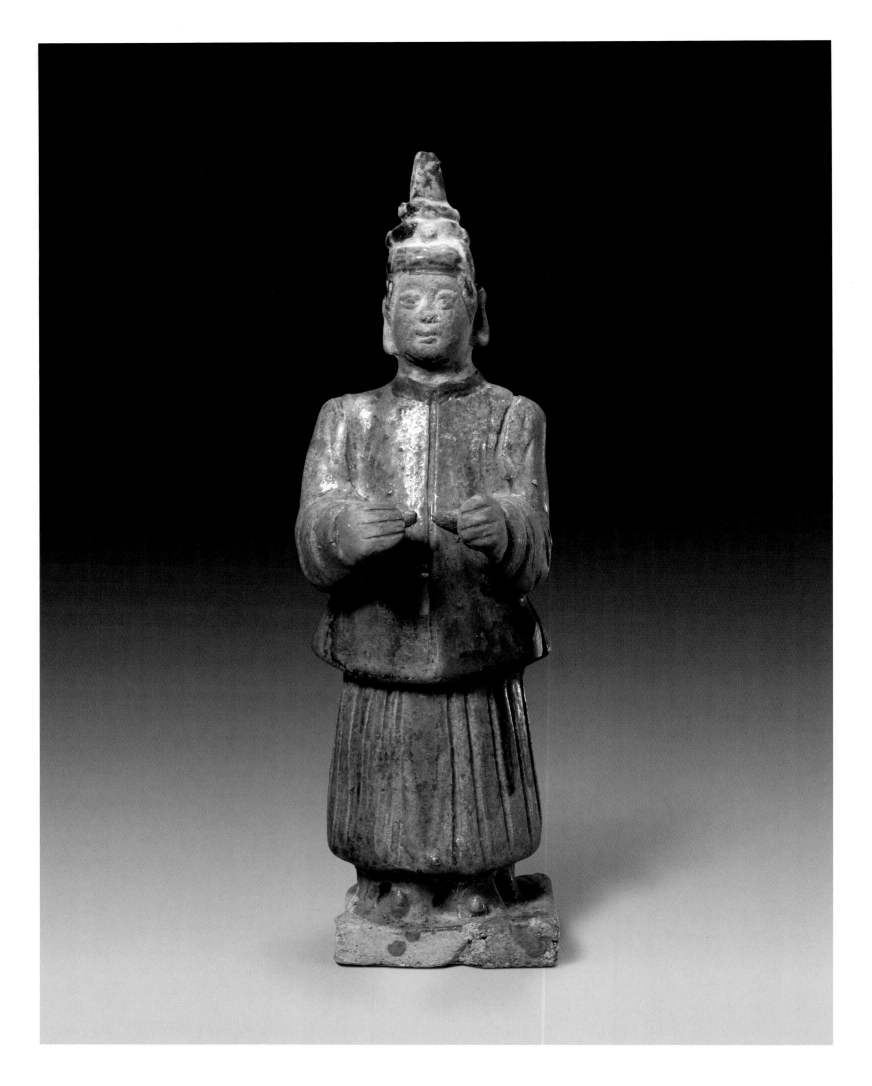

新121907

陶黄绿釉男俑

明

高24.5厘米　底宽6.3厘米

72

Xin 121907

Yellow-green Glazed Pottery Male Figure
Ming Dynasty (1368-1644)
Height　24.5 cm
Bottom width　6.3 cm

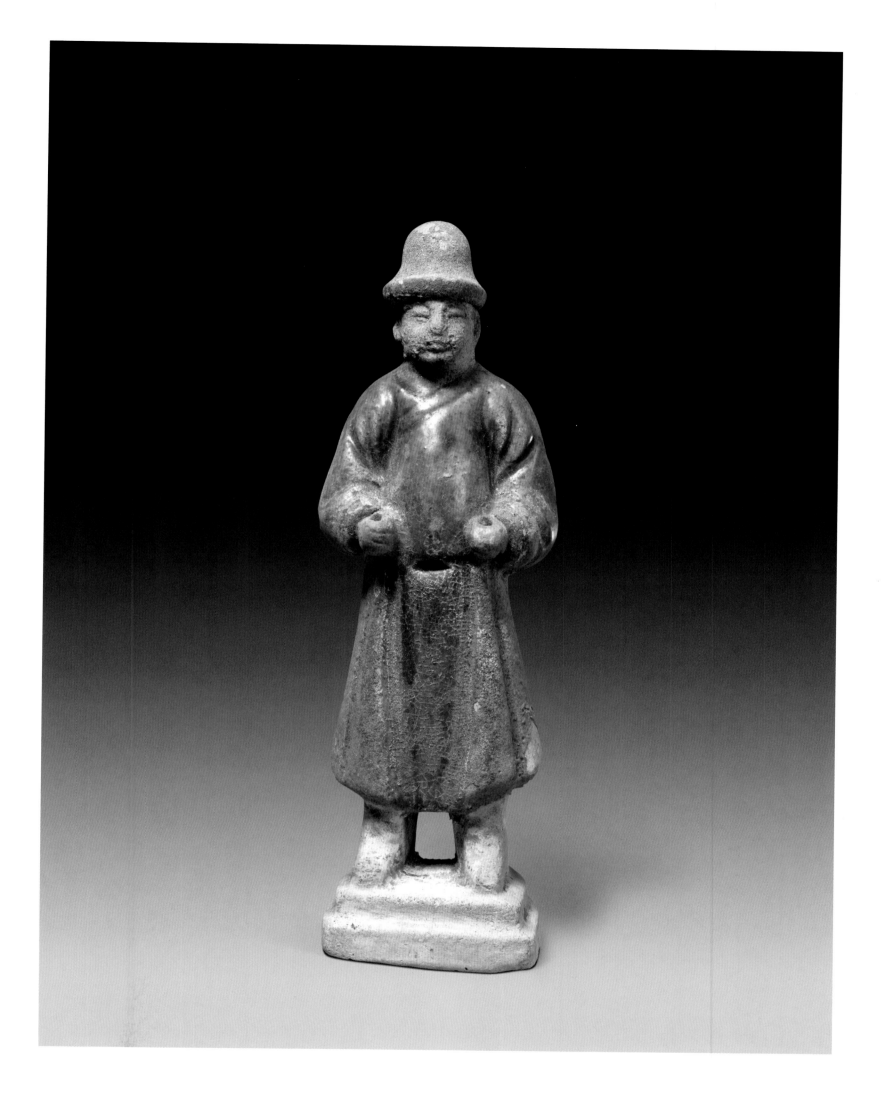

新121903

陶绿釉男俑

明

高20.5厘米 底宽6厘米

73

Xin 121903

Green Glazed Pottery Male Figure

Ming Dynasty (1368-1644)

Height 20.5 cm

Bottom width 6 cm

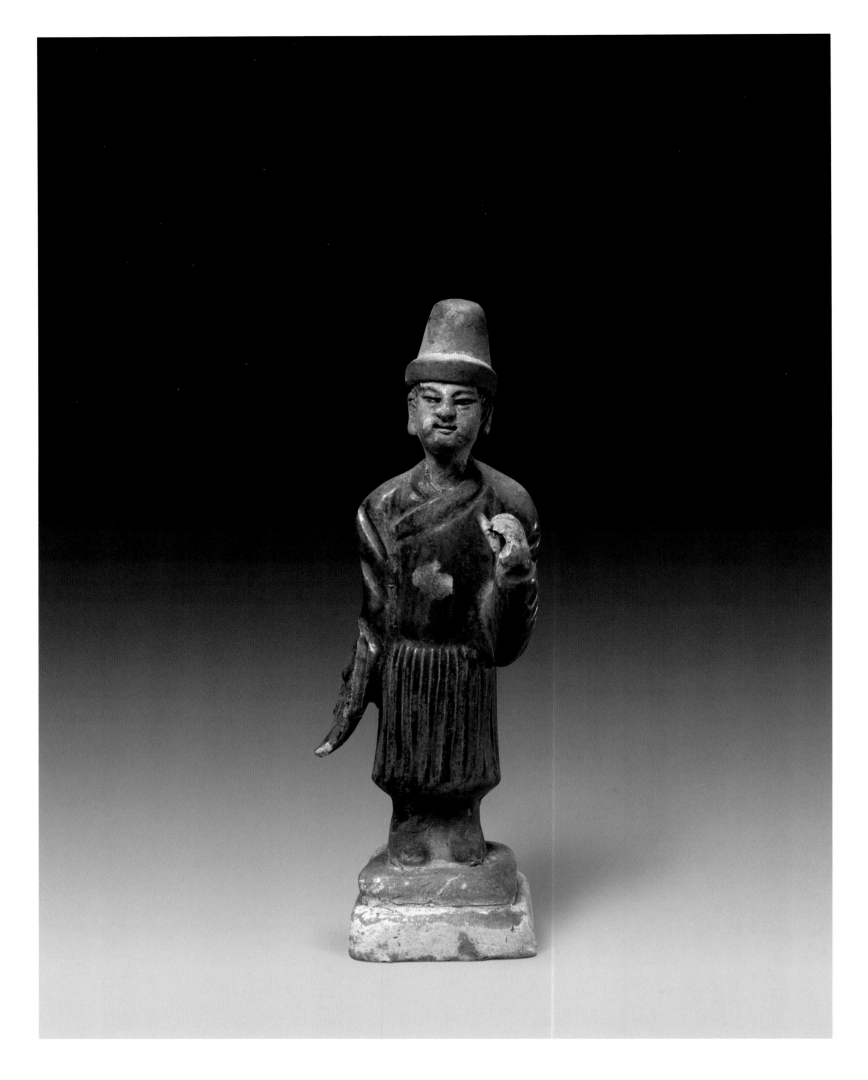

新121906
陶绿釉男俑
明

74 高22厘米 底宽6厘米

Xin 121906

Green Glazed Pottery Male Figure
Ming Dynasty (1368-1644)
Height 22 cm
Bottom width 6 cm

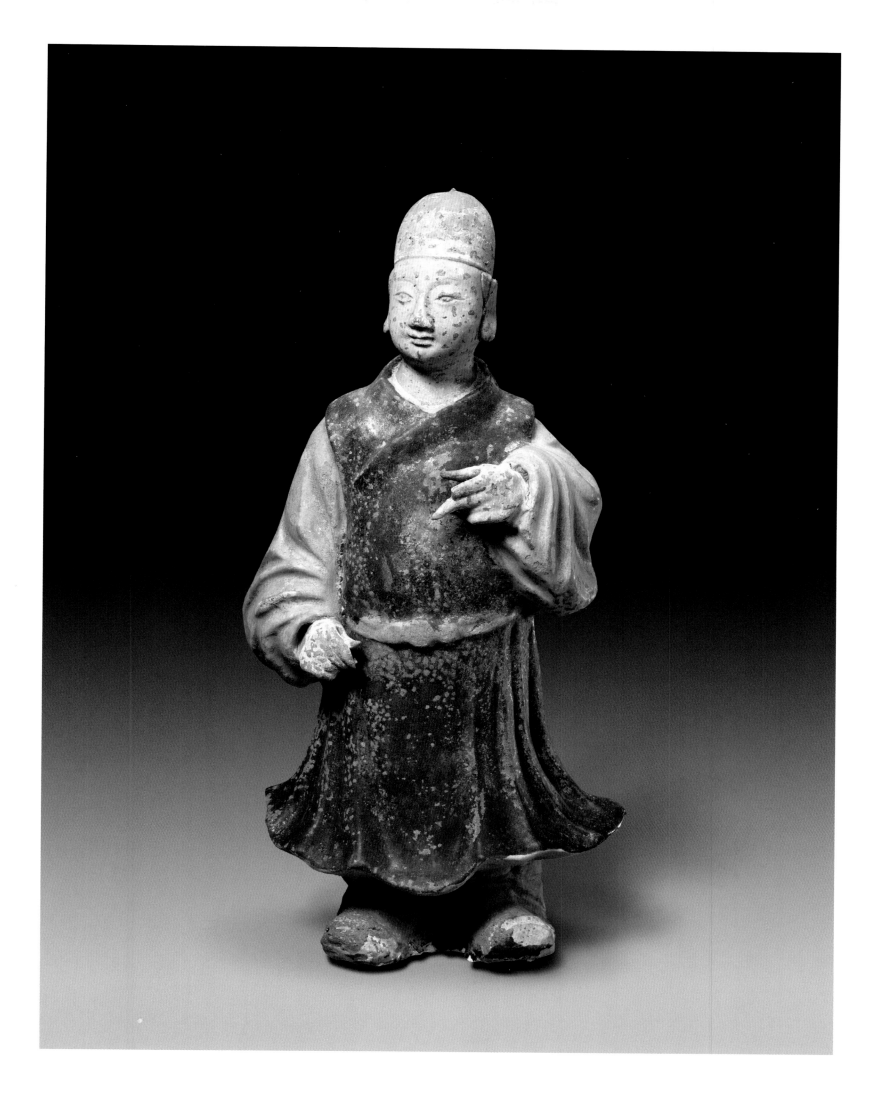

新156742

陶紫绿釉男俑

明

高38厘米 底宽17厘米

75 Xin 156742

Purple-green Glazed Pottery Male Figure
Ming Dynasty (1368-1644)
Height 38 cm
Bottom width 17 cm

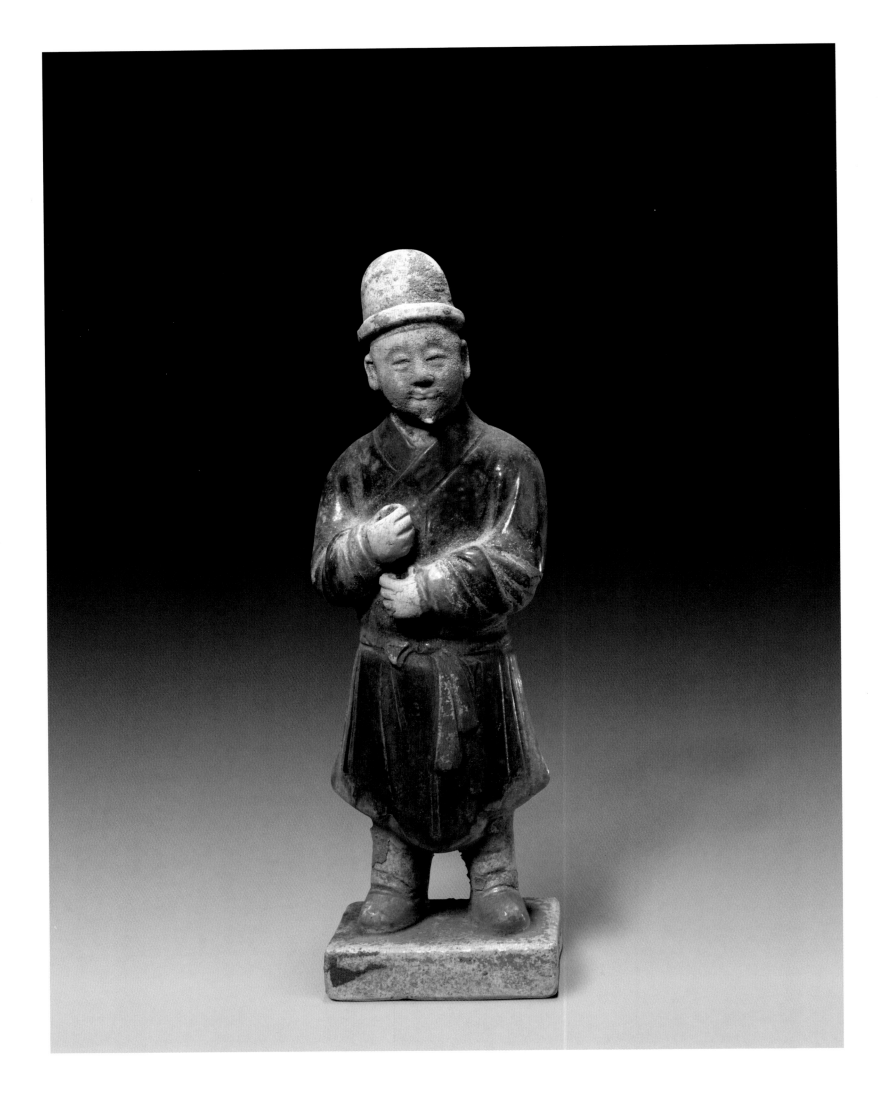

新43879

陶紫蓝釉男俑

明

高24厘米 底宽7.2厘米

76

Xin 43879

Purple-blue Glazed Pottery Male Figure

Ming Dynasty (1368-1644)

Height 24 cm

Bottom width 7.2 cm

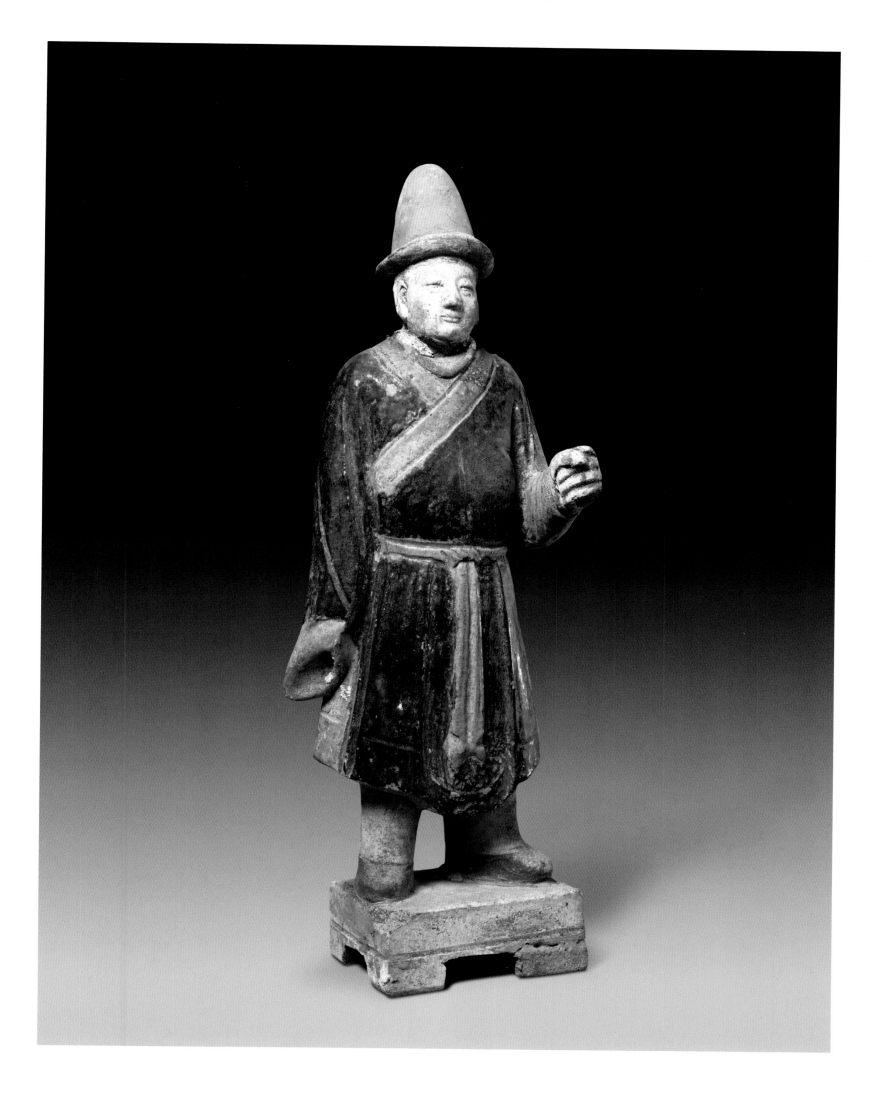

新43910

陶紫蓝釉男俑

明

高30厘米　底宽7.5厘米

Xin 43910

Purple-blue Glazed Pottery Male Figure

Ming Dynasty (1368-1644)

Height　30 cm

Bottom width　7.5 cm

新156741
陶紫绿釉男俑
明

高41厘米　底宽17厘米

78 | Xin 156741

Purple-green Glazed Pottery Male Figure
Ming Dynasty (1368-1644)
Height 41 cm
Bottom width 17 cm

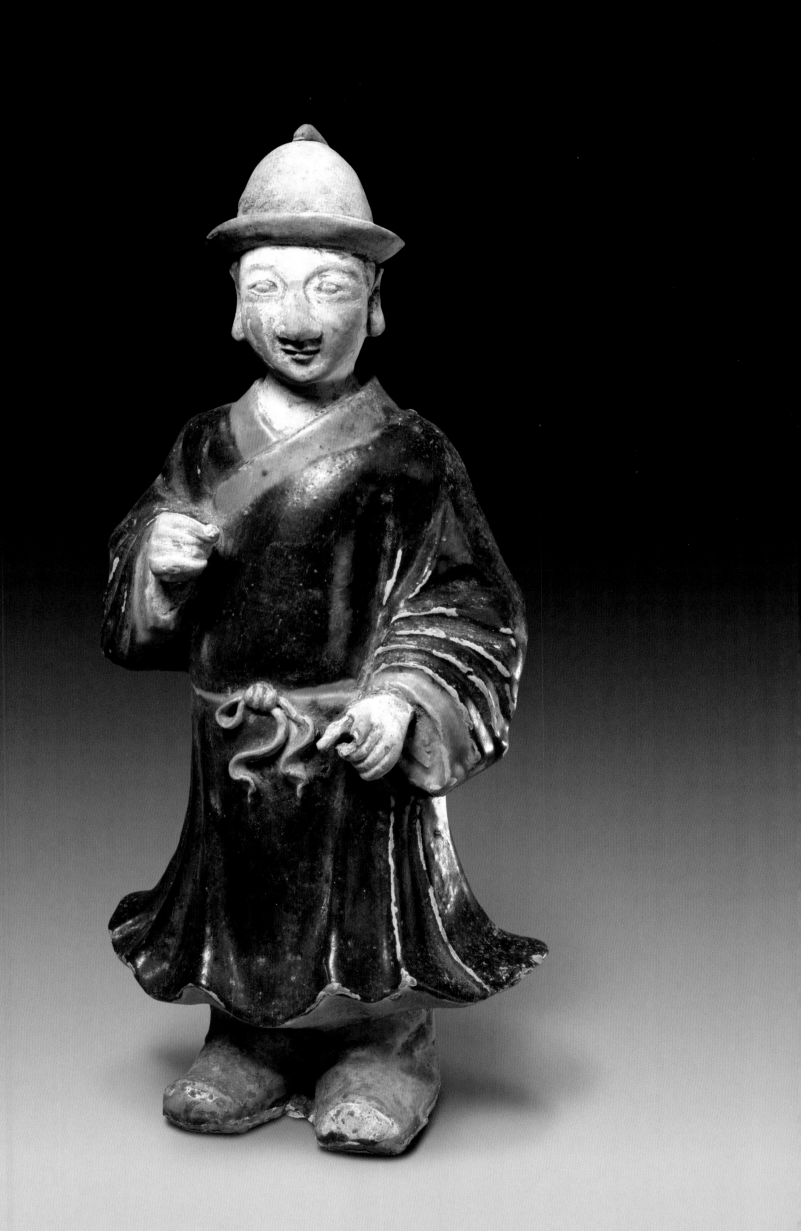

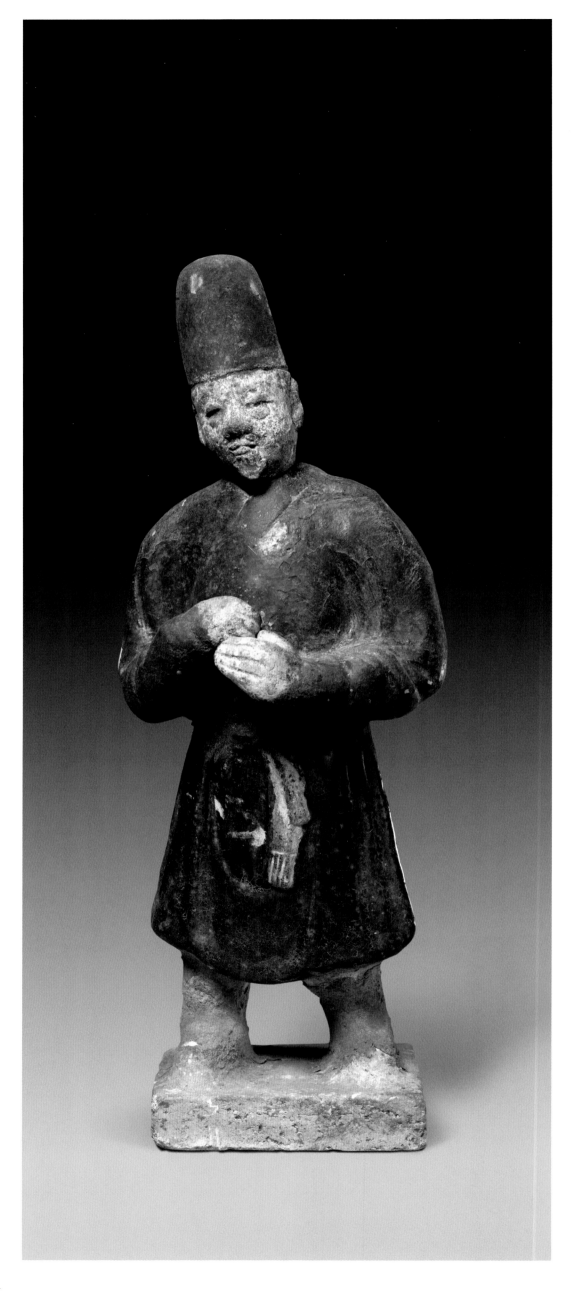

新121910
陶紫釉男俑
明
高28厘米 底宽8厘米
79
Xin 121910
Purple Glazed Pottery Male Figure
Ming Dynasty (1368-1644)
Height 28 cm
Bottom width 8 cm

新52452
陶紫蓝釉男俑
明

80 高30厘米 底宽6.8厘米

Xin 52452
Purple-blue Glazed Pottery
Male Figure
Ming Dynasty (1368-1644)
Height 30 cm
Bottom width 6.8 cm

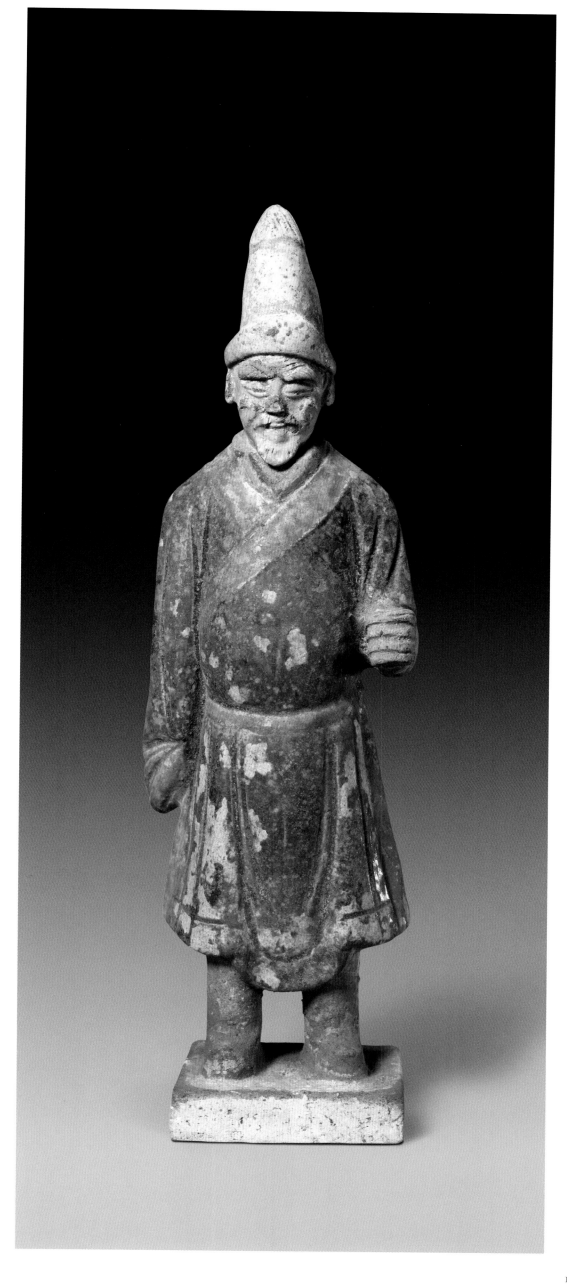

新143235

陶紫蓝釉男俑

明

高27厘米　底宽7厘米

81

Xin 143235

Purple-blue Glazed Pottery Male Figure

Ming Dynasty (1368-1644)

Height 27 cm

Bottom width 7 cm

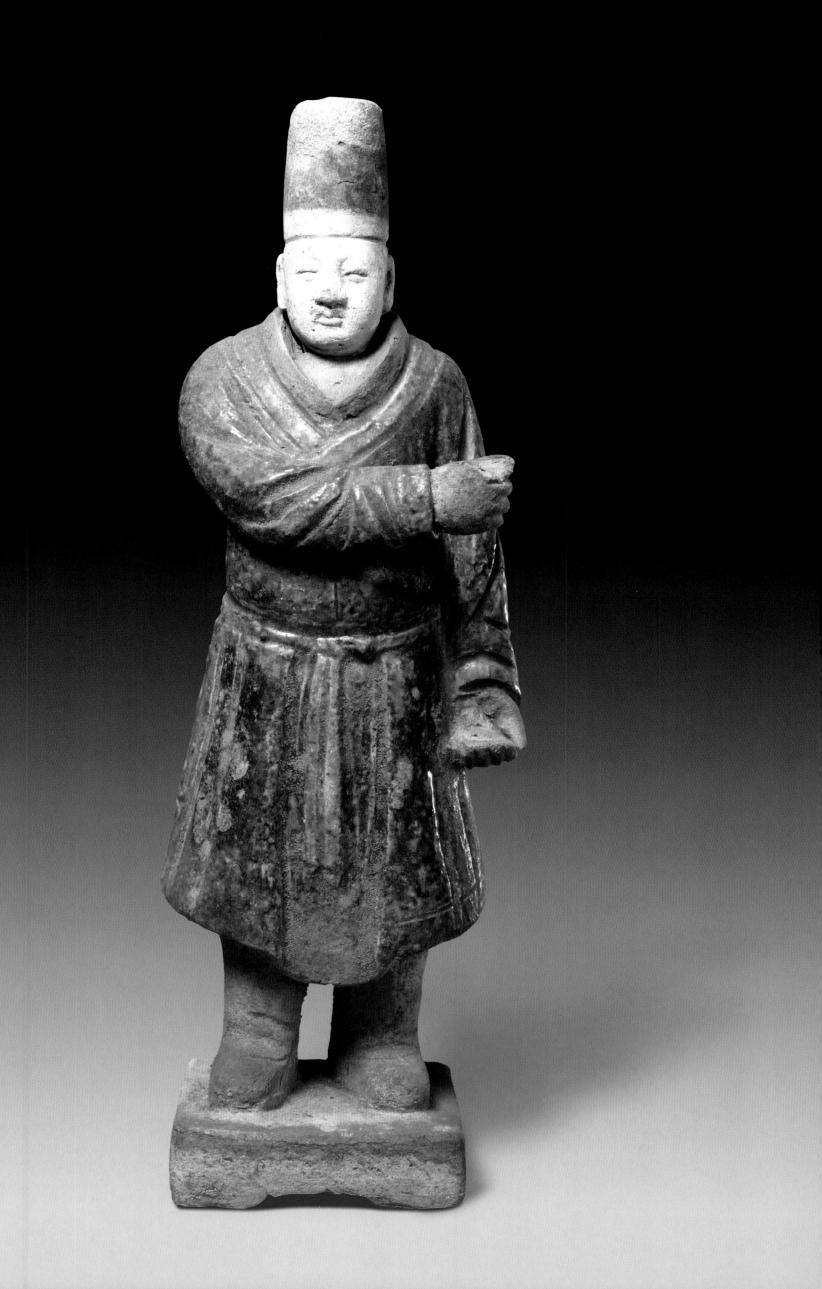

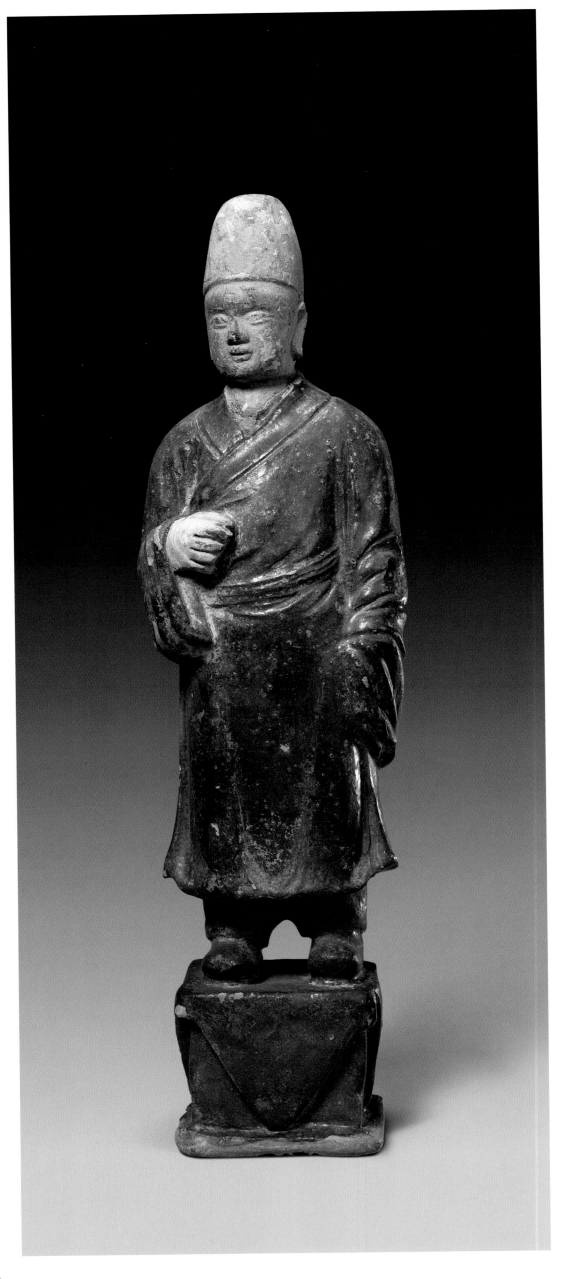

新135533

陶黑釉男俑

明

高30.5厘米　底宽6.3厘米

82

Xin 135533

Black Glazed Pottery Male Figure

Ming Dynasty (1368-1644)

Height　30.5 cm

Bottom width　6.3 cm

新154171
陶蓝釉男俑
明

高28.5厘米 底宽7.3厘米

83

Xin 154171
Blue Glazed Pottery Male Figure
Ming Dynasty (1368-1644)
Height 28.5 cm
Bottom width 7.3 cm

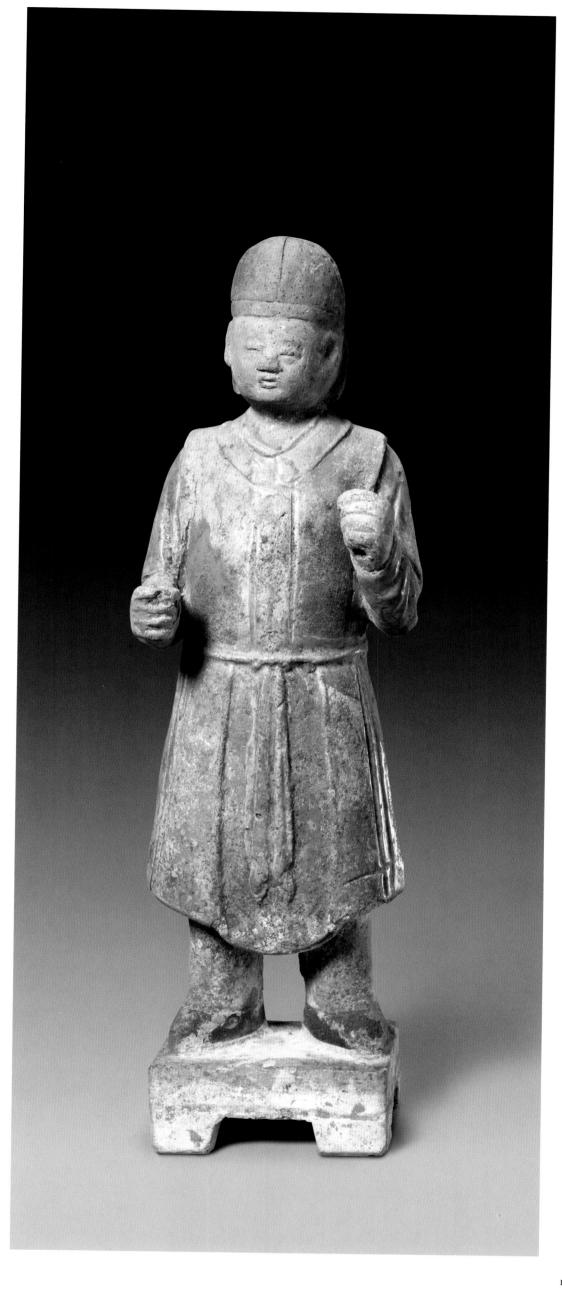

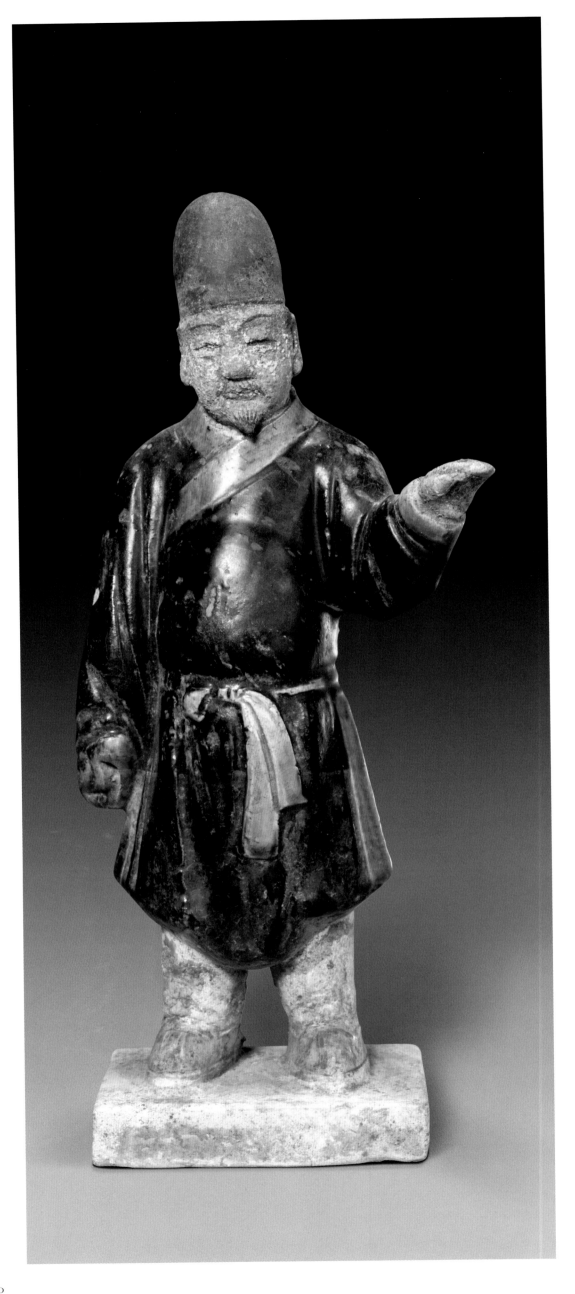

新43893
陶紫绿釉男俑
明

84 高28厘米　底宽8.3厘米

Xin 43893
Purple-green Glazed Pottery Male Figure
Ming Dynasty (1368-1644)
Height　28 cm
Bottom width　8.3 cm

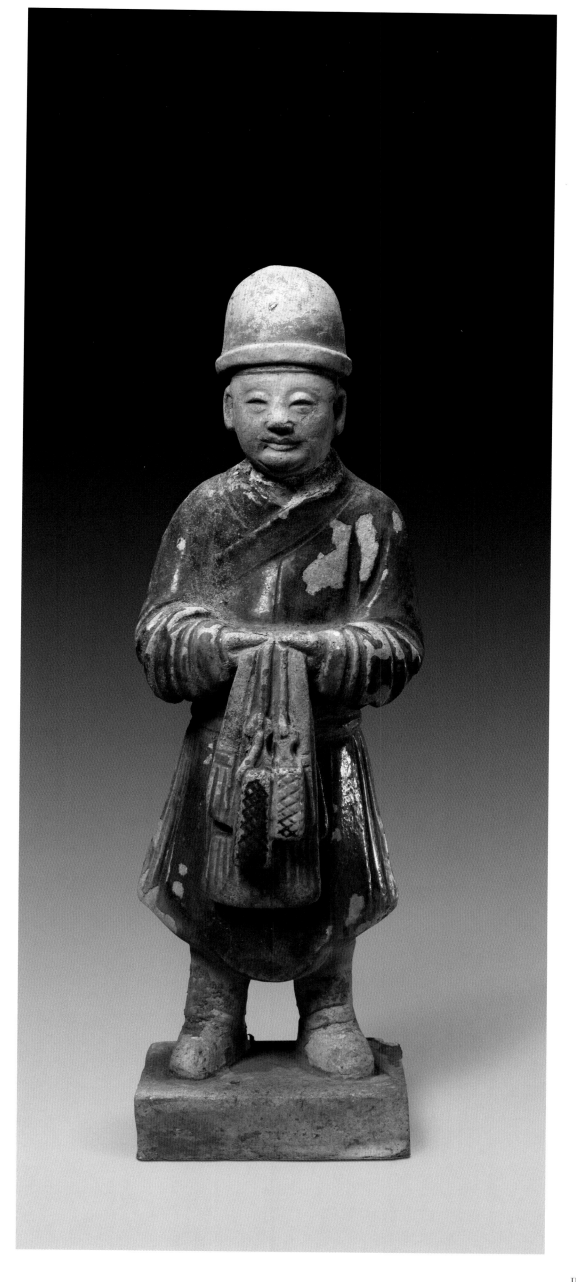

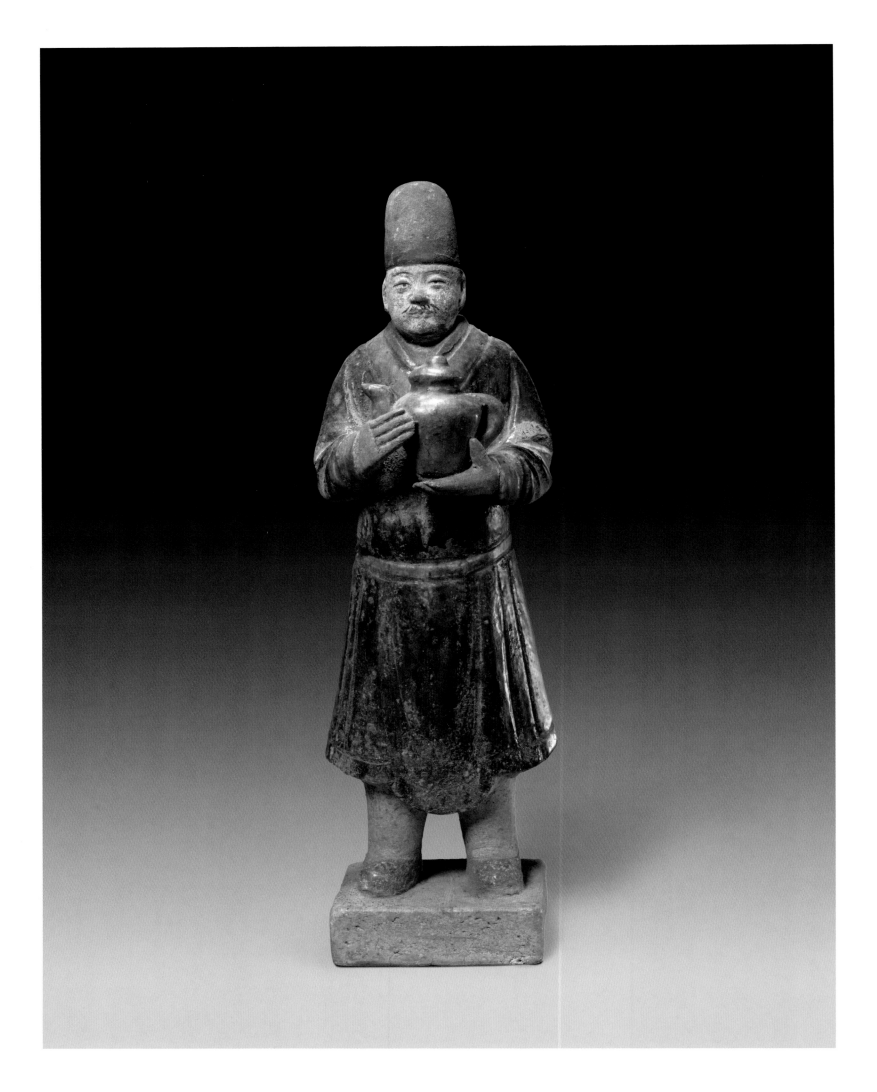

新43895

陶紫蓝釉男俑

明

高26.5厘米　底宽7厘米

86 | Xin 43895

Purple-blue Glazed Pottery Male Figure

Ming Dynasty (1368-1644)

Height　26.5 cm

Bottom width　7 cm

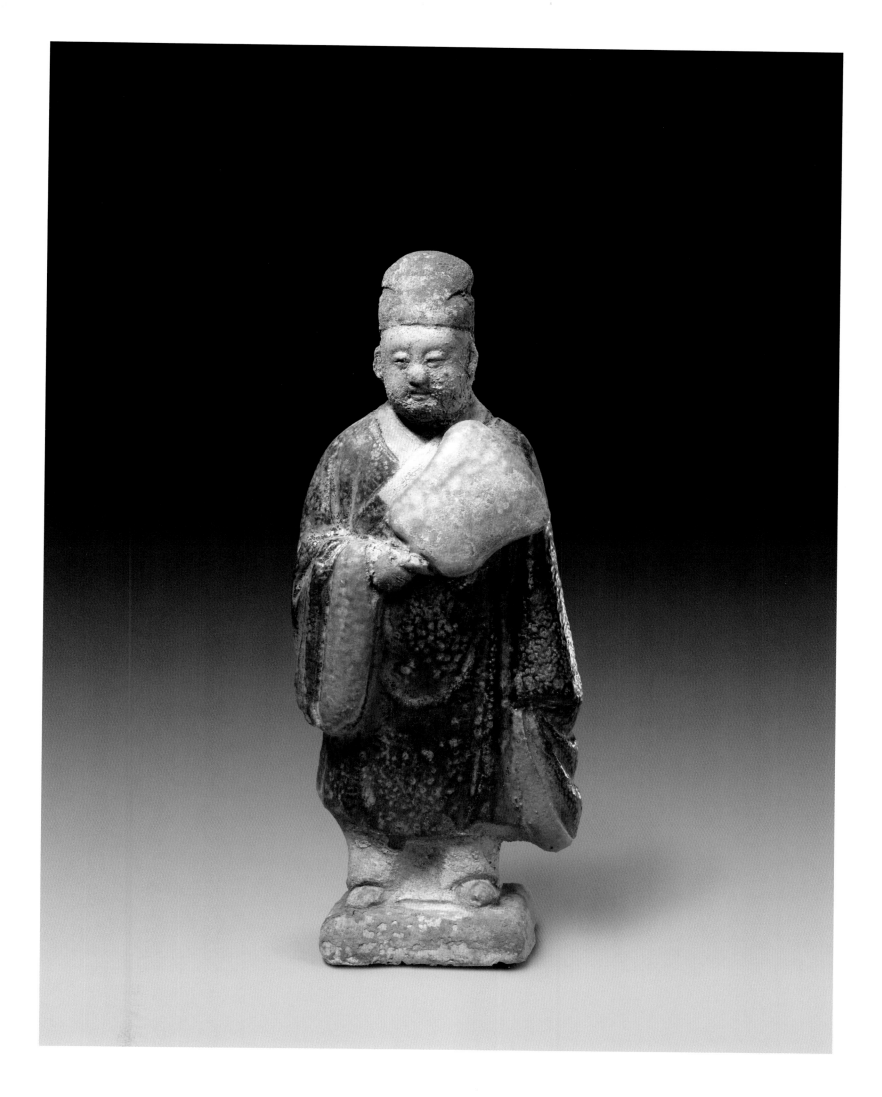

新43908
陶紫蓝釉男俑
明

87 高20厘米 底宽5.7厘米

Xin 43908
Purple-blue Glazed Pottery Male Figure
Ming Dynasty (1368-1644)
Height 20 cm
Bottom width 5.7 cm

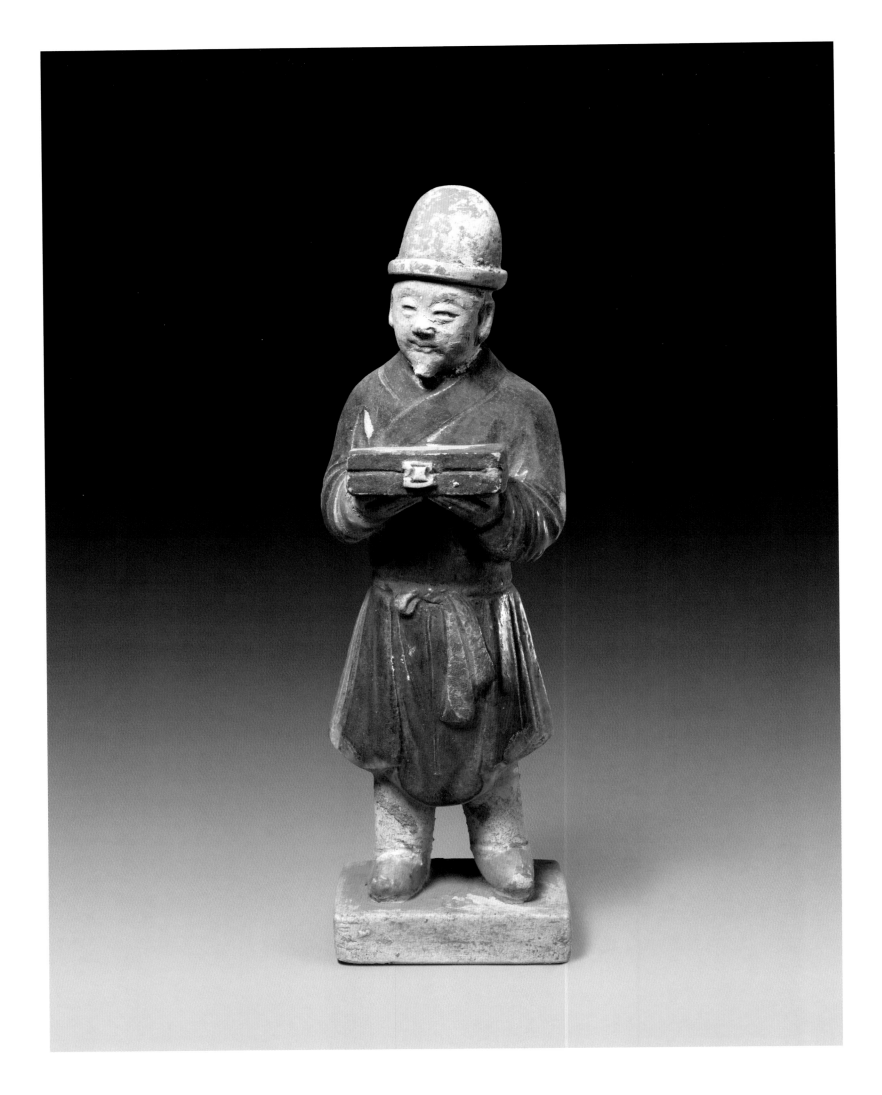

新43889

陶紫蓝釉男俑

明

高24.5厘米　底宽7.2厘米

88

Xin 43889

Purple-blue Glazed Pottery Male Figure
Ming Dynasty (1368-1644)
Height 24.5 cm
Bottom width 7.2 cm

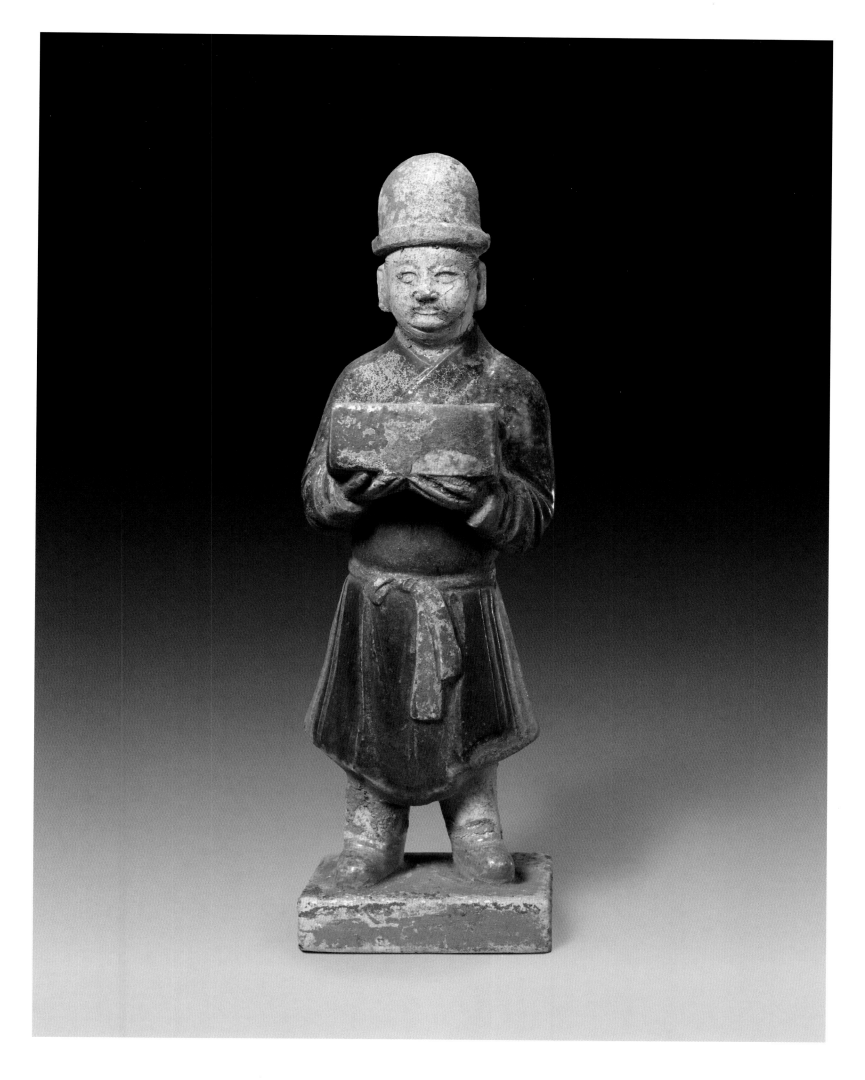

新43876
陶紫绿釉男俑
明

高25厘米 底宽7.5厘米

89 | Xin 43876
Purple-green Glazed Pottery Male Figure
Ming Dynasty (1368-1644)
Height 25 cm
Bottom width 7.5 cm

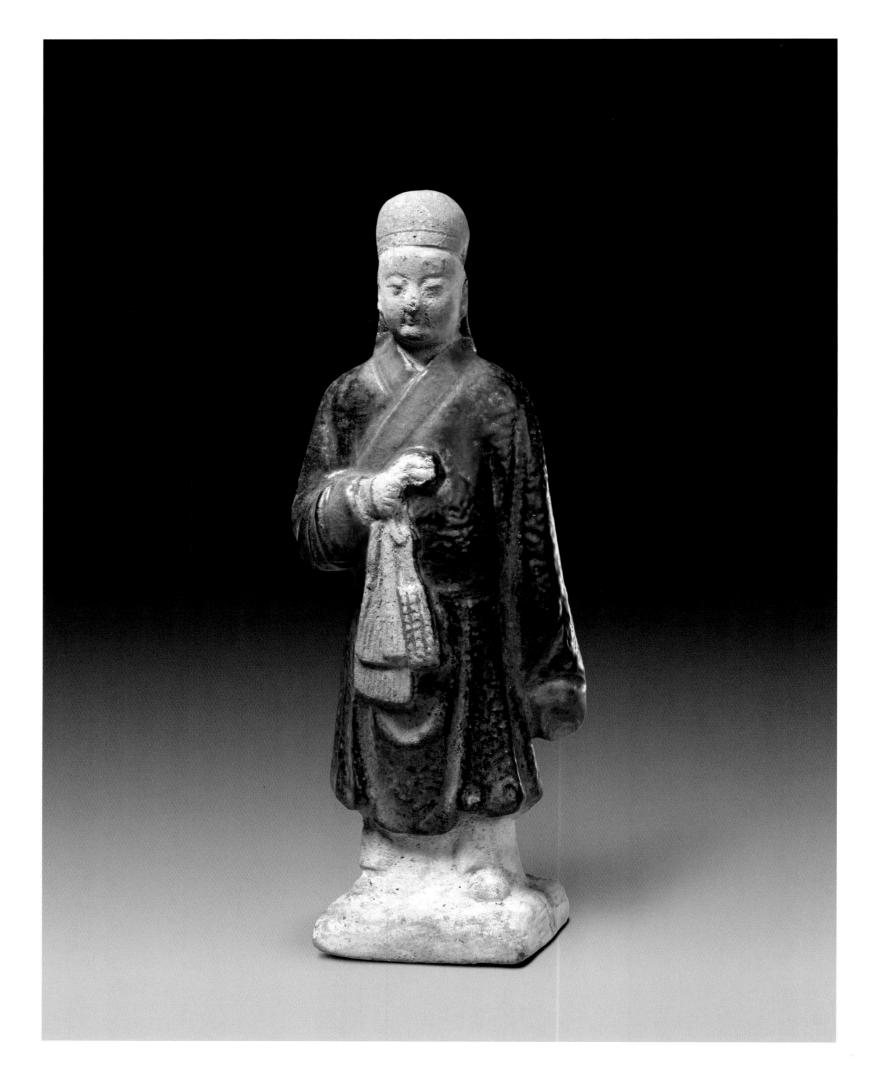

新43888
陶紫蓝釉男俑
明
高19厘米 底宽5.5厘米

90 | Xin 43888
Purple-blue Glazed Pottery Male Figure
Ming Dynasty (1368-1644)
Height 19 cm
Bottom width 5.5 cm

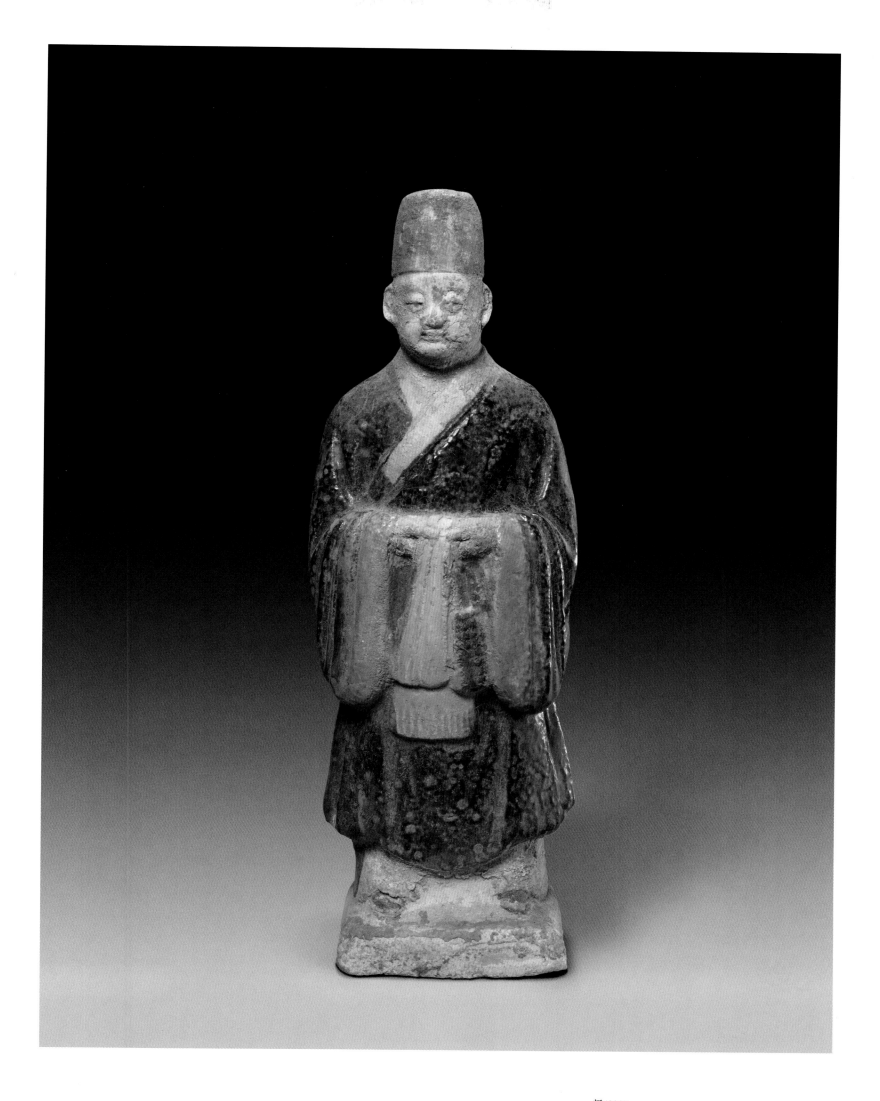

新43892

陶紫绿釉男俑

明

高21厘米 底宽6厘米

91 Xin 43892
Purple-green Glazed Pottery Male Figure
Ming Dynasty (1368-1644)
Height 21 cm
Bottom width 6 cm

新43877

陶紫绿釉男俑

明

高27.5厘米 底宽8厘米

92

Xin 43877

Purple-green Glazed Pottery Male Figure

Ming Dynasty (1368-1644)

Height 27.5 cm

Bottom width 8 cm

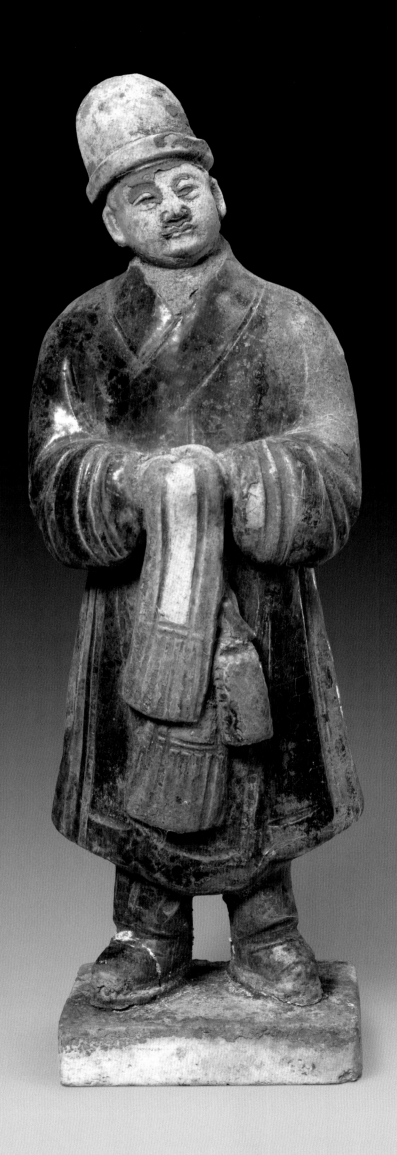

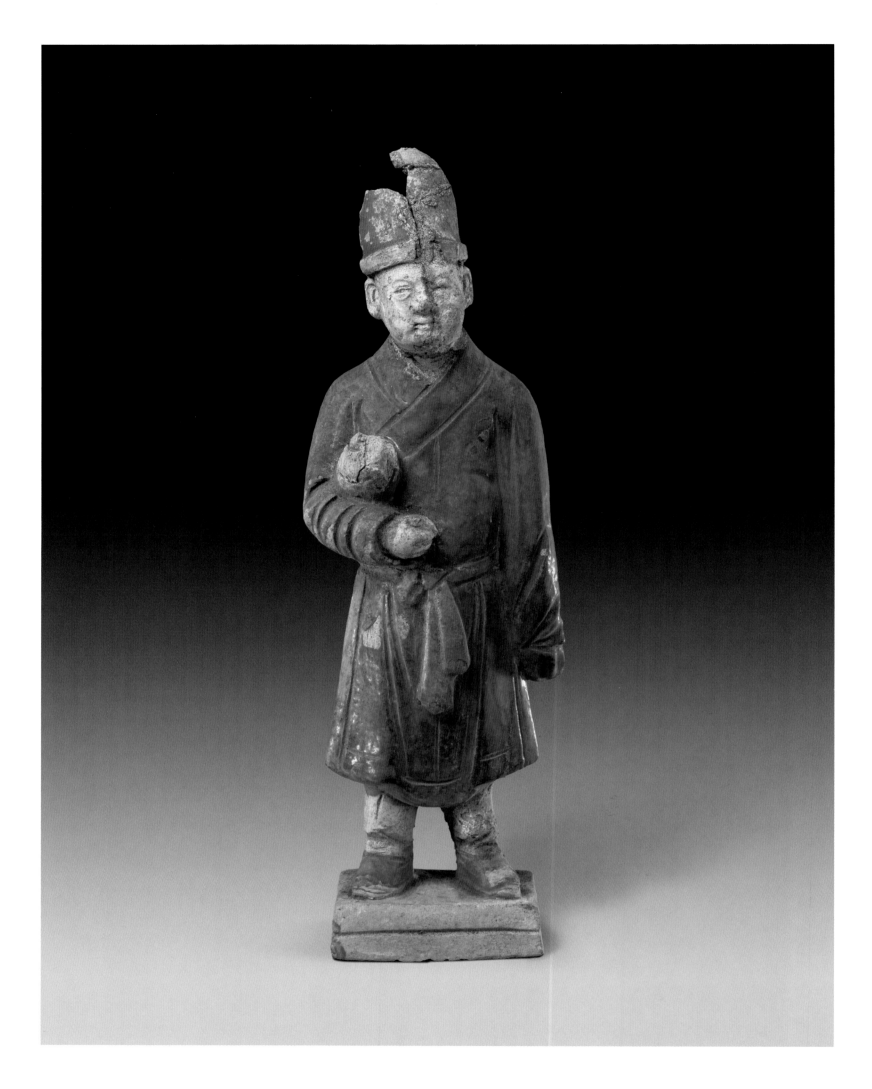

新43875

陶紫绿釉男俑

明

高29.5厘米　底宽7.5厘米

93

Xin 43875

Purple-green Glazed Pottery Male Figure

Ming Dynasty (1368-1644)

Height　29.5 cm

Bottom width　7.5 cm

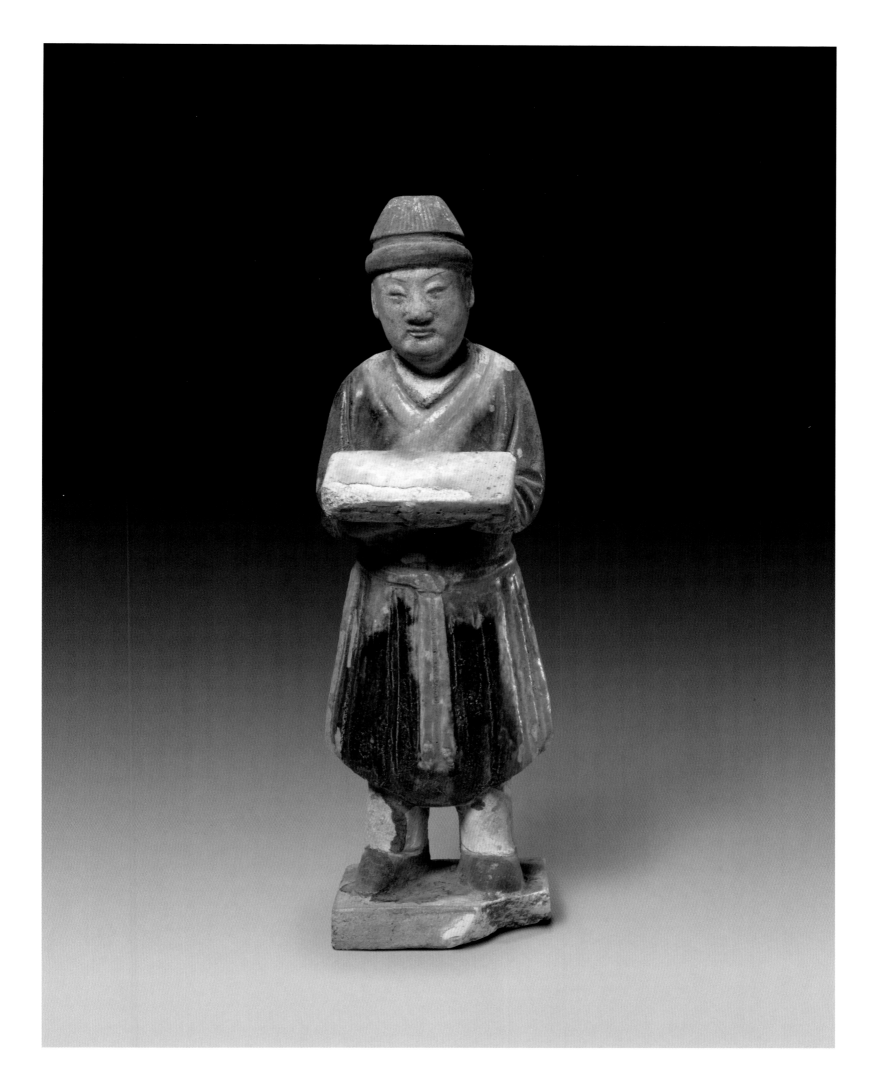

新103746

陶紫绿釉男俑

明

高25厘米 底宽7厘米

94

Xin 103746

Purple-green Glazed Pottery Male Figure
Ming Dynasty (1368-1644)
Height 25 cm
Bottom width 7 cm

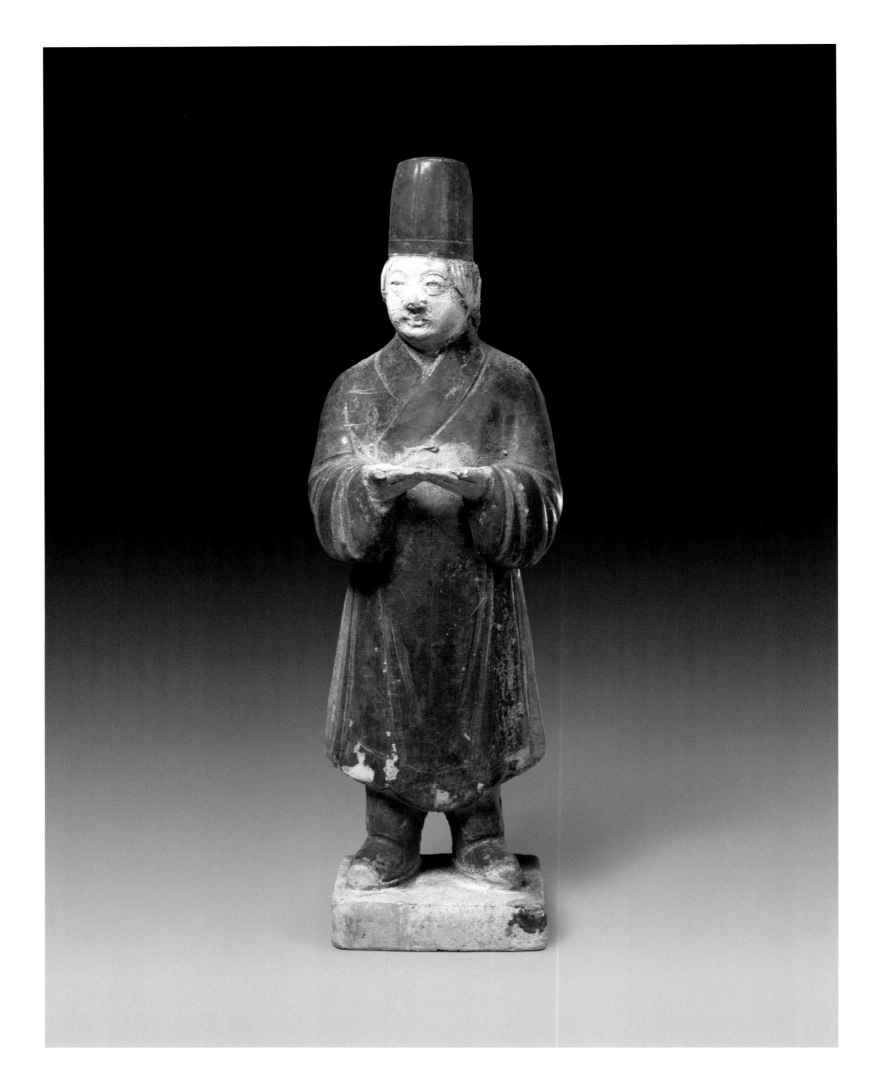

新43867

陶紫绿釉男俑

明

高28.5厘米 底宽7.7厘米

95 | Xin 43867

Purple-green Glazed Pottery Male Figure
Ming Dynasty (1368-1644)
Height 28.5 cm
Bottom width 7.7 cm

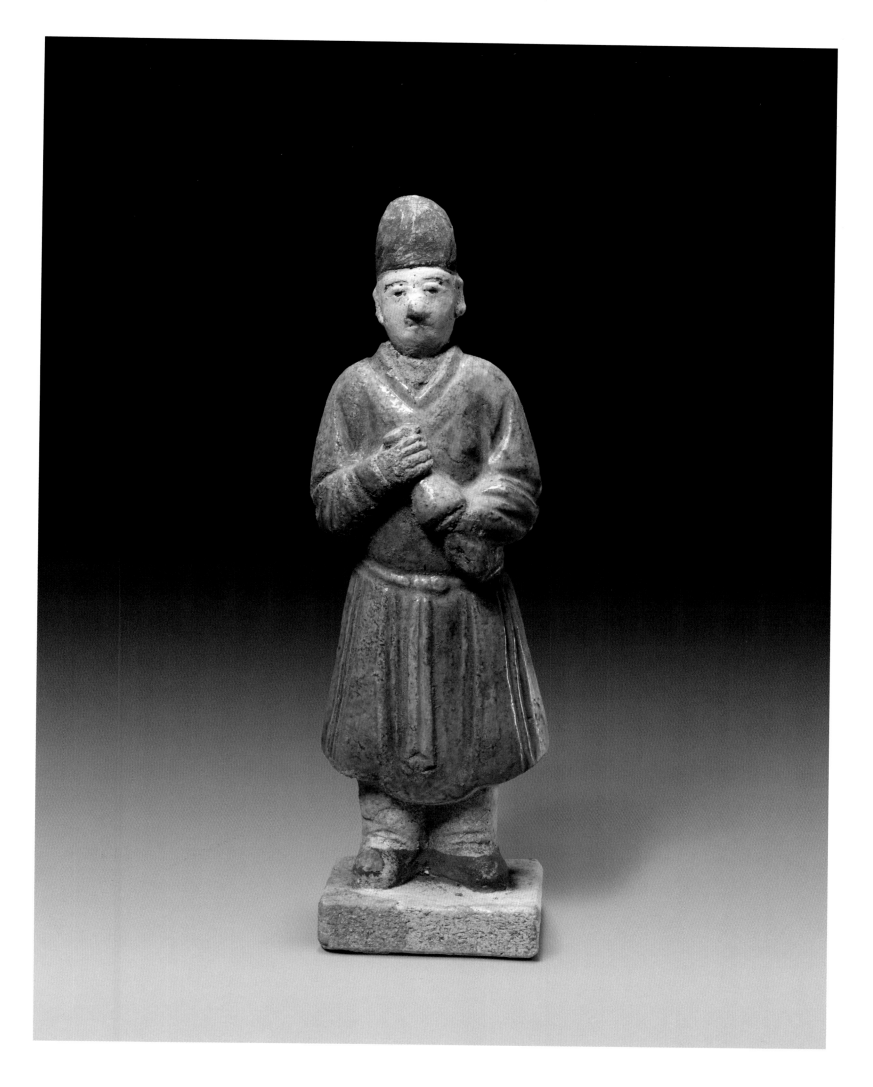

新43858

陶黄绿釉男俑

明

高24厘米 底宽6.5厘米

96

Xin 43858

Yellow-green Glazed Pottery Male Figure

Ming Dynasty (1368-1644)

Height 24 cm

Bottom width 6.5 cm

新43860

陶黄绿釉男俑

明

高31厘米 底宽11.2厘米

97 | Xin 43860

Yellow-green Glazed Pottery Male Figure
Ming Dynasty (1368-1644)

Height 31 cm
Bottom width 11.2 cm

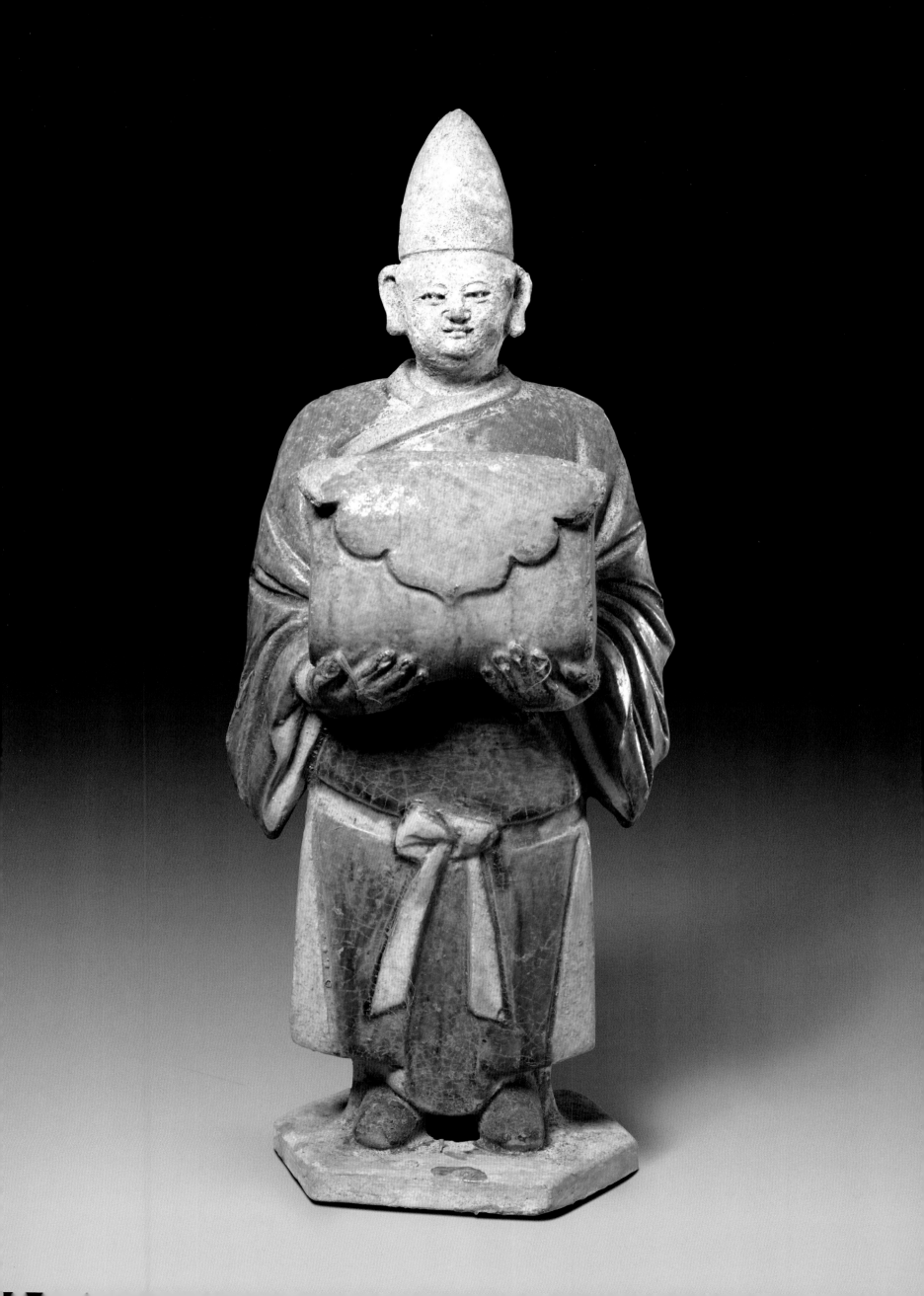

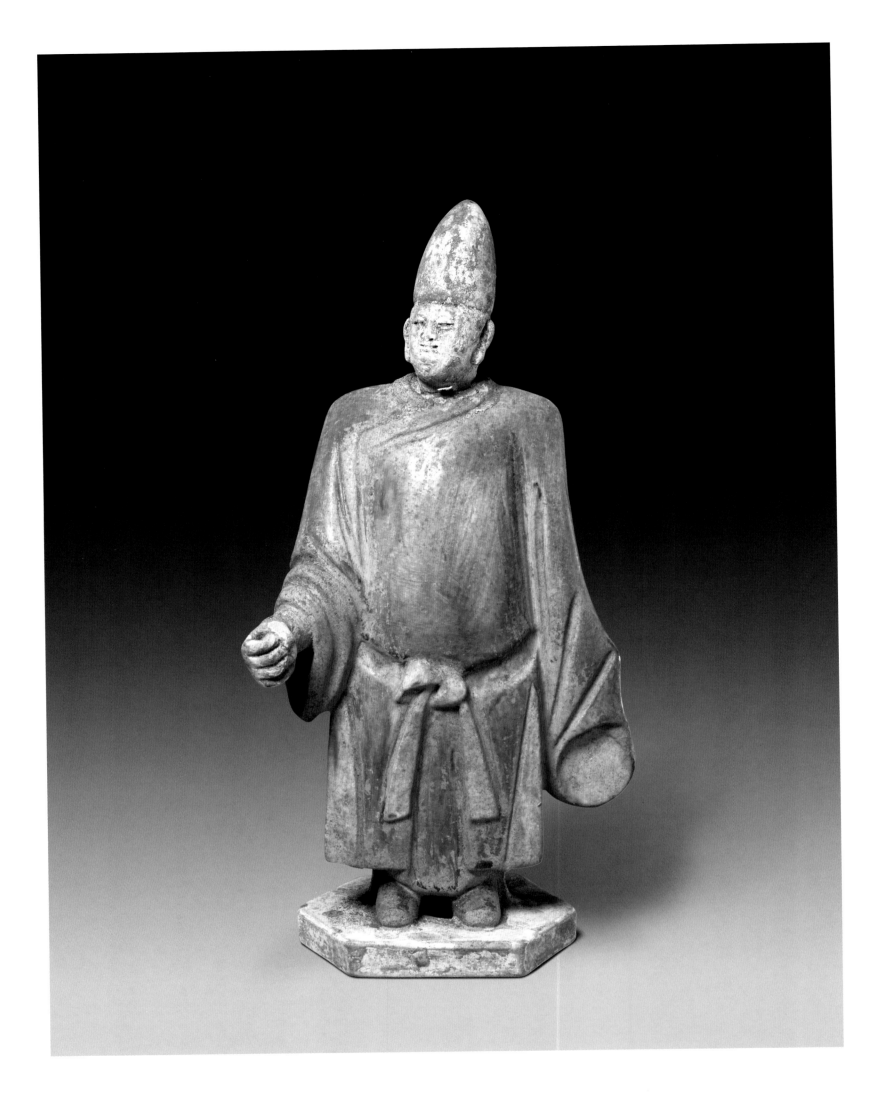

新43859

陶黄绿釉男俑

明

高31厘米 底宽14厘米

98

Xin 43859

Yellow-green Glazed Pottery Male Figure

Ming Dynasty (1368-1644)

Height 31 cm

Bottom width 14 cm

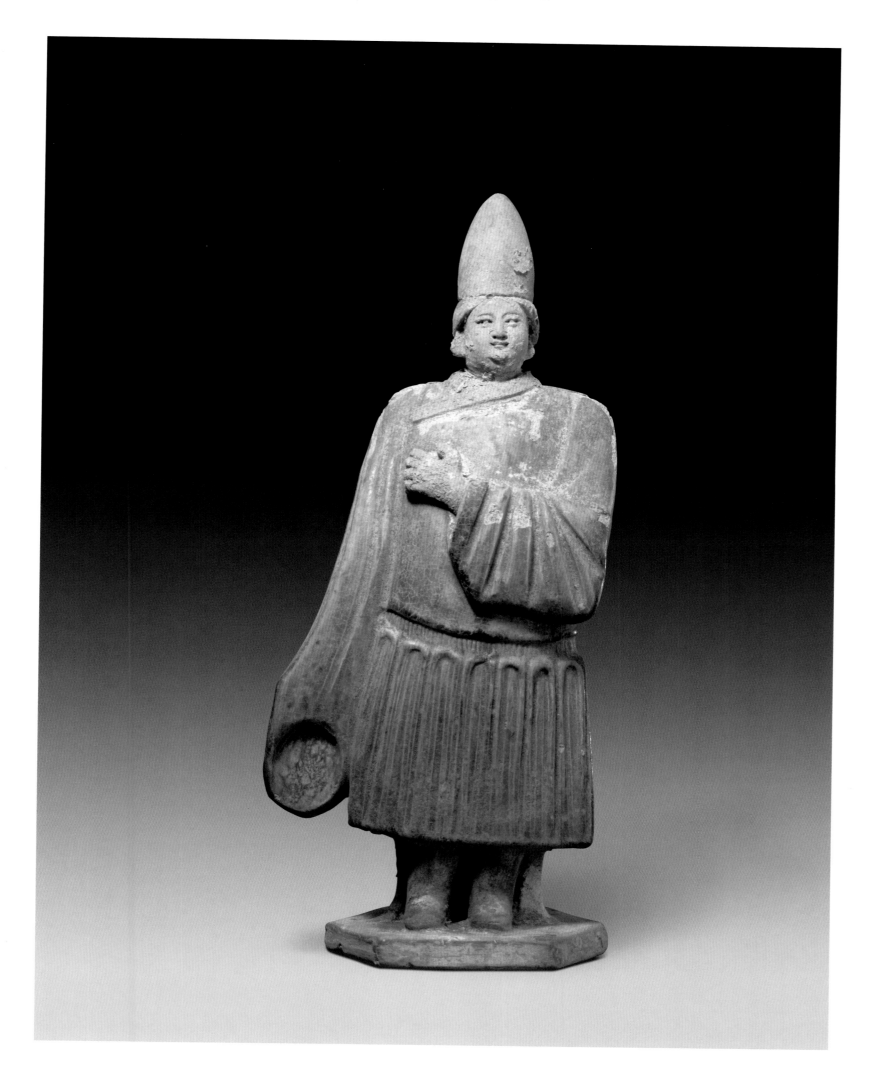

新43861

陶黄绿釉男俑

明

高31厘米　底宽12厘米

99

Xin 43861

Yellow-green Glazed Pottery Male Figure

Ming Dynasty (1368-1644)

Height　31 cm

Bottom width　12 cm

陶黄绿釉男俑(背面)
Yellow-green Glazed Pottery Male Figure（back）

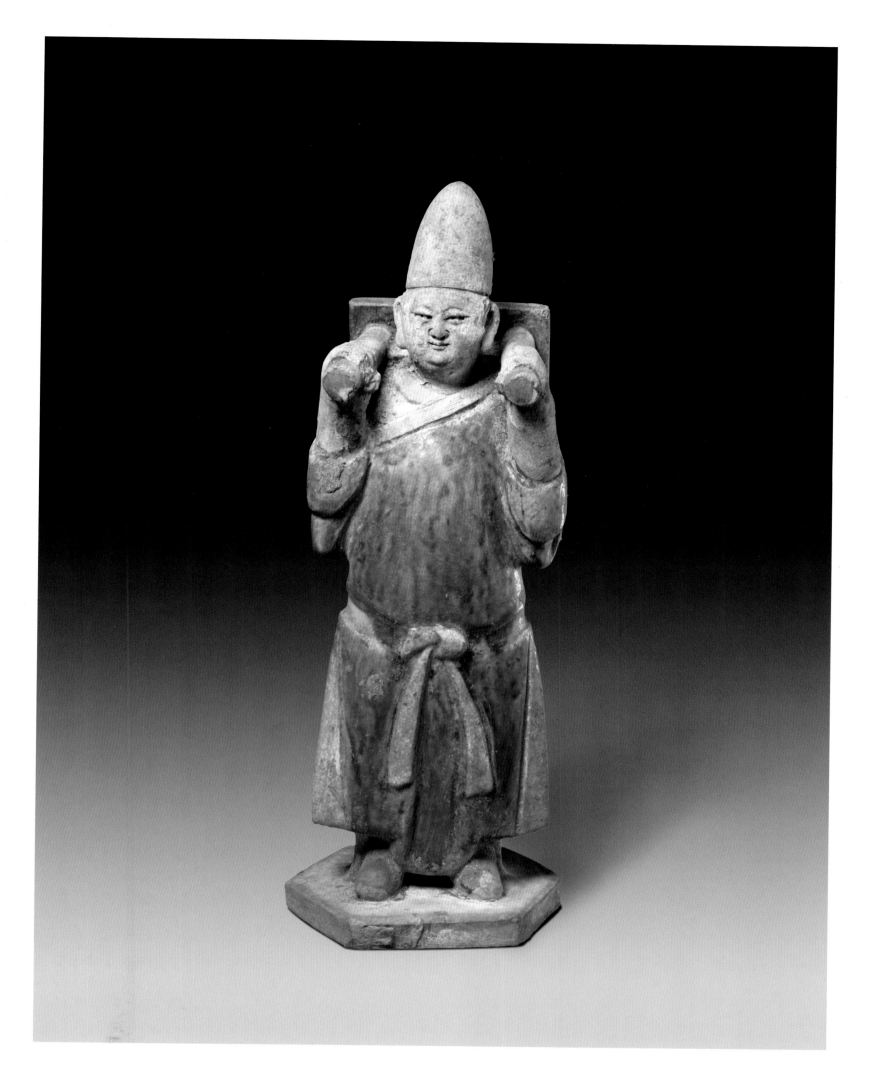

新43862
陶黄绿釉男俑
明

高30厘米 底宽10.8厘米

100

Xin 43862
Yellow-green Glazed Pottery Male Figure
Ming Dynasty (1368-1644)
Height　30 cm
Bottom width　10.8 cm

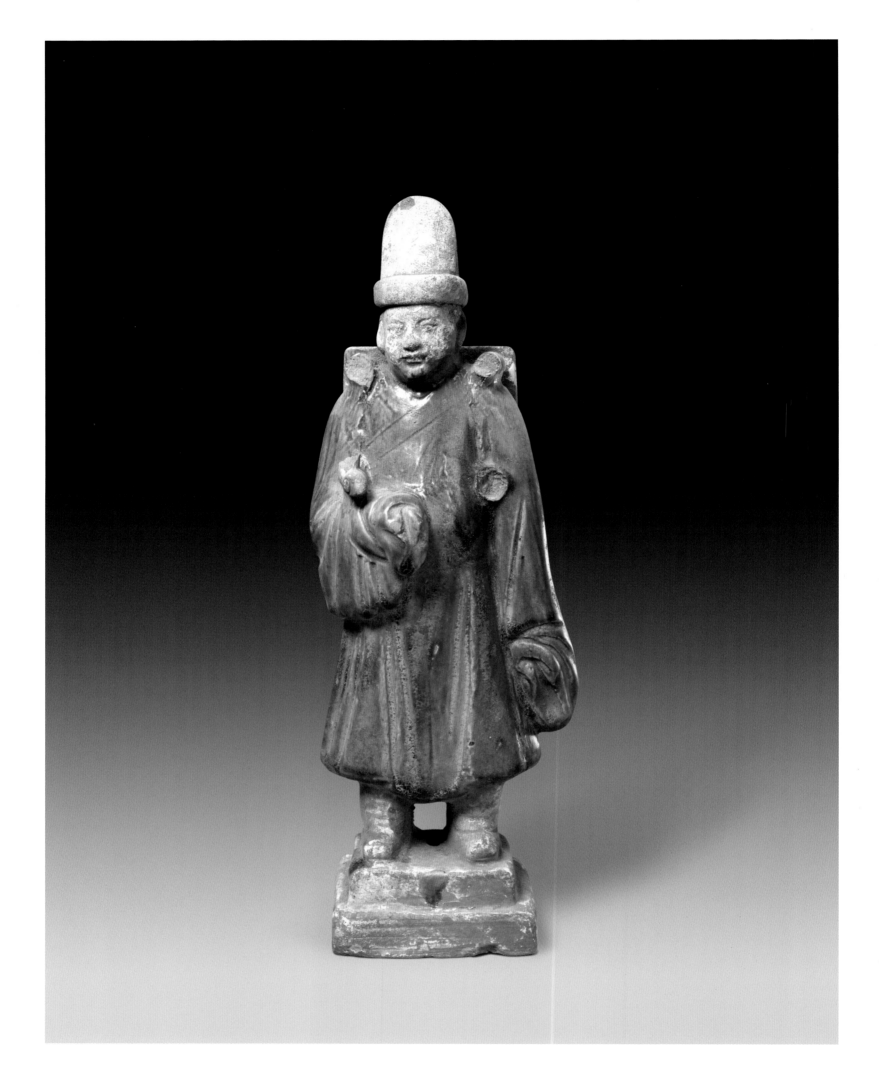

新60060
陶绿釉男俑
明

高26.5厘米 底宽7厘米

101

Xin 60060
Green Glazed Pottery Male Figure
Ming Dynasty (1368-1644)
Height 26.5 cm
Bottom width 7 cm

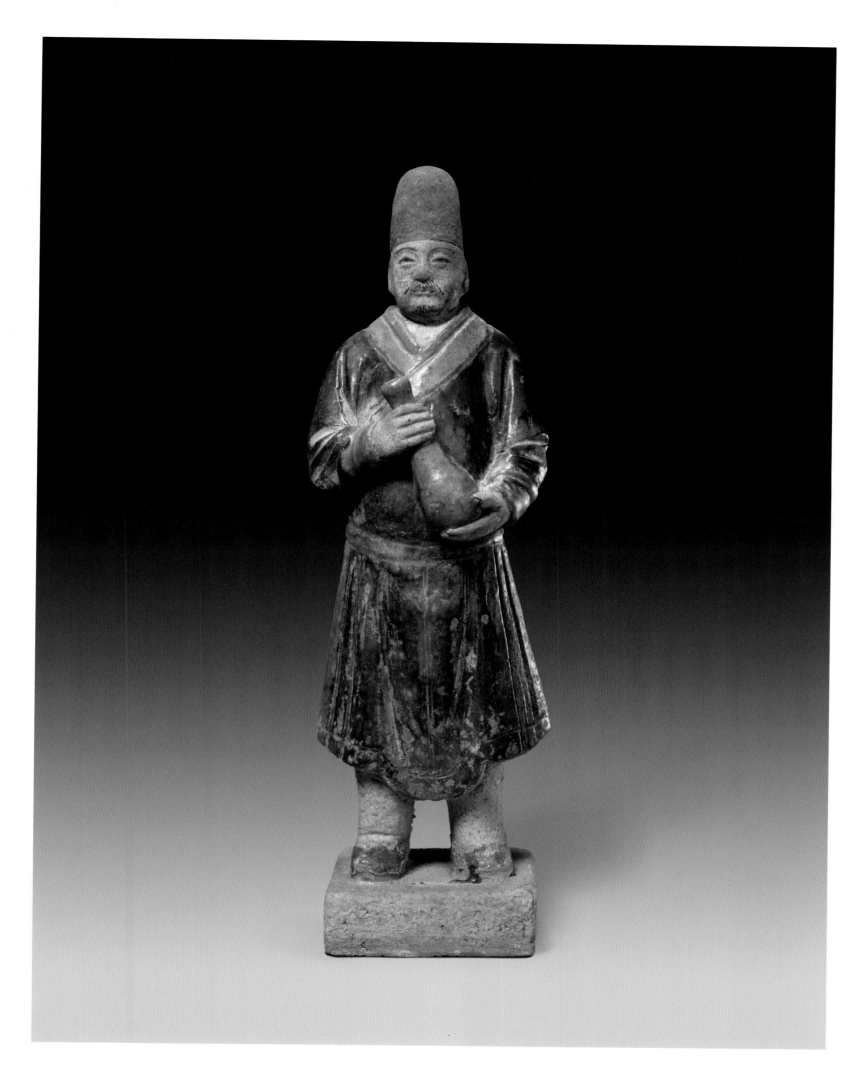

陶紫蓝釉男俑

明

高28.5厘米 底宽7厘米

102

Xin 43907

Purple-blue Glazed Pottery Male Figure

Ming Dynasty (1368-1644)

Height 28.5 cm

Bottom width 7 cm

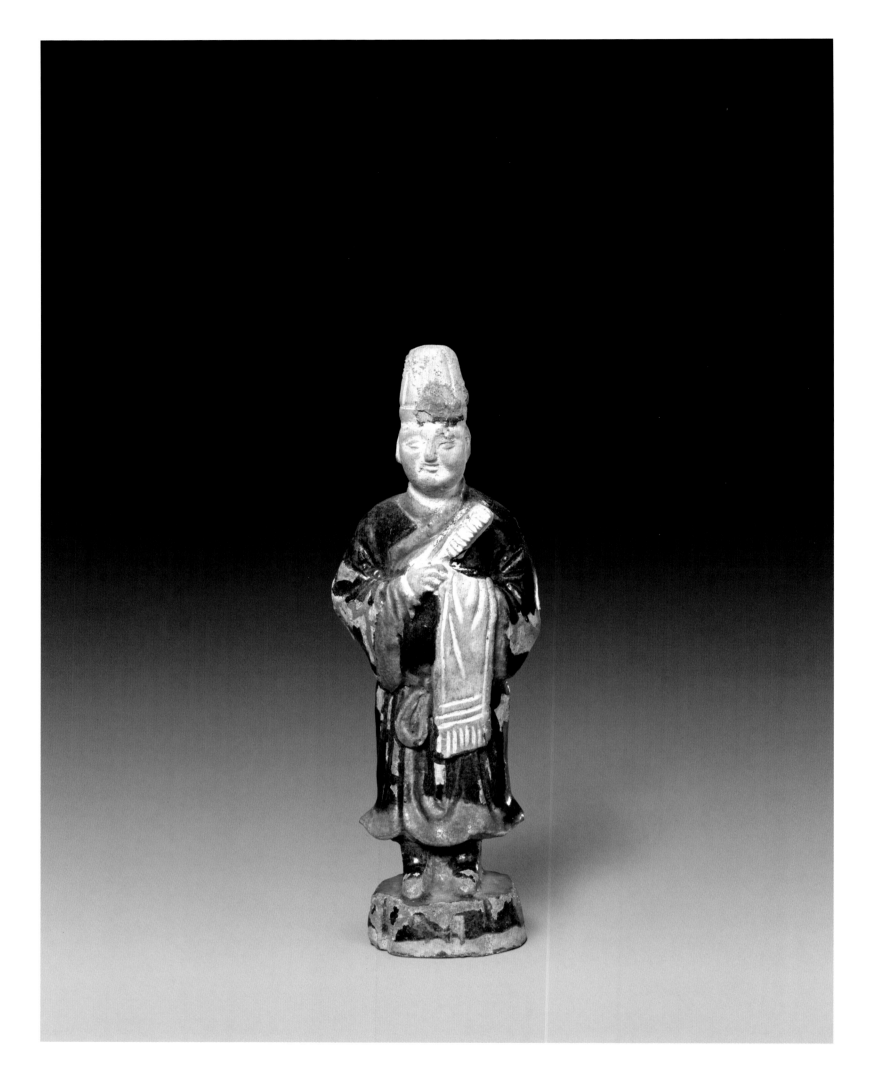

新128204

陶蓝绿釉男俑

明

高16.7厘米　底宽4.3厘米

103

Xin 128204

Blue-green Glazed Pottery Male Figure

Ming Dynasty (1368-1644)

Height　16.7 cm

Bottom width　4.3 cm

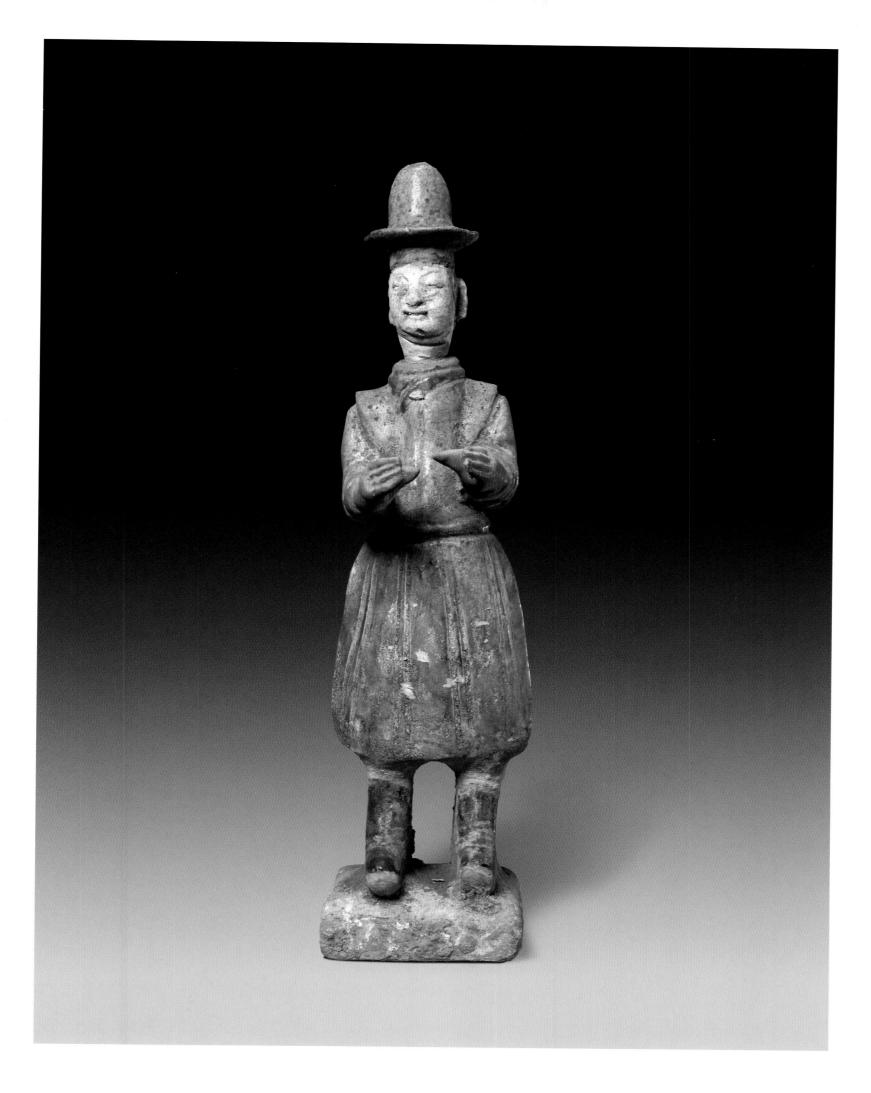

新112070

陶黄绿釉男俑

明

高33厘米 底宽8.2厘米

104

Xin 112070

Yellow-green Glazed Pottery Male Figure
Ming Dynasty (1368-1644)
Height 33 cm
Bottom width 8.2 cm

新112071

陶黄绿釉男俑

明

高31.5厘米 底宽8厘米

105

Xin 112071

Yellow-green Glazed Pottery Male Figure

Ming Dynasty (1368-1644)

Height 31.5 cm

Bottom width 8 cm

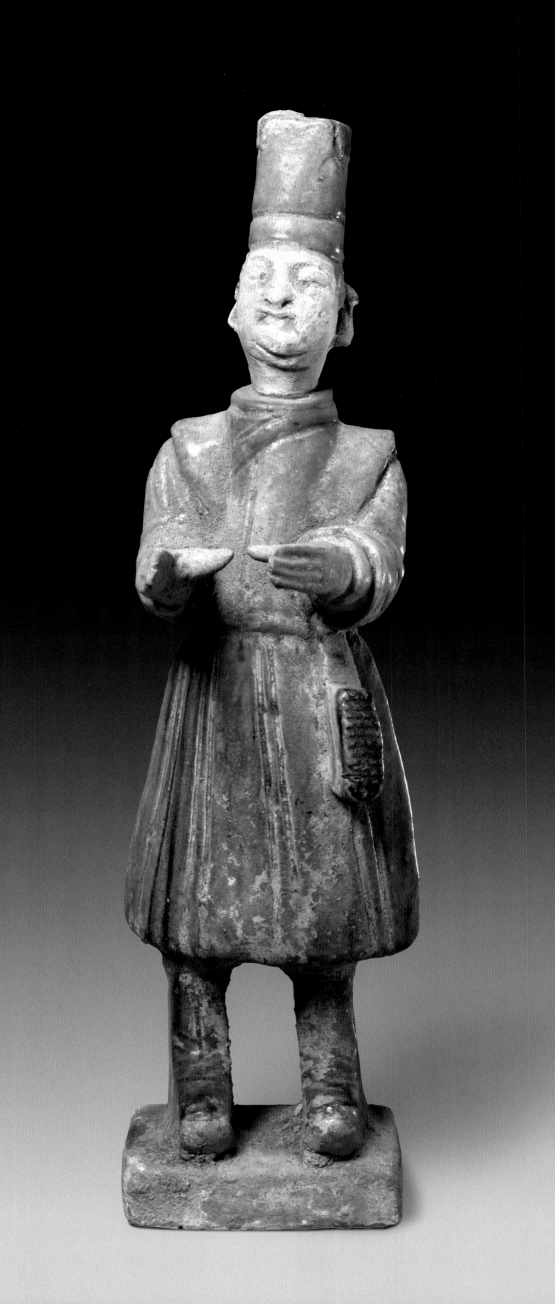

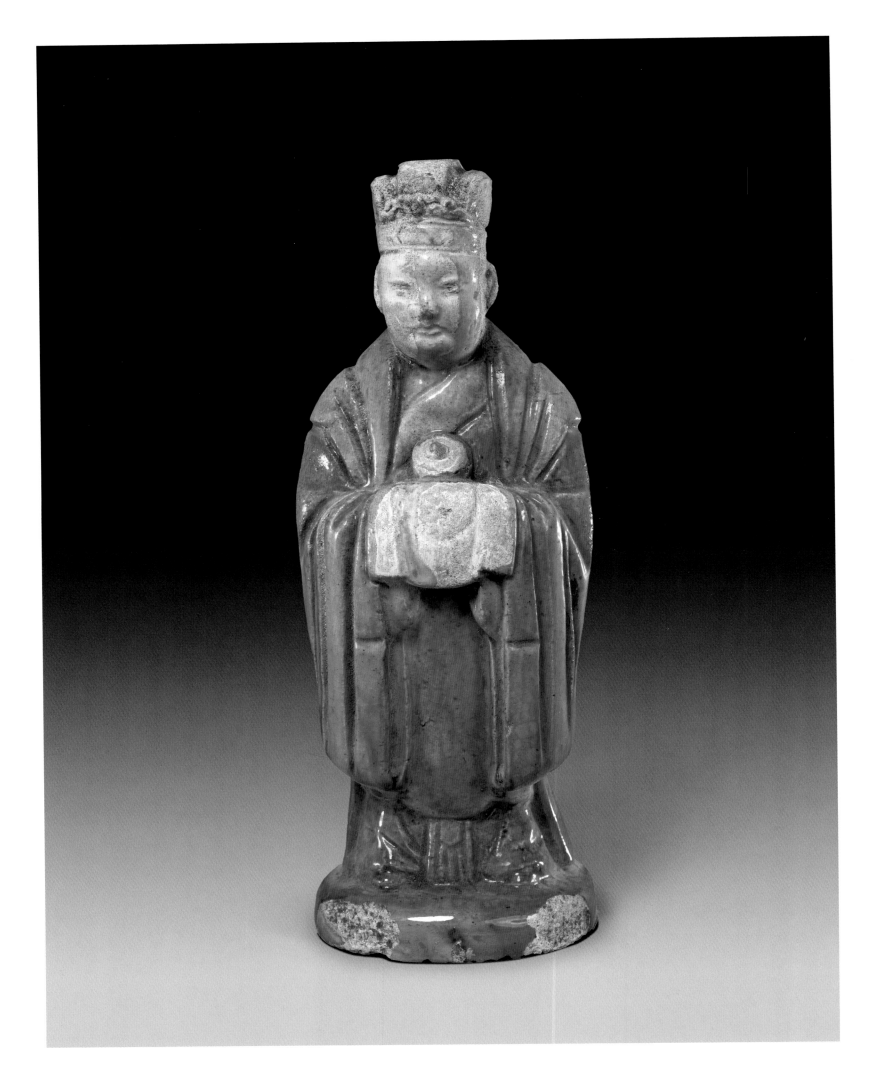

新60597

陶黄绿釉男俑

明

高22厘米 底宽8厘米

106 | Xin 60597

Yellow-green Glazed Pottery Male Figure

Ming Dynasty (1368-1644)

Height 22 cm
Bottom width 8 cm

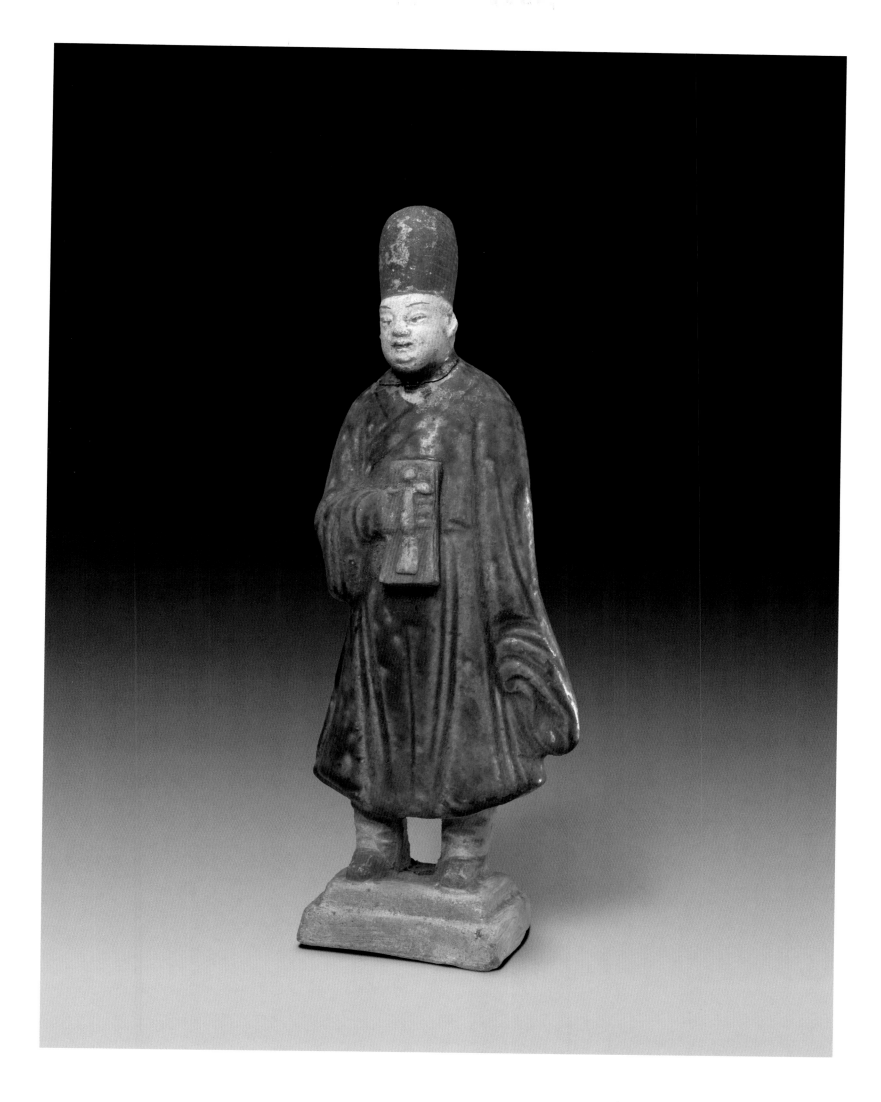

新103733

陶绿釉男俑
明
高21厘米 底宽5.3厘米

107

Xin 103733

Green Glazed Pottery Male Figure
Ming Dynasty (1368-1644)
Height 21 cm
Bottom width 5.3 cm

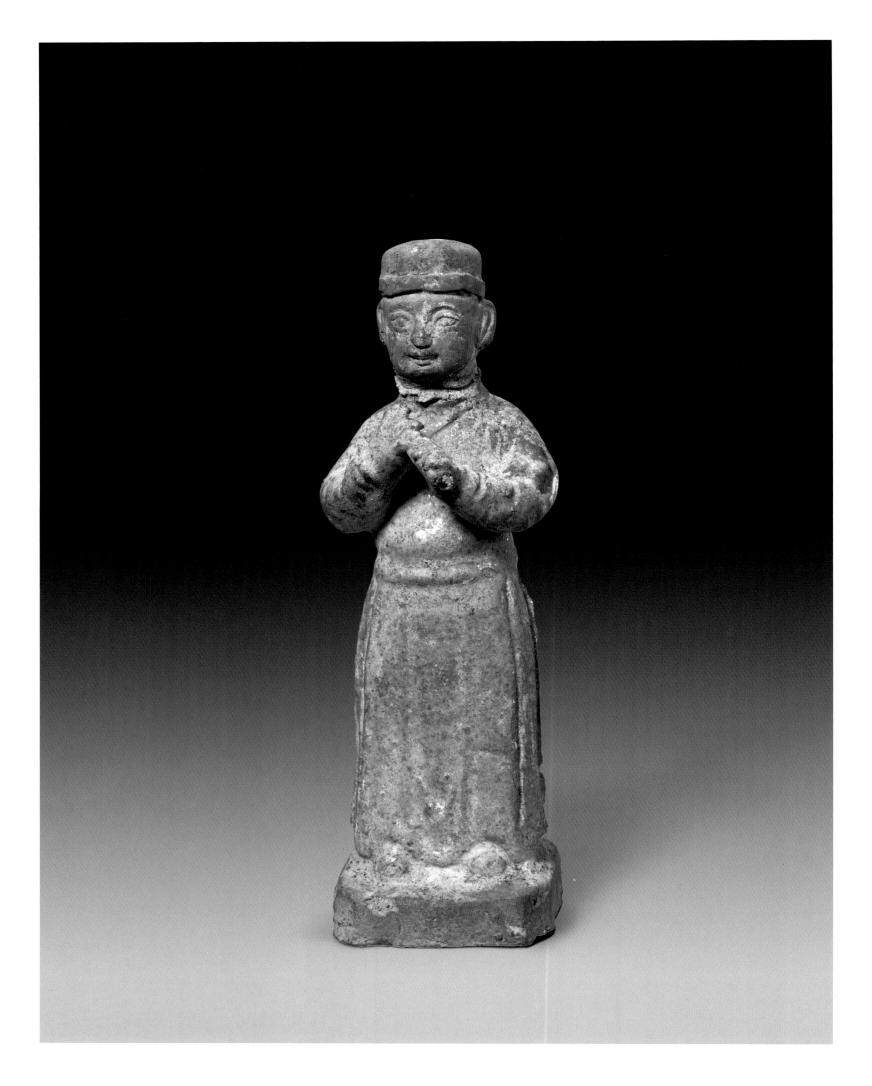

新155657

陶绿釉男俑

明

高20.5厘米 底宽6厘米

108

Xin 155657

Green Glazed Pottery Male Figure

Ming Dynasty (1368-1644)

Height 20.5 cm

Bottom width 6 cm

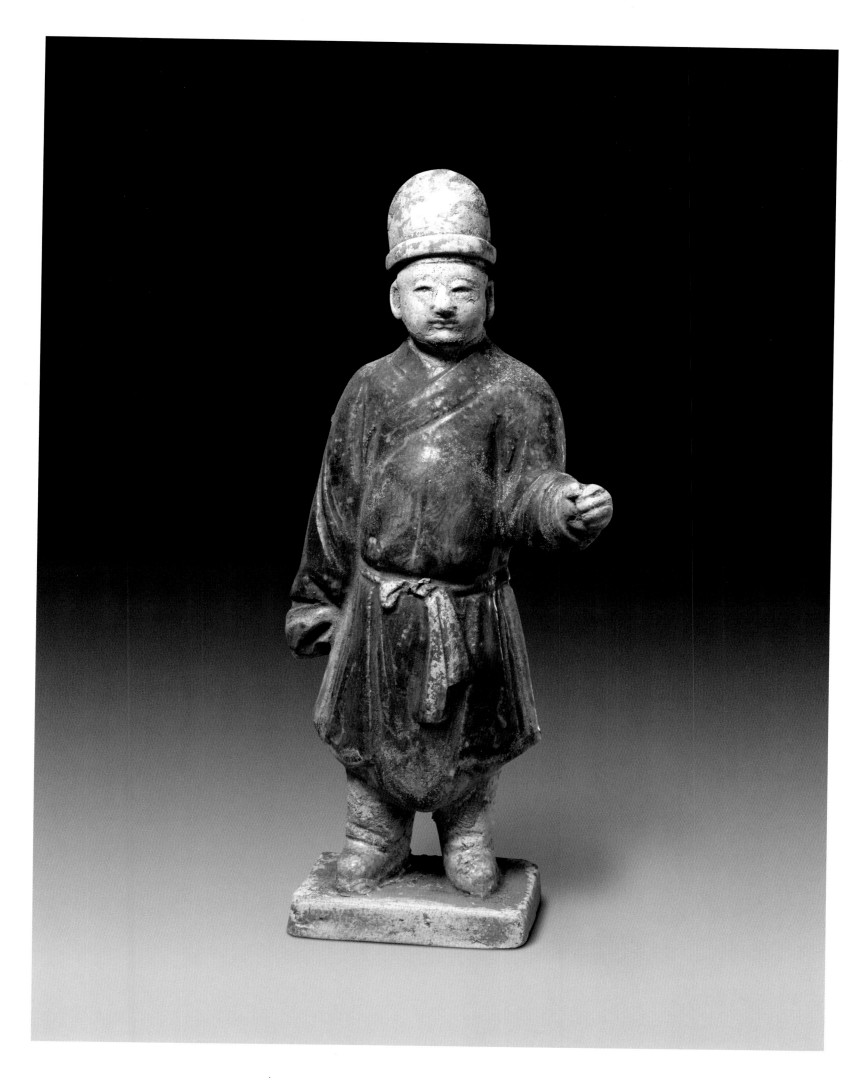

新43878

陶紫绿釉男俑

明

高24厘米　底宽7.5厘米

109

Xin 43878

Purple-green Glazed Pottery Male Figure

Ming Dynasty (1368-1644)

Height　24 cm

Bottom width　7.5 cm

新43863

陶蓝釉男俑

明

高29.5厘米 底宽7.5厘米

110

Xin 43863

Blue Glazed Pottery Male Figure

Ming Dynasty (1368-1644)

Height 29.5 cm
Bottom width 7.5 cm

新121908

陶紫釉男俑

明

高26厘米　底宽8厘米

III

Xin 121908

Purple Glazed Pottery Male Figure

Ming Dynasty (1368-1644)

Height　26 cm

Bottom width　8 cm

新60594

陶黄绿釉男俑

明

高33厘米 底宽9厘米

112

Xin 60594

Yellow-green Glazed Pottery Male Figure

Ming Dynasty (1368-1644)

Height 33 cm

Bottom width 9 cm

新60593

陶黄绿釉男俑

明

高34厘米　底宽8.2厘米

113

Xin 60593

Yellow-green Glazed Pottery Male Figure
Ming Dynasty (1368-1644)
Height　34 cm
Bottom width　8.2 cm

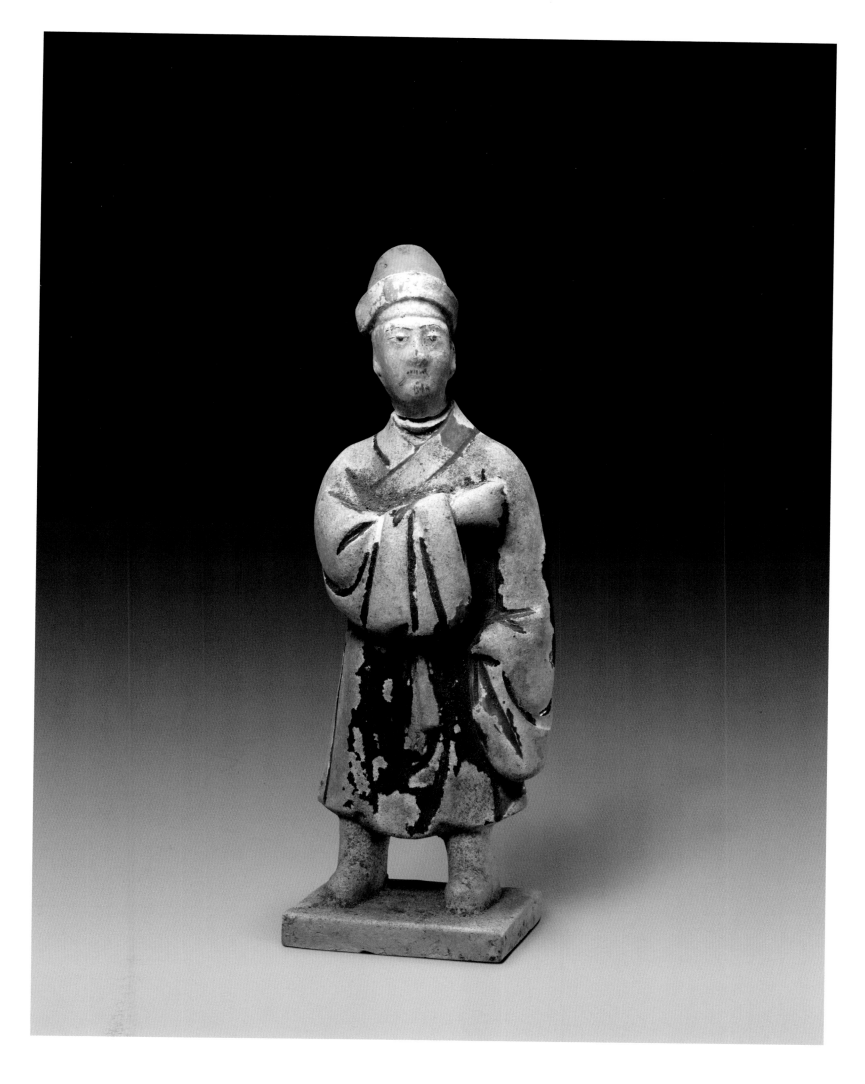

新60061

陶紫蓝釉男俑

明

高25厘米 底宽7.5厘米

114

Xin 60061

Purple-blue Glazed Pottery Male Figure

Ming Dynasty (1368-1644)

Height 25 cm

Bottom width 7.5 cm

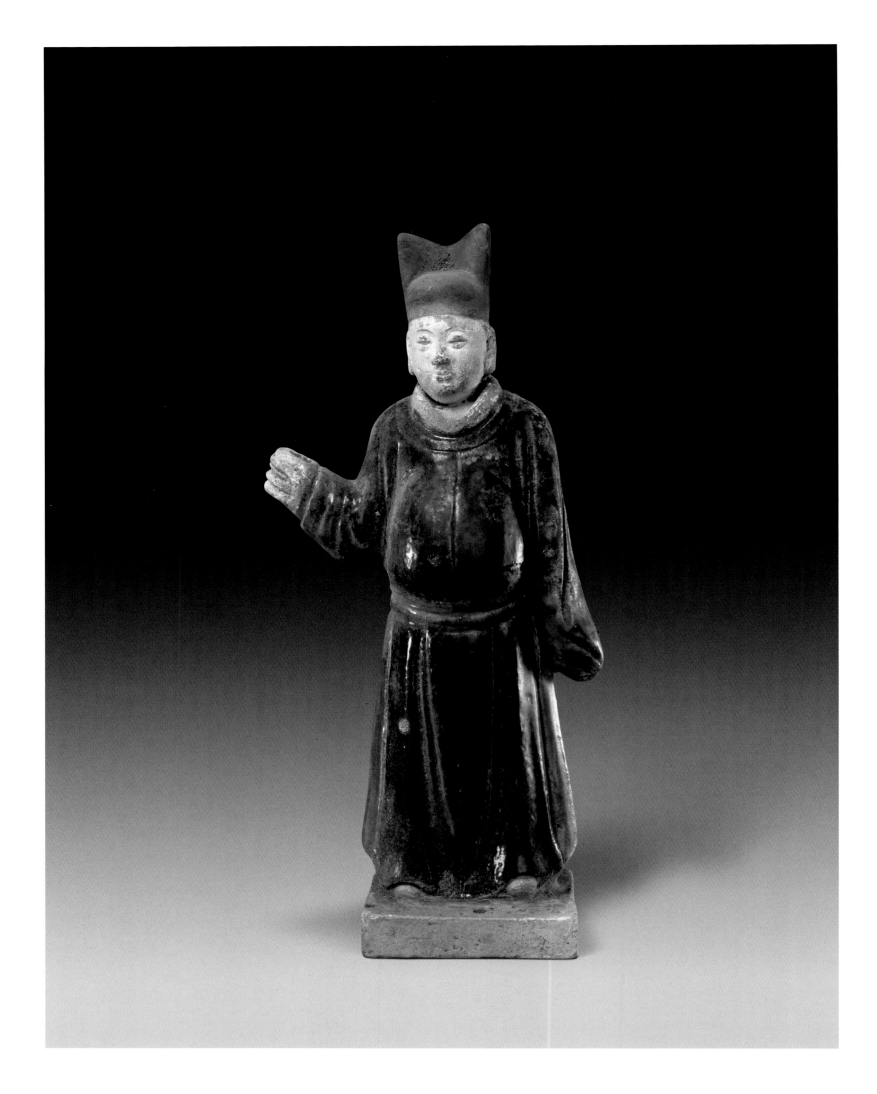

新103727

陶紫蓝釉男俑

明

高24.5厘米　底宽6.8厘米

115

Xin 103727

Purple-blue Glazed Pottery Male Figure

Ming Dynasty (1368-1644)

Height　24.5 cm

Bottom width　6.8 cm

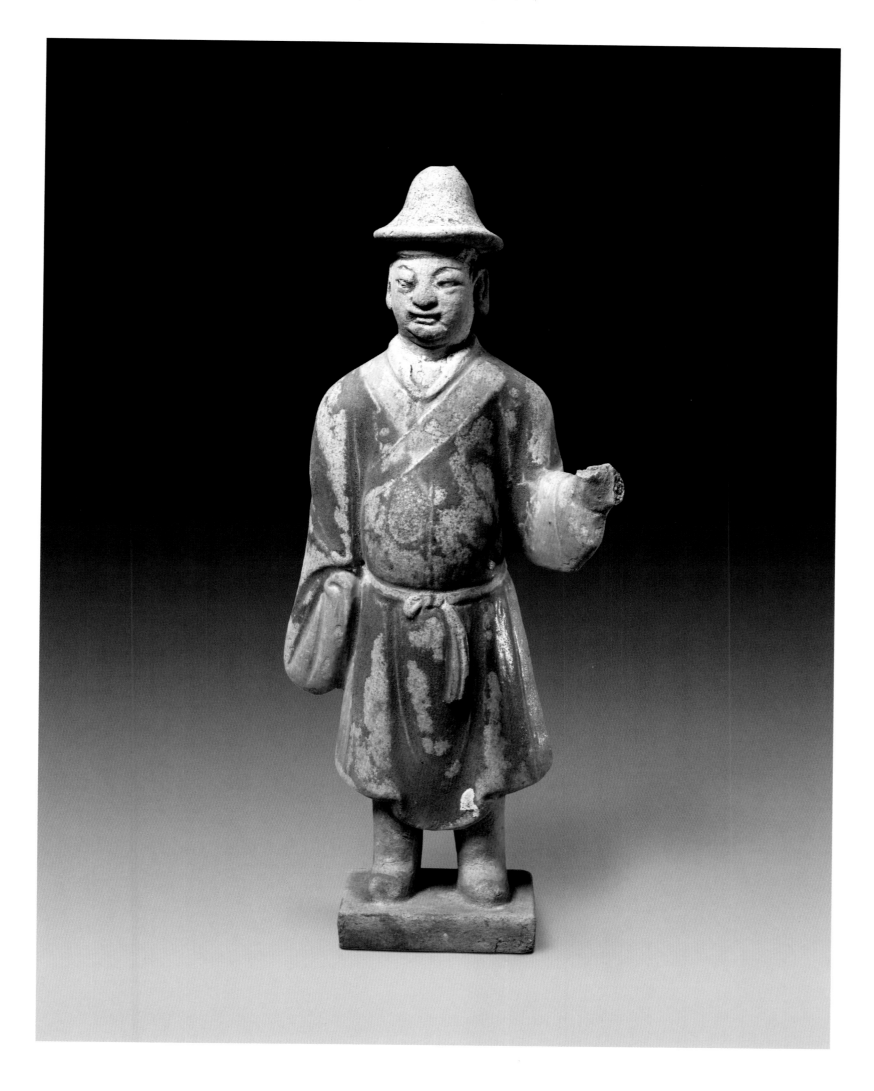

新103747

陶紫蓝釉男俑

明

高28.5厘米 底宽6.8厘米

116

Xin 103747

Purple-blue Glazed Pottery Male Figure
Ming Dynasty (1368-1644)

Height 28.5 cm
Bottom width 6.8 cm

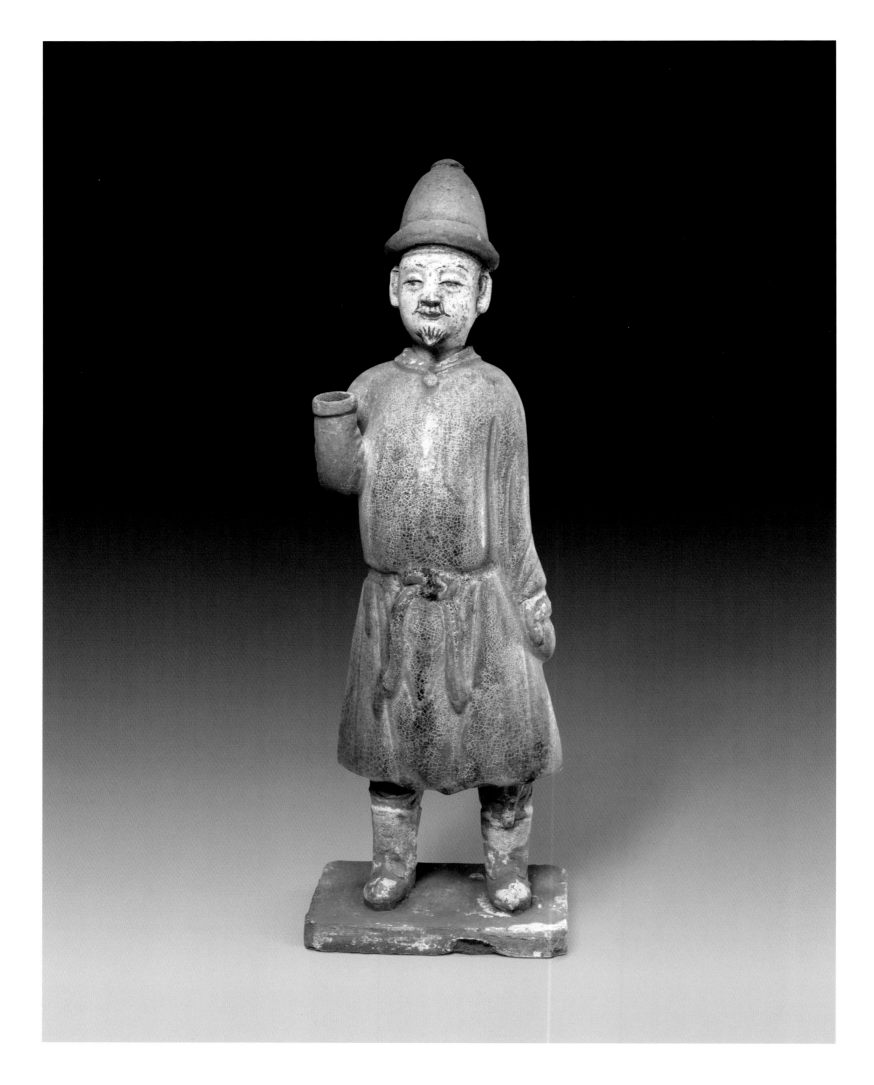

新60591

陶蓝釉男俑

明

高30厘米 底宽9.7厘米

117

Xin 60591

Blue Glazed Pottery Male Figure
Ming Dynasty (1368-1644)
Height 30 cm
Bottom width 9.7 cm

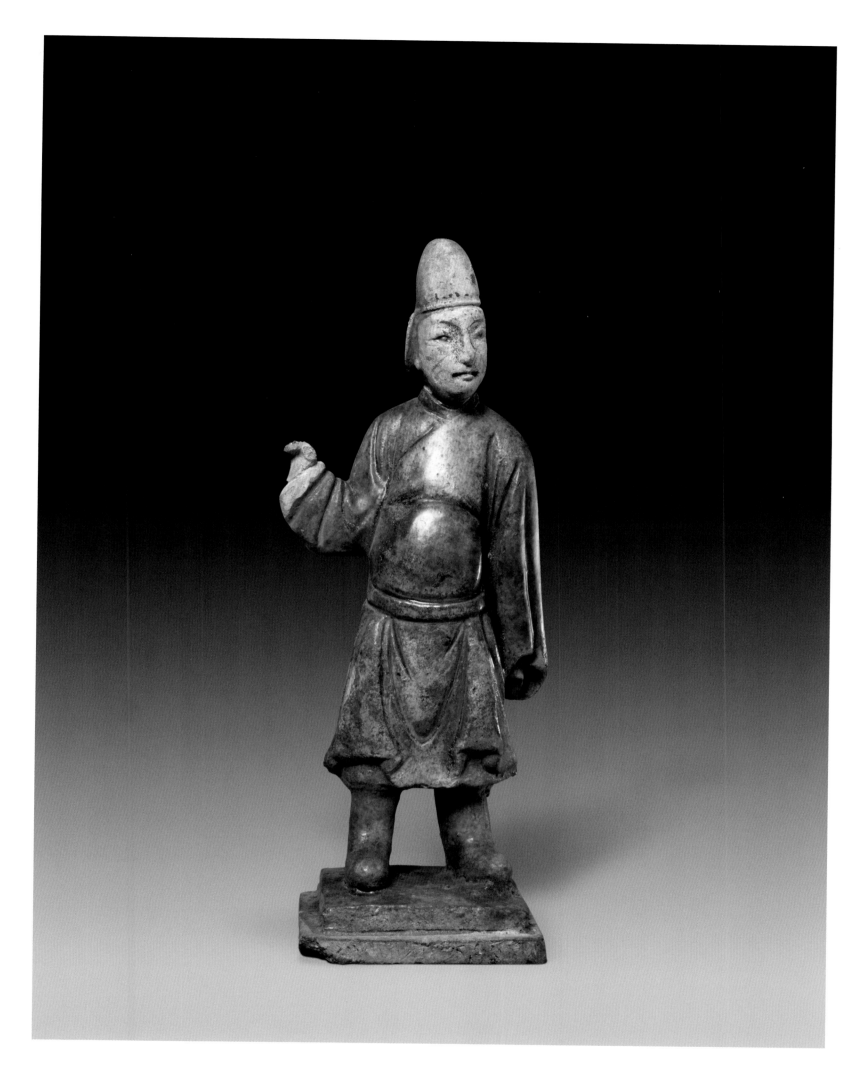

新135536

陶绿釉男俑

明

高24厘米　底宽7.8厘米

118

Xin 135536

Green Glazed Pottery Male Figure

Ming Dynasty (1368-1644)

Height 24 cm

Bottom width 7.8 cm

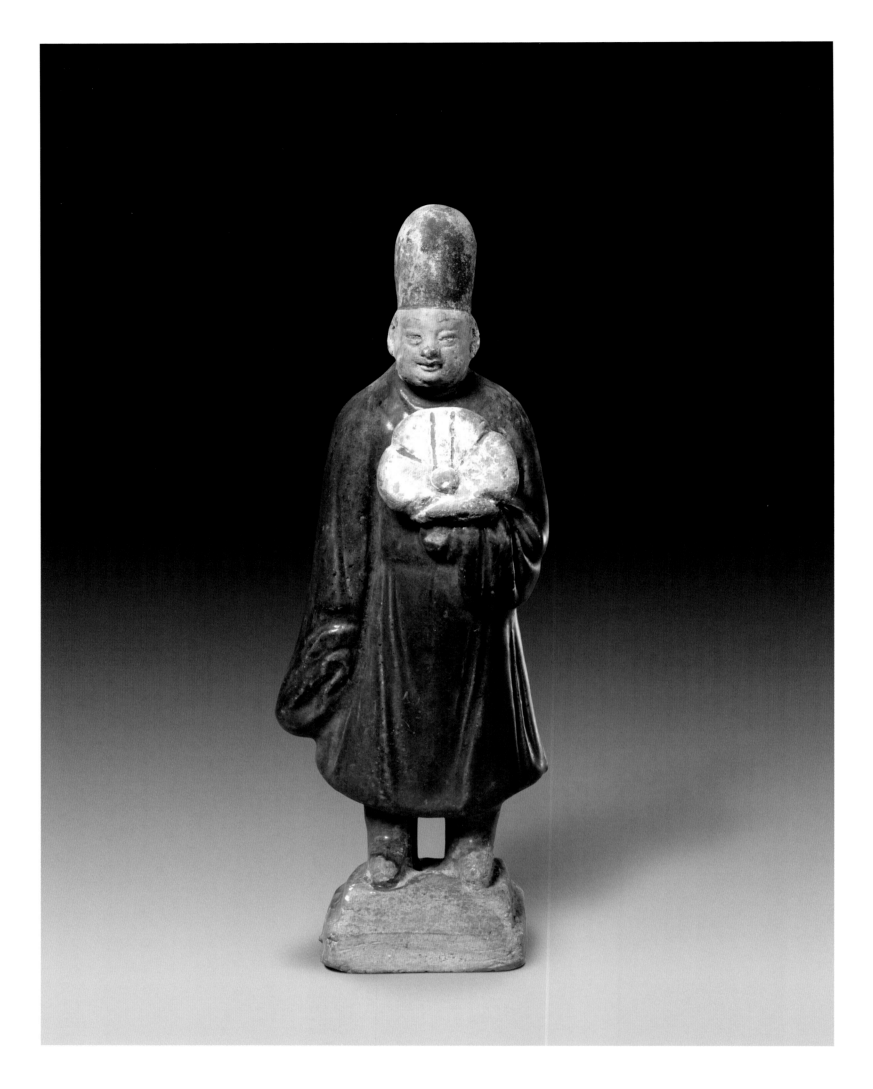

新144288
陶绿釉男俑
明

高21厘米 底宽5.5厘米

119 | Xin 144288
Green Glazed Pottery Male Figure
Ming Dynasty (1368-1644)
Height 21 cm
Bottom width 5.5 cm

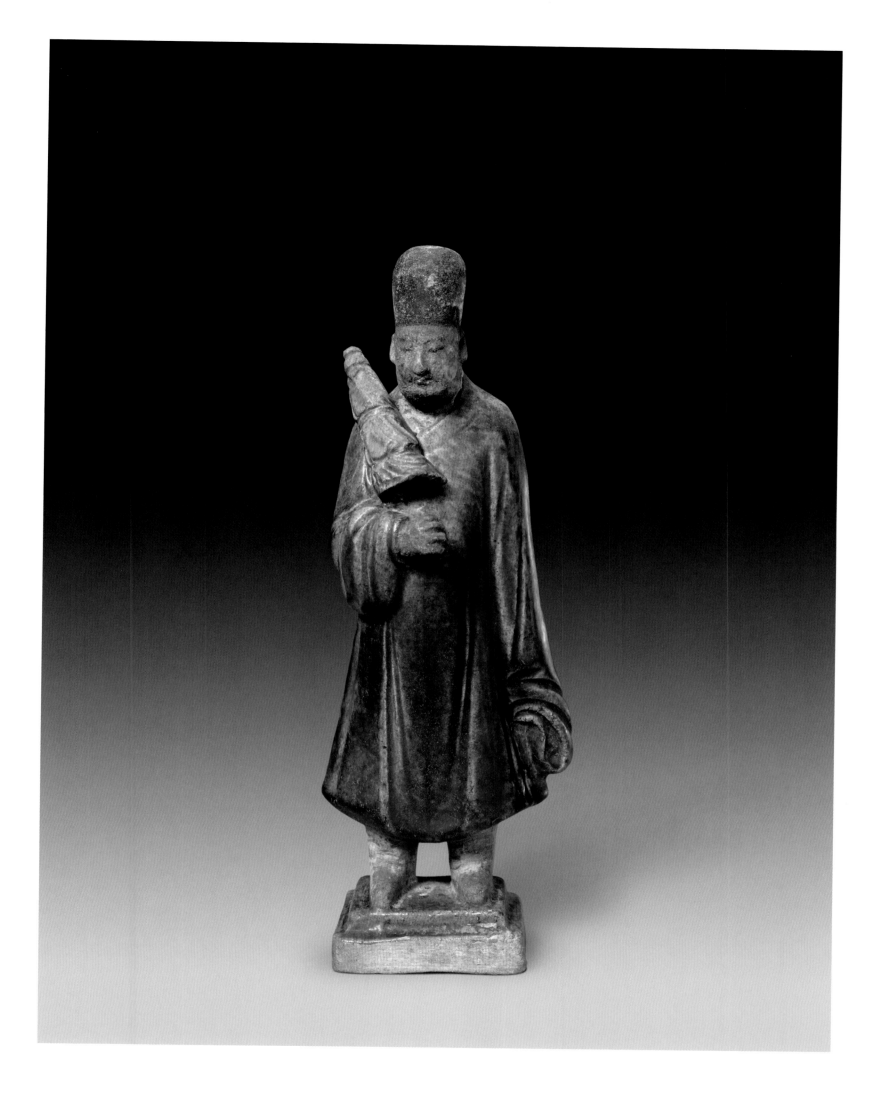

新144274

陶绿釉男俑

明

高20厘米 底宽5.2厘米

120

Xin 144274

Green Glazed Pottery Male Figure

Ming Dynasty (1368-1644)

Height 20 cm

Bottom width 5.2 cm

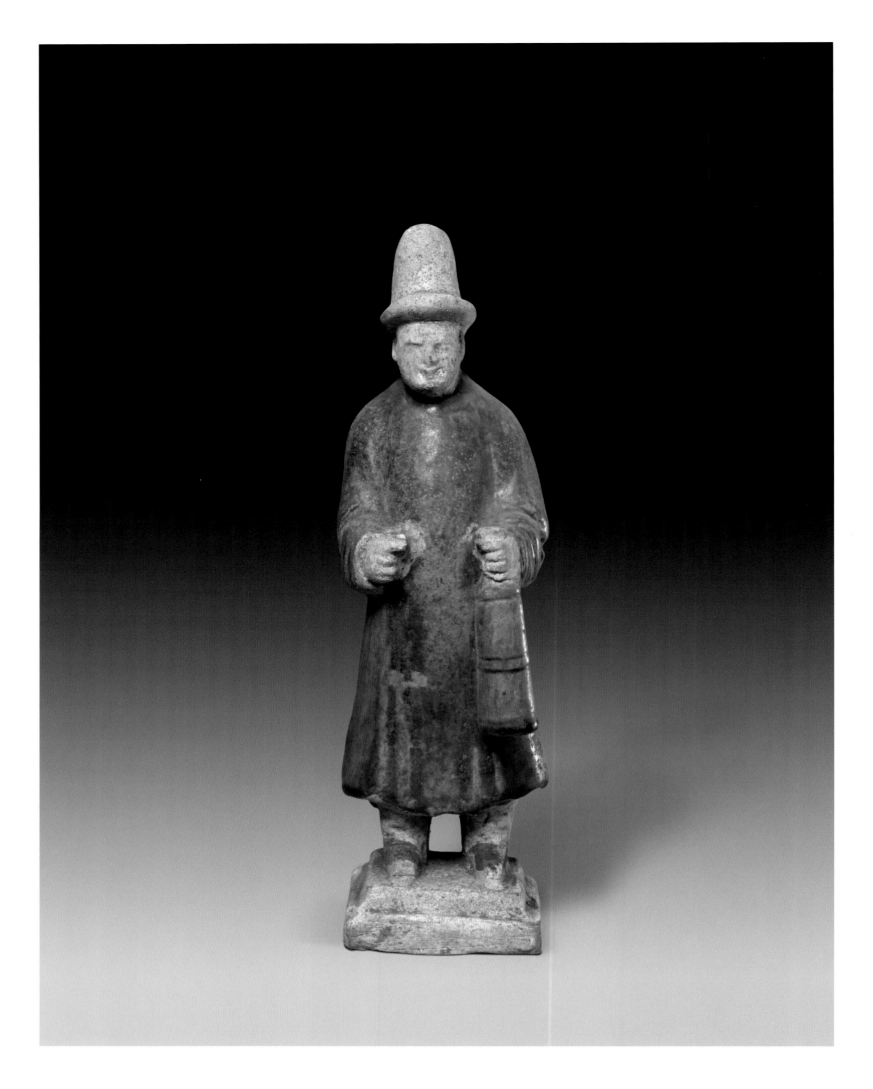

新112471

陶黄绿釉男俑

明

高20厘米 底宽5.4厘米

121

Xin 112471

Yellow-green Glazed Pottery Male Figure

Ming Dynasty (1368-1644)

Height 20 cm

Bottom width 5.4 cm

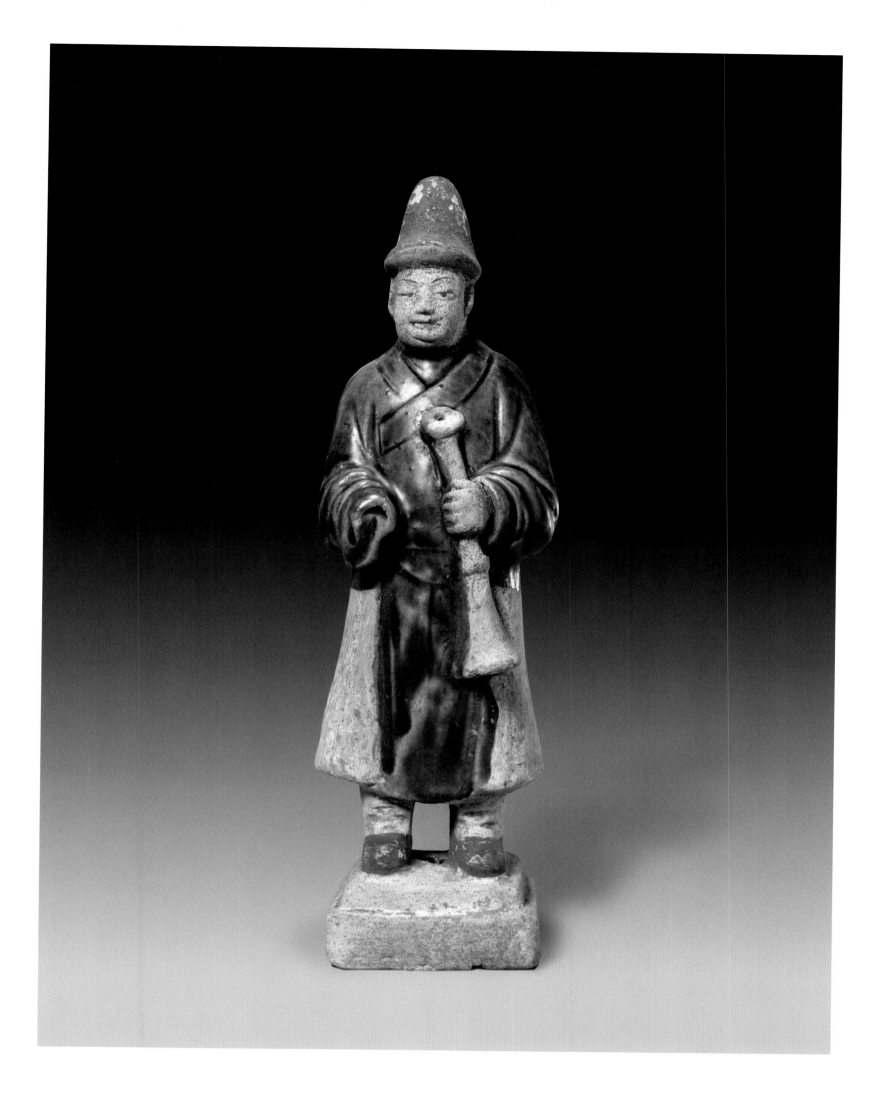

新103728

陶绿釉男俑

明

高22厘米 底宽5.7厘米

126

Xin 103728

Green Glazed Pottery Male Figure

Ming Dynasty (1368-1644)

Height 22 cm

Bottom width 5.7 cm

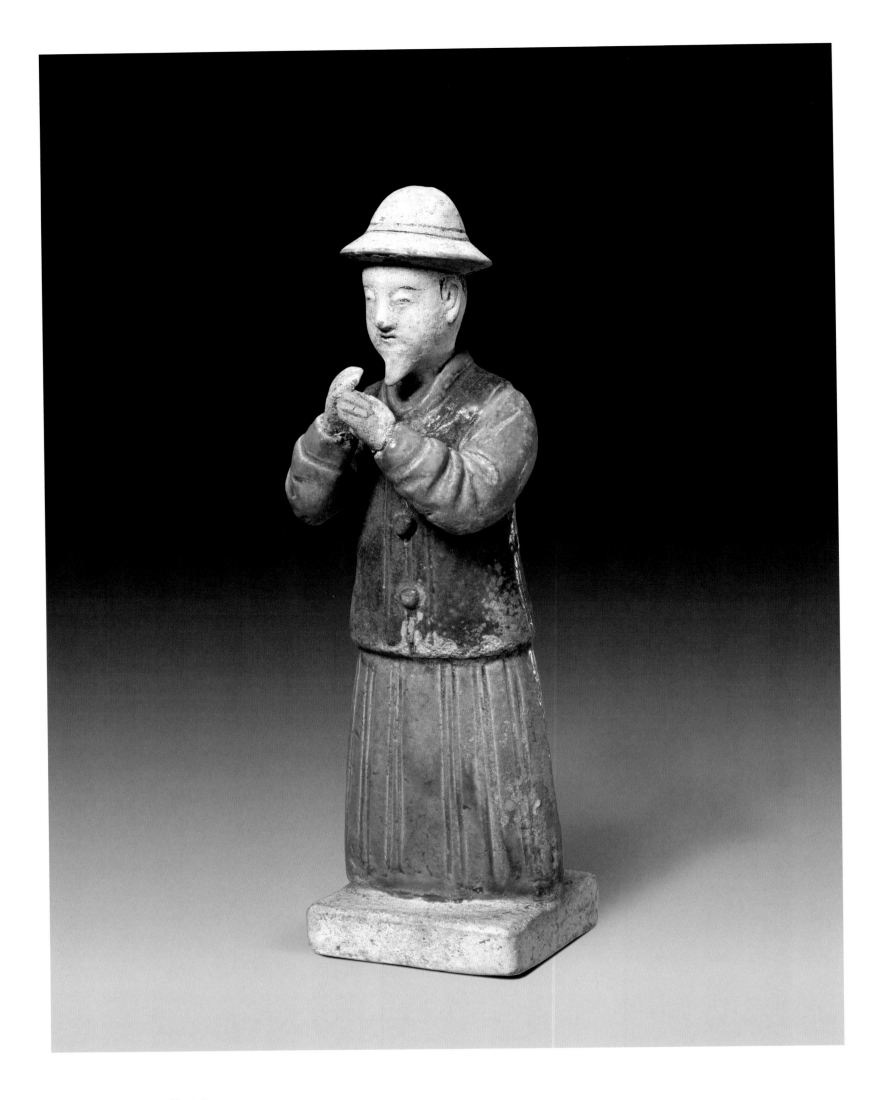

新105119

陶紫蓝釉男俑

明

高26厘米 底宽7.2厘米

127

Xin 105119

Purple-blue Glazed Pottery Male Figure
Ming Dynasty (1368-1644)
Height 26 cm
Bottom width 7.2 cm

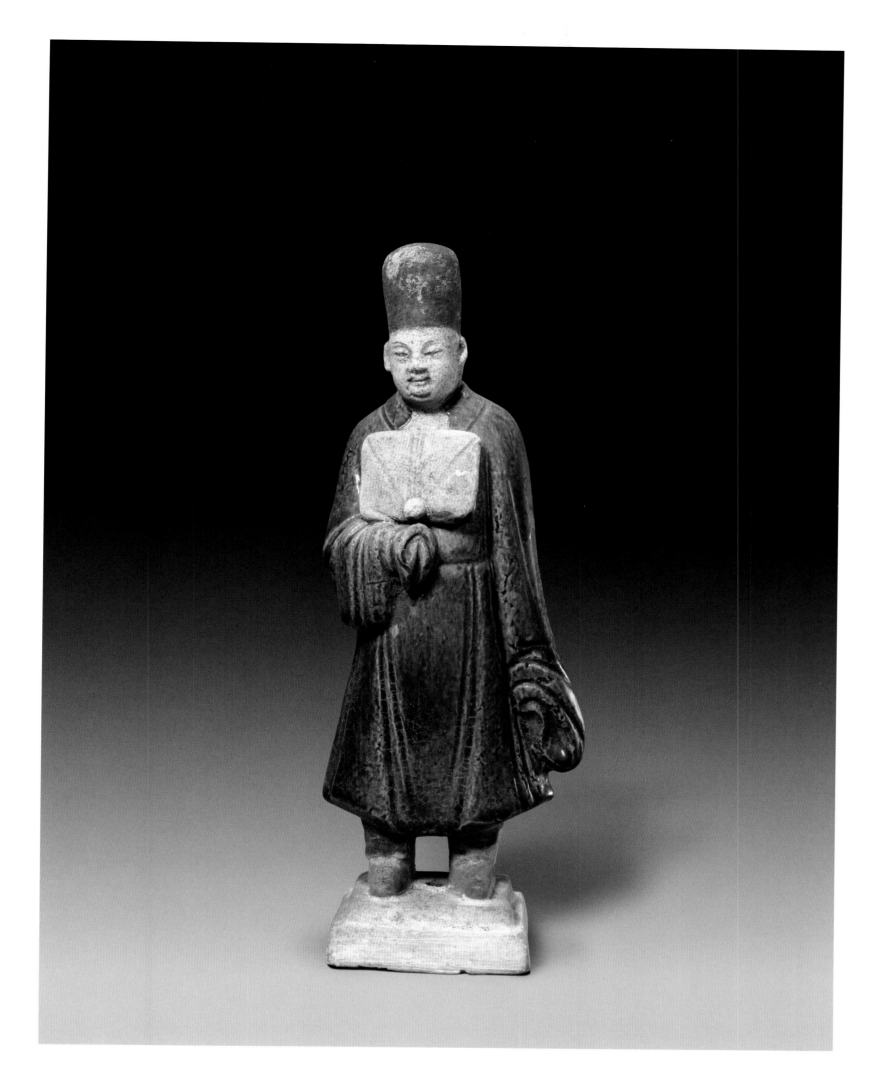

新103744

陶绿釉男俑

明

高22厘米 底宽6.5厘米

128

Xin 103744

Green Glazed Pottery Male Figure
Ming Dynasty (1368-1644)

Height 22 cm
Bottom width 6.5 cm

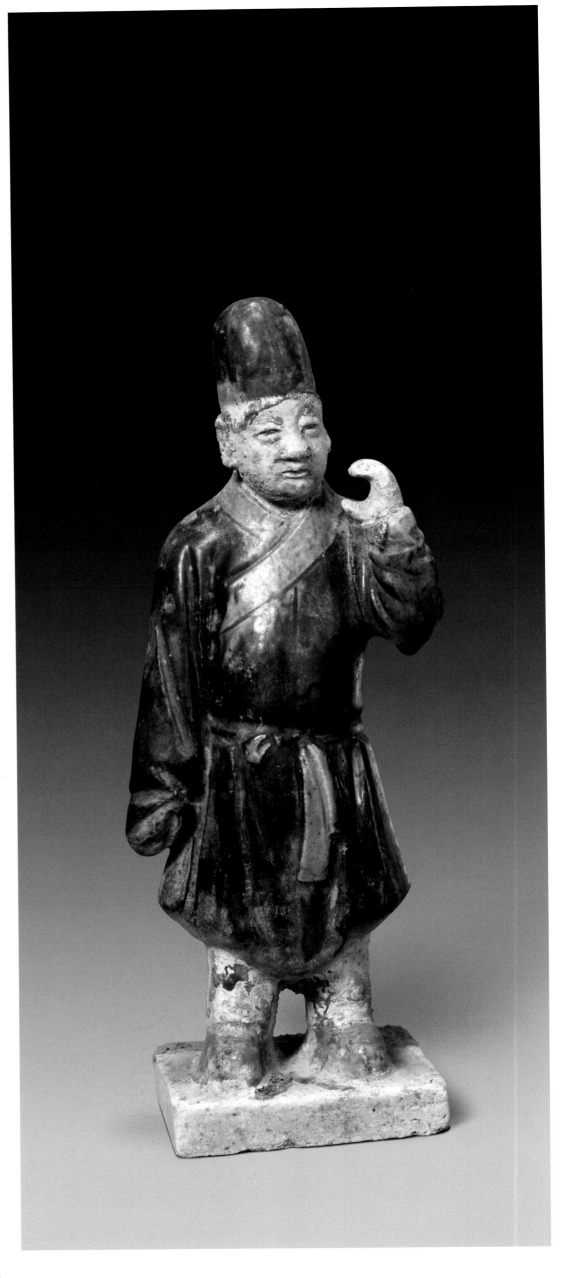

新43890
陶紫绿釉男俑
明

129 | 高24厘米　底宽7.8厘米

Xin 43890
Purple-green Glazed Pottery Male Figure
Ming Dynasty (1368-1644)
Height　24 cm
Bottom width　7.8 cm

新43914
陶紫绿釉男俑
明

高30厘米　底宽8.2厘米

130

Xin 43914
**Purple-green Glazed Pottery
Male Figure**
Ming Dynasty (1368-1644)
Height　30 cm
Bottom width　8.2 cm

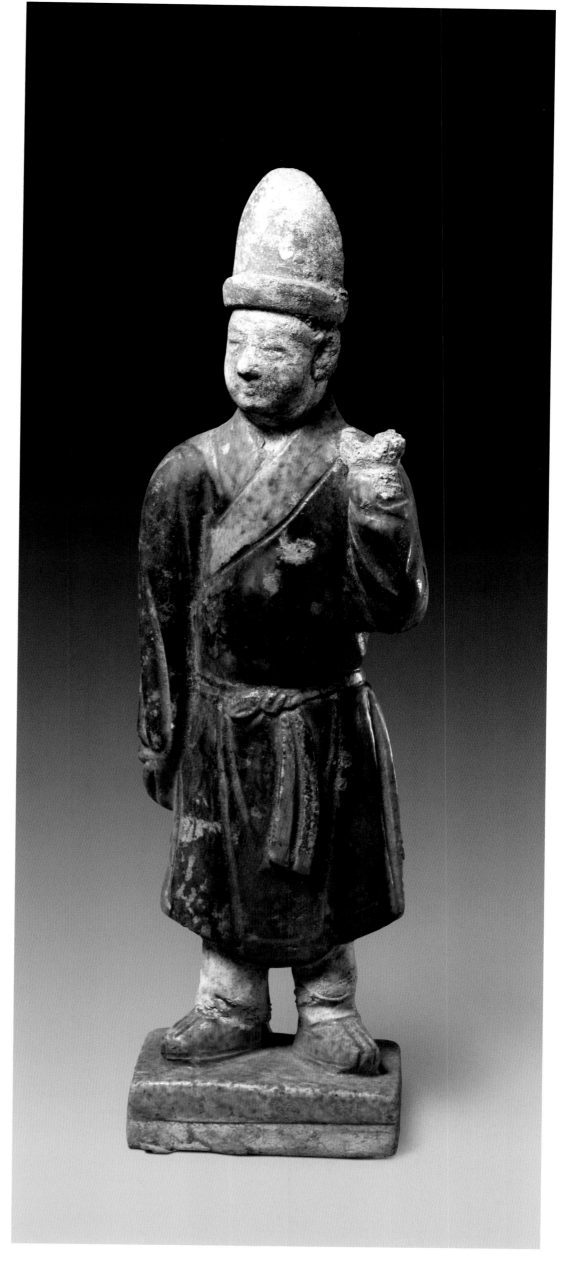

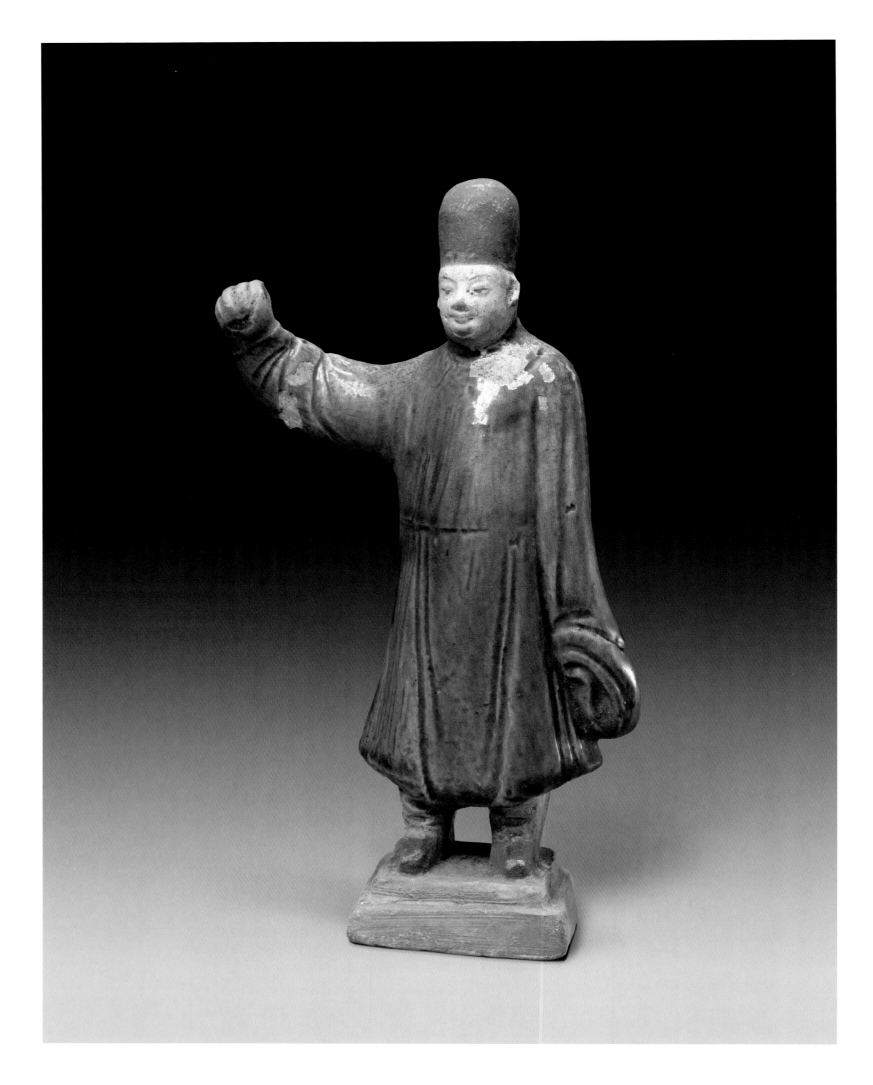

新60595

陶绿釉男俑

明

高21厘米 底宽5.5厘米

131 Xin 60595

Green Glazed Pottery Male Figure

Ming Dynasty (1368-1644)

Height 21 cm
Bottom width 5.5 cm

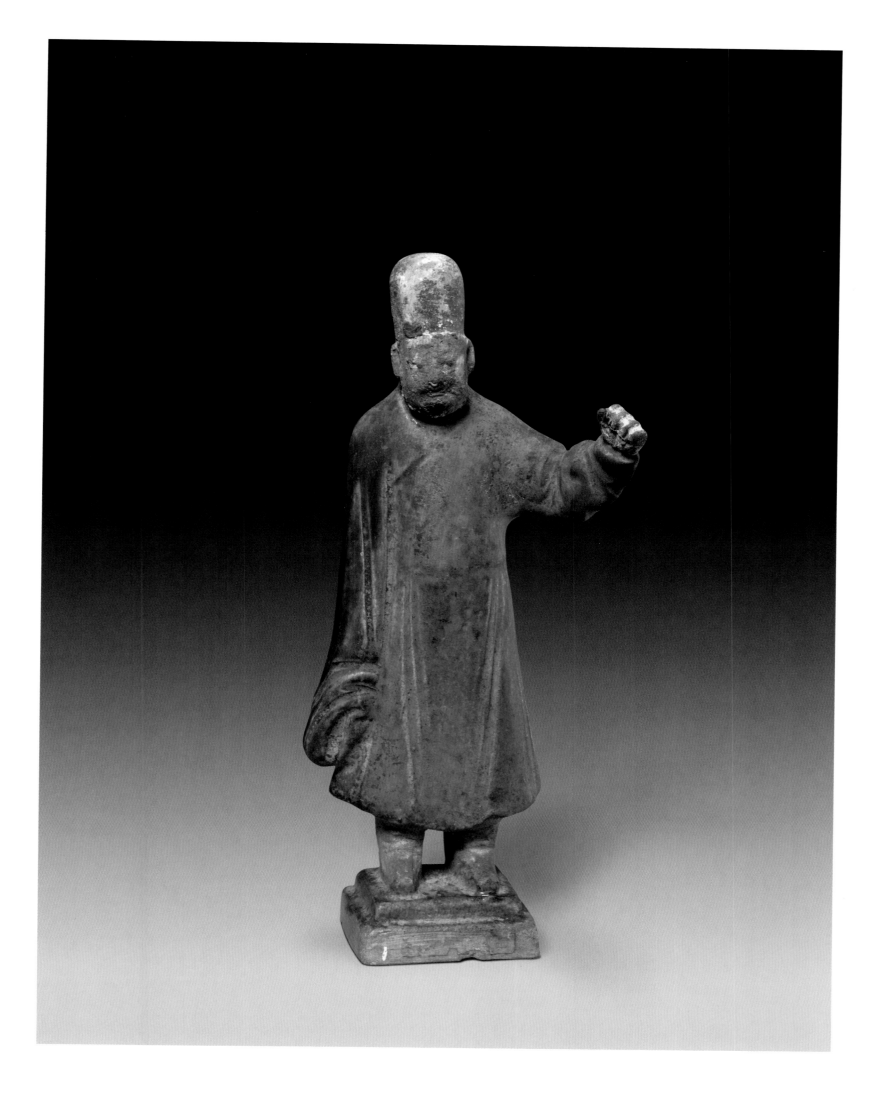

新144153

陶绿釉男俑
明

高19.5厘米　底宽8厘米

132

Xin 144153

Green Glazed Pottery Male Figure
Ming Dynasty (1368-1644)
Height 19.5 cm
Bottom width 8 cm

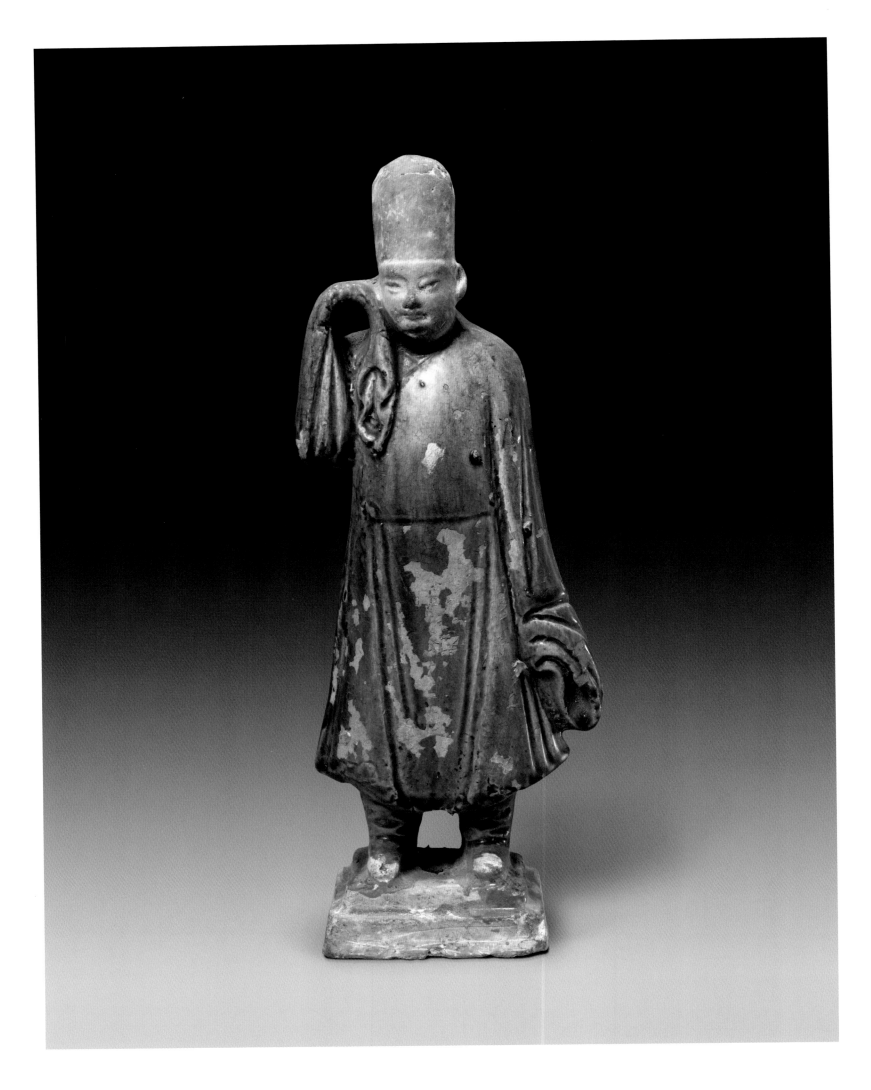

新121904

陶绿釉男俑

明

高23厘米 底宽6.2厘米

133 | Xin 121904

Green Glazed Pottery Male Figure

Ming Dynasty (1368-1644)

Height　23 cm
Bottom width　6.2 cm

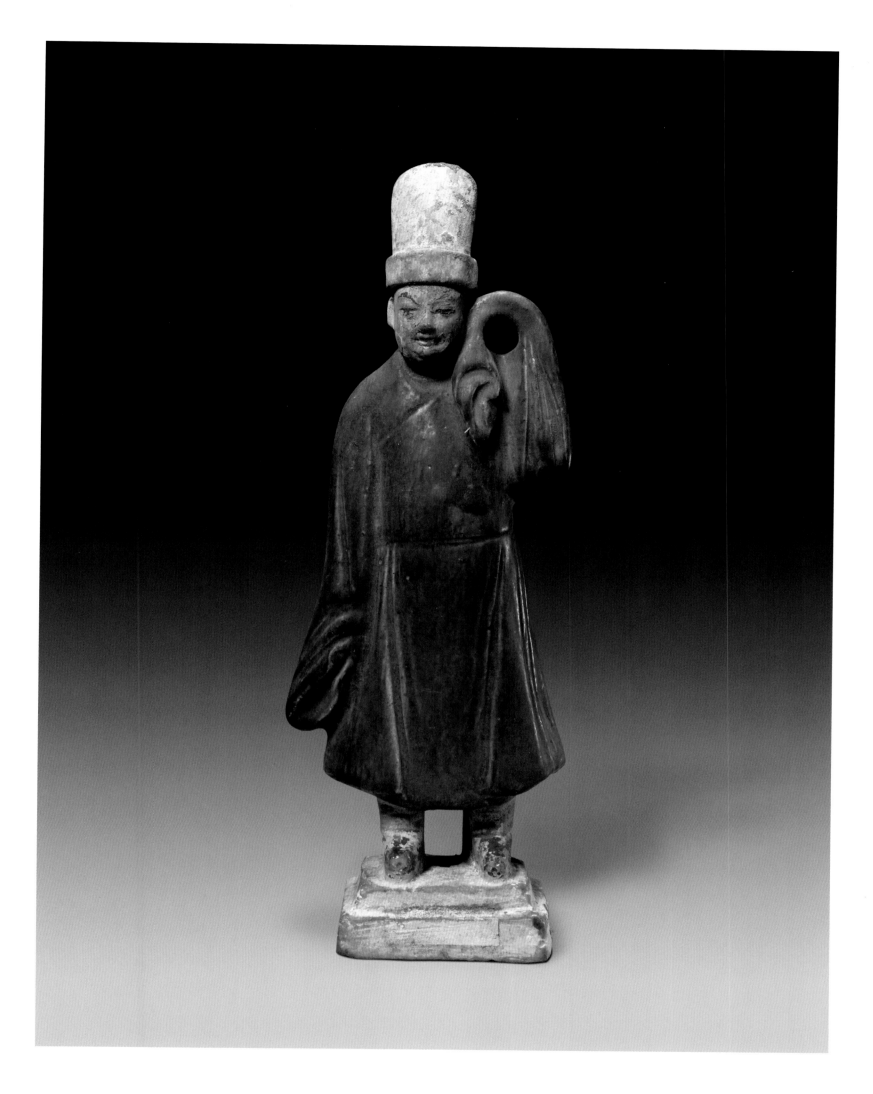

新144285

陶绿釉男俑

明

高23厘米 底宽7厘米

134

Xin 144285

Green Glazed Pottery Male Figure

Ming Dynasty (1368-1644)

Height 23 cm
Bottom width 7 cm

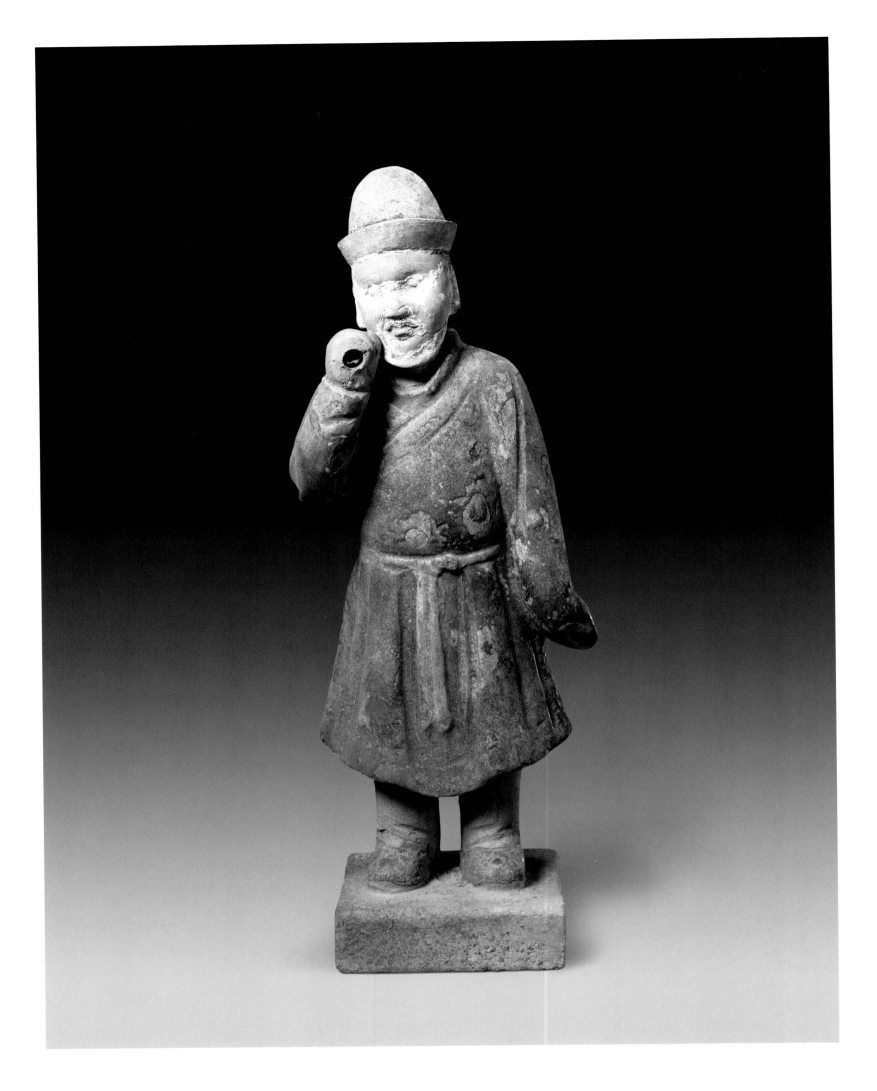

新60592

陶紫绿釉男俑

明

高29厘米 底宽7.8厘米

135

Xin 60592

Purple-green Glazed Pottery Male Figure

Ming Dynasty (1368-1644)

Height 29 cm

Bottom width 7.8 cm

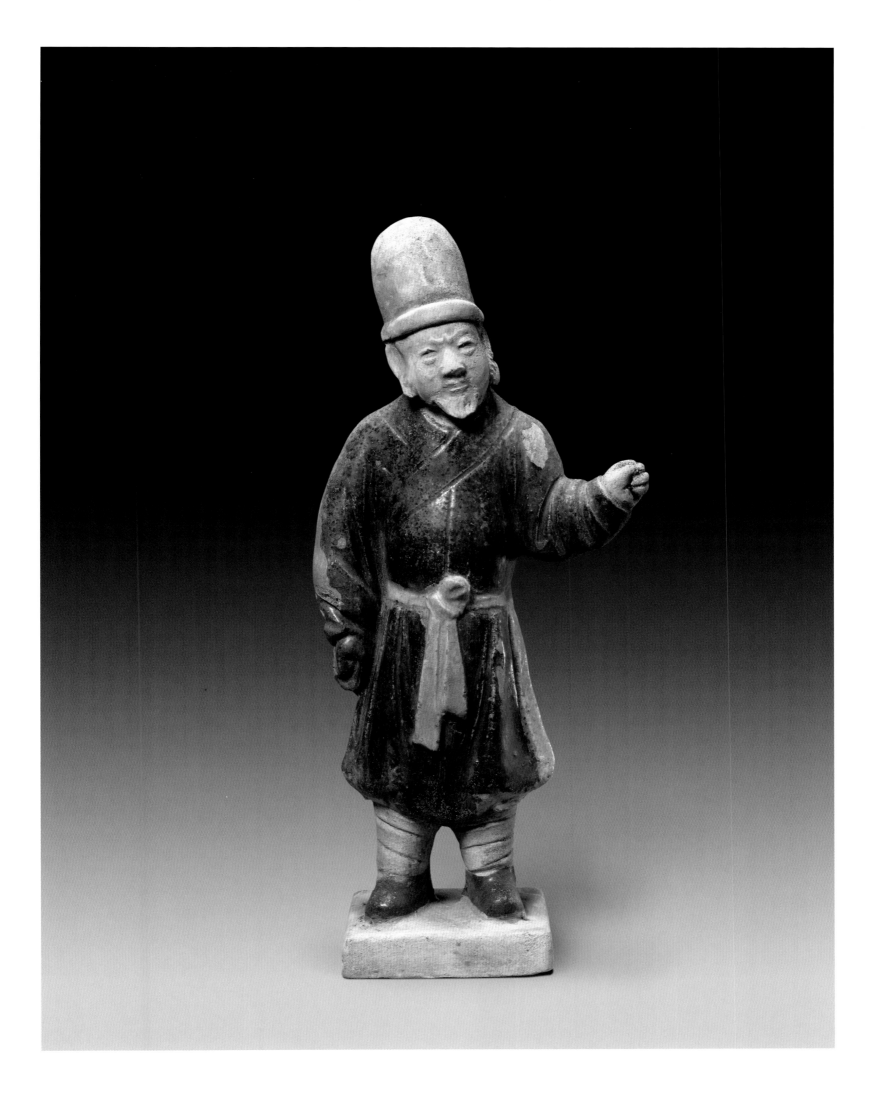

新43884

陶紫蓝釉男俑

明

高27厘米 底宽7.2厘米

136

Xin 43884

Purple-blue Glazed Pottery Male Figure

Ming Dynasty (1368-1644)

Height 27 cm

Bottom width 7.2 cm

新43882

陶紫绿釉男俑

明

高30厘米　底宽9厘米

137

Xin 43882

Purple-green Glazed Pottery Male Figure

Ming Dynasty (1368-1644)

Height　30 cm

Bottom width　9 cm

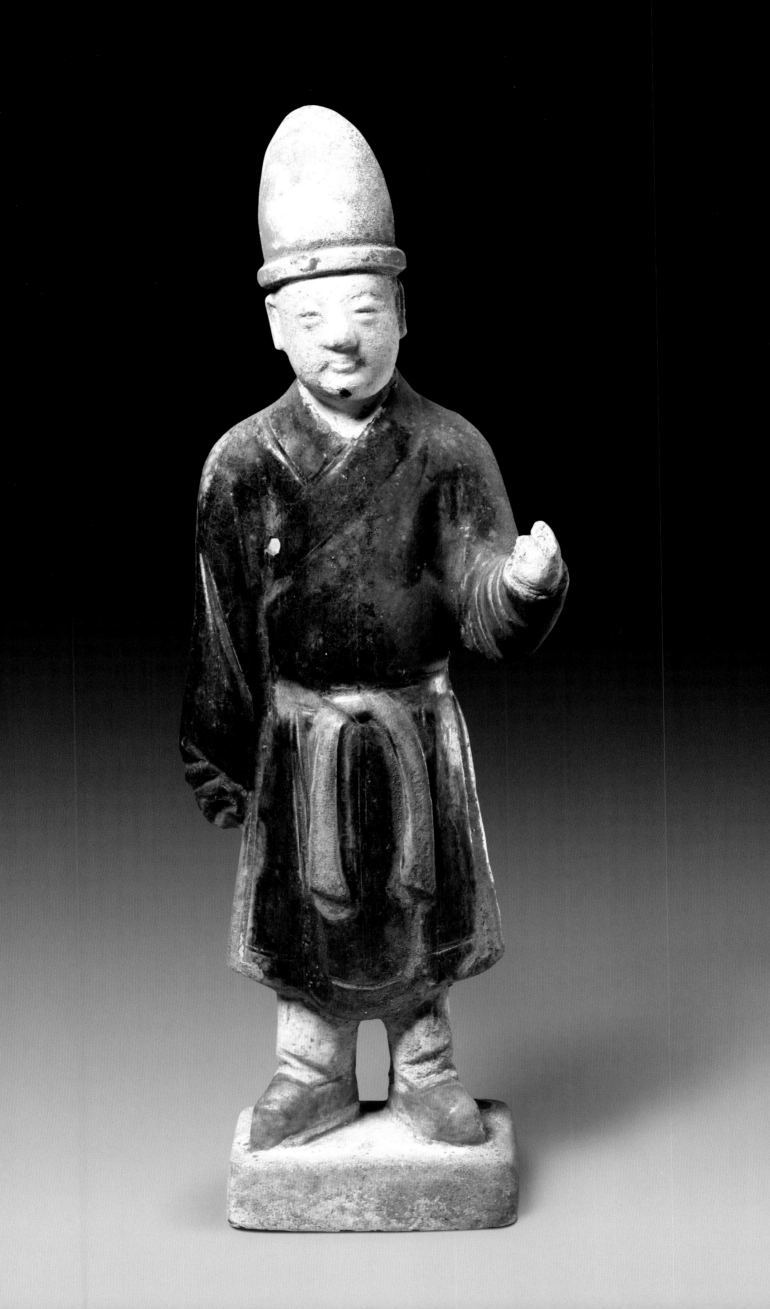

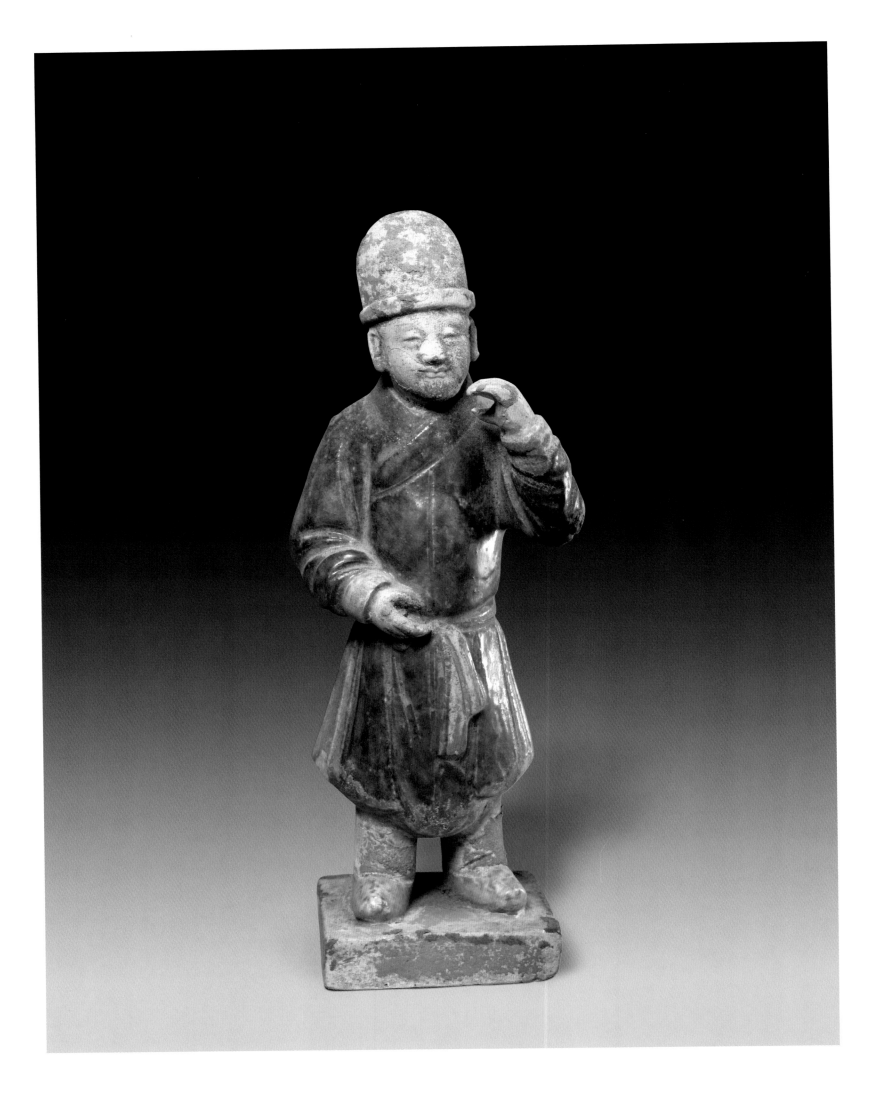

新43872

陶紫绿釉男俑

明

高24.5厘米　底宽7.2厘米

138

Xin 43872

Purple-green Glazed Pottery Male Figure

Ming Dynasty (1368-1644)

Height　24.5 cm

Bottom width　7.2 cm

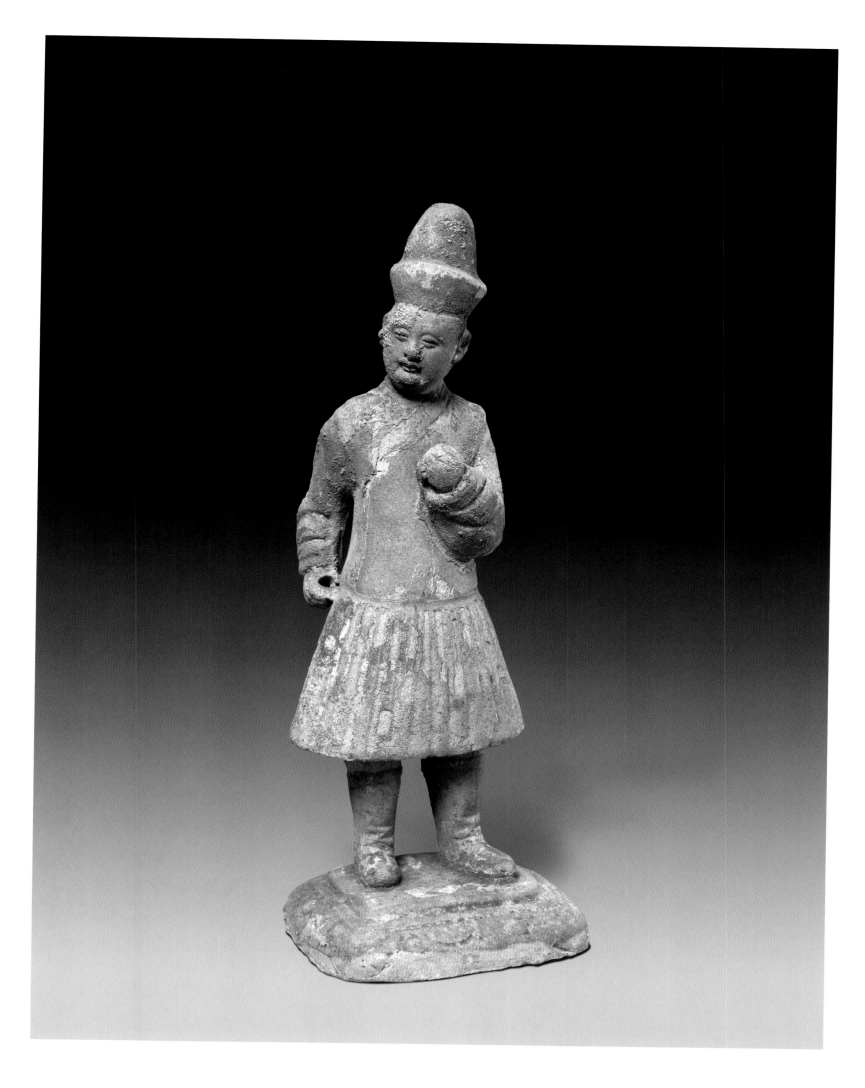

新112068
陶紫蓝釉男俑
明

高24.5厘米 底宽9厘米

139 | Xin 112068
Purple-blue Glazed Pottery Male Figure
Ming Dynasty (1368-1644)
Height 24.5 cm
Bottom width 9 cm

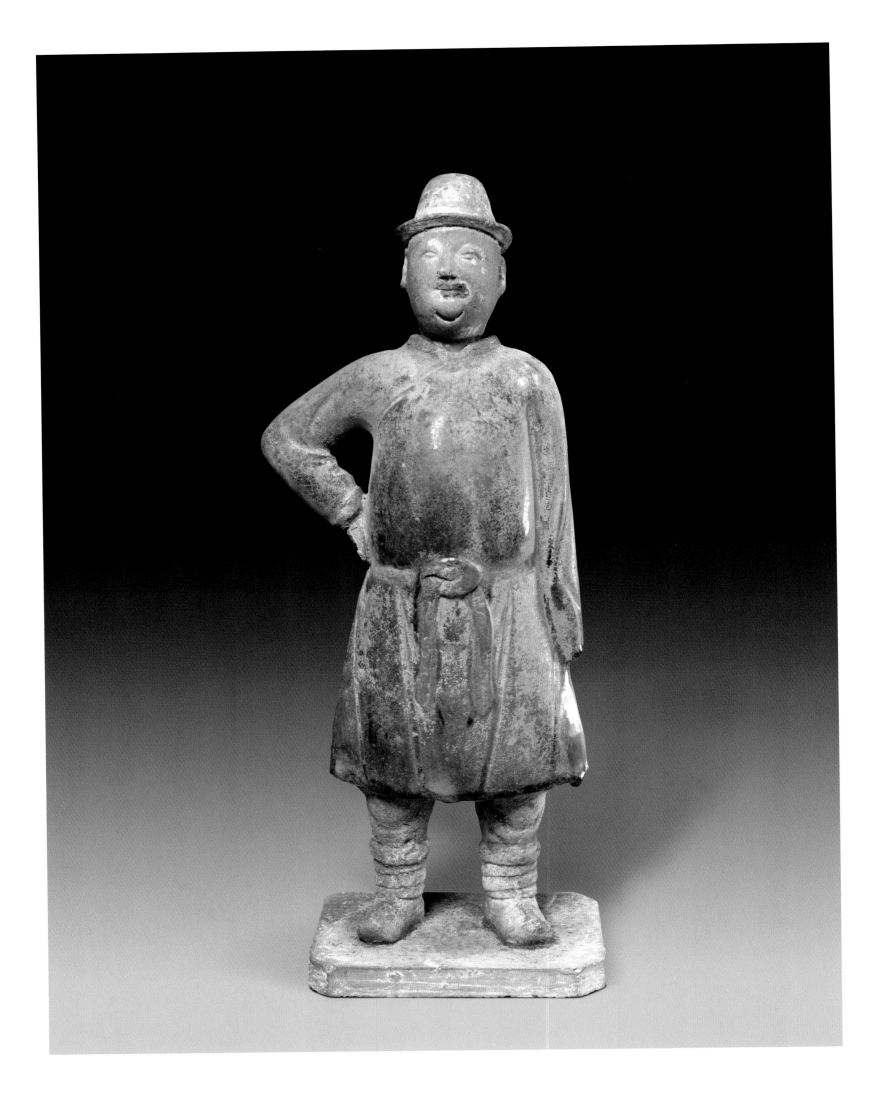

新144318

陶酱釉男俑

明

高28厘米 底宽9.8厘米

140

Xin 144318

Soy-color Glazed Pottery Male Figure

Ming Dynasty (1368-1644)

Height 28 cm

Bottom width 9.8 cm

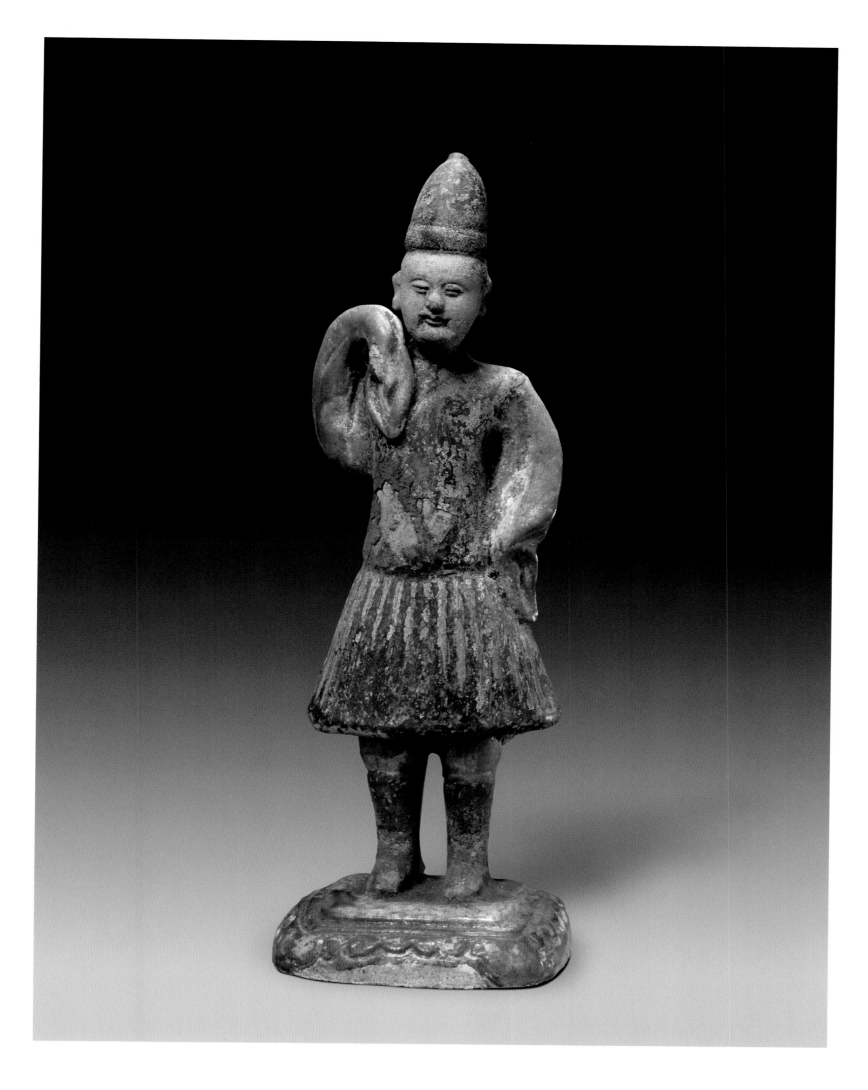

新112067

陶紫绿釉男俑

明

高28.5厘米 底宽9.7厘米

141

Xin 112067

Purple-green Glazed Pottery Male Figure
Ming Dynasty (1368-1644)

Height 28.5 cm
Bottom width 9.7 cm

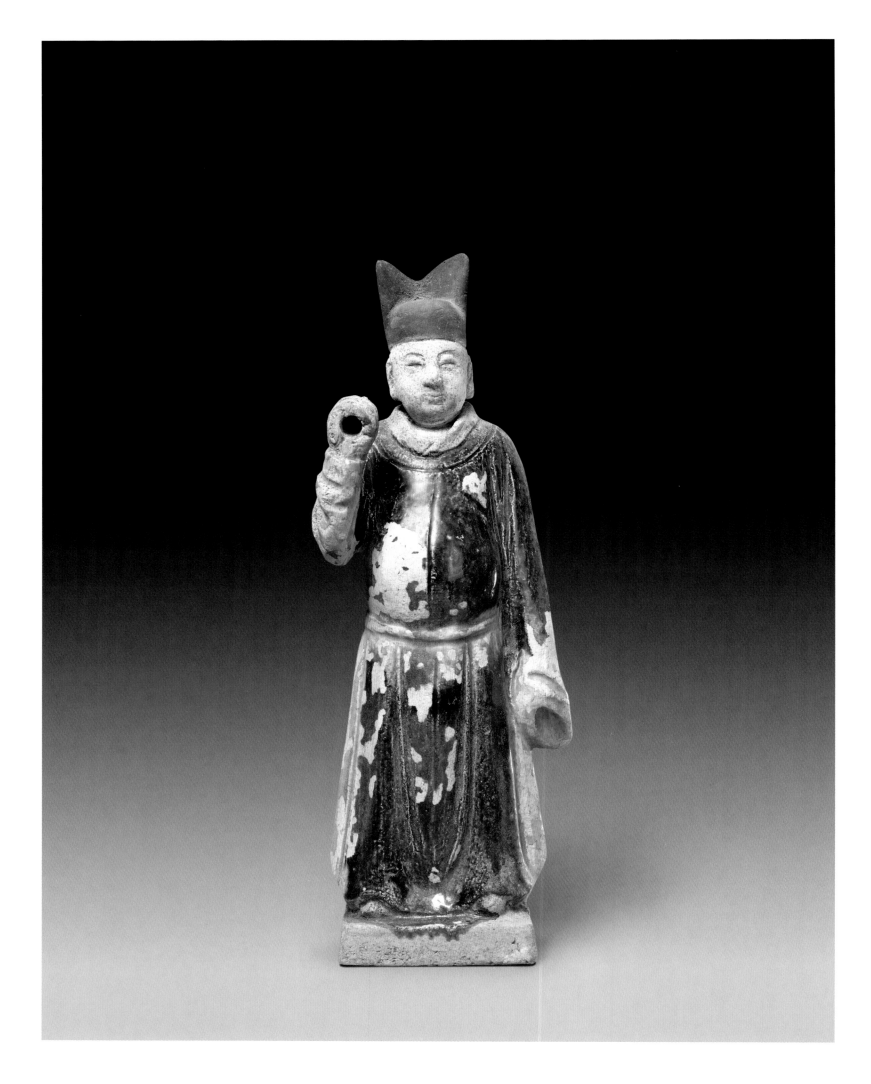

新55581

陶紫绿釉男俑

明

高24厘米 底宽6.2厘米

142

Xin 55581

Purple-green Glazed Pottery Male Figure

Ming Dynasty (1368-1644)

Height 24 cm

Bottom width 6.2 cm

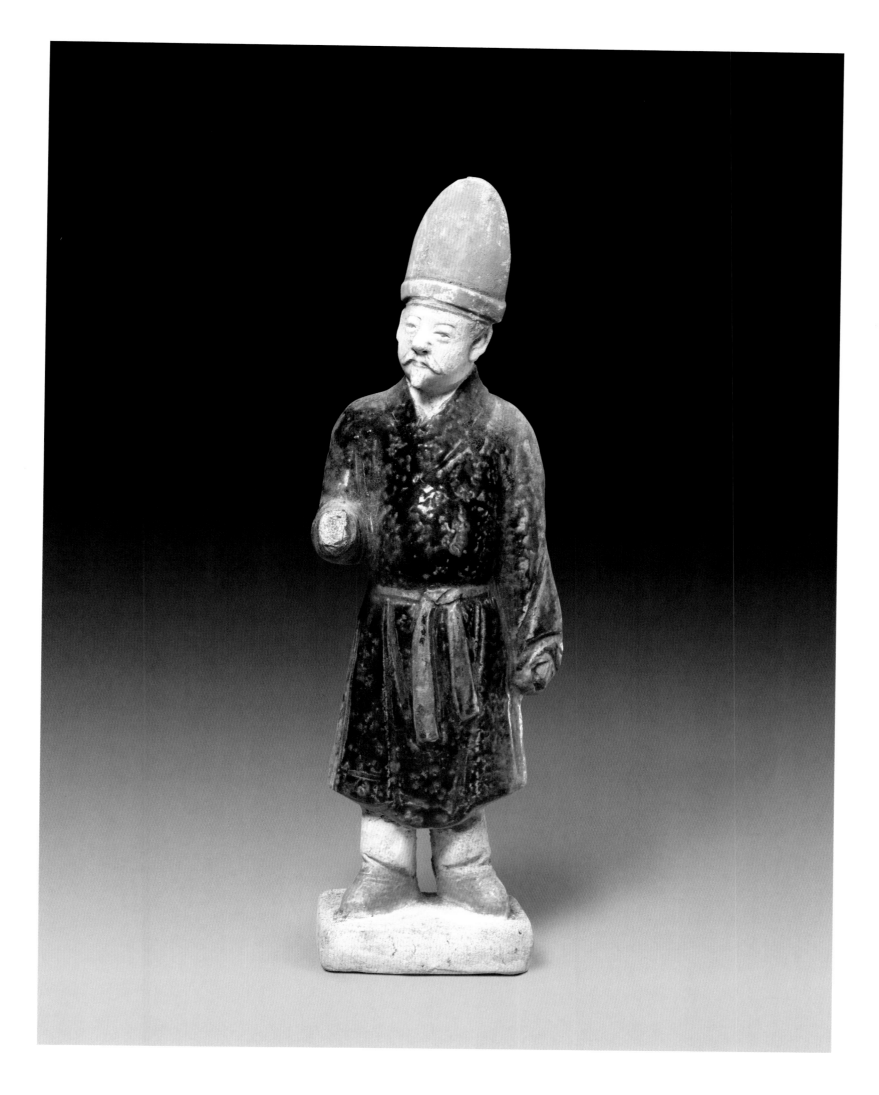

新43909

陶紫绿釉男俑

明

高30.5厘米 底宽8厘米

143

Xin 43909

Purple-green Glazed Pottery Male Figure
Ming Dynasty (1368-1644)
Height 30.5 cm
Bottom width 8 cm

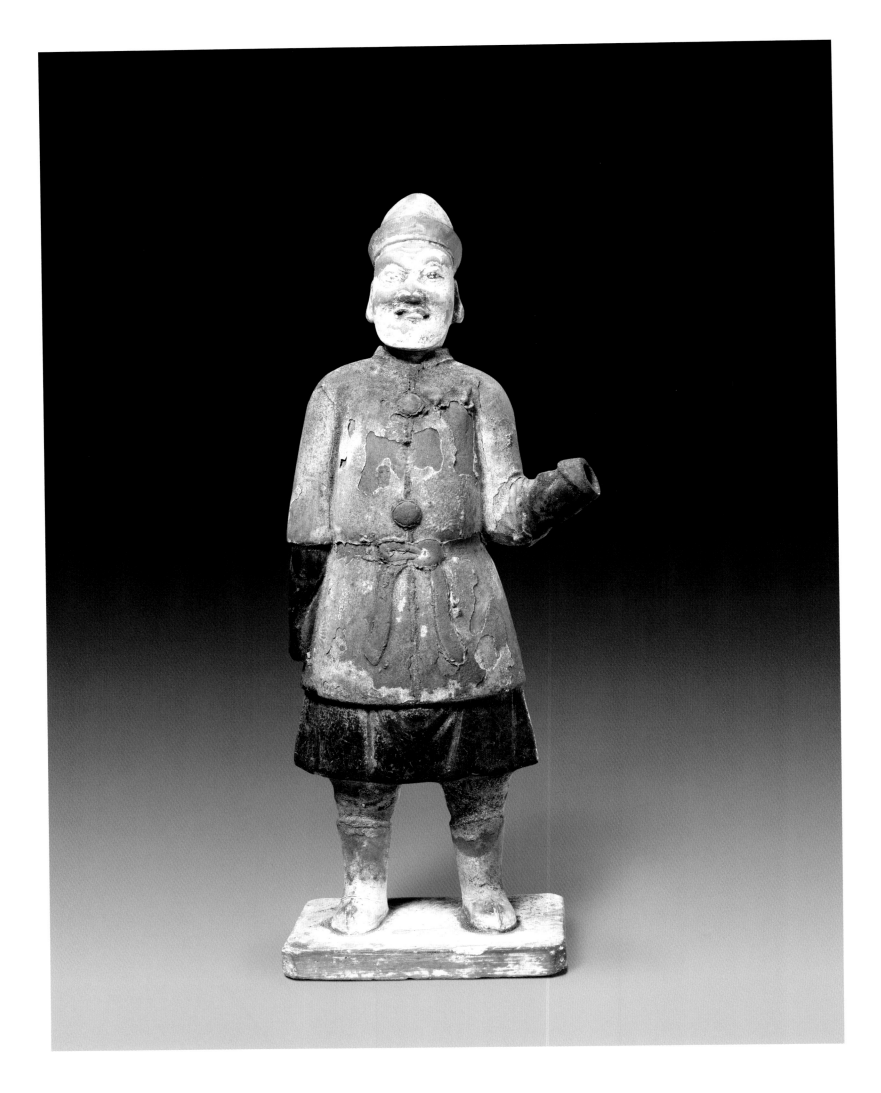

新144317

陶紫釉男俑

明

高29厘米 底宽10厘米

144 Xin 144317
Purple Glazed Pottery Male Figure
Ming Dynasty (1368-1644)
Height 29 cm
Bottom width 10 cm

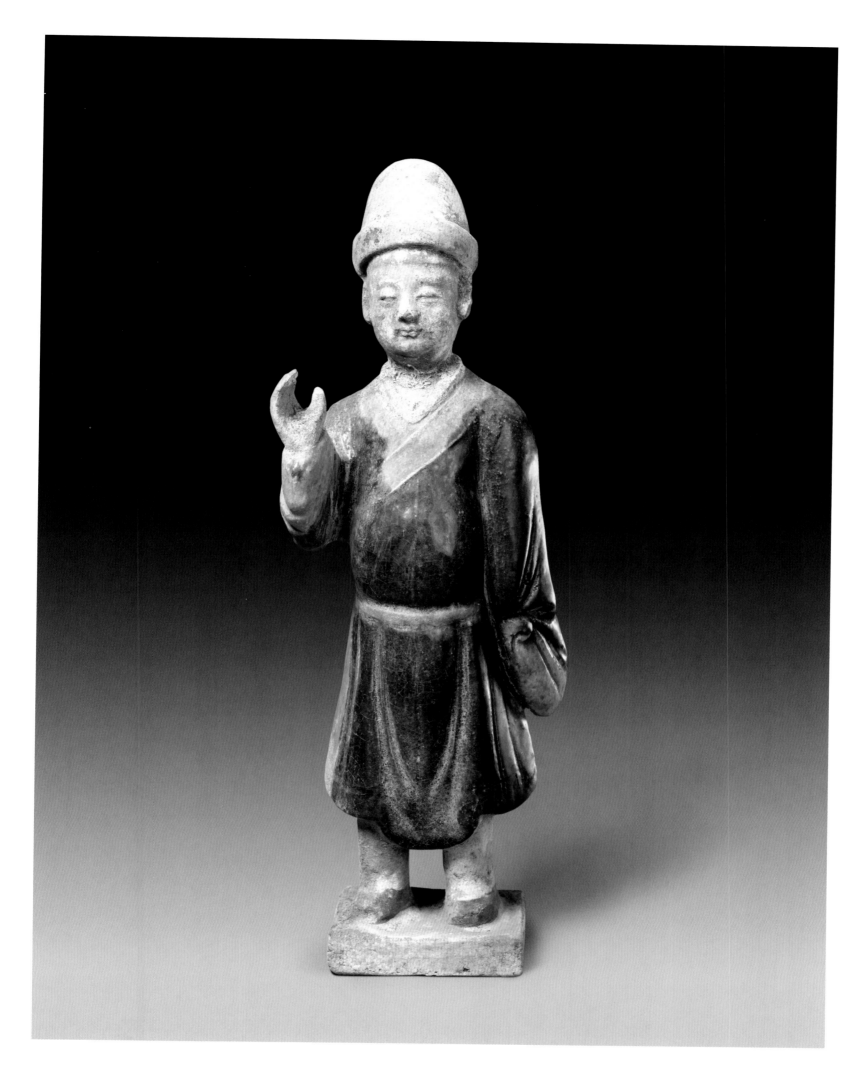

新43912

陶紫蓝釉男俑

明

高30.5厘米 底宽7厘米

145

Xin 43912

Purple-blue Glazed Pottery Male Figure

Ming Dynasty (1368-1644)

Height 30.5 cm
Bottom width 7 cm

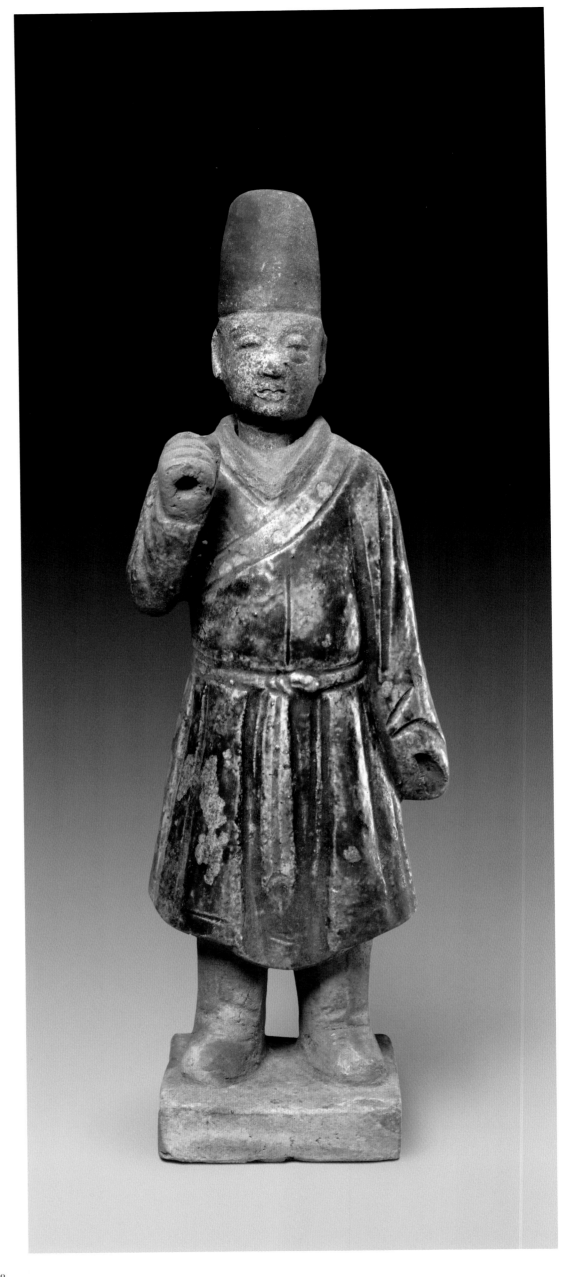

新143234
陶紫绿釉男俑
明

高28厘米 底宽6.7厘米

146

Xin 143234
**Purple-green Glazed Pottery
Male Figure**
Ming Dynasty (1368-1644)
Height 28 cm
Bottom width 6.7 cm

新143236

陶紫绿釉男俑

明

高28厘米　底宽7.2厘米

147

Xin 143236

Purple-green Glazed Pottery
Male Figure
Ming Dynasty (1368-1644)

Height 28 cm
Bottom width 7.2 cm

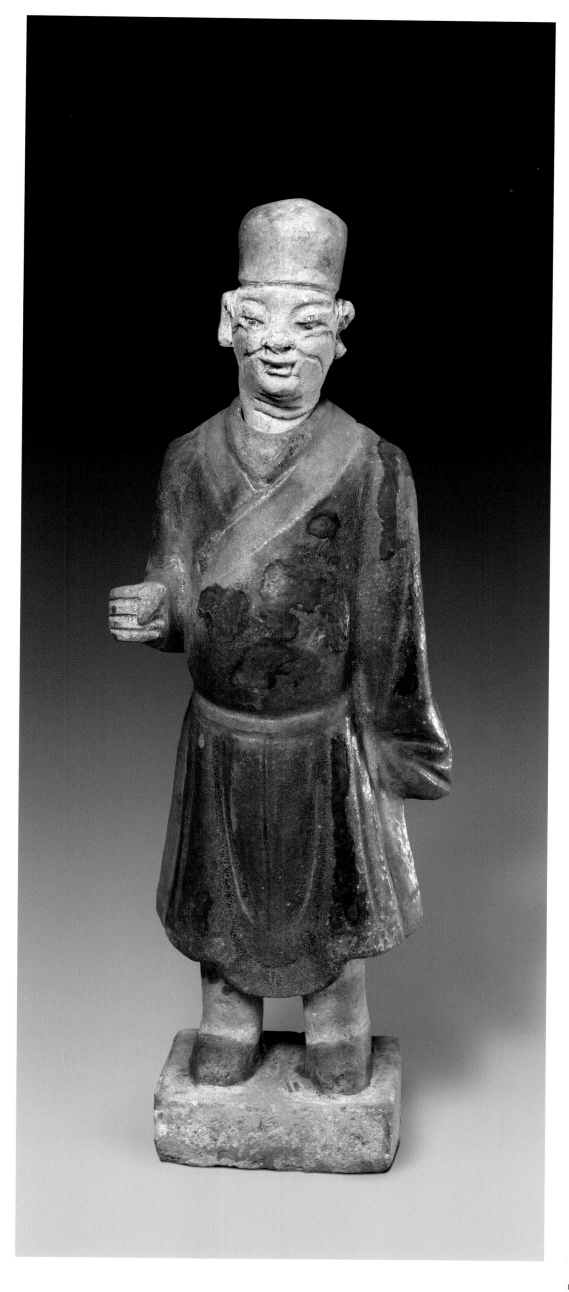

新143237

陶紫绿釉男俑

明

高28厘米 底宽7厘米

148

Xin 143237

Purple-green Glazed Pottery Male Figure

Ming Dynasty (1368-1644)

Height 28 cm
Bottom width 7 cm

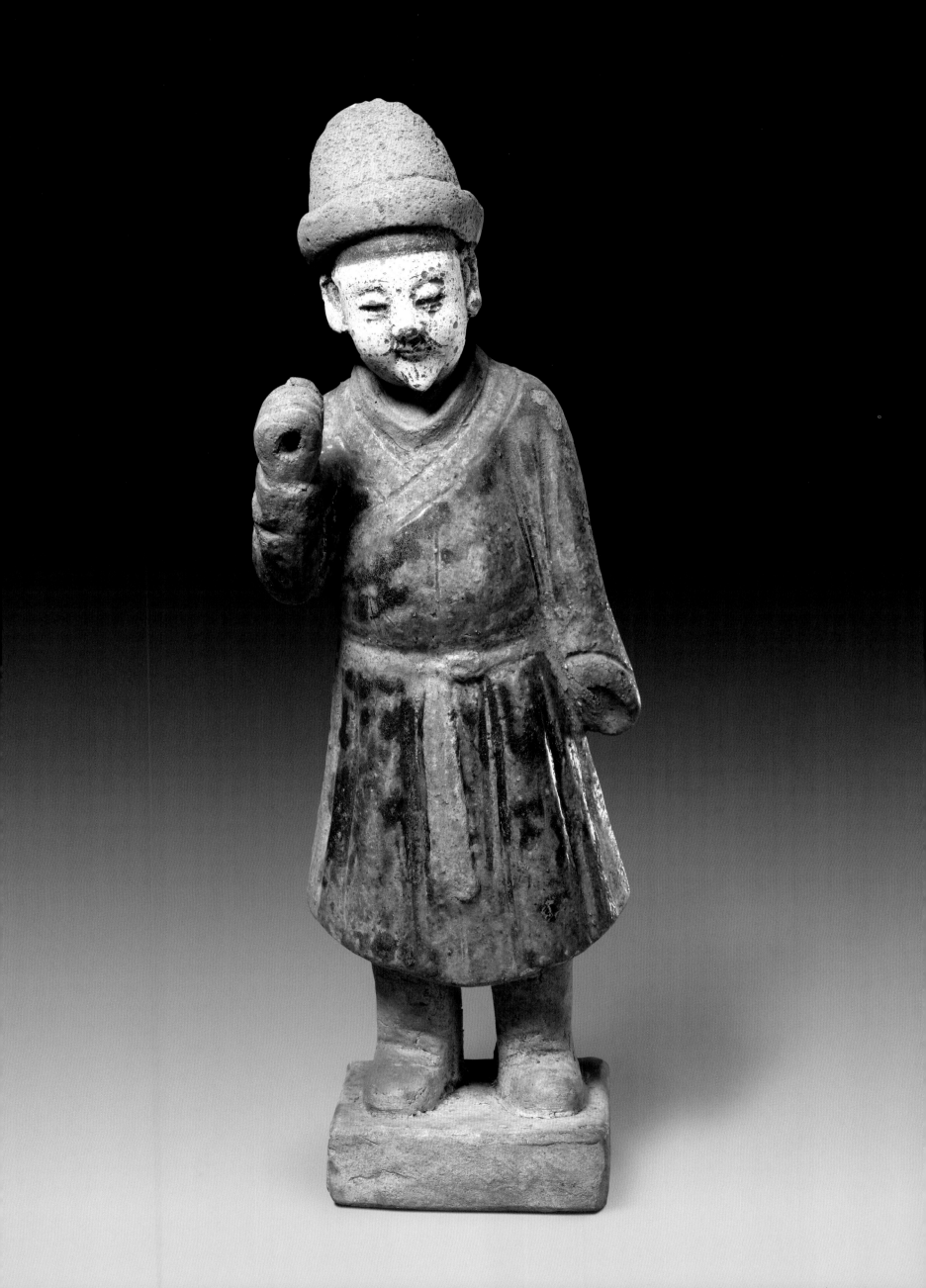

新125535
陶黄绿釉侏儒俑
明
高13.5厘米　底宽3.5厘米

149 | Xin 125535
Yellow-green Glazed Pottery Figure of a Dwarf
Ming Dynasty (1368-1644)
Height　13.5 cm
Bottom width　3.5 cm

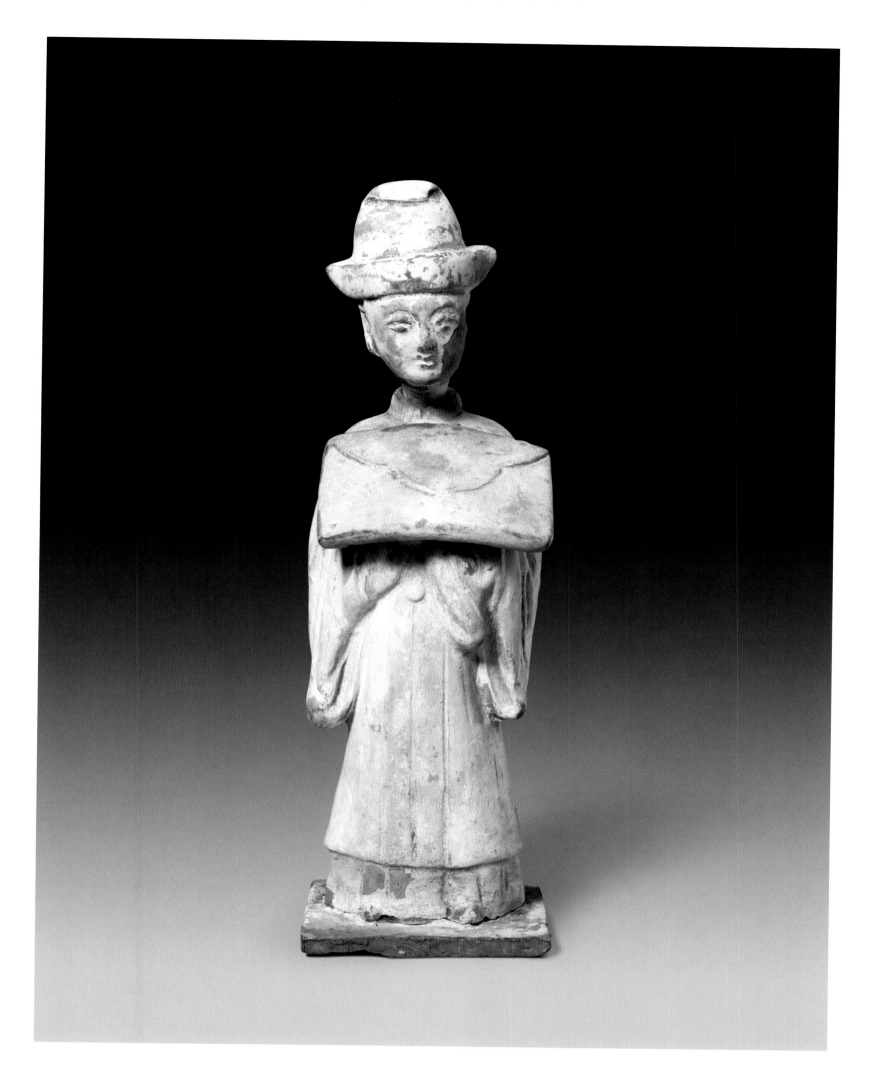

新138927
陶彩绘男俑
明

高26厘米 底宽7.8厘米

150

Xin 138927
Painted Pottery Male Figure
Ming Dynasty (1368-1644)
Height 26 cm
Bottom width 7.8 cm

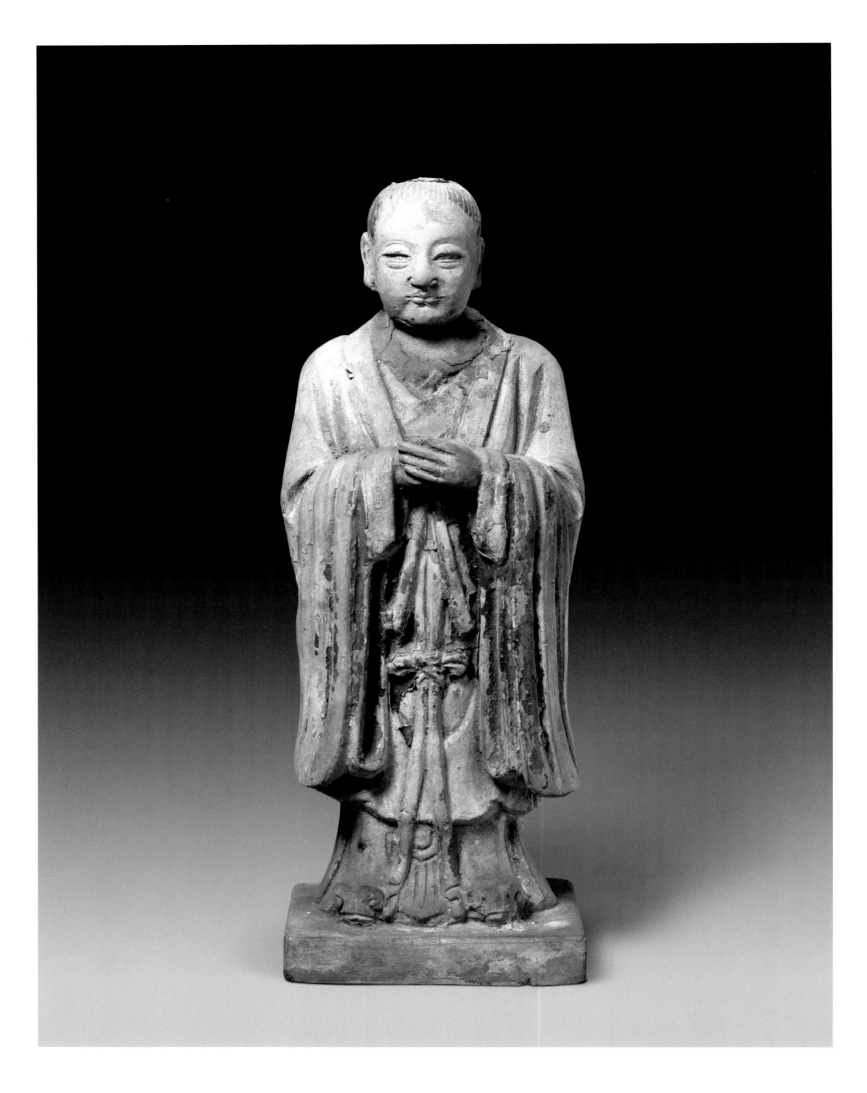

新125717

陶彩绘男俑

明

高34厘米 底宽12.3厘米

151

Xin 125717

Painted Pottery Male Figure

Ming Dynasty (1368-1644)

Height 34 cm
Bottom width 12.3 cm

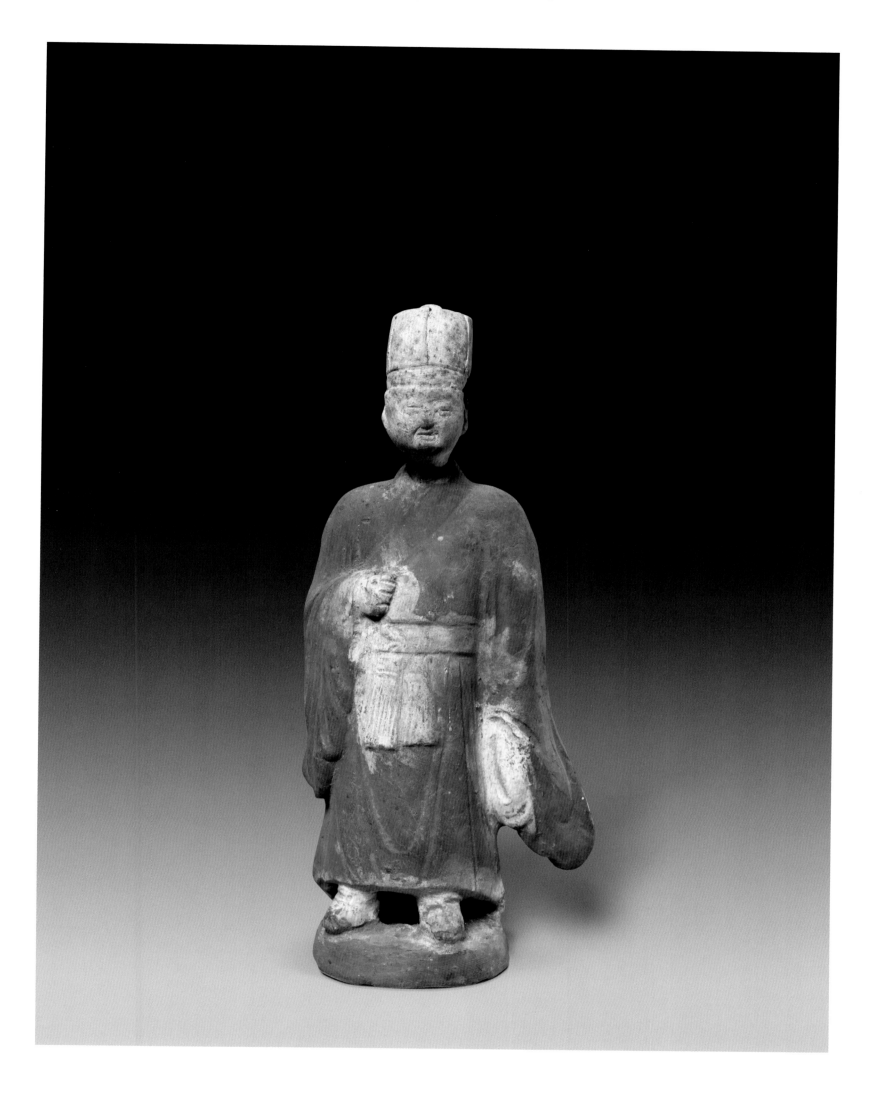

新138932
陶彩绘男俑
明

高25.5厘米 底宽7厘米

152

Xin 138932
Painted Pottery Male Figure
Ming Dynasty (1368-1644)
Height 25.5 cm
Bottom width 7 cm

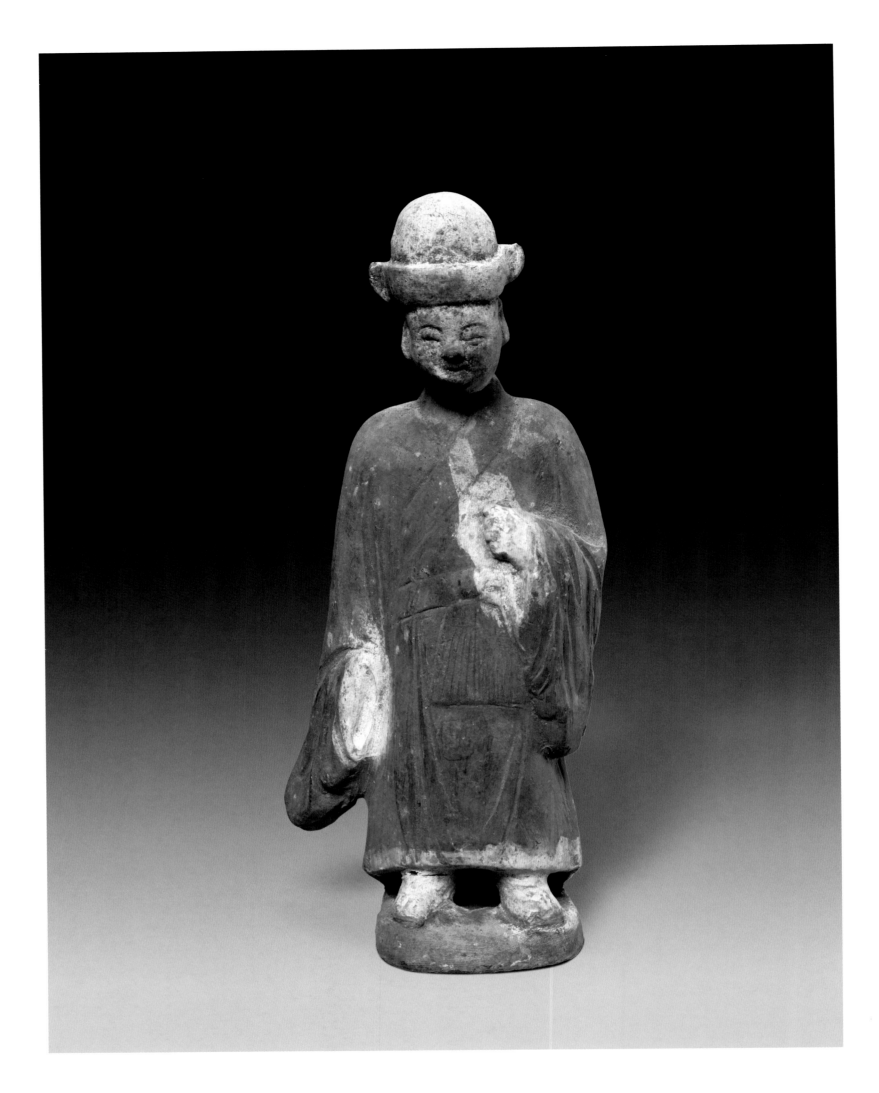

新138933

陶彩绘男俑

明

高25厘米 底宽6.5厘米

153 | Xin 138933

Painted Pottery Male Figure

Ming Dynasty (1368-1644)

Height 25 cm

Bottom width 6.5 cm

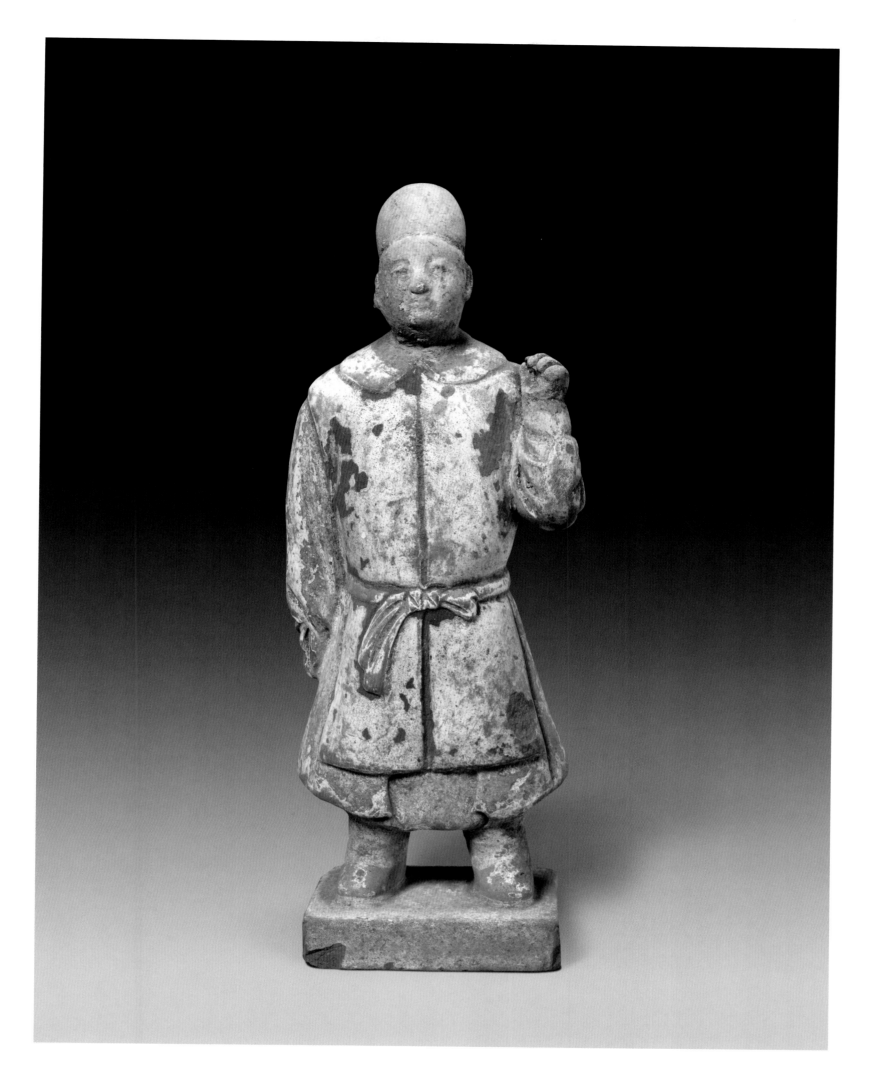

新112053

陶彩绘男俑

明

高25厘米　底宽7.8厘米

154

Xin 112053

Painted Pottery Male Figure

Ming Dynasty (1368-1644)

Height　25 cm

Bottom width　7.8 cm

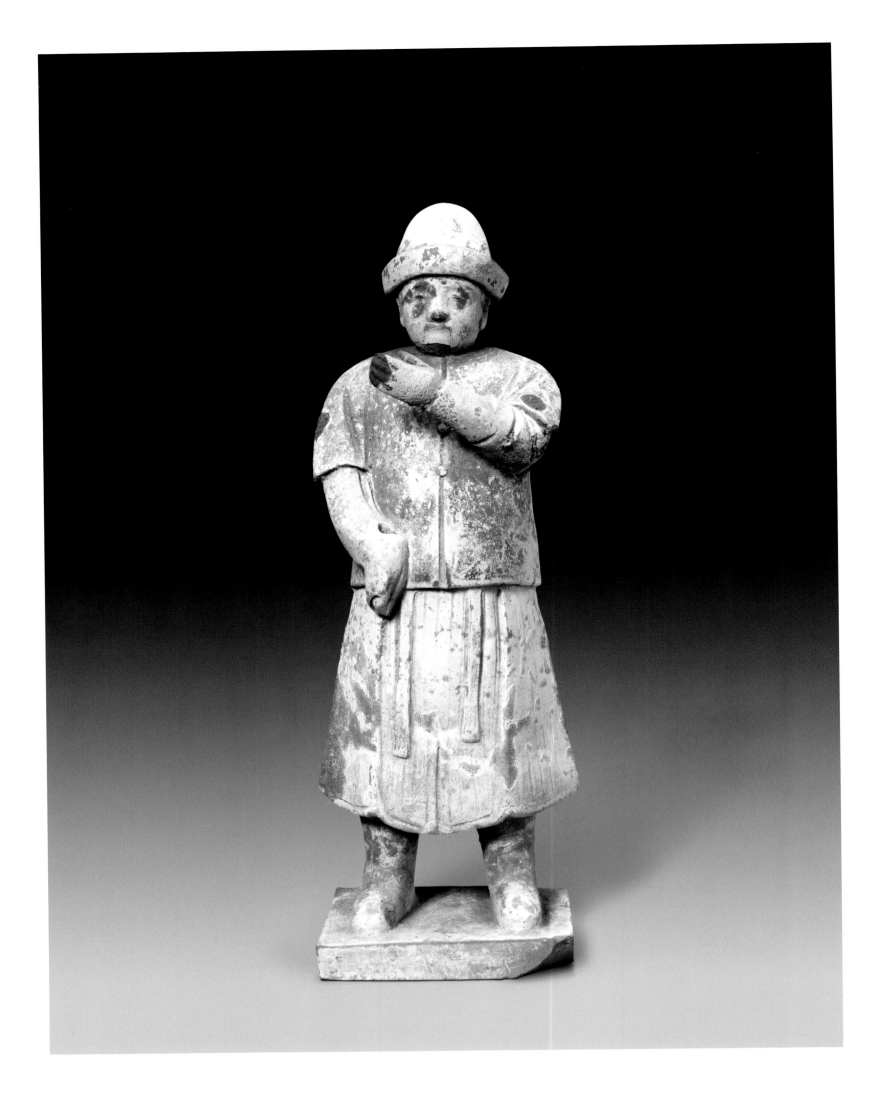

新51635

陶彩绘男俑

明

高31厘米 底宽10厘米

155

Xin 51635

Painted Pottery Male Figure

Ming Dynasty (1368-1644)

Height 31 cm
Bottom width 10 cm

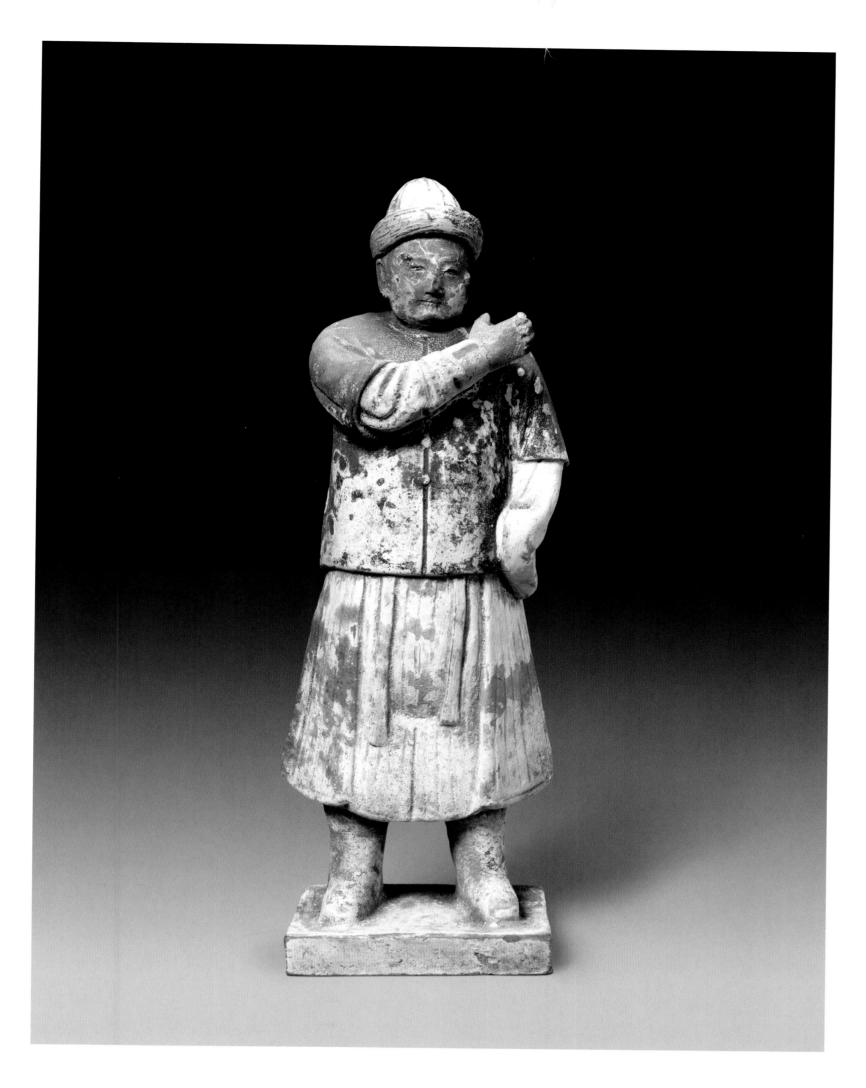

新51642
陶彩绘男俑
明
高32.5厘米 底宽9.8厘米

156

Xin 51642
Painted Pottery Male Figure
Ming Dynasty (1368-1644)
Height 32.5 cm
Bottom width 9.8 cm

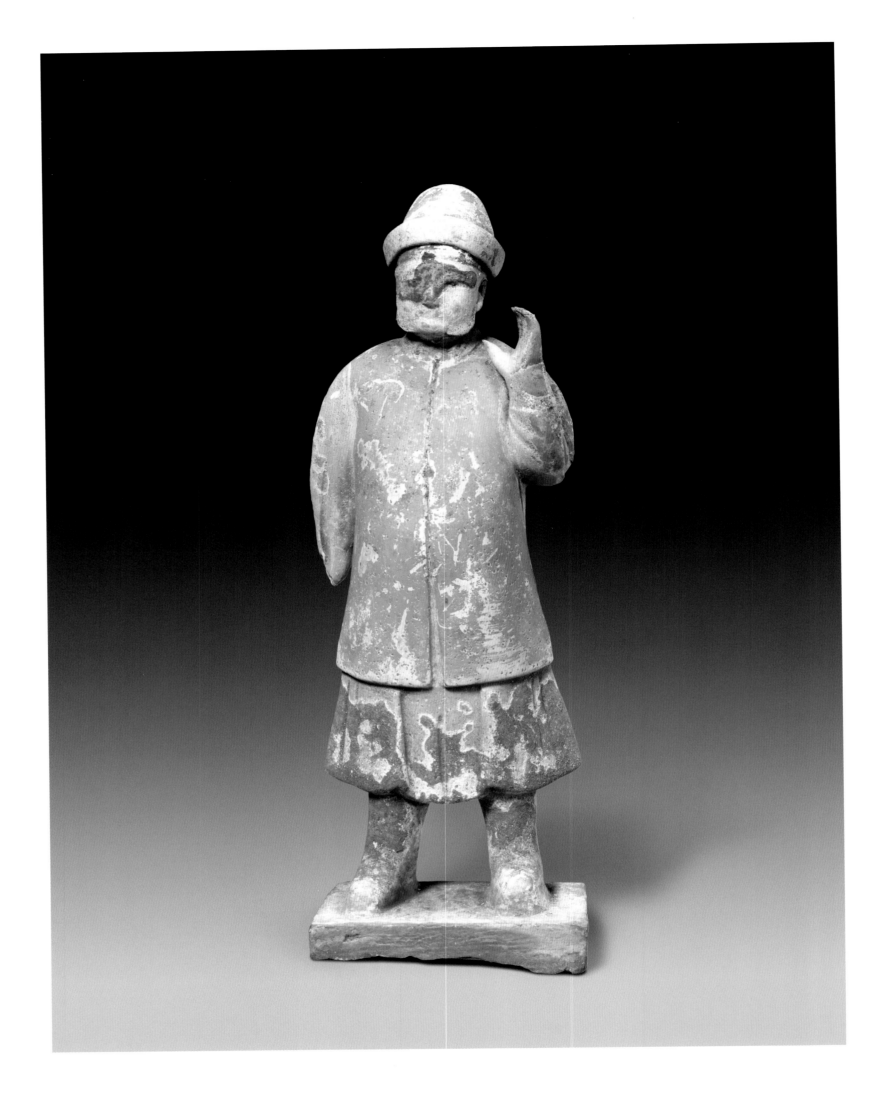

新51643

陶彩绘男俑

明

高31厘米 底宽10.2厘米

157 | Xin 51643

Painted Pottery Male Figure
Ming Dynasty (1368-1644)

Height 31 cm
Bottom width 10.2 cm

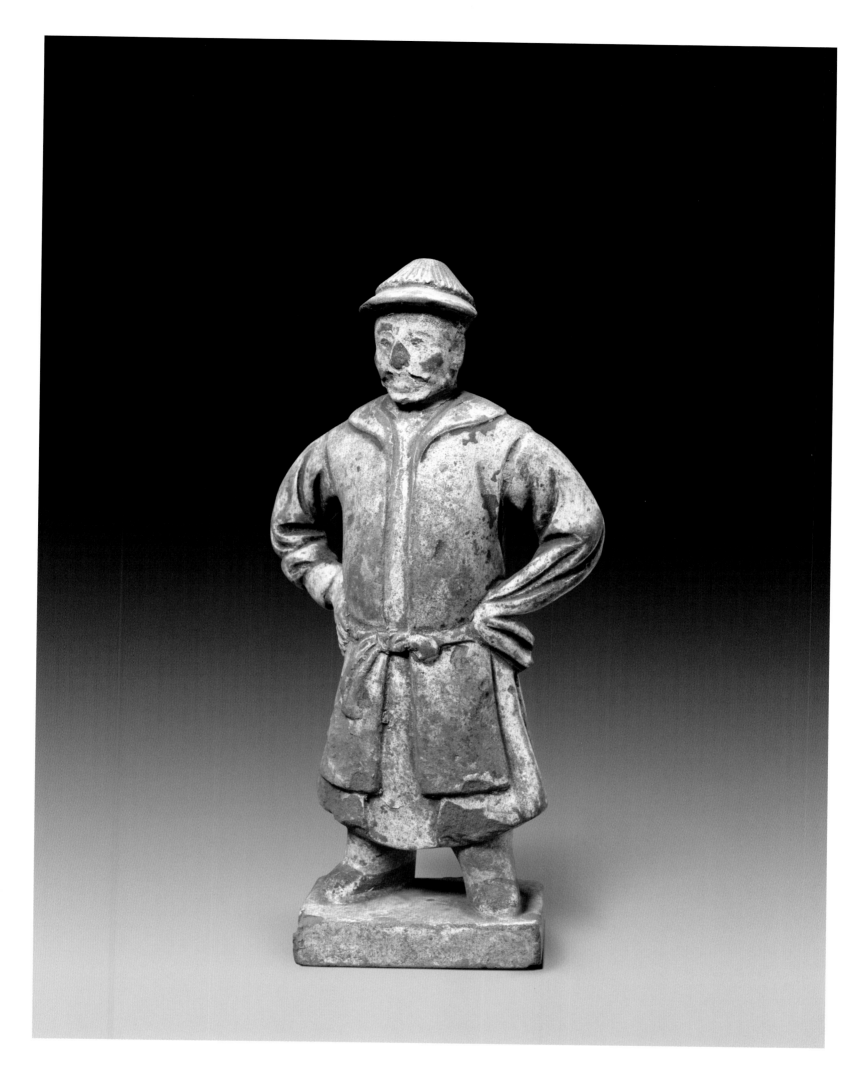

新112065

陶彩绘男俑

明

高25厘米 底宽8.4厘米

158

Xin 112065

Painted Pottery Male Figure

Ming Dynasty (1368-1644)

Height 25 cm

Bottom width 8.4 cm

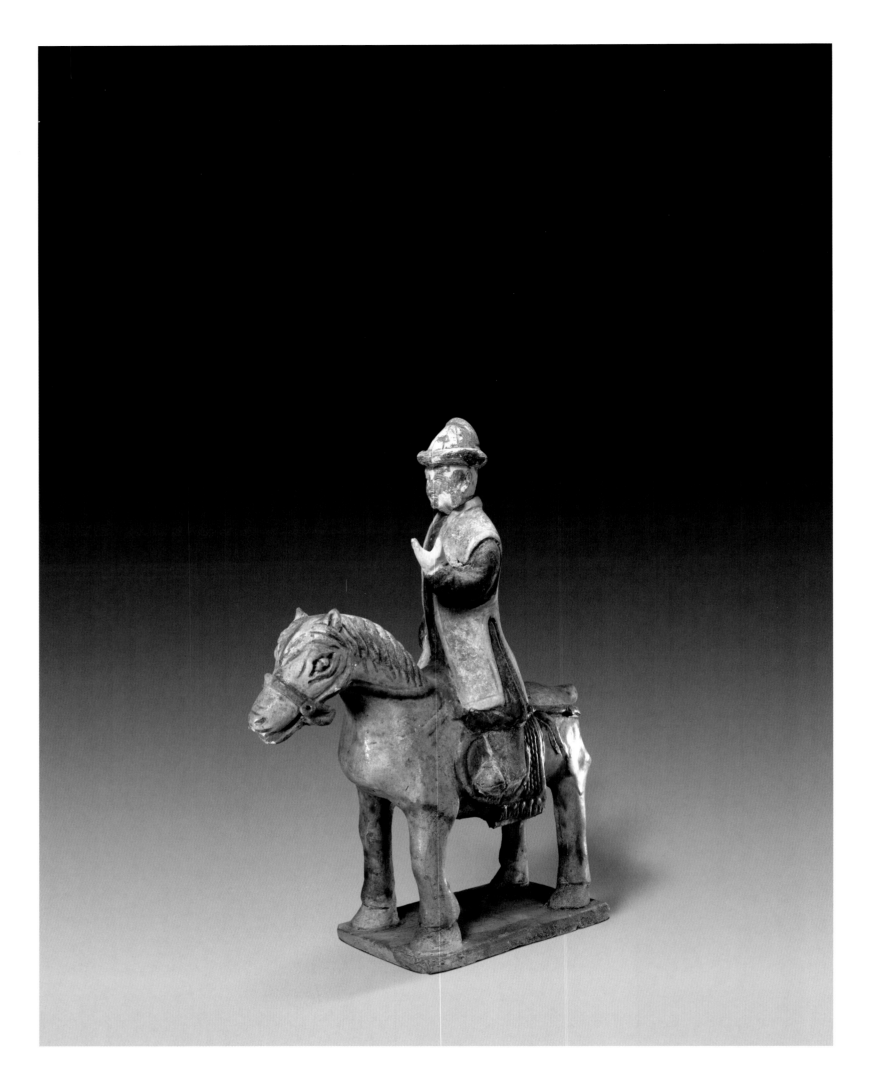

新51623
三彩男骑俑
明
高27厘米 长25厘米

159 Xin 51623

Tricolor Figure of a Horseman
Ming Dynasty (1368-1644)
Height 27 cm
Length 25 cm

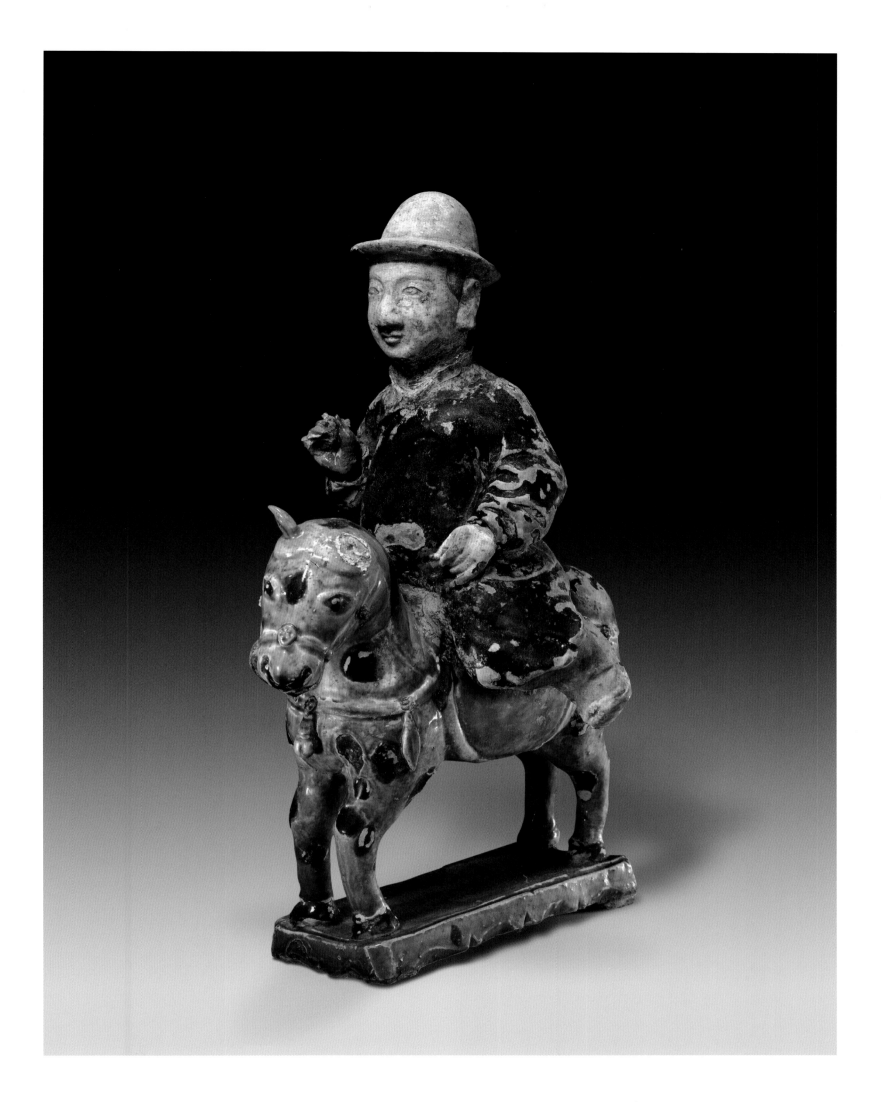

新156740
三彩男骑俑
明

高45厘米 长27厘米

160

Xin 156740
Tricolor Figure of a Horseman
Ming Dynasty (1368-1644)
Height 45 cm
Length 27 cm

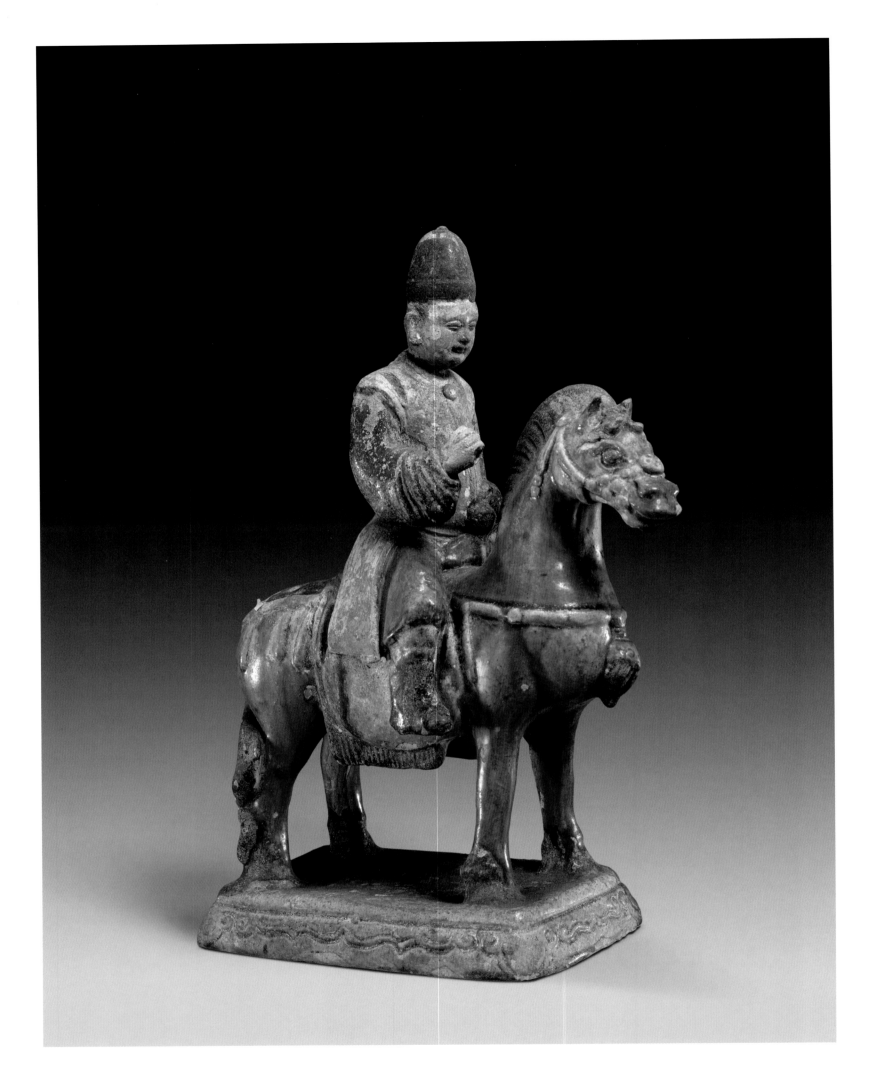

新105196

三彩男骑俑

明

高30.5厘米　长21厘米

161

Xin 105196

Tricolor Figure of a Horseman

Ming Dynasty (1368-1644)

Height 30.5 cm

Length 21 cm

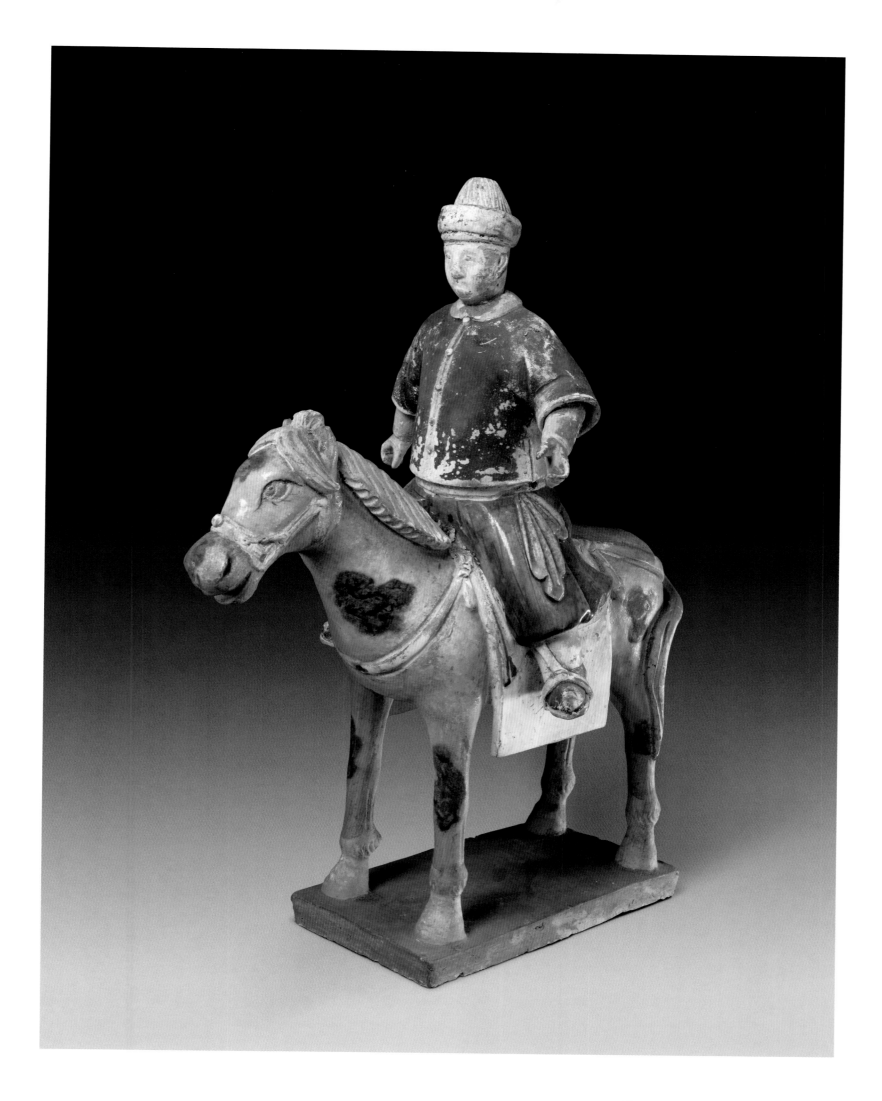

新135526

三彩男骑俑

明

高37.5厘米 长26厘米

162

Xin 135526

Tricolor Figure of a Horseman
Ming Dynasty (1368-1644)
Height 37.5 cm
Length 26 cm

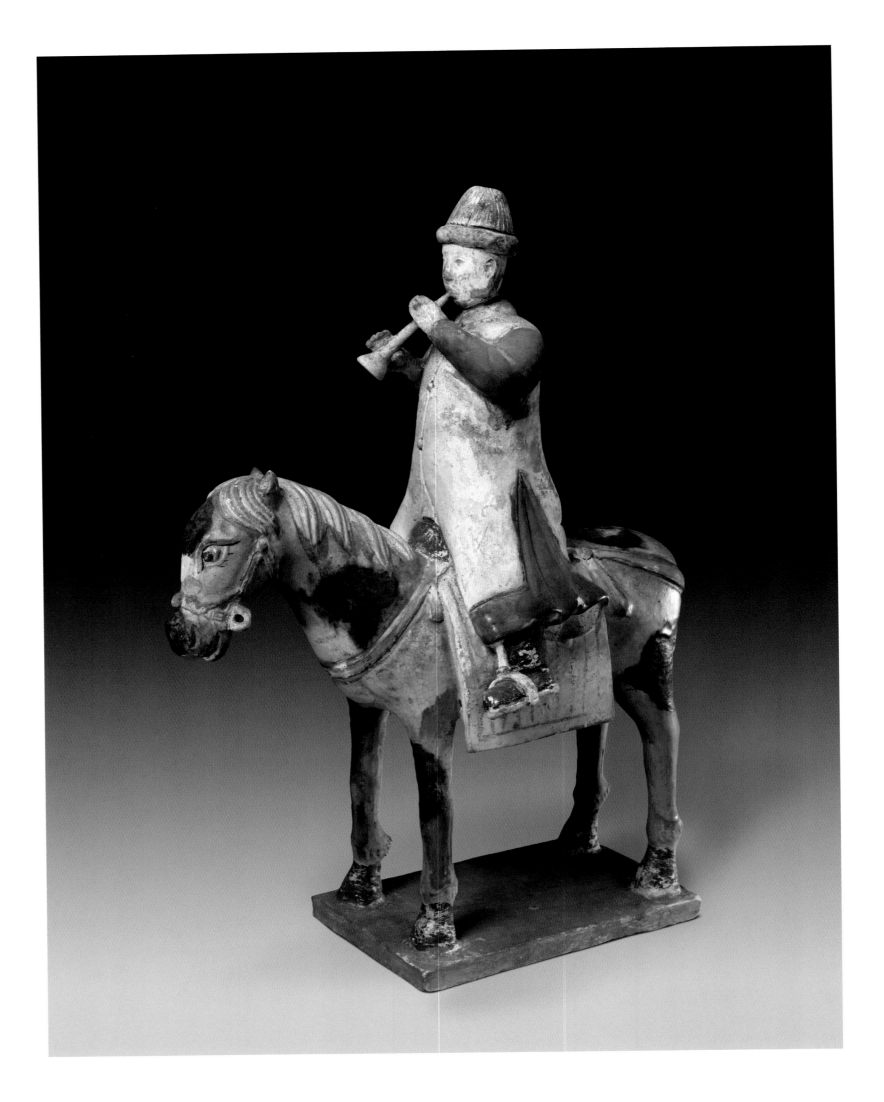

新108609
三彩男骑俑
明

高38厘米 长26厘米

163 | Xin 108609

Tricolor Figure of a Horseman
Ming Dynasty (1368-1644)

Height 38 cm
Length 26 cm

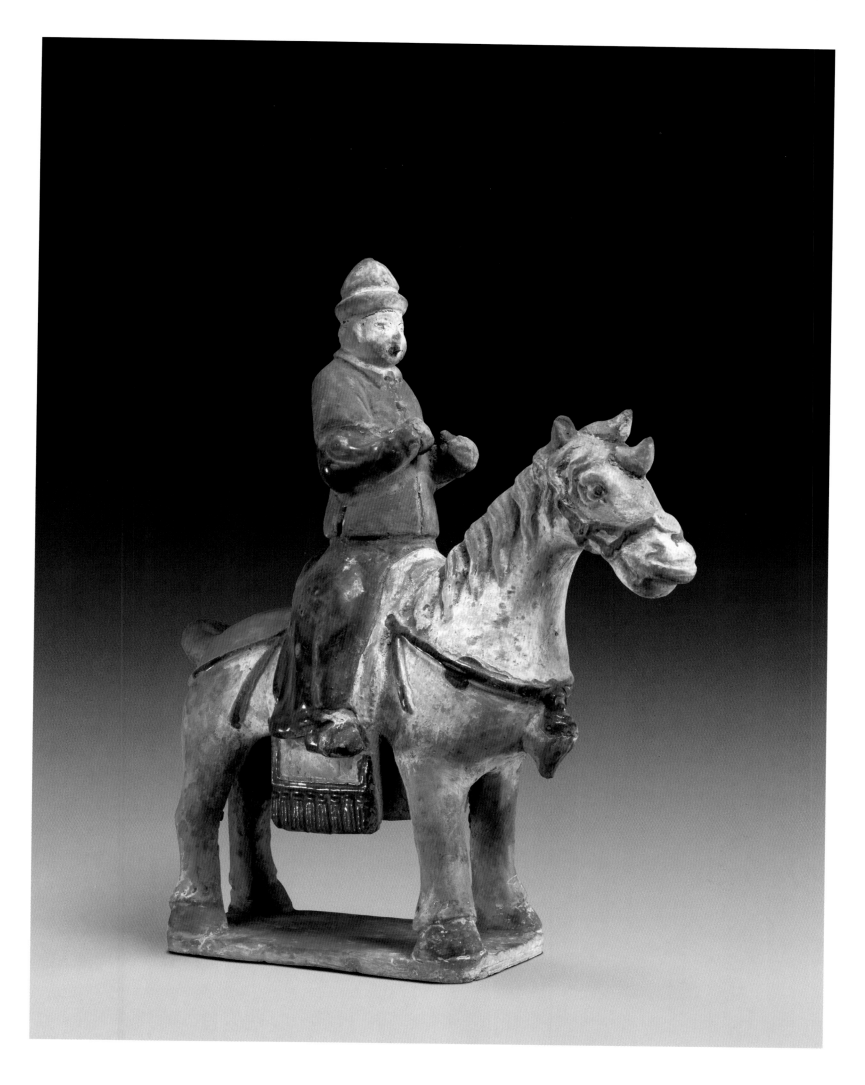

新121605

陶绿釉男骑俑

明

高30厘米 长27厘米

Xin 121605

Green Glazed Pottery Figure of a Horseman

Ming Dynasty (1368-1644)

Height　30 cm

Length　27 cm

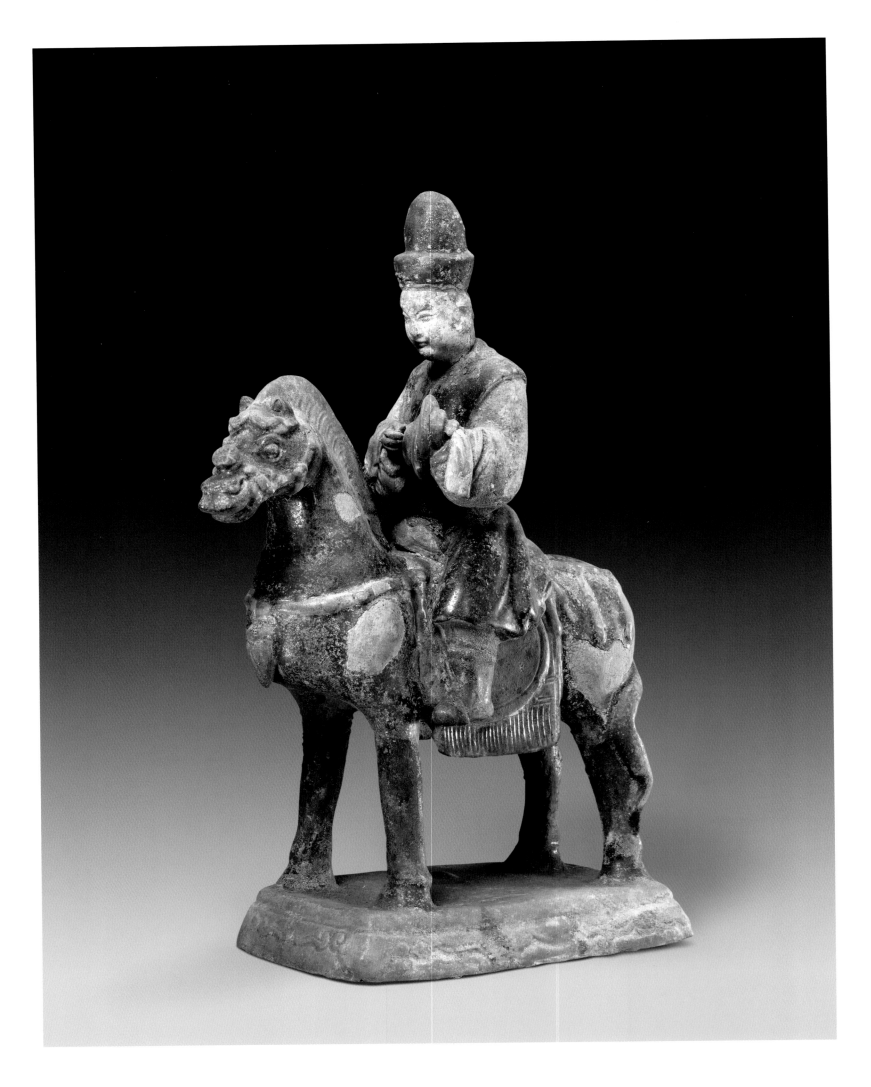

新105200

陶紫黄釉男骑俑

明

高31.5厘米 长20厘米

165

Xin 105200

Purple-yellow Glazed Pottery Figure of a Horseman
Ming Dynasty (1368-1644)
Height 31.5 cm
Length 20 cm

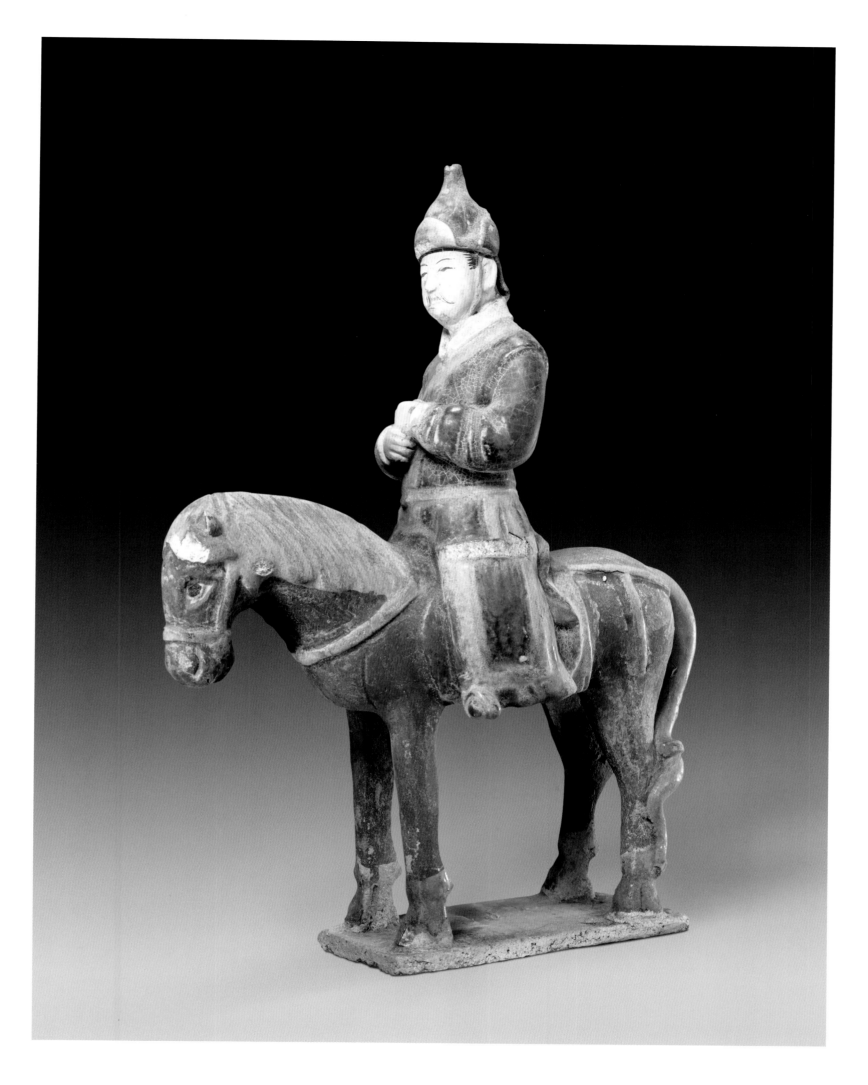

新43847

陶紫蓝釉男骑俑

明

高34厘米 长22厘米

166

Xin 43847

Purple-blue Glazed Pottery Figure of a Horseman
Ming Dynasty (1368-1644)
Height 34 cm
Length 22 cm

199

新43852
陶黄蓝釉男骑俑
明

高30厘米　长24厘米

167

Xin 43852
Yellow-blue Glazed Pottery Figure of a Horseman
Ming Dynasty (1368-1644)
Height　30 cm
Length　24 cm

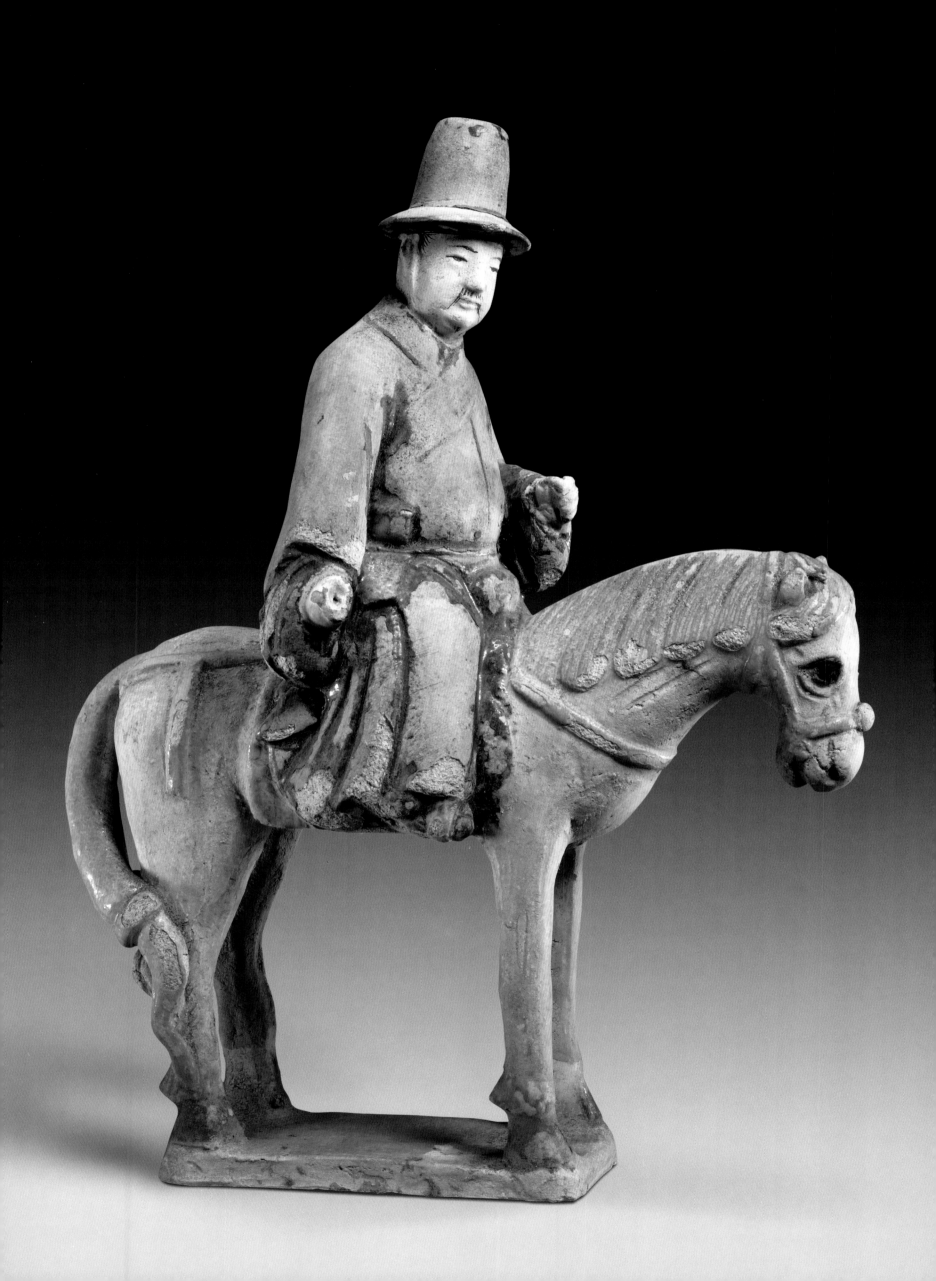

新43870

陶紫蓝釉男骑俑
明

高35厘米　长22厘米

168

Xin 43870

Purple-blue Glazed Pottery Figure of a Horseman
Ming Dynasty (1368-1644)
Height　35 cm
Length　22 cm

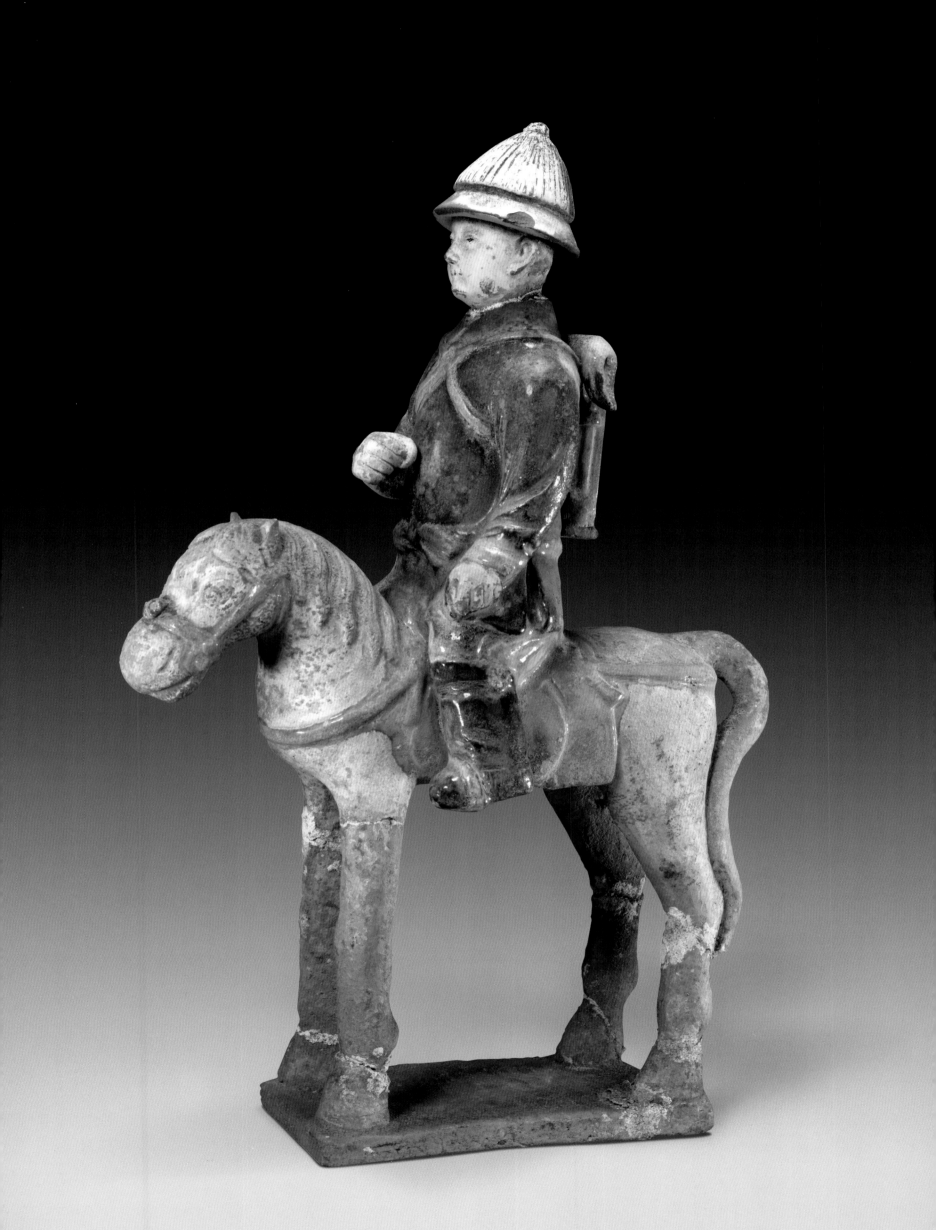

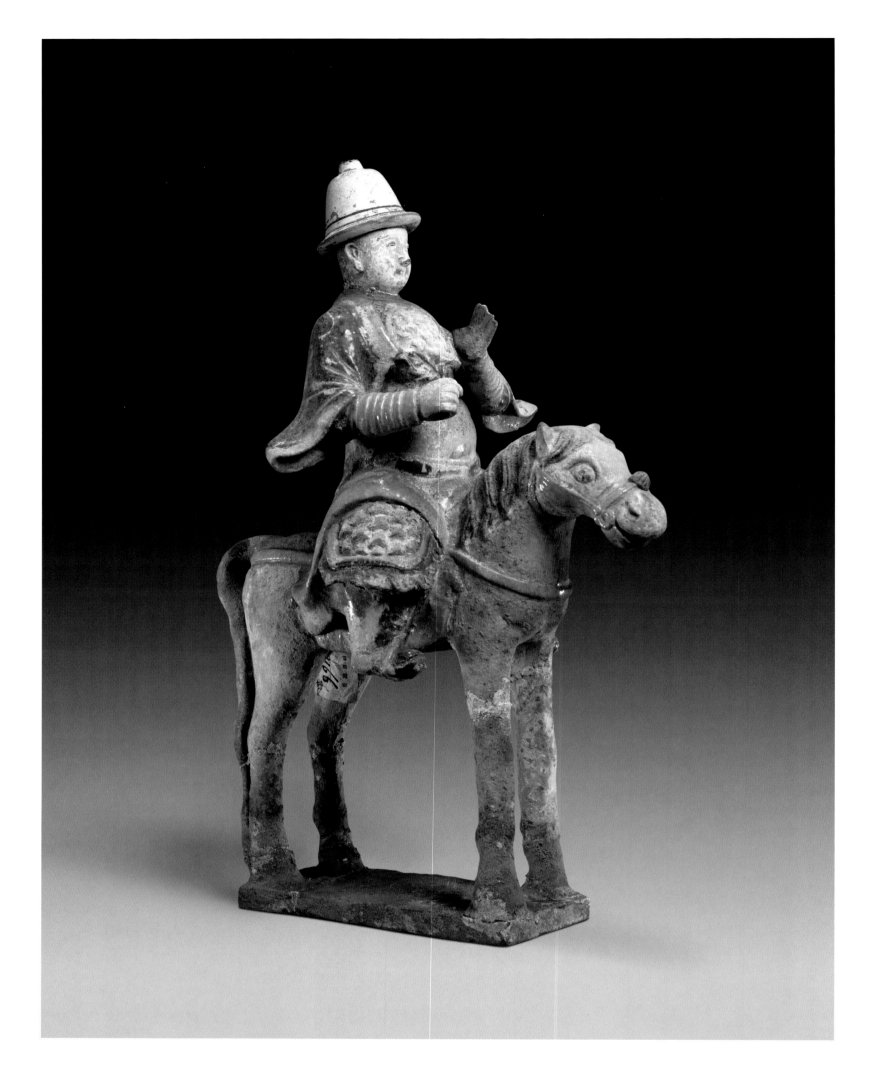

新43857
陶紫蓝釉男骑俑
明
高36厘米 长24厘米

169

Xin 43857
Purple-blue Glazed Pottery Figure of a Horseman
Ming Dynasty (1368-1644)
Height 36 cm
Length 24 cm

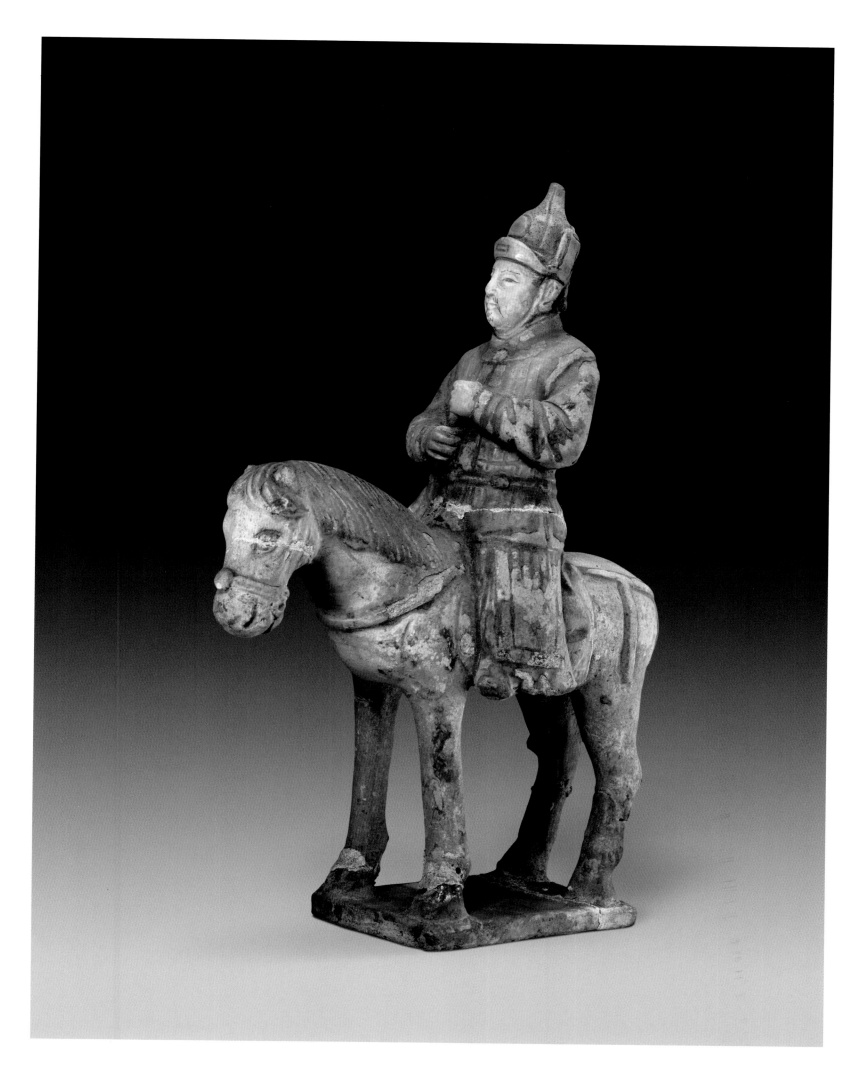

新43840

陶紫蓝釉男骑俑

明

高34厘米 长23厘米

170

Xin 43840

Purple-blue Glazed Pottery Figure of a Horseman
Ming Dynasty (1368-1644)

Height 34 cm
Length 23 cm

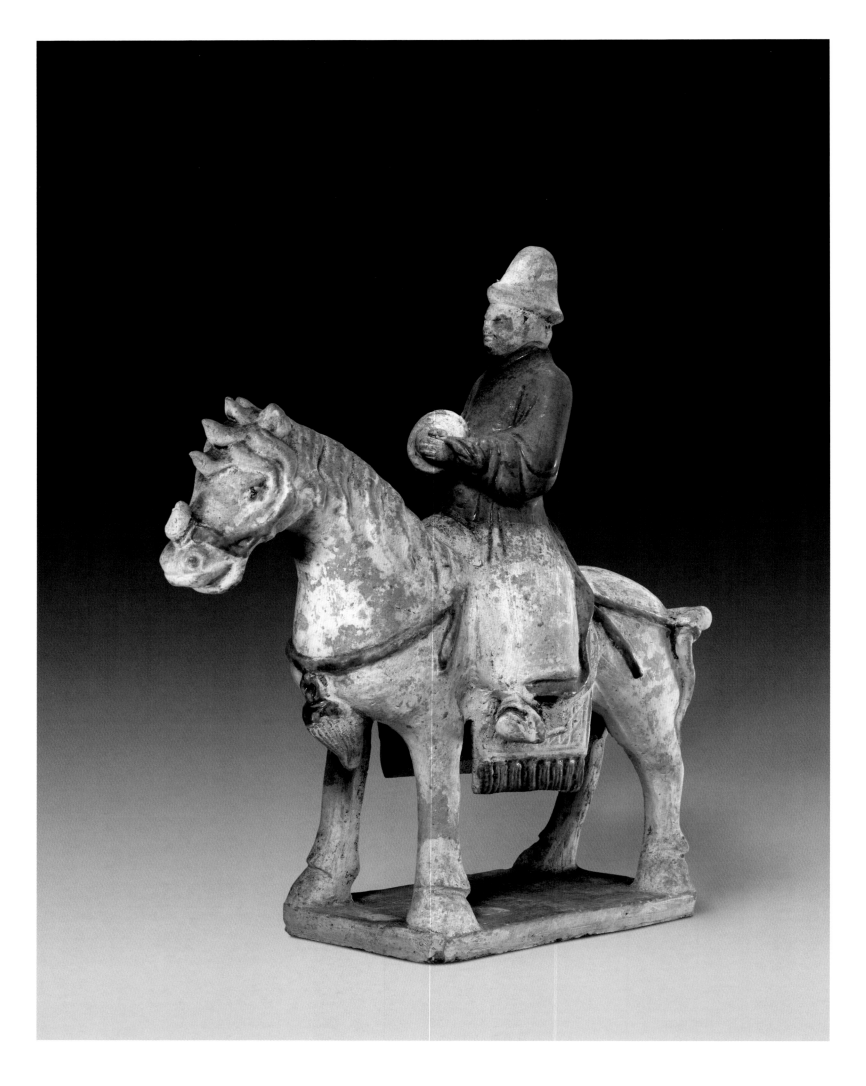

新144180

陶绿釉男骑俑

明

高25厘米 长29厘米

I7I

Xin 144180

Green Glazed Pottery Figure of a Horseman
Ming Dynasty (1368-1644)
Height 25 cm
Length 29 cm

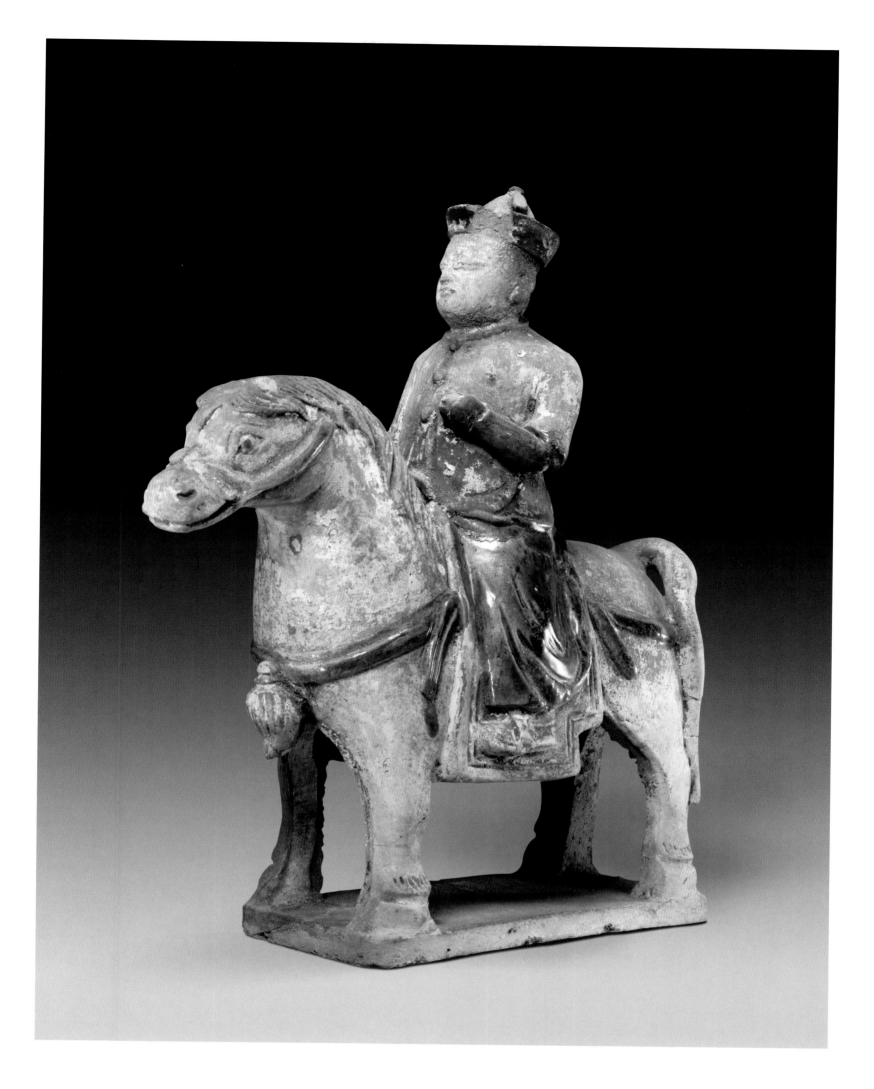

新62388
陶绿釉男骑俑
明

172 高33厘米　长25厘米

Xin 62388
Green Glazed Pottery Figure of a Horseman
Ming Dynasty (1368-1644)
Height　33 cm
Length　25 cm

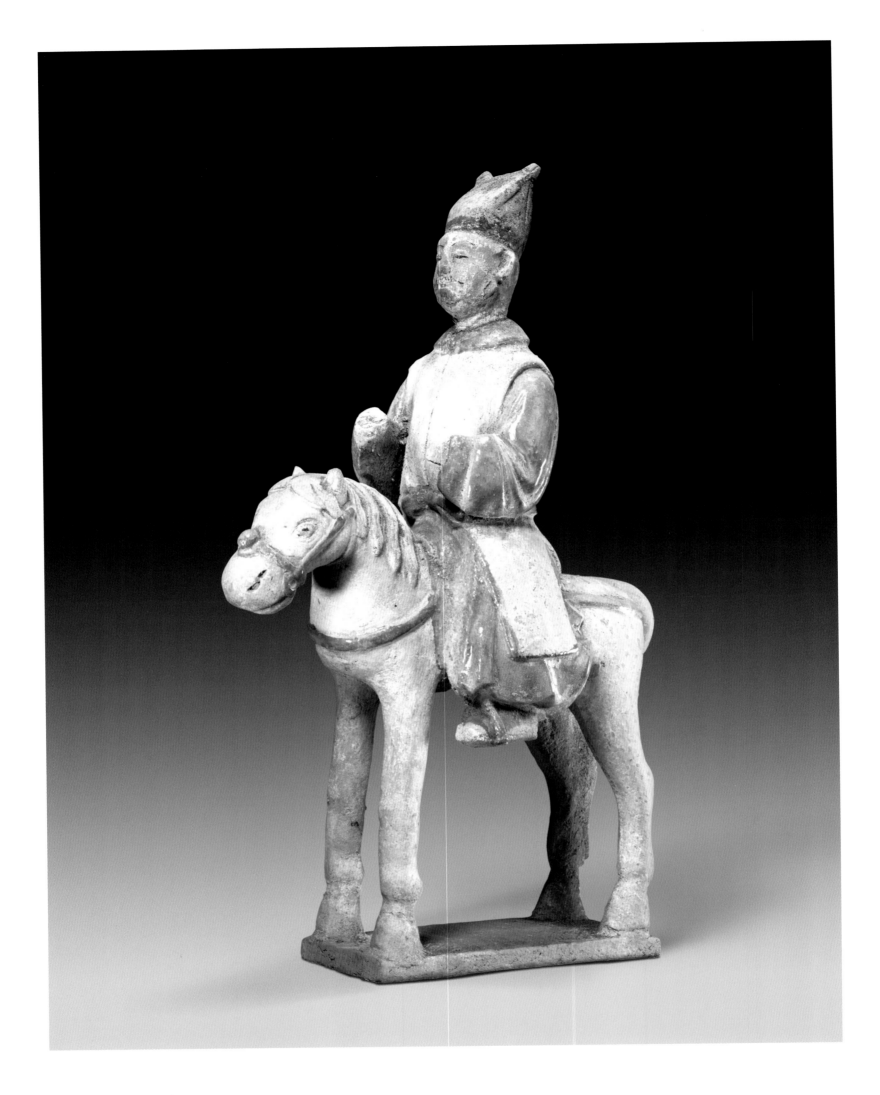

新43843
陶蓝釉男骑俑
明
高36厘米　长22厘米

173

Xin 43843
Blue Glazed Pottery Figure of a Horseman
Ming Dynasty (1368-1644)
Height　36 cm
Length　22 cm

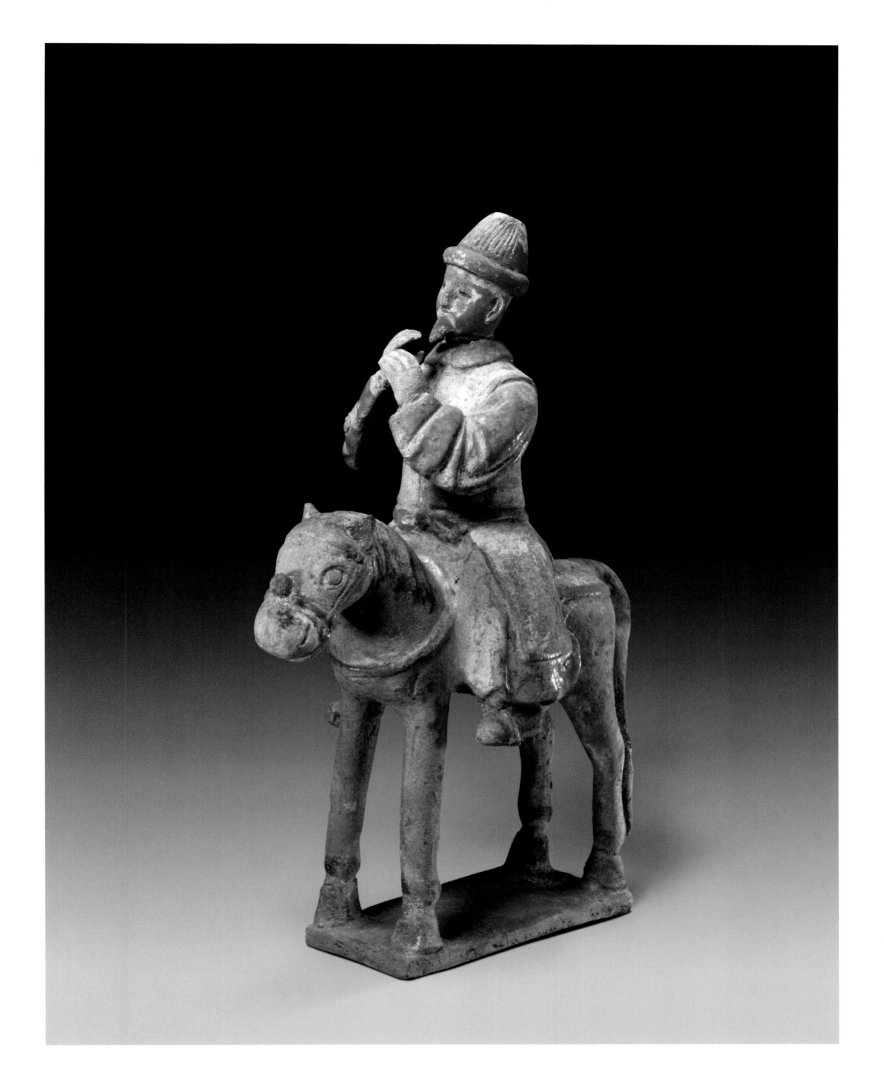

新43850
陶蓝釉男骑俑
明

高33厘米 长23厘米

174

Xin 43850

Blue Glazed Pottery Figure of a Horseman
Ming Dynasty (1368-1644)
Height 33 cm
Length 23 cm

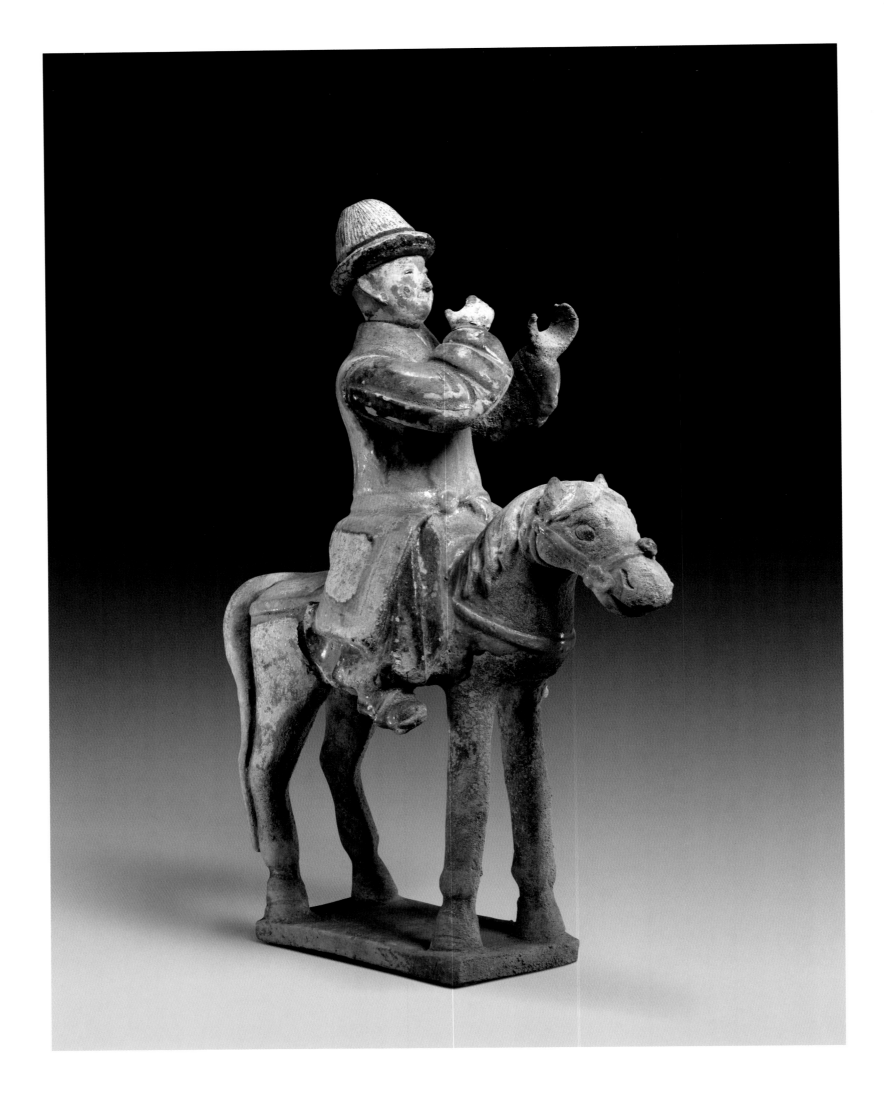

新43855
陶紫蓝釉男骑俑
明

高34厘米　长22厘米

175 | Xin 43855
Purple-blue Glazed Pottery Figure of a Horseman
Ming Dynasty (1368-1644)
Height 34 cm
Length 22 cm

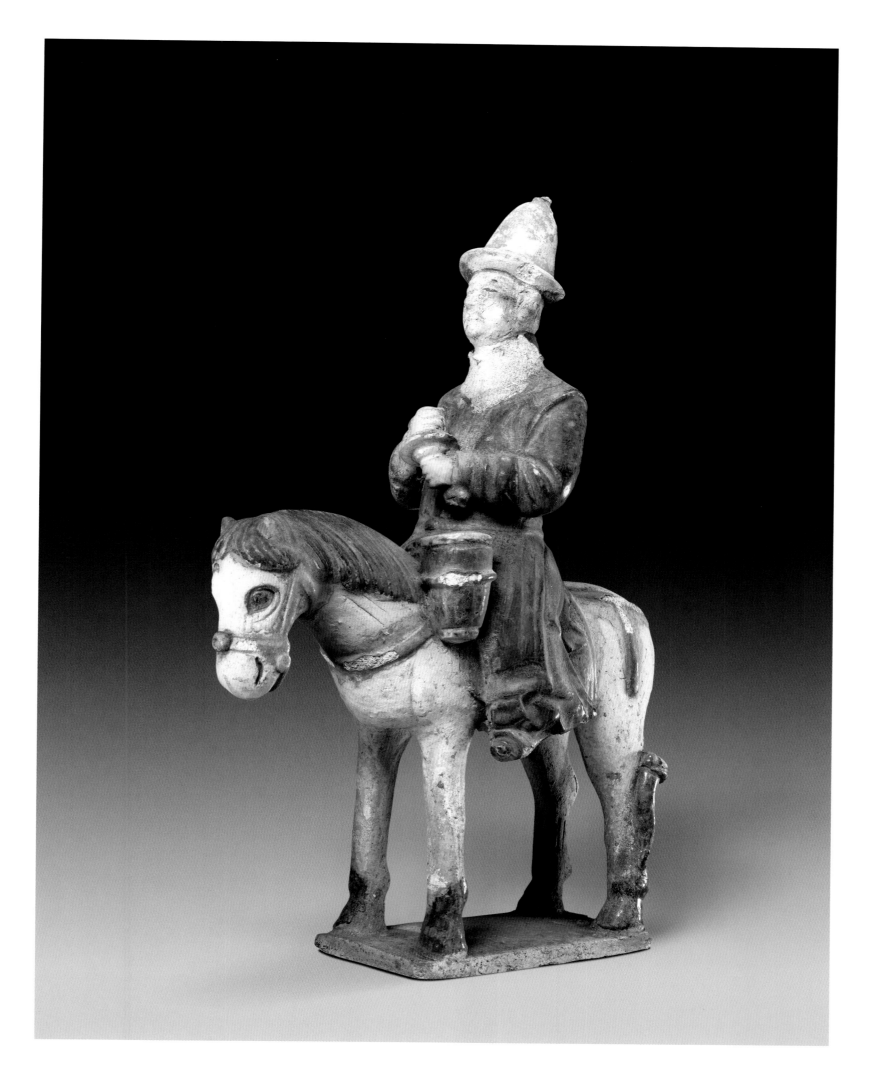

新43848
陶紫绿釉男骑俑
明

高34厘米 长22厘米

176 | Xin 43848
Purple-green Glazed Pottery Figure of a Horseman
Ming Dynasty (1368-1644)
Height 34 cm
Length 22 cm

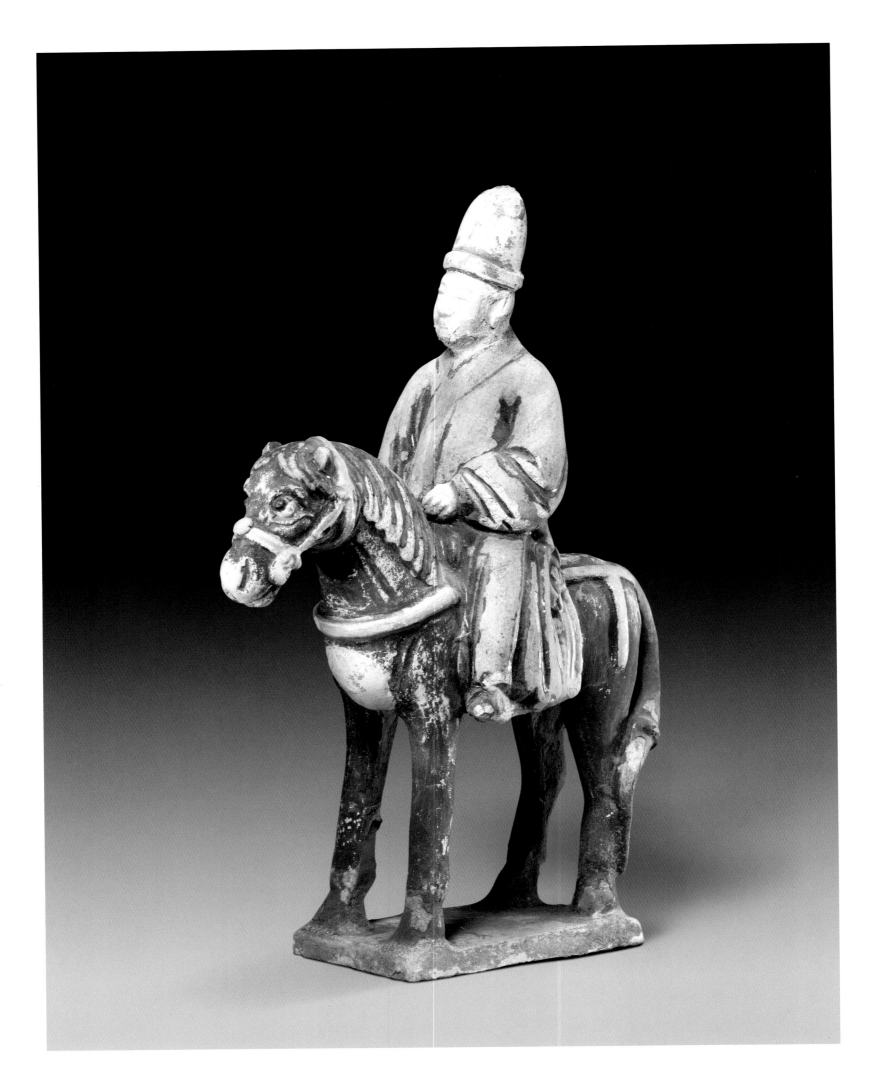

新43849

陶紫绿釉男骑俑

明

高33厘米 长24厘米

177 Xin 43849

Purple-green Glazed Pottery Figure of a Horseman

Ming Dynasty (1368-1644)

Height 33 cm

Length 24 cm

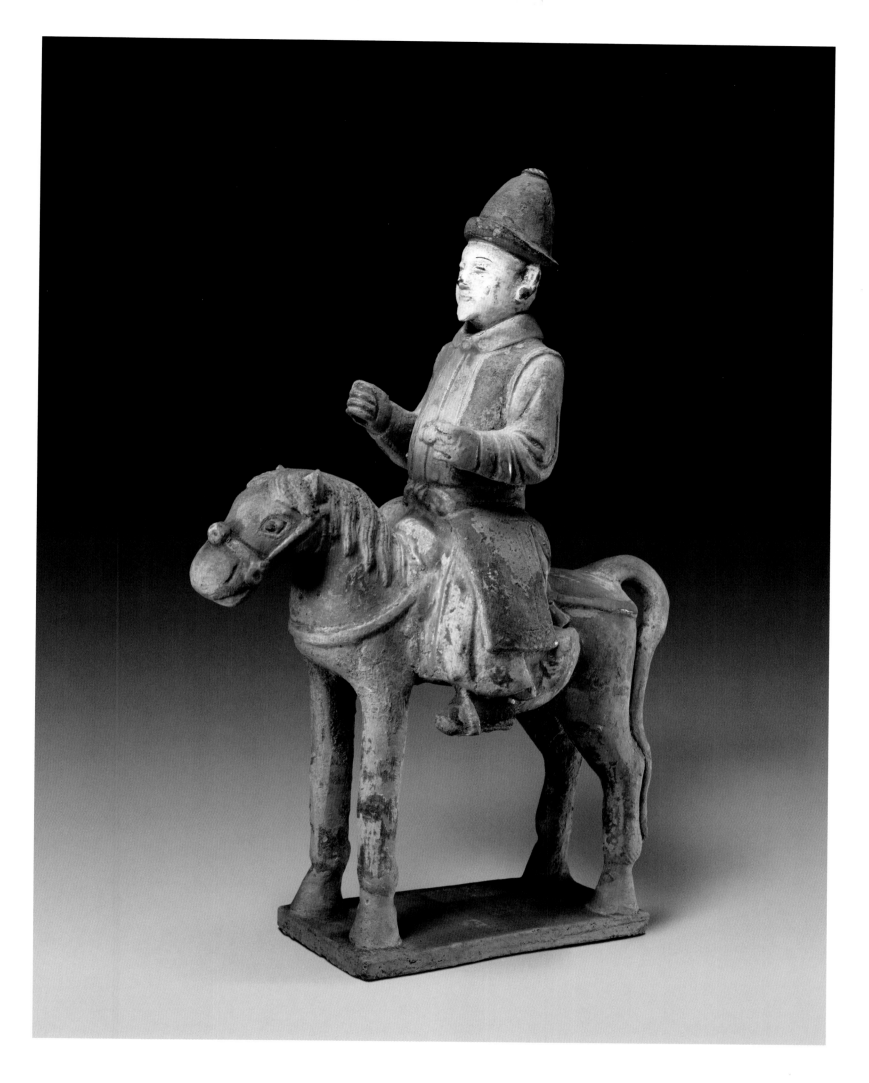

新62387

陶紫绿釉男骑俑
明

高35厘米 长22厘米

178

Xin 62387

Purple-green Glazed Pottery Figure of a Horseman
Ming Dynasty (1368-1644)
Height 35 cm
Length 22 cm

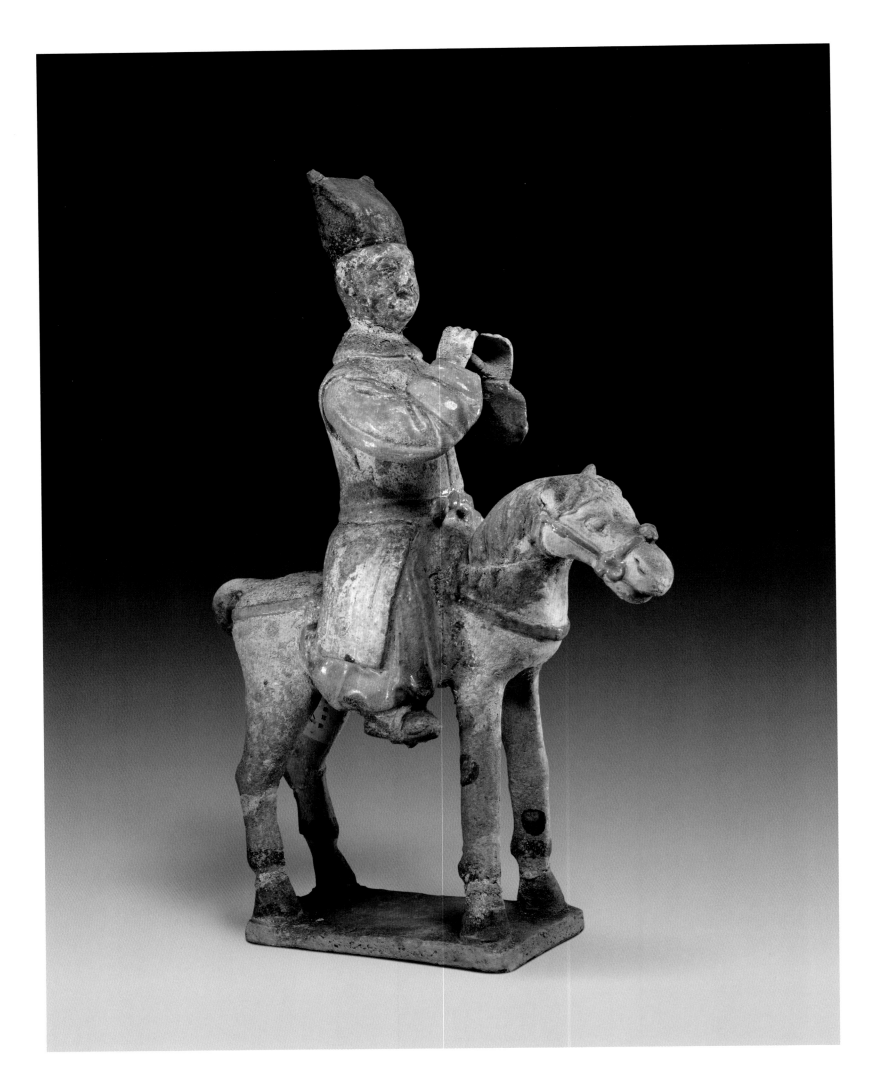

新43856
陶蓝釉男骑俑
明

高36.5厘米　长22厘米

179

Xin 43856
Blue Glazed Pottery Figure of a Horseman
Ming Dynasty (1368-1644)
Height　36.5 cm
Length　22 cm

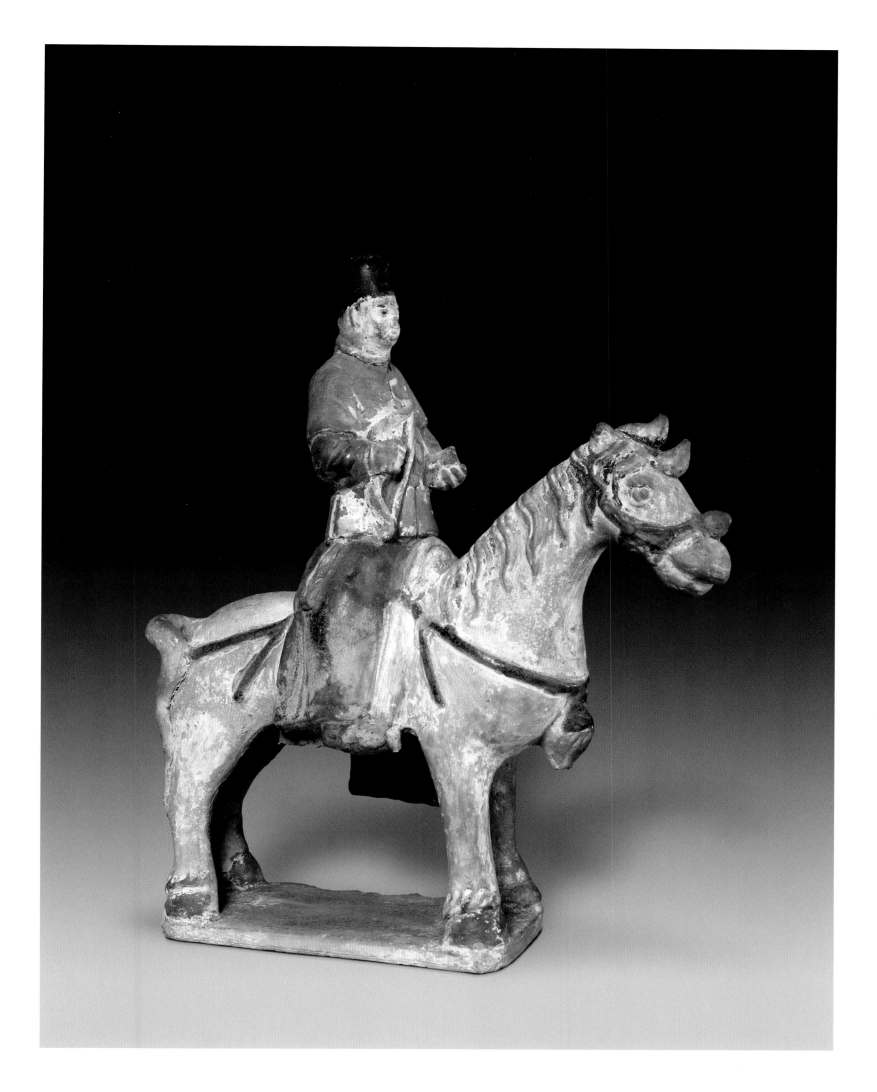

新121604
陶绿釉男骑俑
明

高30厘米 长25厘米

180

Xin 121604
Green Glazed Pottery Figure of a Horseman
Ming Dynasty (1368-1644)
Height 30 cm
Length 25 cm

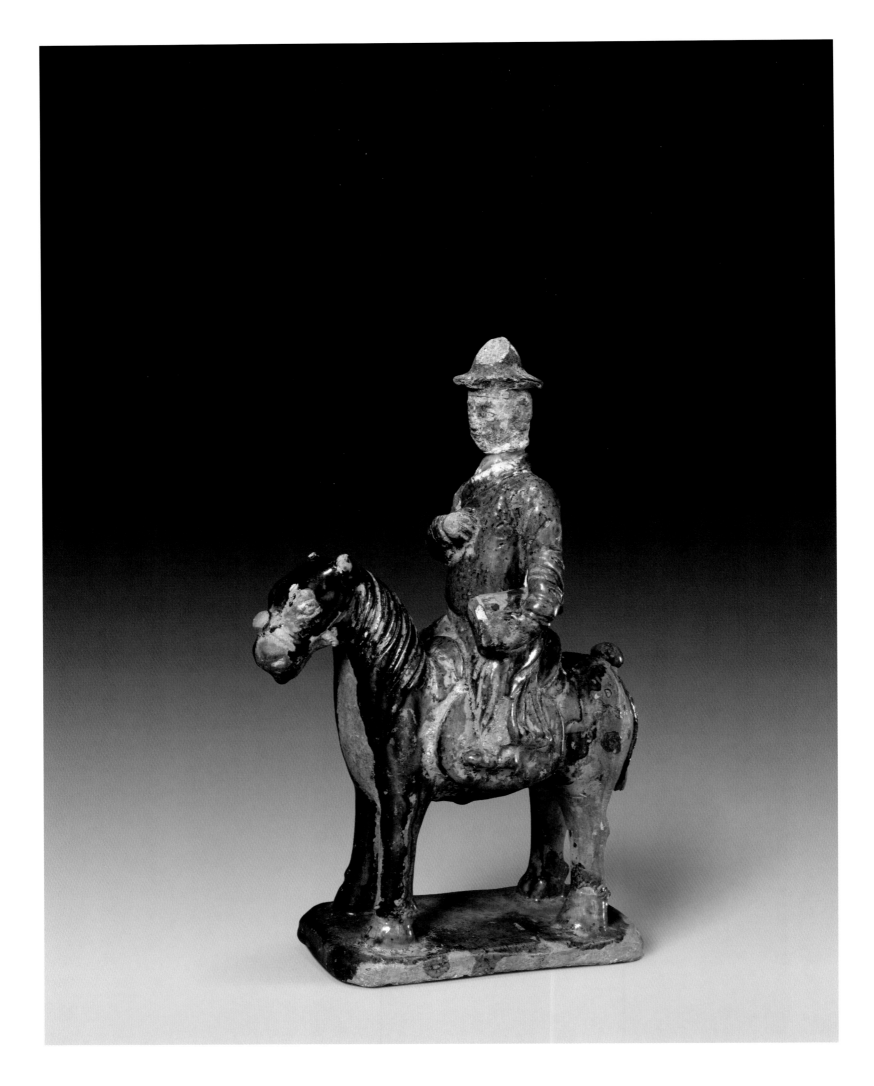

新155656

陶绿釉男骑俑

明

高29厘米　长18厘米

181

Xin 155656

Green Glazed Pottery Figure of a Horseman

Ming Dynasty (1368-1644)

Height　29 cm
Length　18 cm

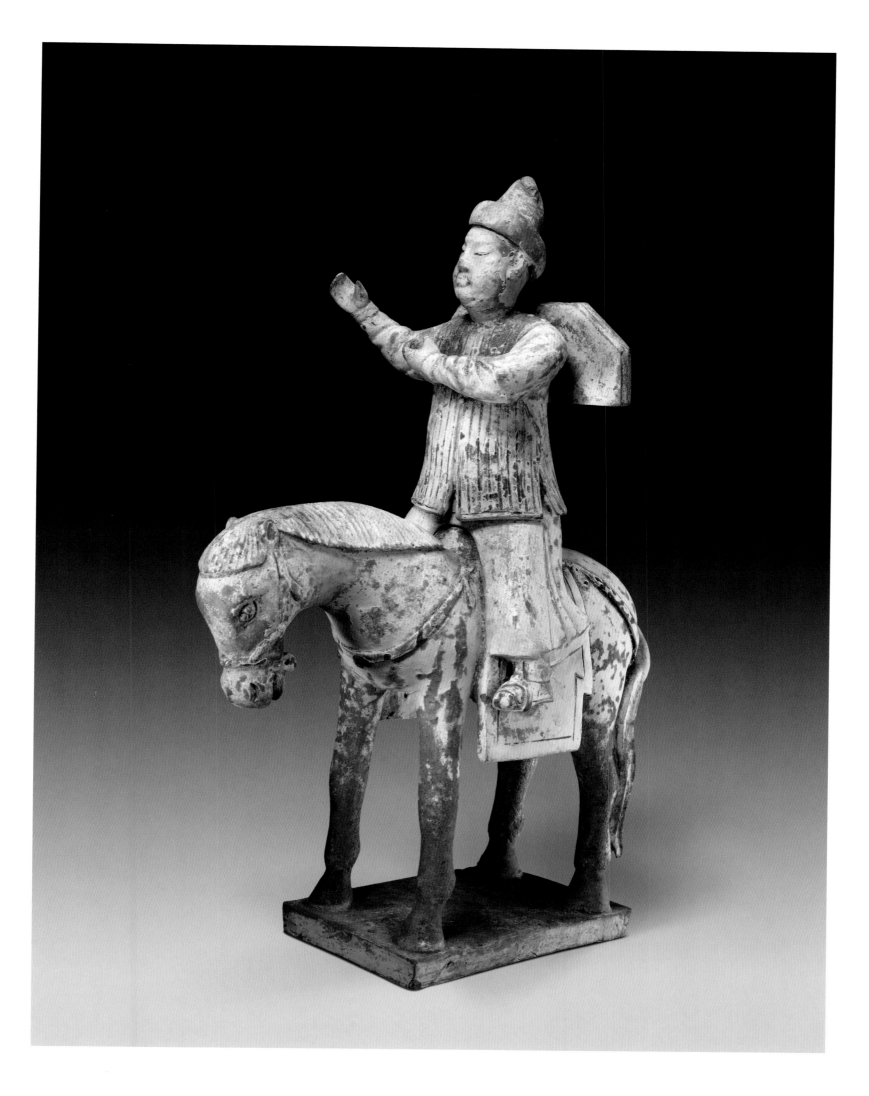

新51631

陶彩绘男骑俑

明

高45厘米 长31厘米

182

Xin 51631

Painted Pottery Figure of a Horseman
Ming Dynasty (1368-1644)
Height 45 cm
Length 31 cm

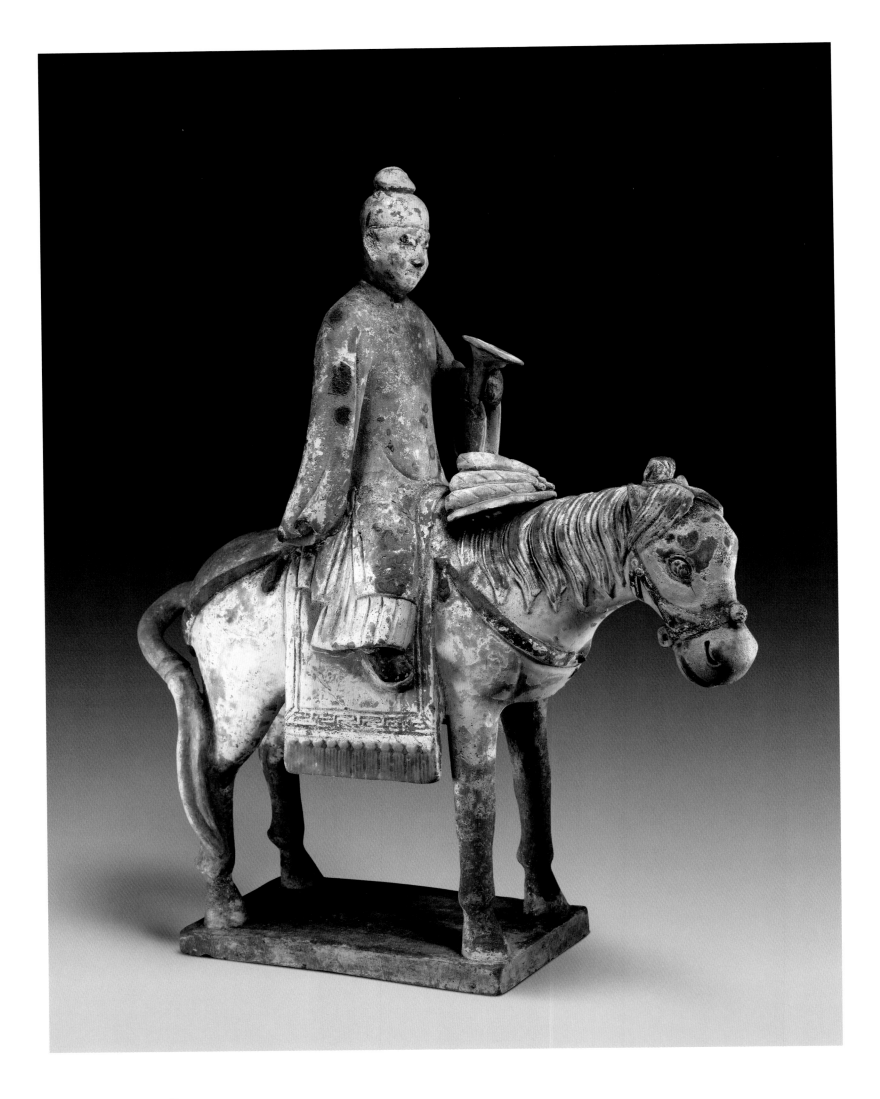

新51627

陶彩绘男骑俑

明

高39厘米　长30厘米

183

Xin 51627

Painted Pottery Figure of a Horseman

Ming Dynasty (1368-1644)

Height 39 cm

Length 30 cm

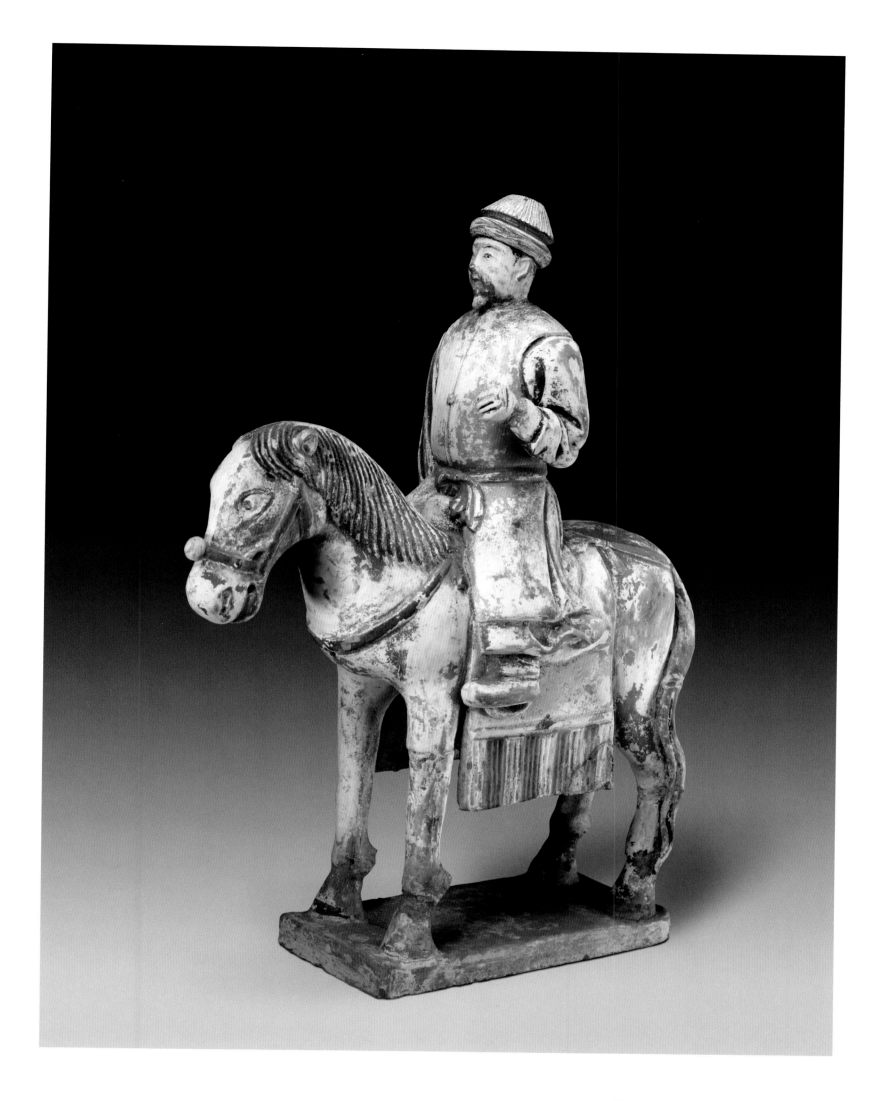

新105199

陶彩绘男骑俑

明

高37厘米 长25厘米

184

Xin 105199

Painted Pottery Figure of a Horseman

Ming Dynasty (1368-1644)

Height 37 cm

Length 25 cm

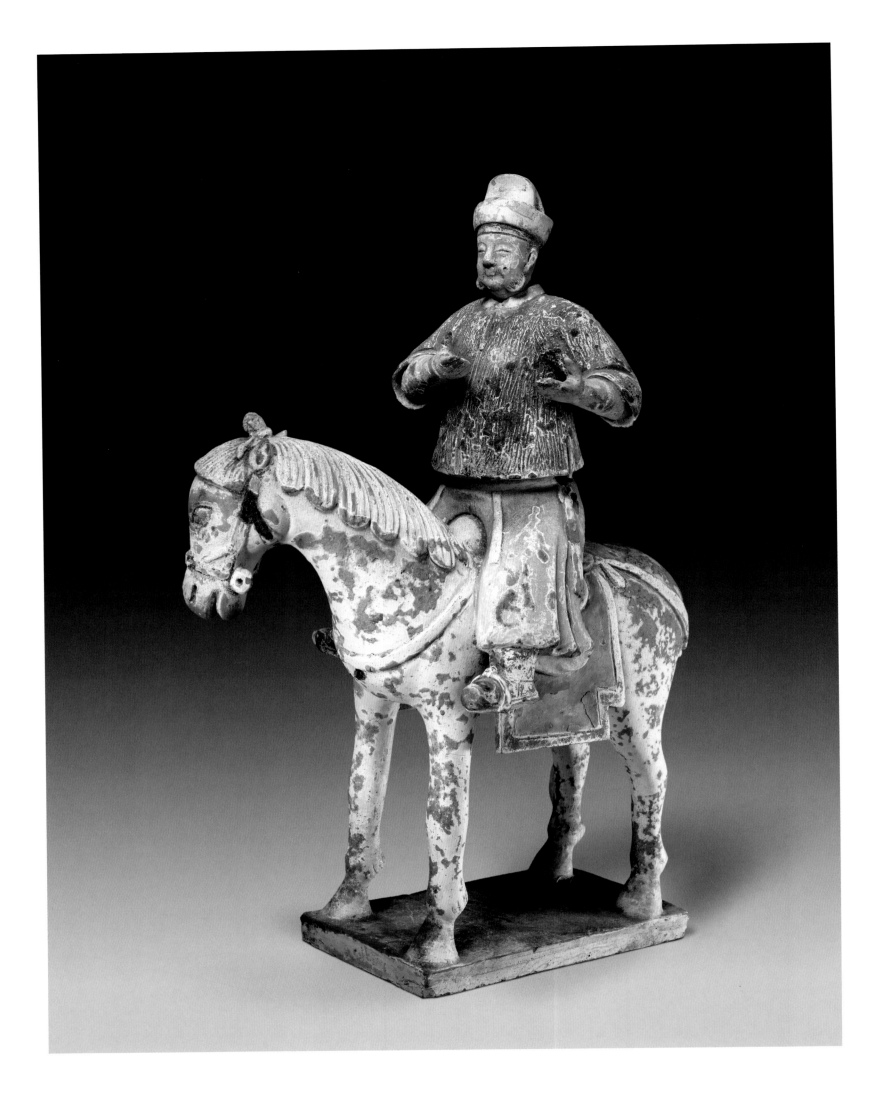

新51629
陶彩绘男骑俑
明
高43厘米 长30厘米

185
Xin 51629
Painted Pottery Figure of a Horseman
Ming Dynasty (1368-1644)
Height 43 cm
Length 30 cm

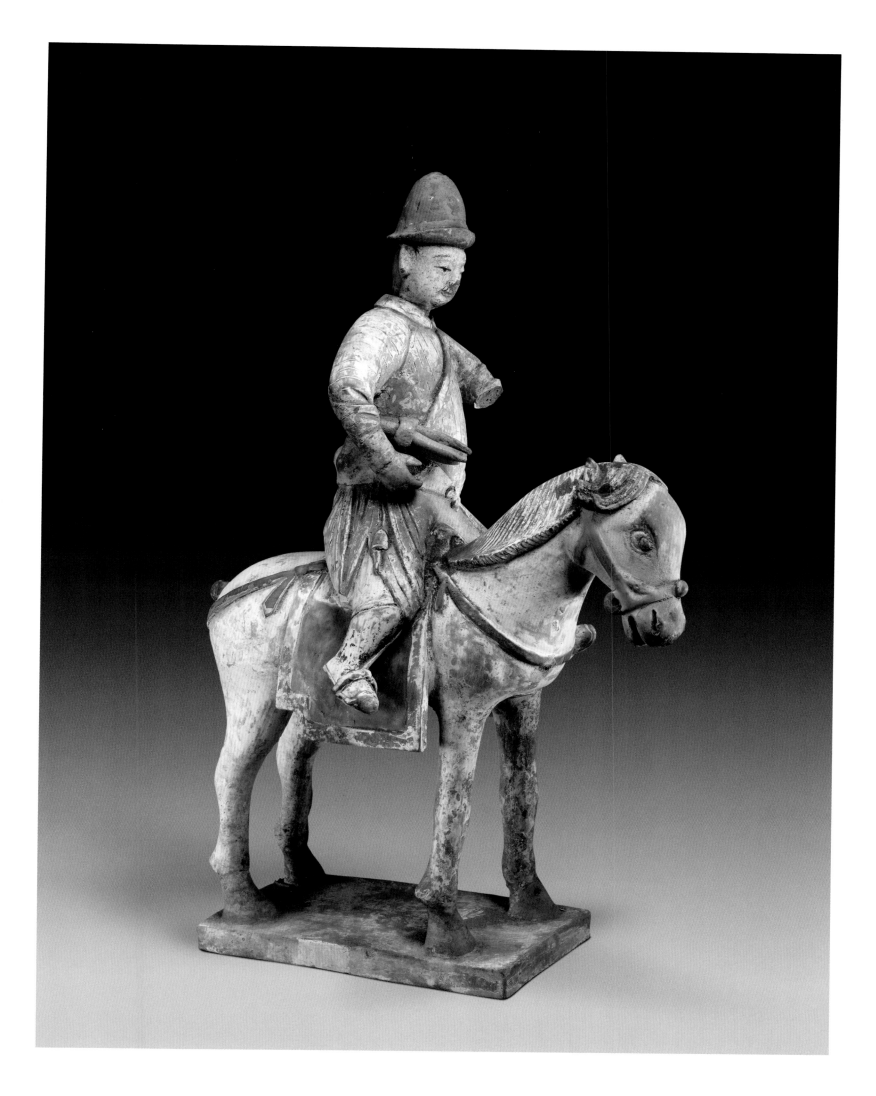

新51630
陶彩绘男骑俑
明

高43厘米 长30厘米

186

Xin 51630

Painted Pottery Figure of a Horseman
Ming Dynasty (1368-1644)
Height 43 cm
Length 30 cm

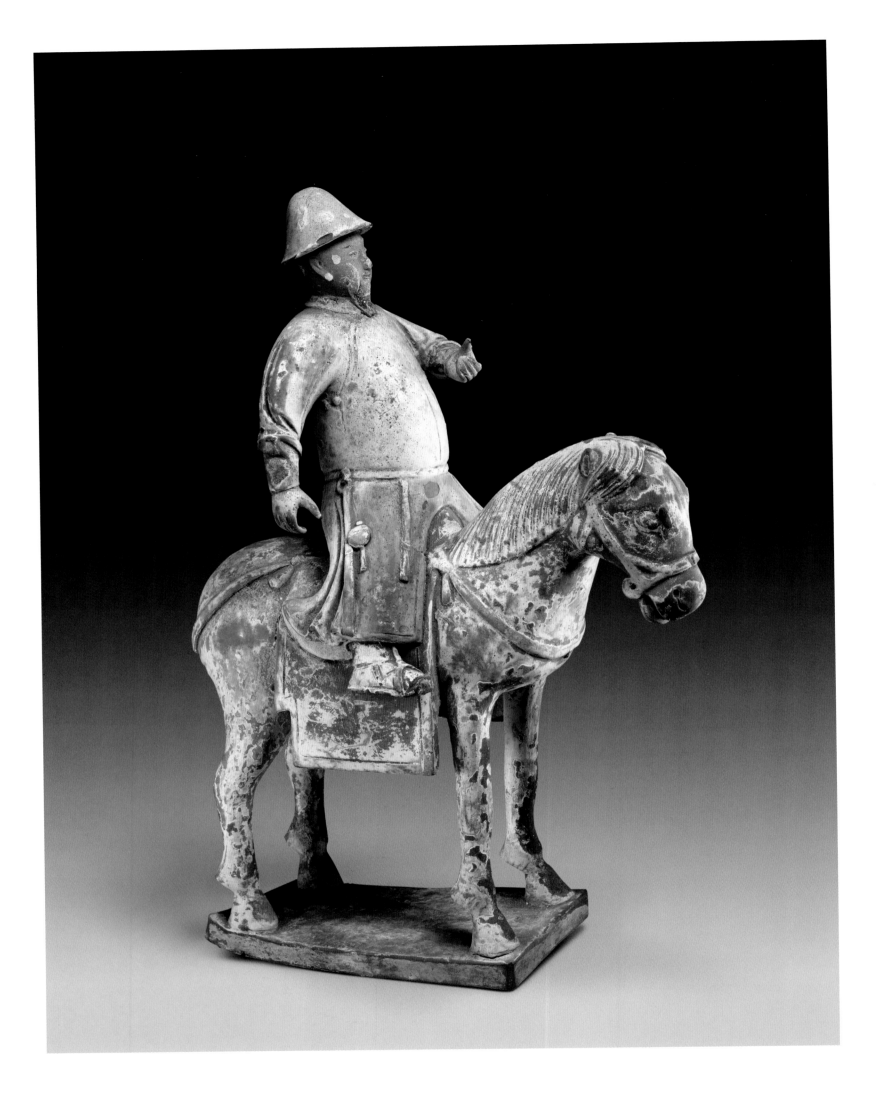

新118494
陶彩绘男骑俑
明

高41厘米 长27厘米

187

Xin 118494
Painted Pottery Figure of a Horseman
Ming Dynasty (1368-1644)
Height 41 cm
Length 27 cm

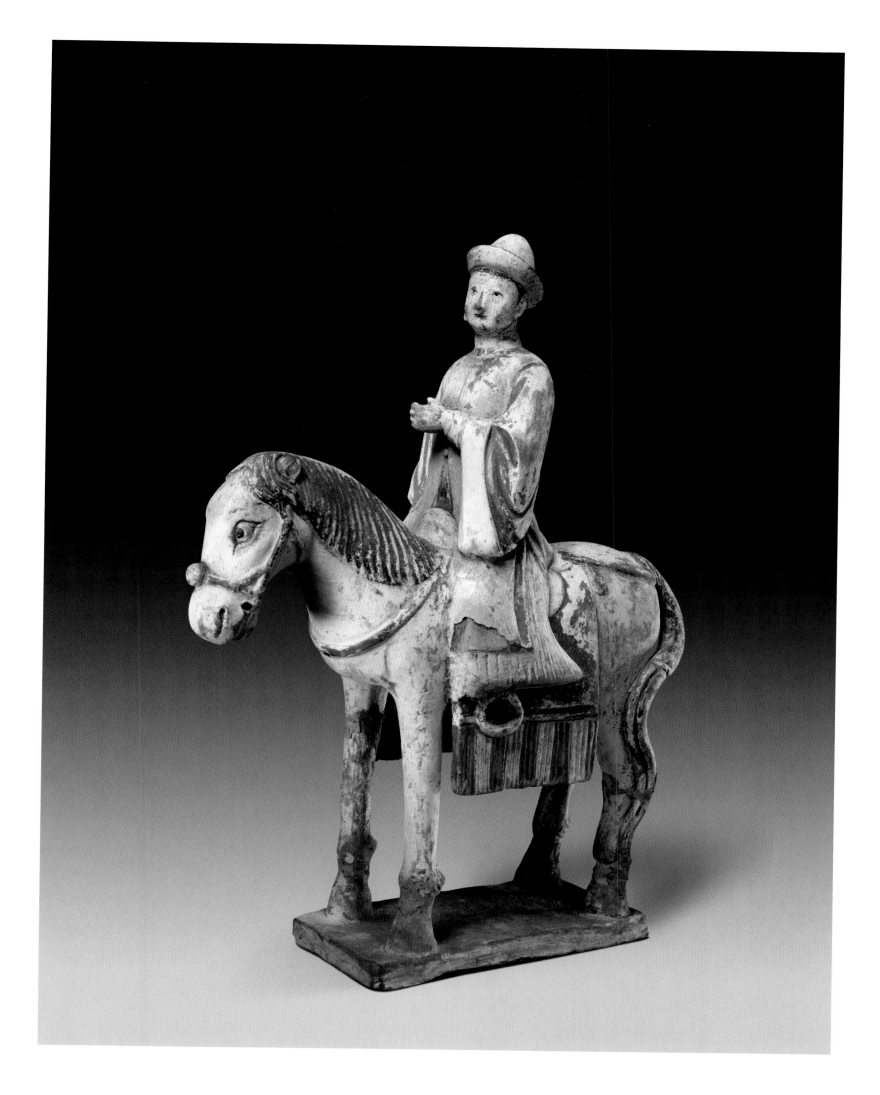

新105201
陶彩绘男骑俑
明

高36厘米 长24厘米

188

Xin 105201

Painted Pottery Figure of a Horseman
Ming Dynasty (1368-1644)
Height 36 cm
Length 24 cm

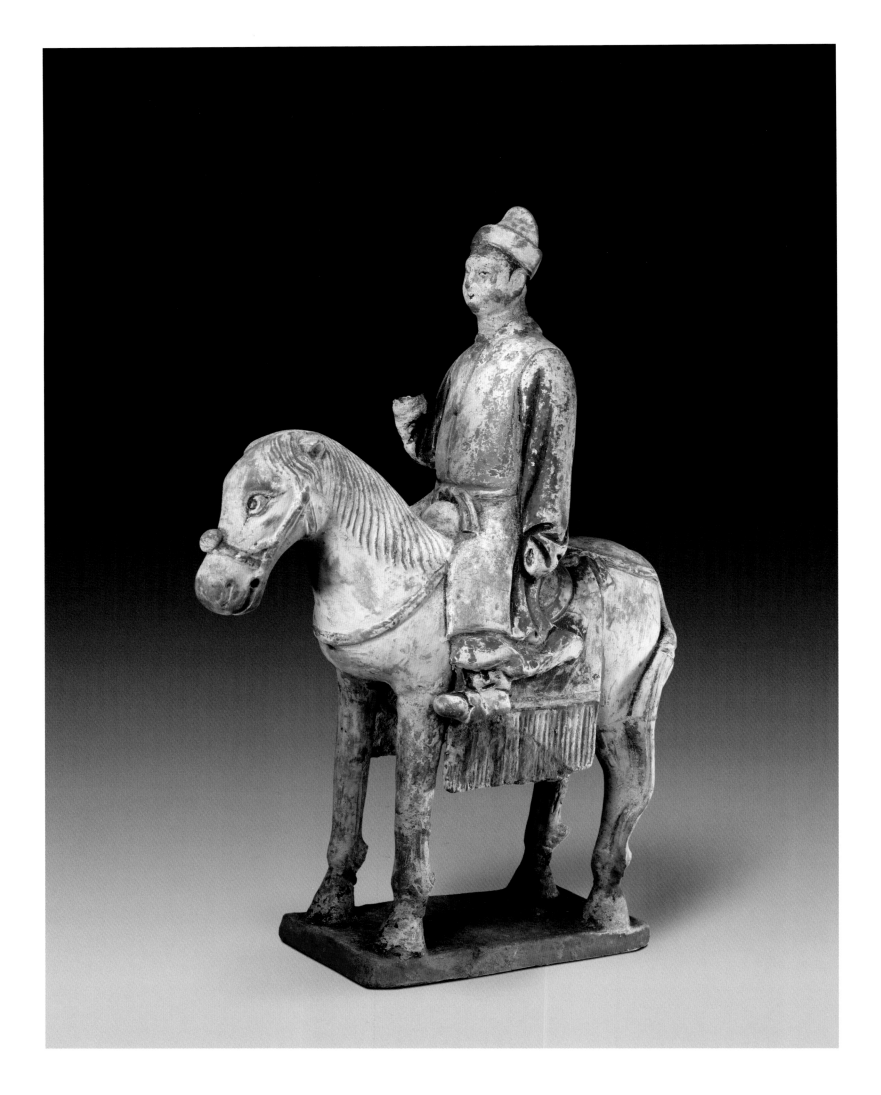

新105202

陶彩绘男骑俑

明

高37厘米　长24厘米

189 | Xin 105202
Painted Pottery Figure of a Horseman
Ming Dynasty (1368-1644)
Height 37 cm
Length 24 cm

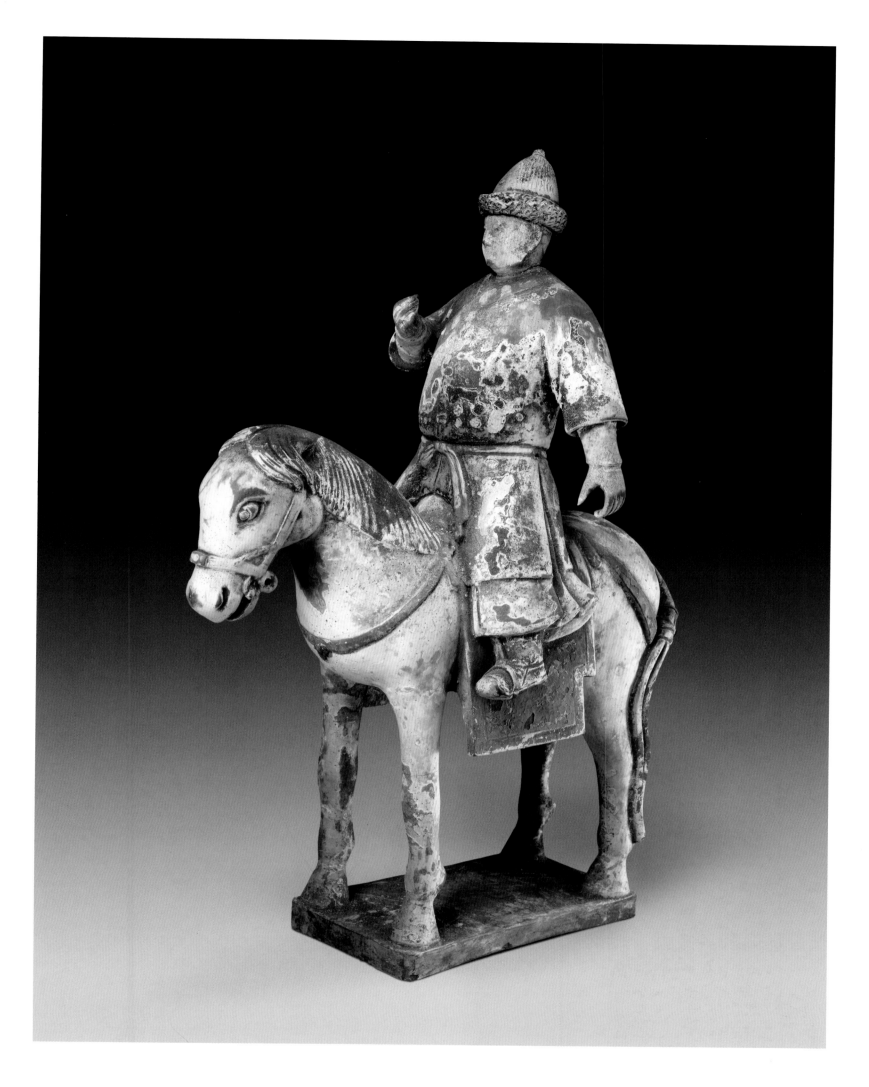

新118495
陶彩绘男骑俑
明

高43厘米　长30厘米

190
Xin 118495
Painted Pottery Figure of a Horseman
Ming Dynasty (1368-1644)
Height　43 cm
Length　30 cm

新118496

陶彩绘男骑俑

明

高43厘米　长34厘米

191

Xin 118496

Painted Pottery Figure of a Horseman
Ming Dynasty (1368-1644)

Height　43 cm
Length　34 cm

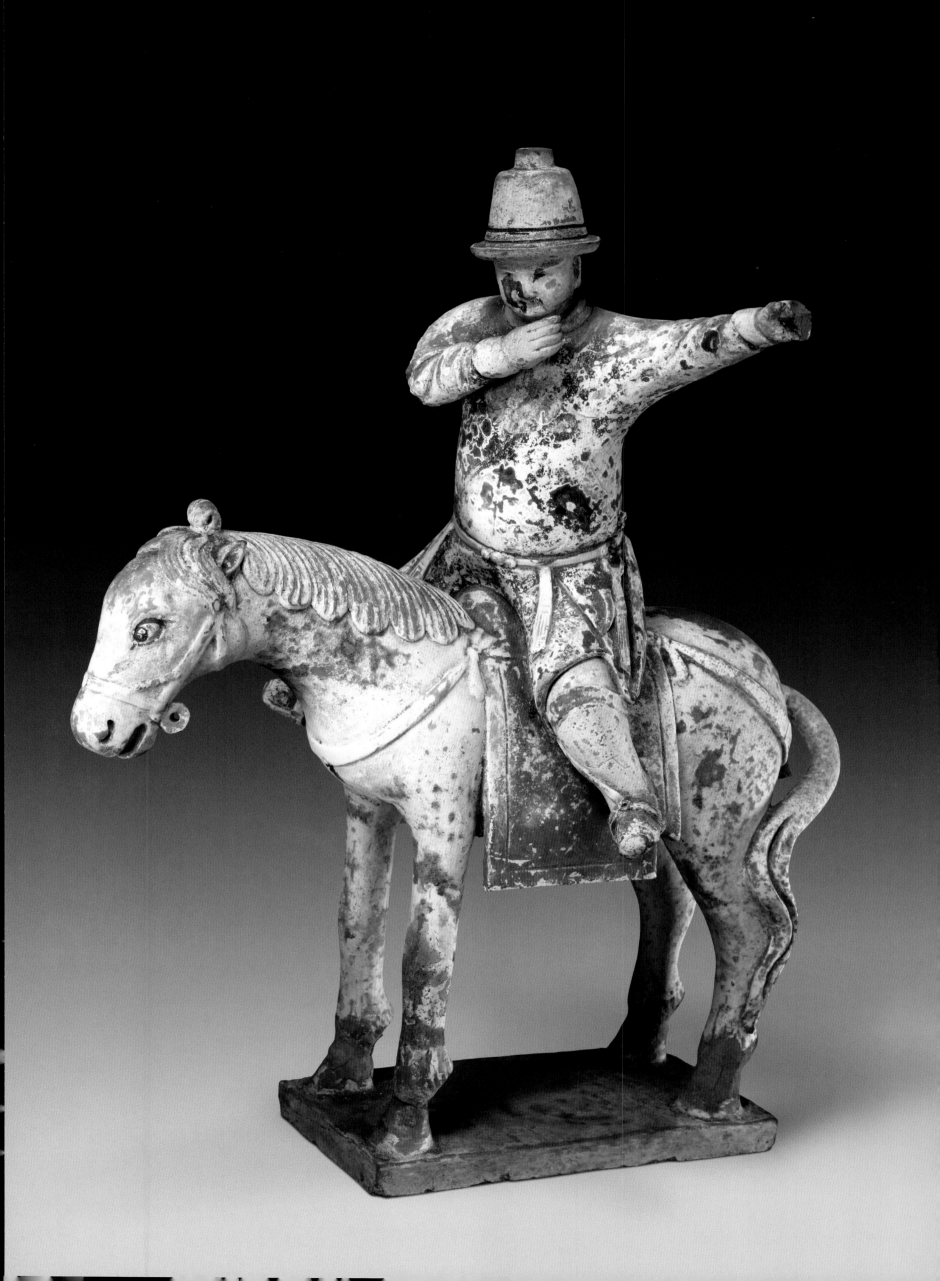

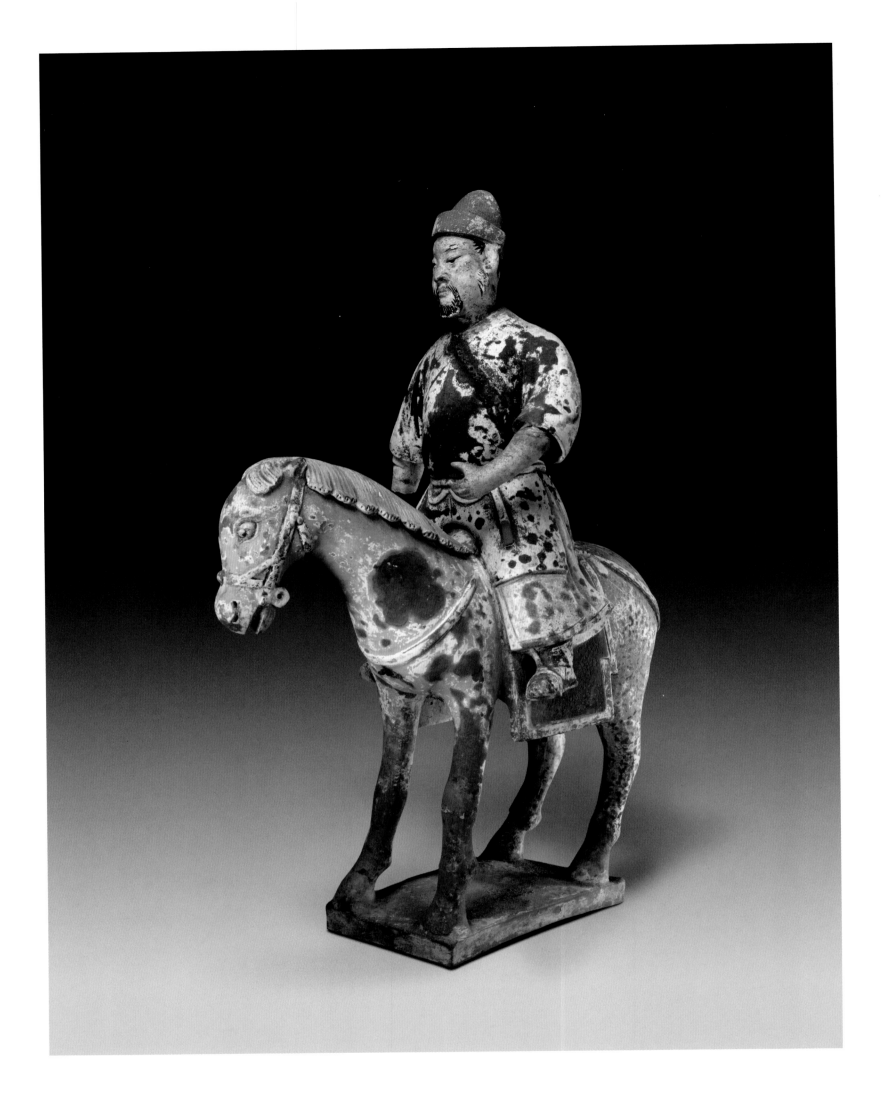

新51625

陶彩绘男骑俑

明

高43厘米　长30厘米

192

Xin 51625

Painted Pottery Figure of a Horseman

Ming Dynasty (1368-1644)

Height　43 cm

Length　30 cm

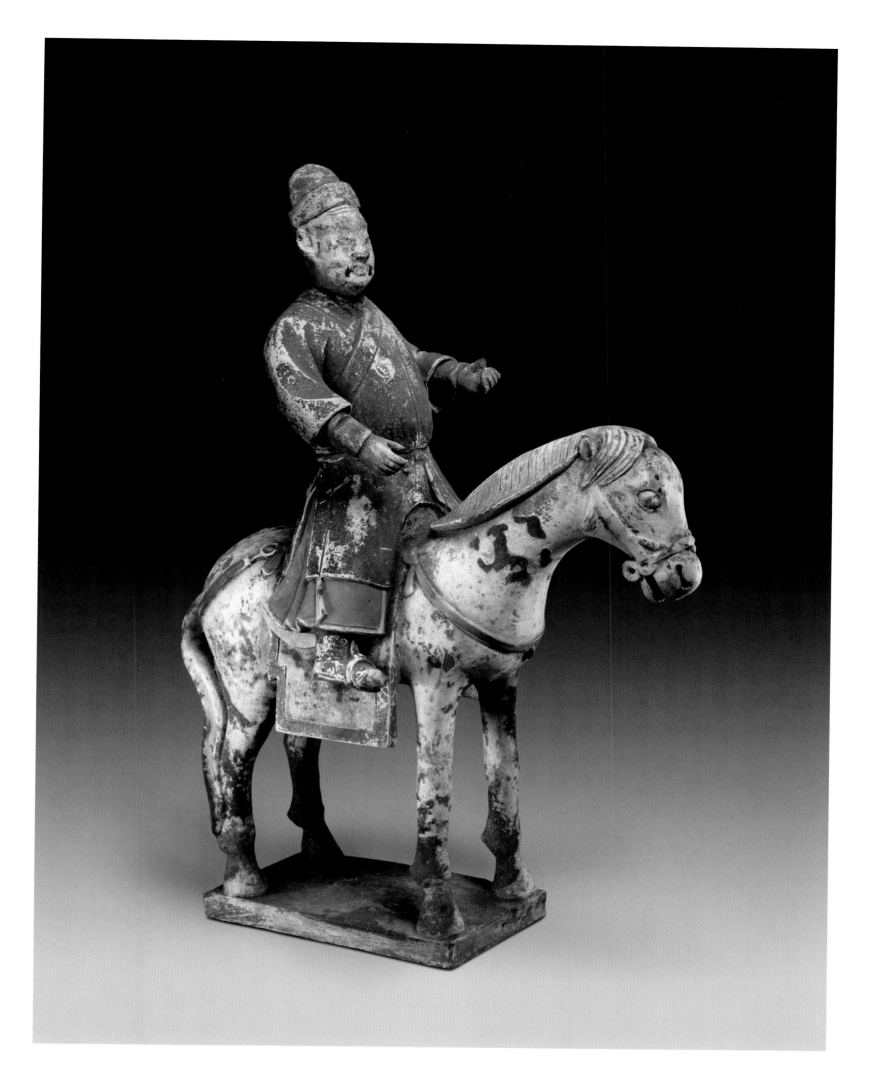

新51628
陶彩绘男骑俑
明

高44厘米 长30厘米

193

Xin 51628
Painted Pottery Figure of a Horseman
Ming Dynasty (1368-1644)
Height 44 cm
Length 30 cm

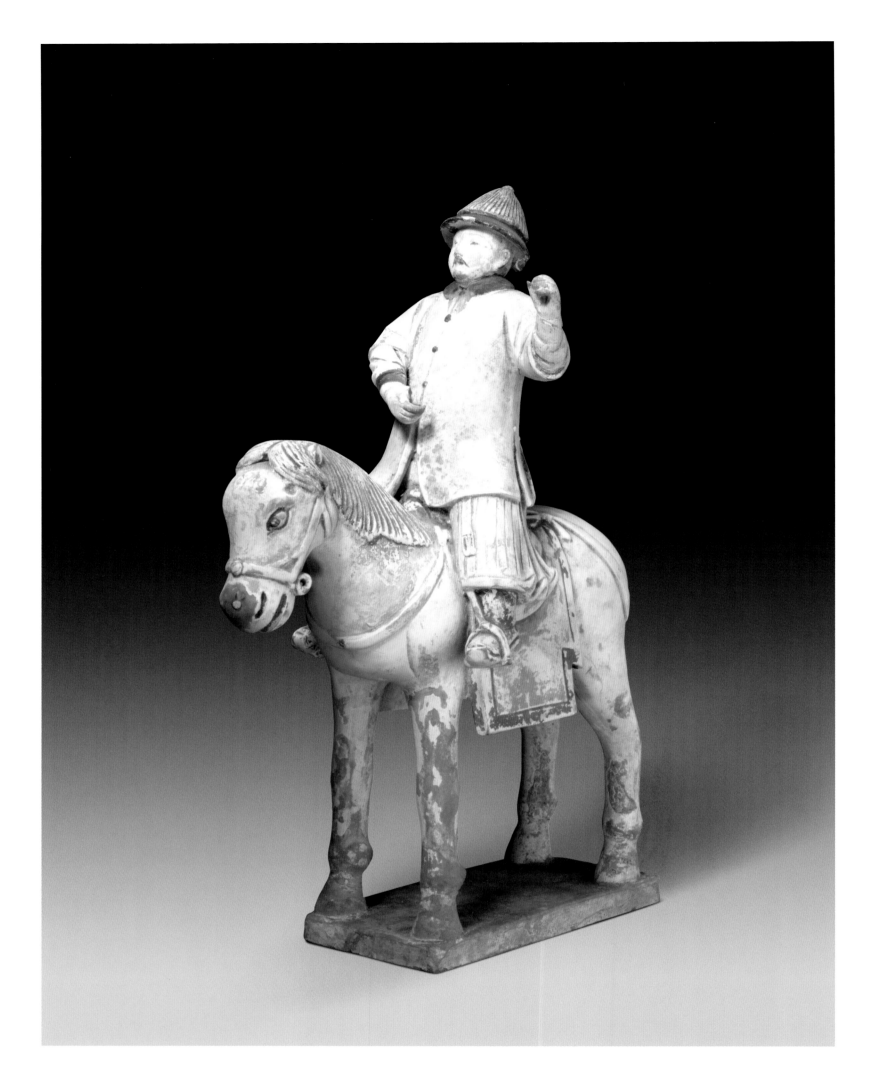

新118493

陶彩绘男骑俑

明

高42厘米　长30厘米

194 Xin 118493

Painted Pottery Figure of a Horseman
Ming Dynasty (1368-1644)
Height 42 cm
Length 30 cm

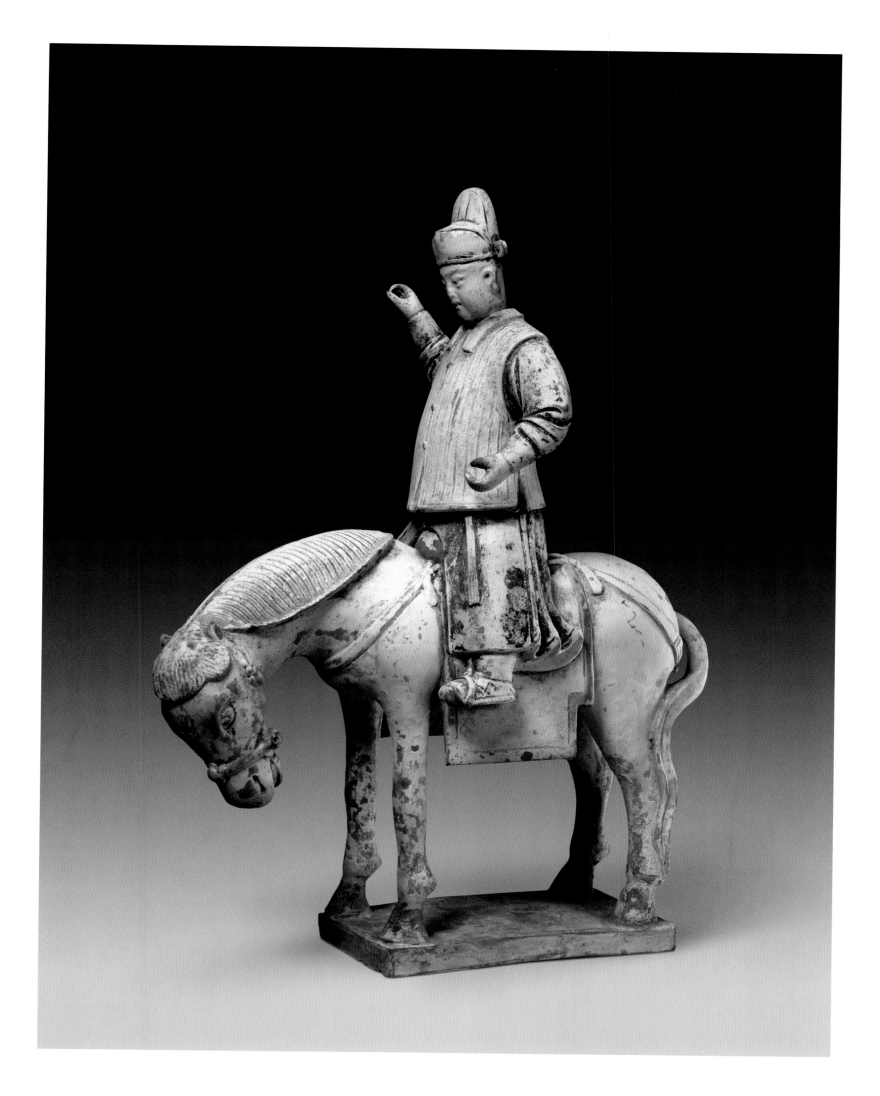

新51624
陶彩绘男骑俑
明

高42厘米 长32厘米

195

Xin 51624
Painted Pottery Figure of a Horseman
Ming Dynasty (1368-1644)
Height 42 cm
Length 32 cm

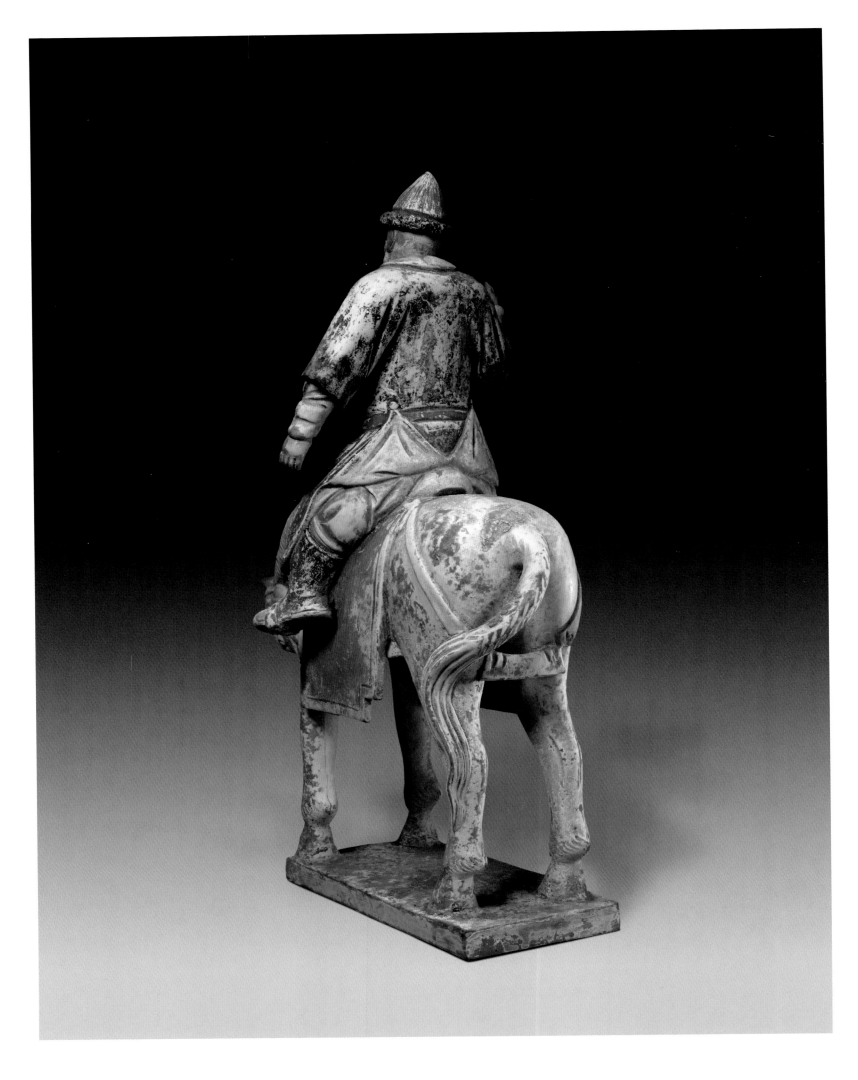

陶彩绘男骑俑（背面）
Painted Pottery Figure of a Horseman（back）

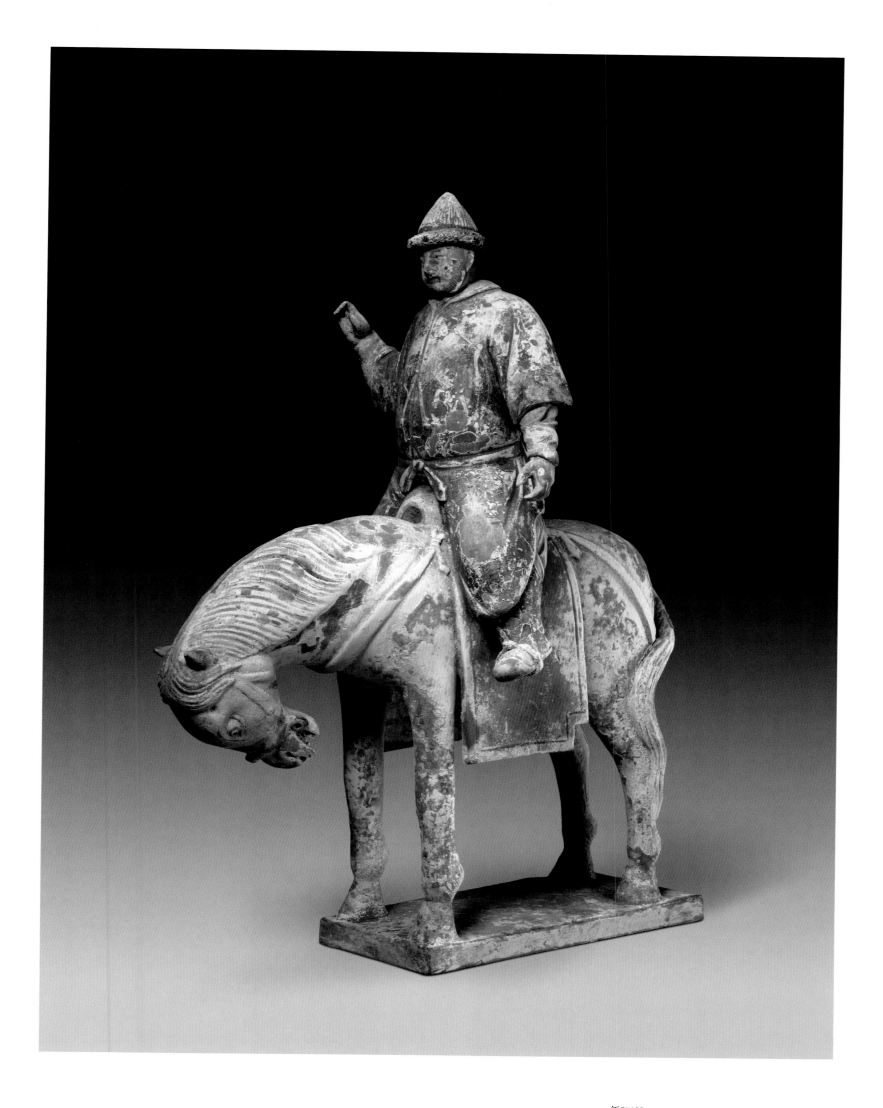

新51632
陶彩绘男骑俑
明

高42厘米 长30厘米

196

Xin 51632
Painted Pottery Figure of a Horseman
Ming Dynasty (1368-1644)
Height 42 cm
Length 30 cm

新51626

陶彩绘男骑俑

明

高46厘米　长28厘米

197

Xin 51626

Painted Pottery Figure of a Horseman

Ming Dynasty (1368-1644)

Height　46 cm

Length　28 cm

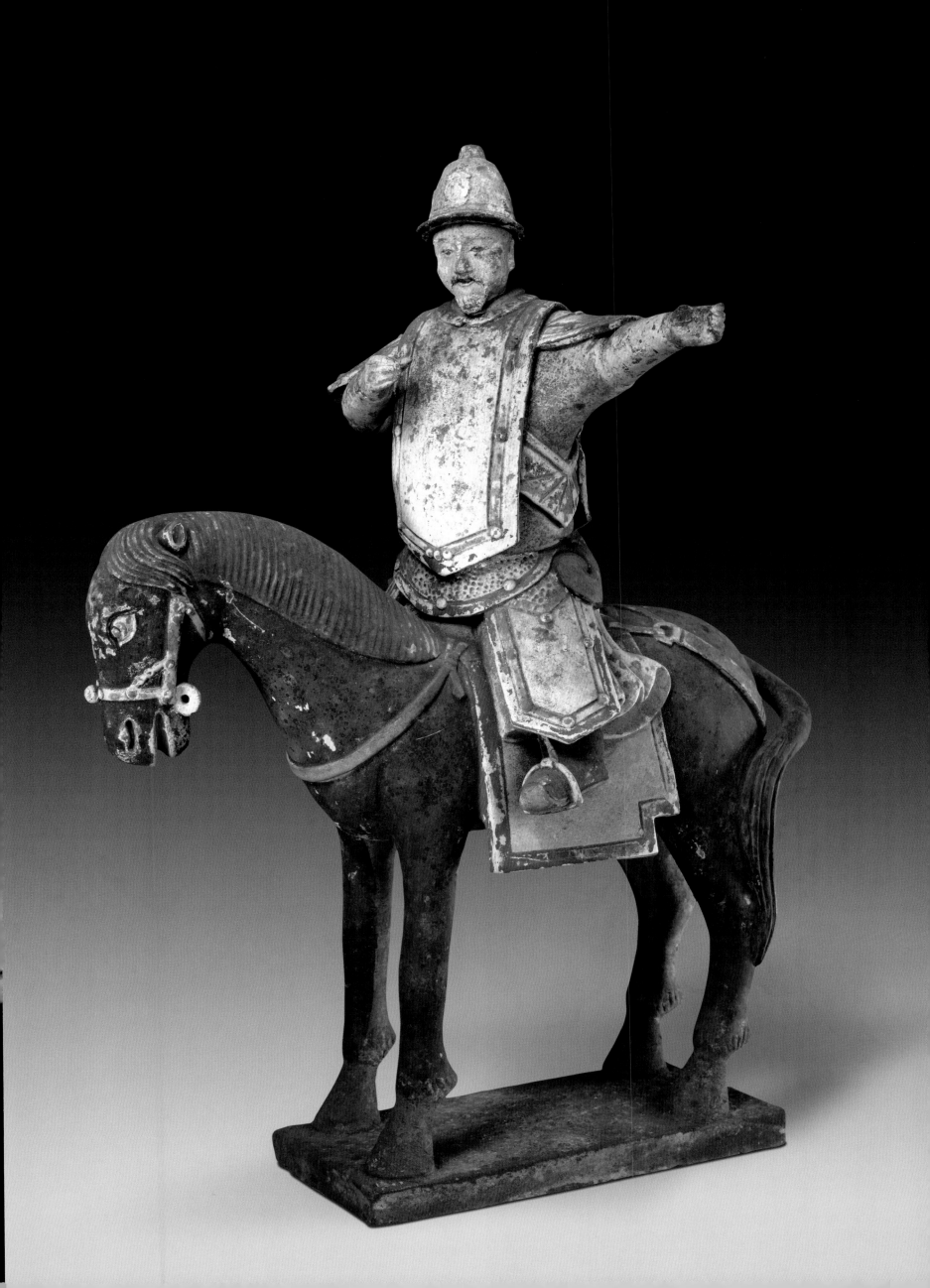

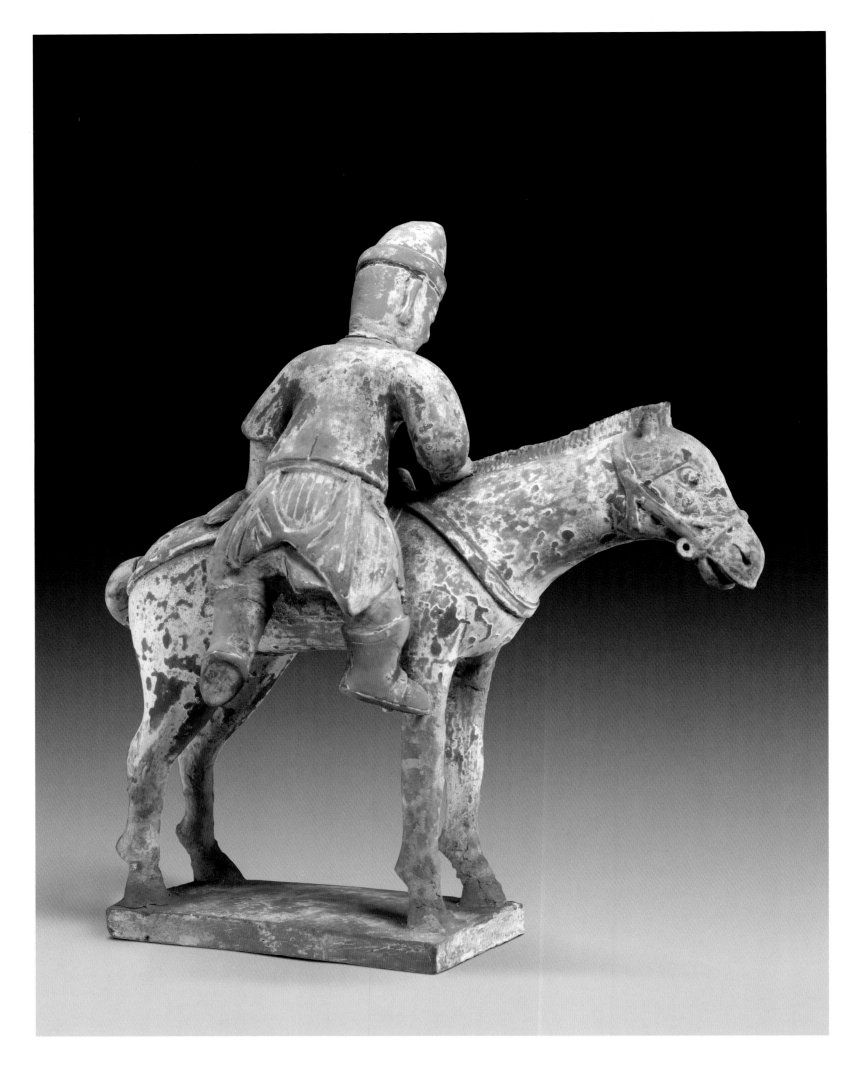

陶彩绘男骑俑（背面）
Painted Pottery Figure of a Horseman（back）

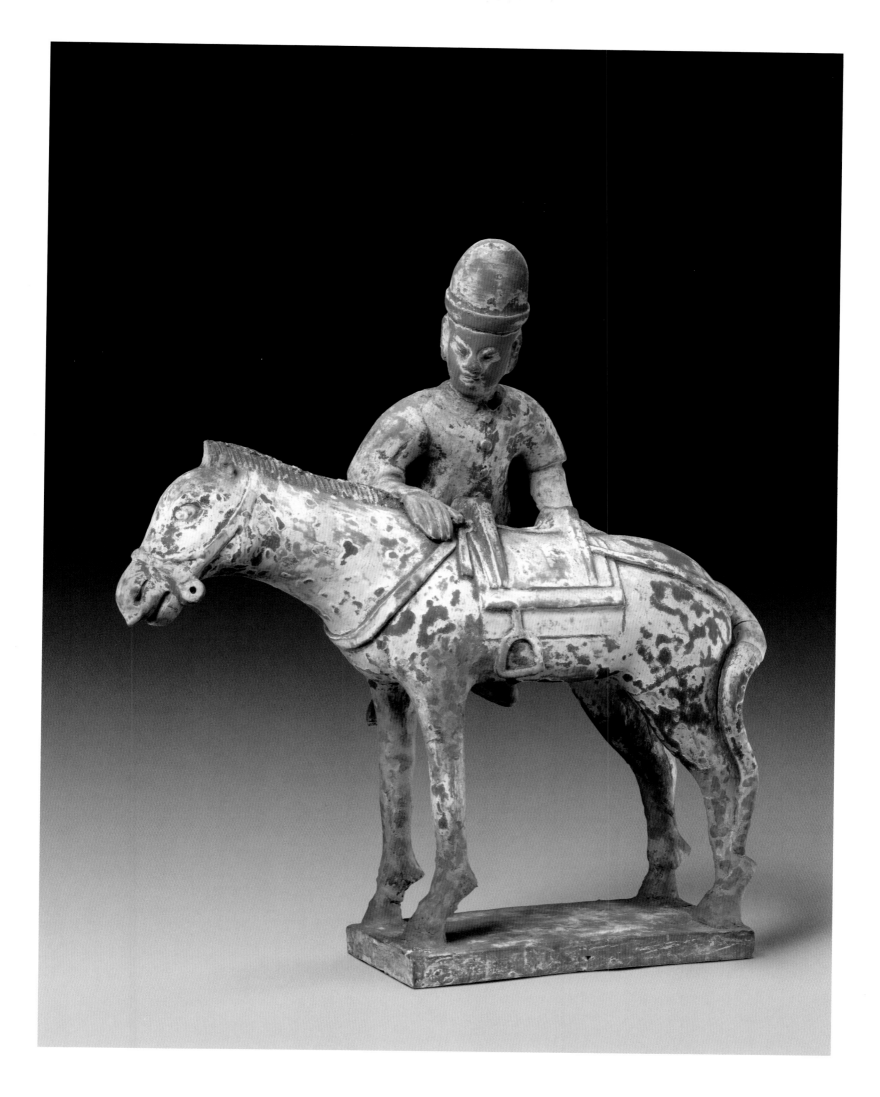

新156556
陶彩绘男骑俑
明

高39厘米 长35厘米

198

Xin 156556
Painted Pottery Figure of a Horseman
Ming Dynasty (1368-1644)
Height 39 cm
Length 35 cm

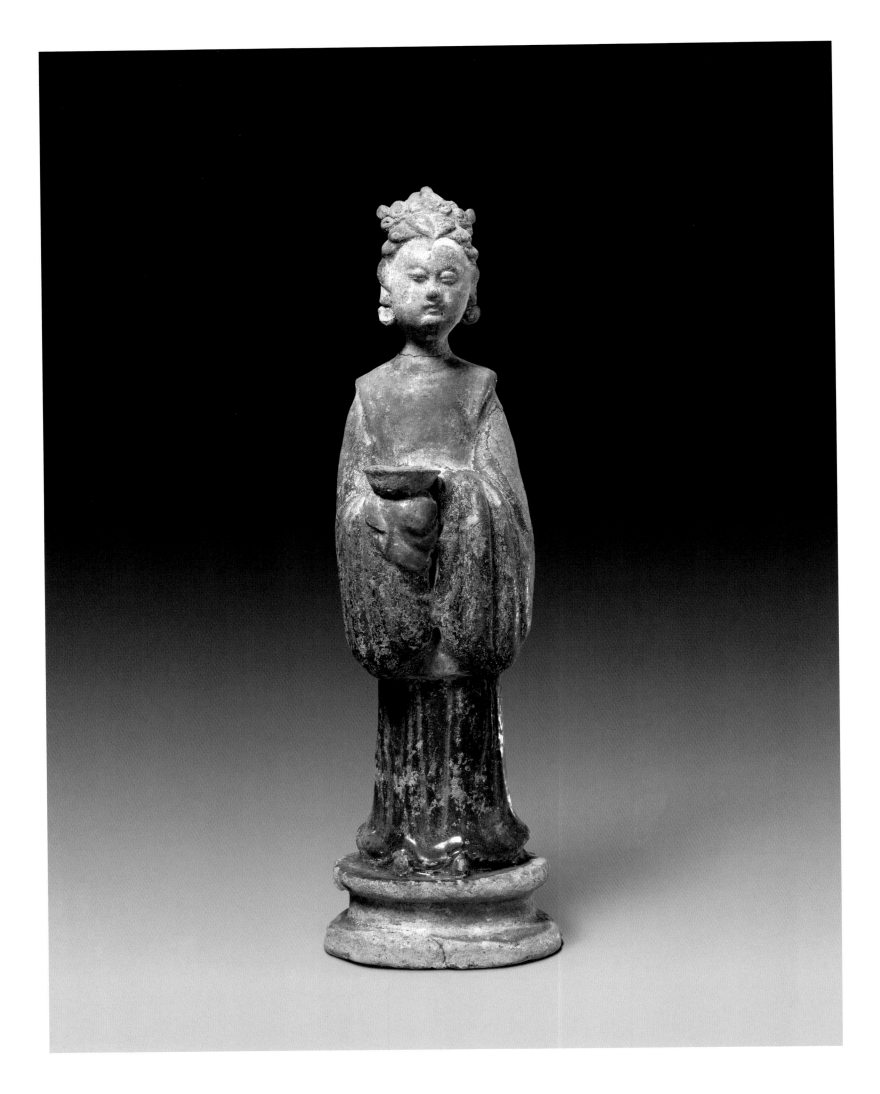

新112072
三彩女俑
明

高23厘米 底宽7厘米

199

Xin 112072
Tricolor Female Figure
Ming Dynasty (1368-1644)
Height 23 cm
Bottom width 7 cm

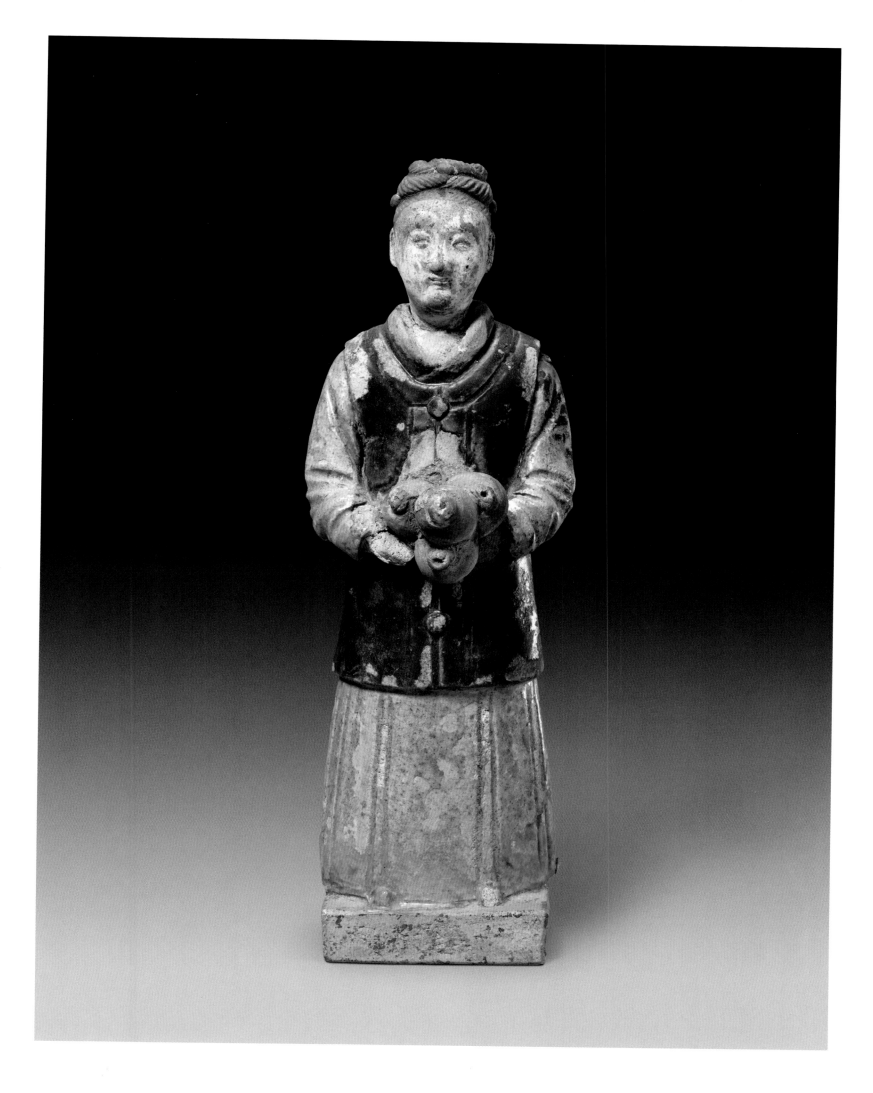

新135529

三彩女俑

明

高24厘米 底宽6.5厘米

200

Xin 135529

Tricolor Female Figure

Ming Dynasty (1368-1644)

Height 24 cm

Bottom width 6.5 cm

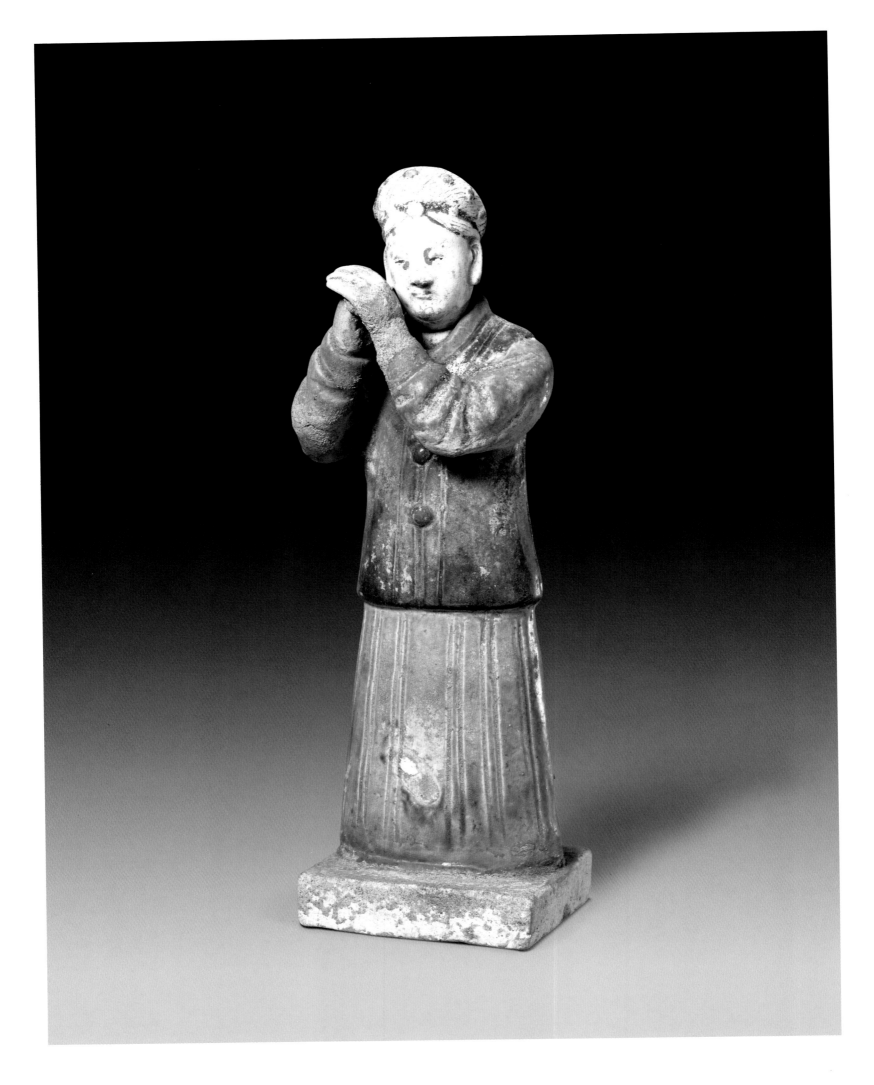

新105118
陶紫蓝釉女俑
明

高26.5厘米　底宽7.8厘米

201

Xin 105118
Purple-blue Glazed Pottery Female Figure
Ming Dynasty (1368-1644)
Height　26.5 cm
Bottom width　7.8 cm

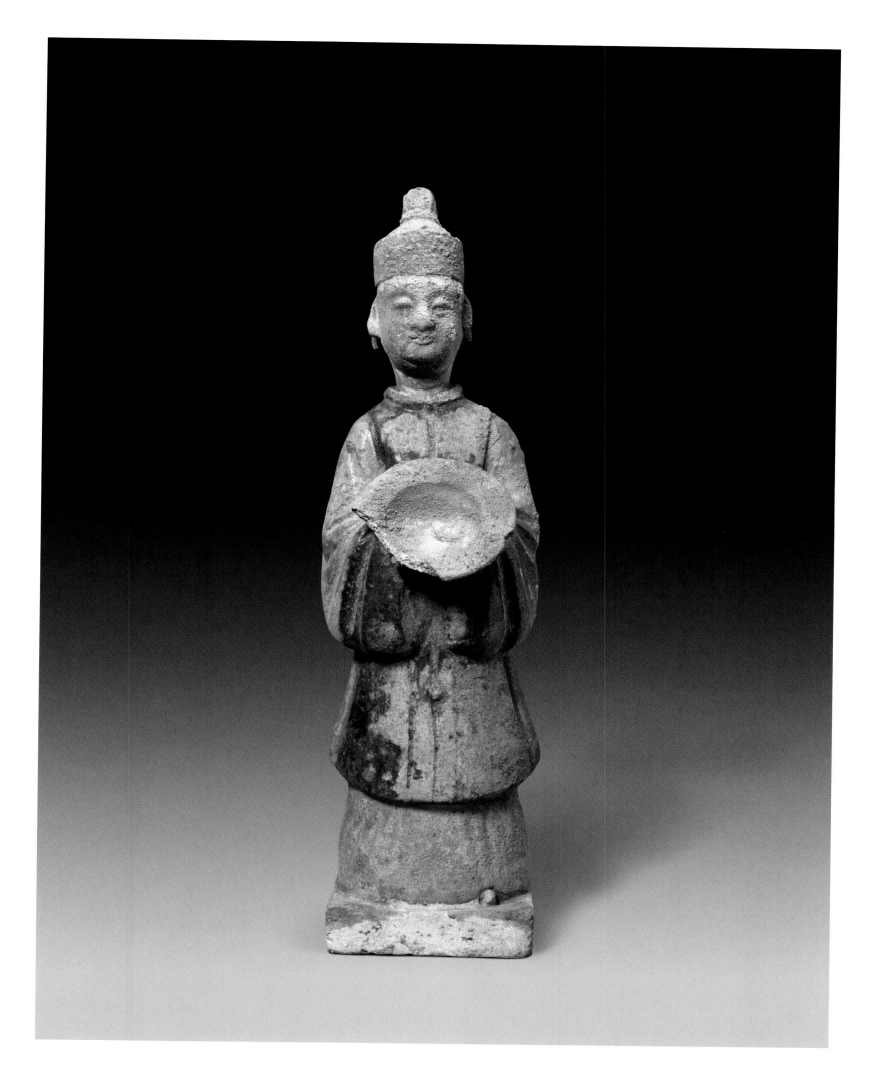

新43864

陶紫蓝釉女俑

明

高26厘米 底宽6.5厘米

202

Xin 43864

Purple-blue Glazed Pottery Female Figure

Ming Dynasty (1368-1644)

Height 26 cm

Bottom width 6.5 cm

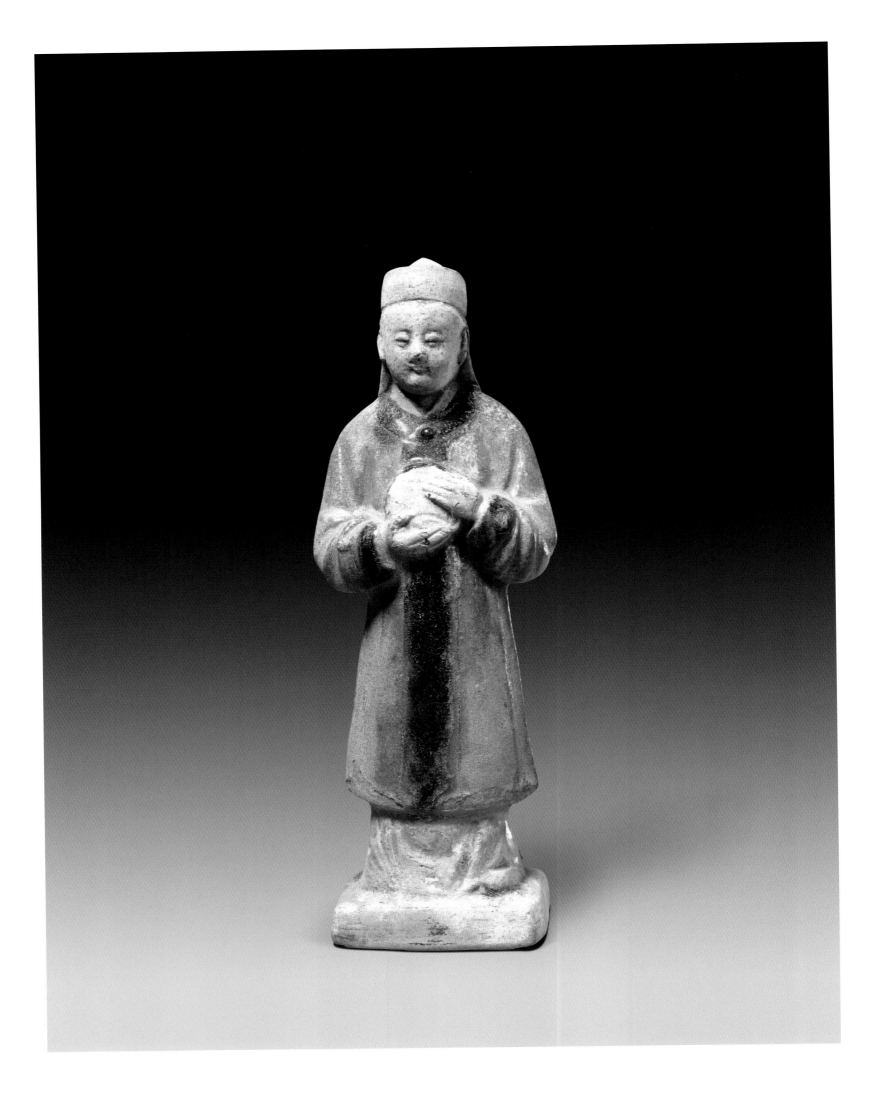

新43865

陶紫蓝釉女俑

明

高19厘米　底宽6厘米

203

Xin 43865

Purple-blue Glazed Pottery Female Figure

Ming Dynasty (1368-1644)

Height　19 cm

Bottom width　6 cm

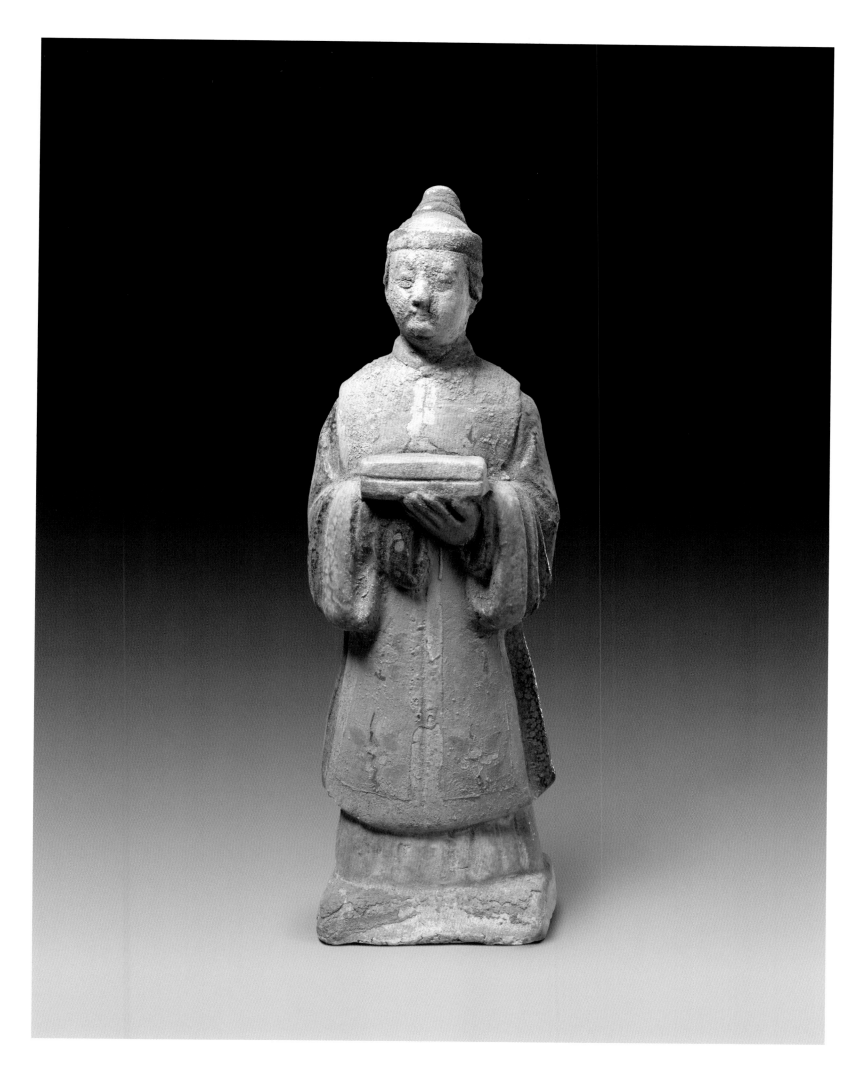

新43866

陶紫蓝釉女俑

明

高21厘米 底宽6厘米

204

Xin 43866

Purple-blue Glazed Pottery Female Figure
Ming Dynasty (1368-1644)
Height 21 cm
Bottom width 6 cm

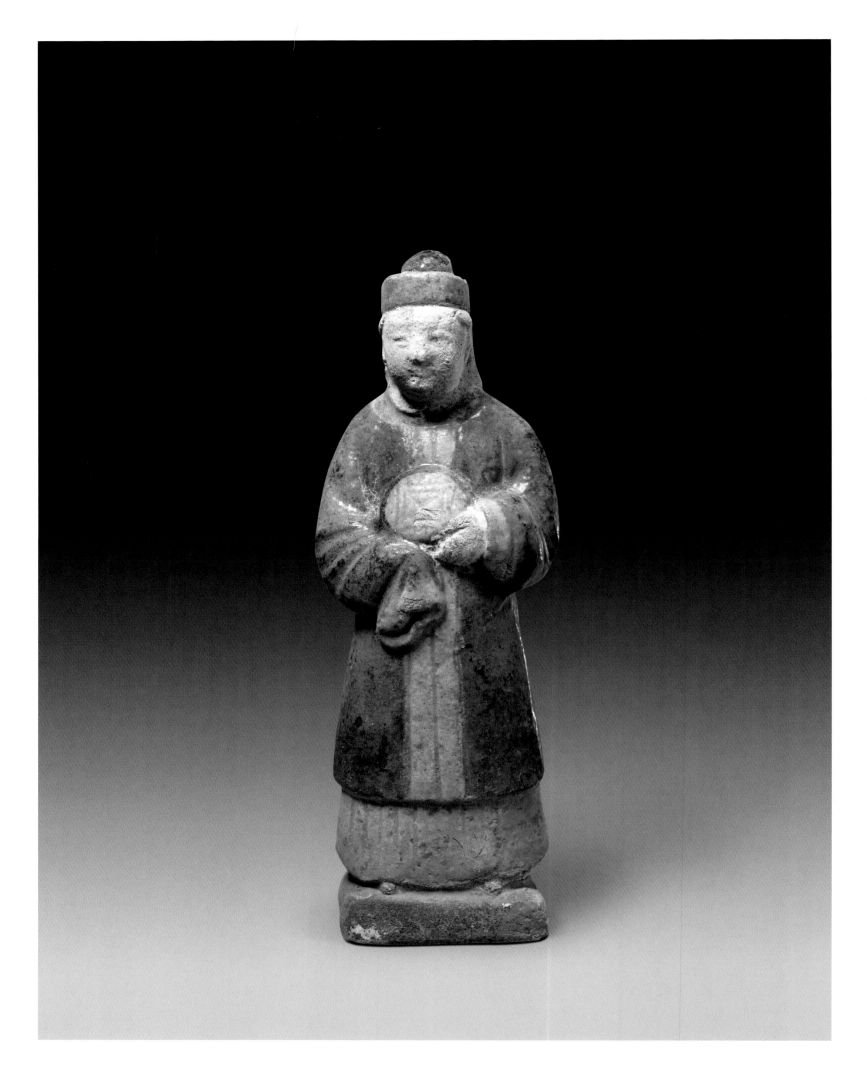

新43869

陶紫蓝釉女俑

明

高19厘米 底宽5.5厘米

205

Xin 43869

Purple-blue Glazed Pottery Female Figure

Ming Dynasty (1368-1644)

Height 19 cm

Bottom width 5.5 cm

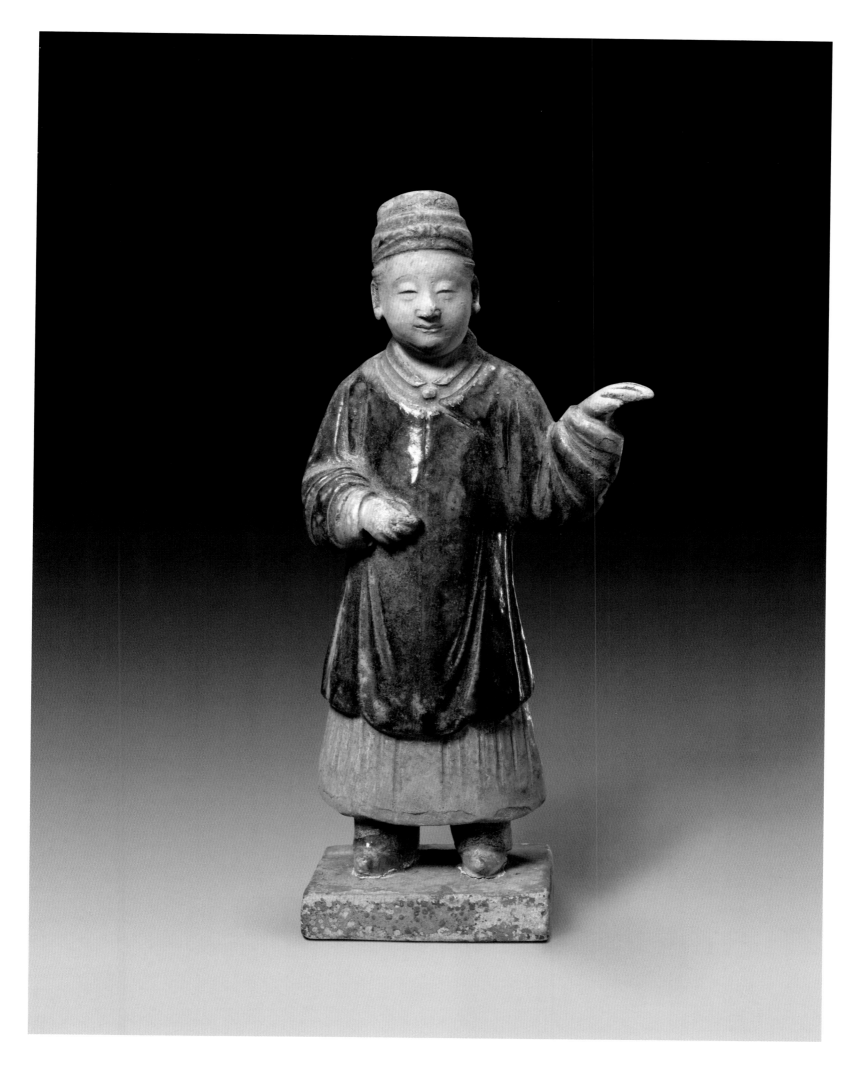

新43886
陶紫蓝釉女俑
明

高23厘米　底宽7.2厘米

206
Xin 43886
Purple-blue Glazed Pottery Female Figure
Ming Dynasty (1368-1644)
Height 23 cm
Bottom width 7.2 cm

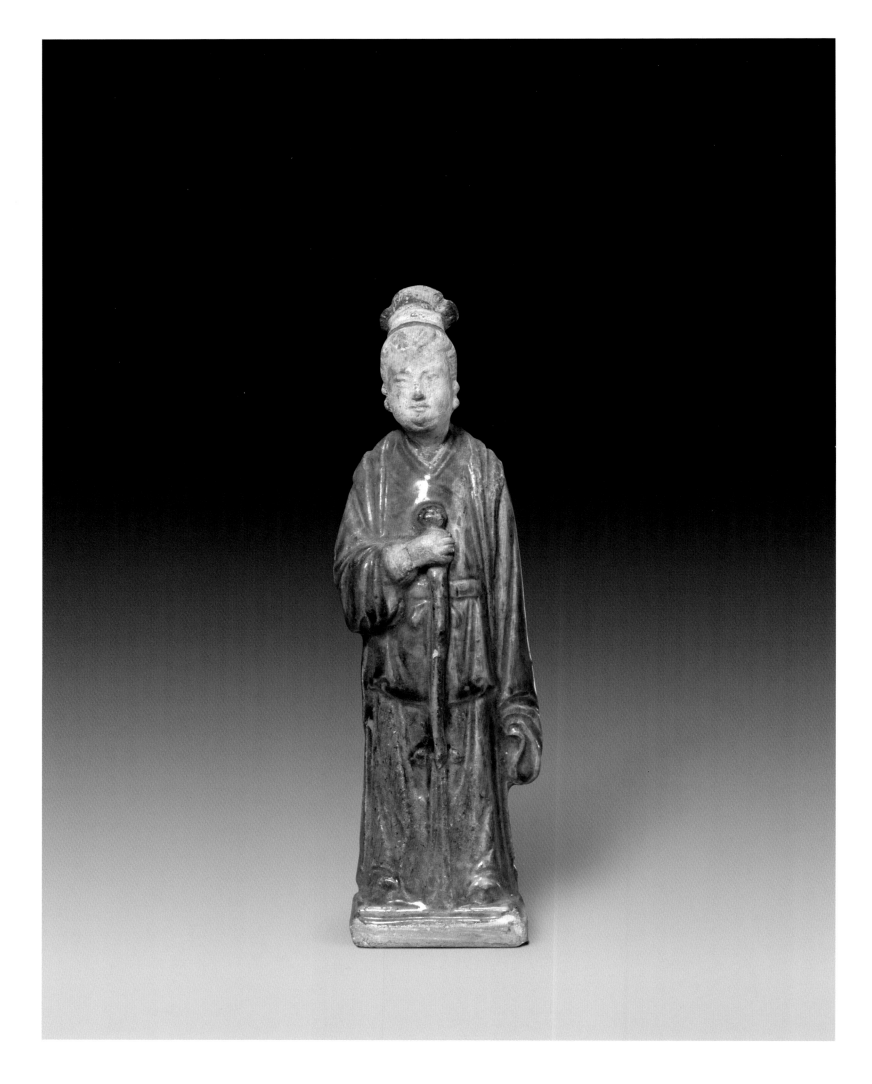

新73234

陶黄绿釉女俑

明

高18厘米 底宽5厘米

207 | Xin 73234

Yellow-green Glazed Pottery Female Figure

Ming Dynasty (1368-1644)

Height 18 cm

Bottom width 5 cm

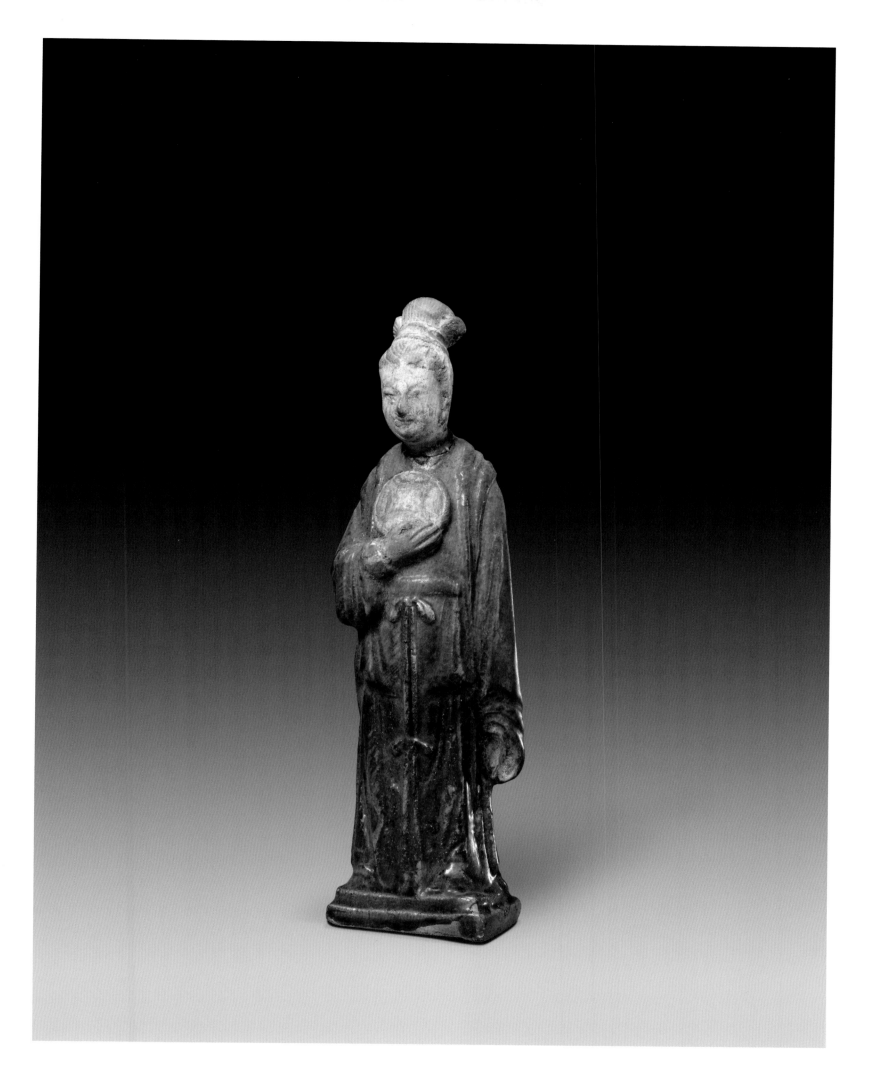

新73235
陶黄绿釉女俑
明

高18厘米　底宽4.5厘米

208

Xin 73235
Yellow-green Glazed Pottery Female Figure
Ming Dynasty (1368-1644)
Height 18 cm
Bottom width 4.5 cm

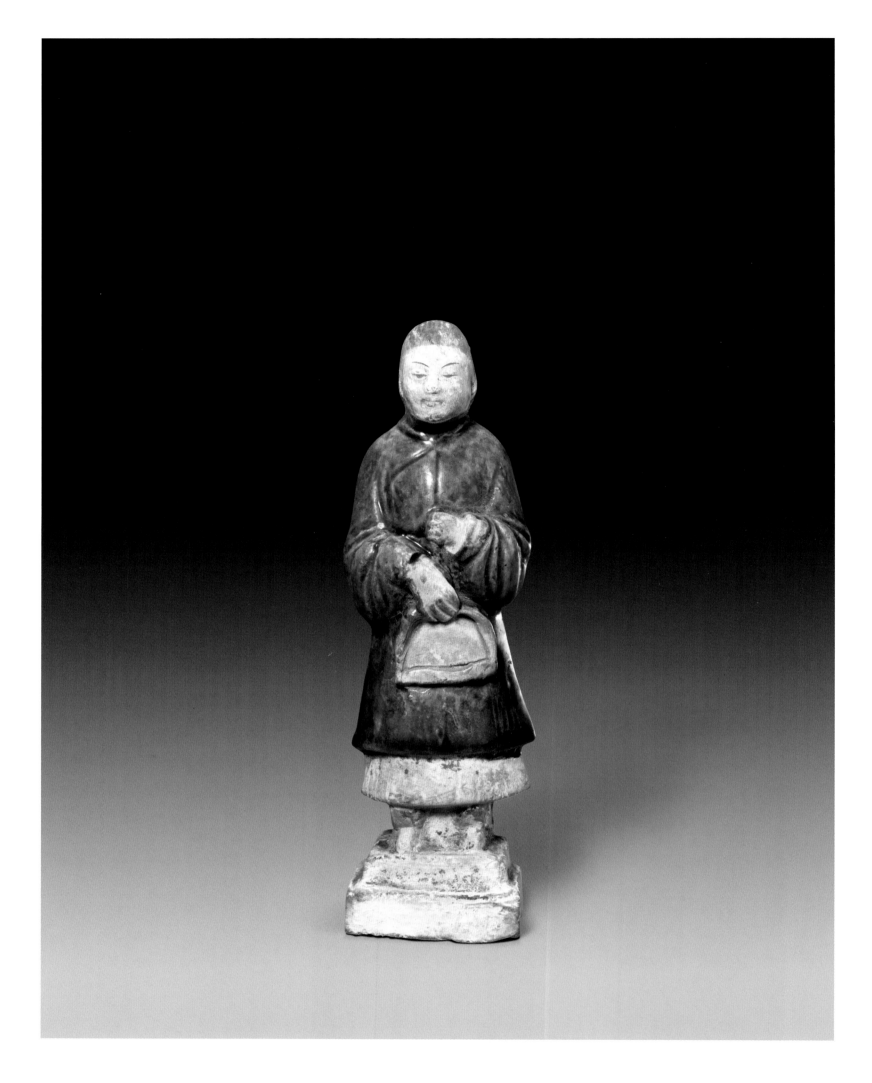

新103729

陶绿釉女俑

明

高17厘米 底宽4.7厘米

209

Xin 103729

Green Glazed Pottery Female Figure

Ming Dynasty (1368-1644)

Height 17 cm

Bottom width 4.7 cm

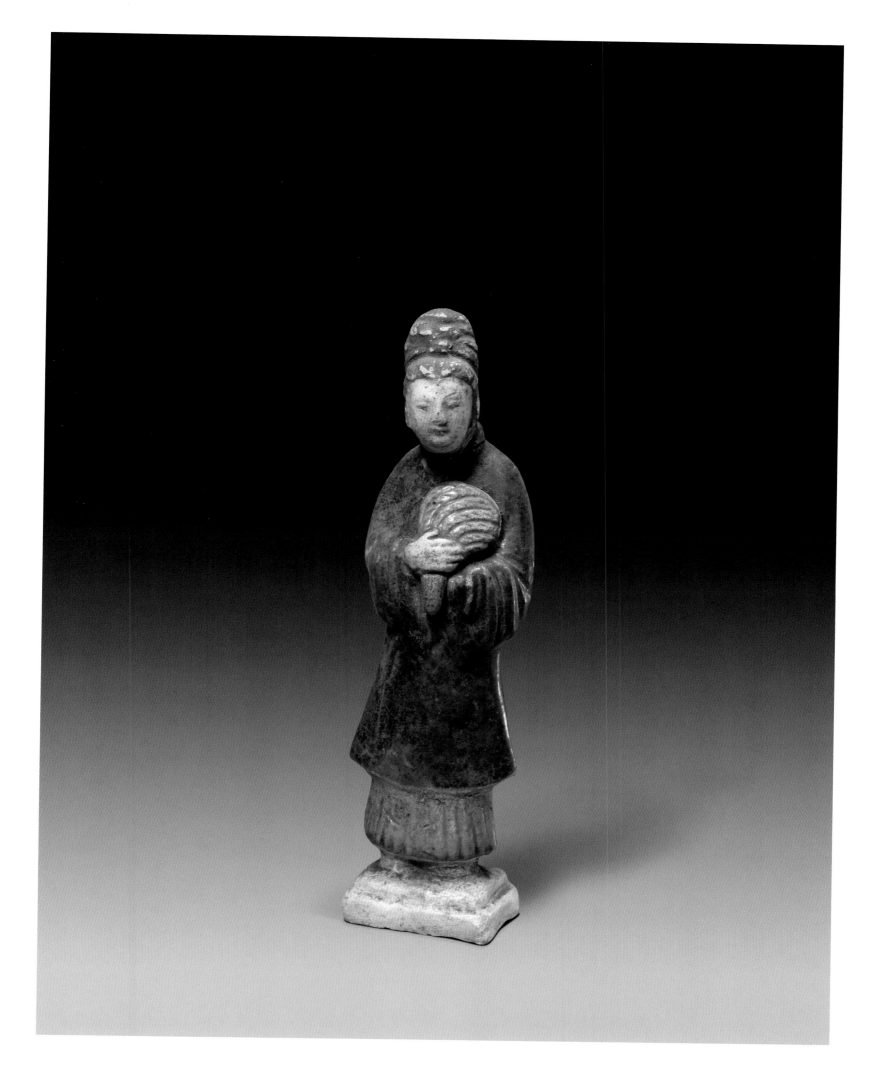

新103730

陶黄绿釉女俑

明

高17.5厘米 底宽4.3厘米

210

Xin 103730

Yellow-green Glazed Pottery Female Figure

Ming Dynasty (1368-1644)

Height 17.5 cm

Bottom width 4.3 cm

新115272

陶绿釉女俑

明

高41厘米　底宽11厘米

211

Xin 115272

Green Glazed Pottery Female Figure

Ming Dynasty (1368-1644)

Height　41 cm

Bottom width　11 cm

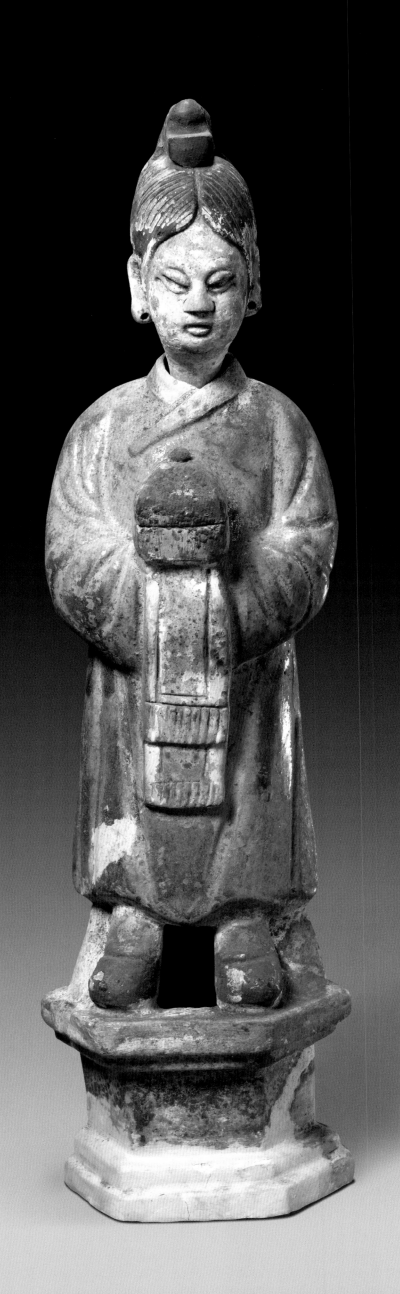

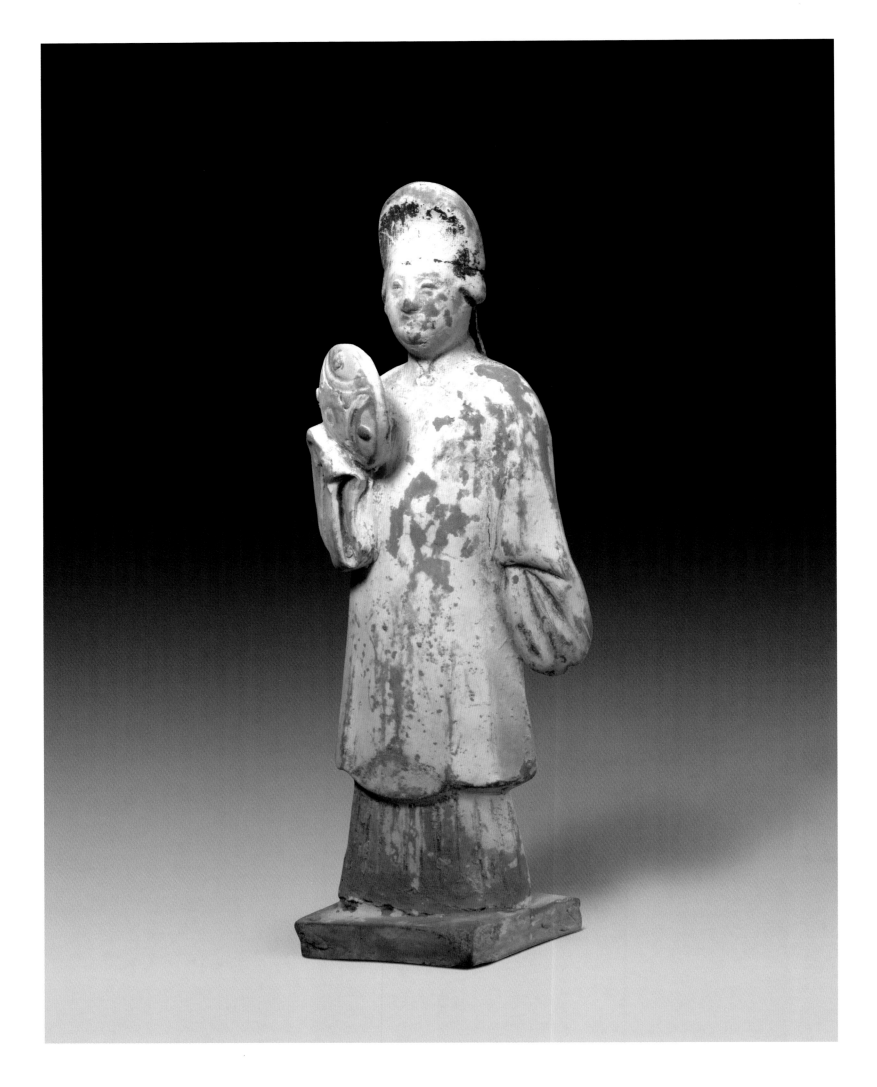

新43838

陶彩绘女俑

明

高23厘米 底宽6.5厘米

212

Xin 43838

Painted Pottery Female Figure

Ming Dynasty (1368-1644)

Height 23 cm

Bottom width 6.5 cm

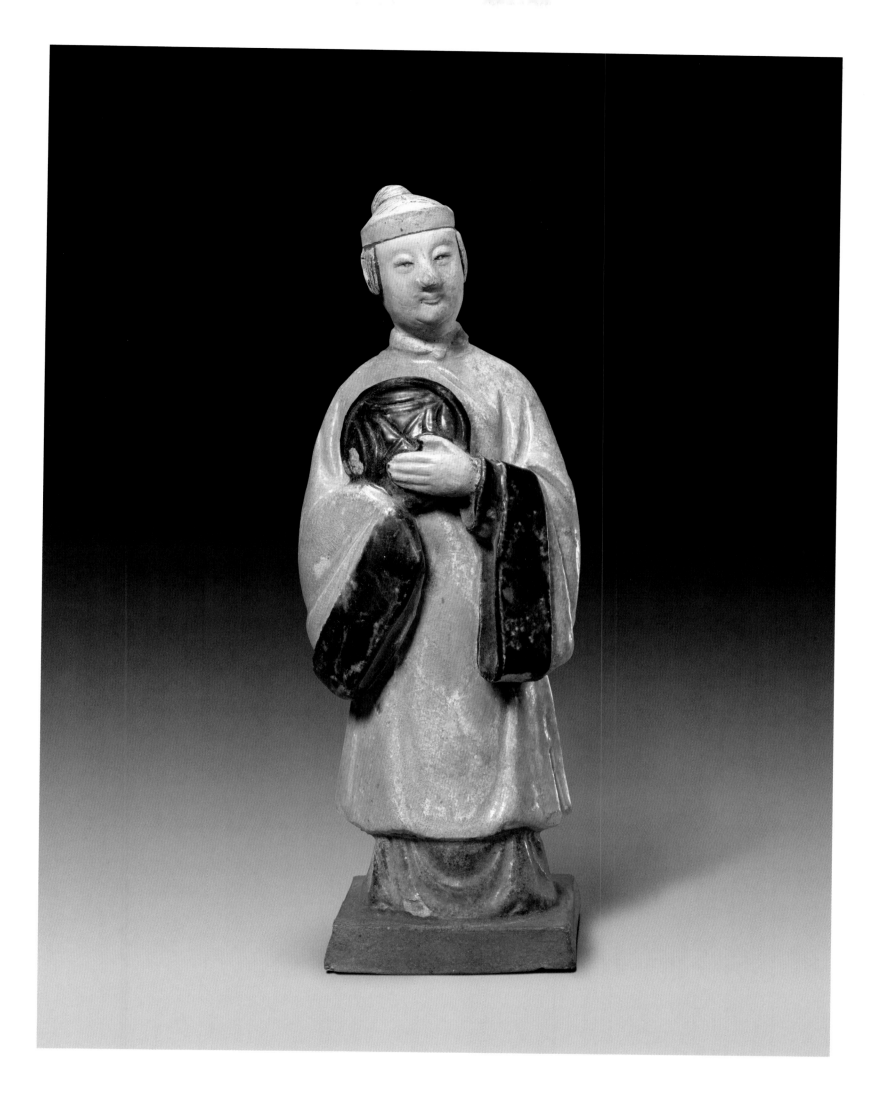

新105117

陶紫蓝釉女俑

明

高23厘米 底宽6.8厘米

213

Xin 105117

Purple-blue Glazed Pottery Female Figure

Ming Dynasty (1368-1644)

Height 23 cm
Bottom width 6.8 cm

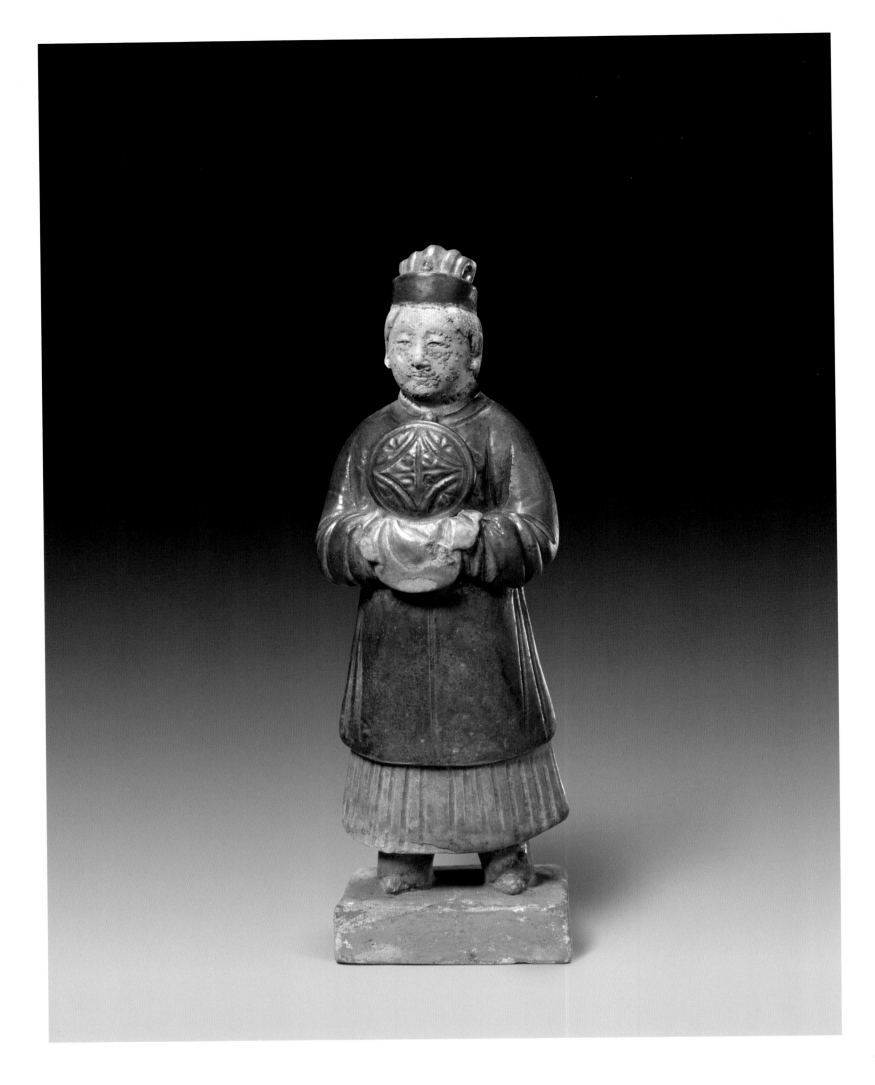

新43868

陶紫蓝釉女俑

明

高23厘米 底宽7厘米

214

Xin 43868

Purple-blue Glazed Pottery Female Figure

Ming Dynasty (1368-1644)

Height 23 cm

Bottom width 7 cm

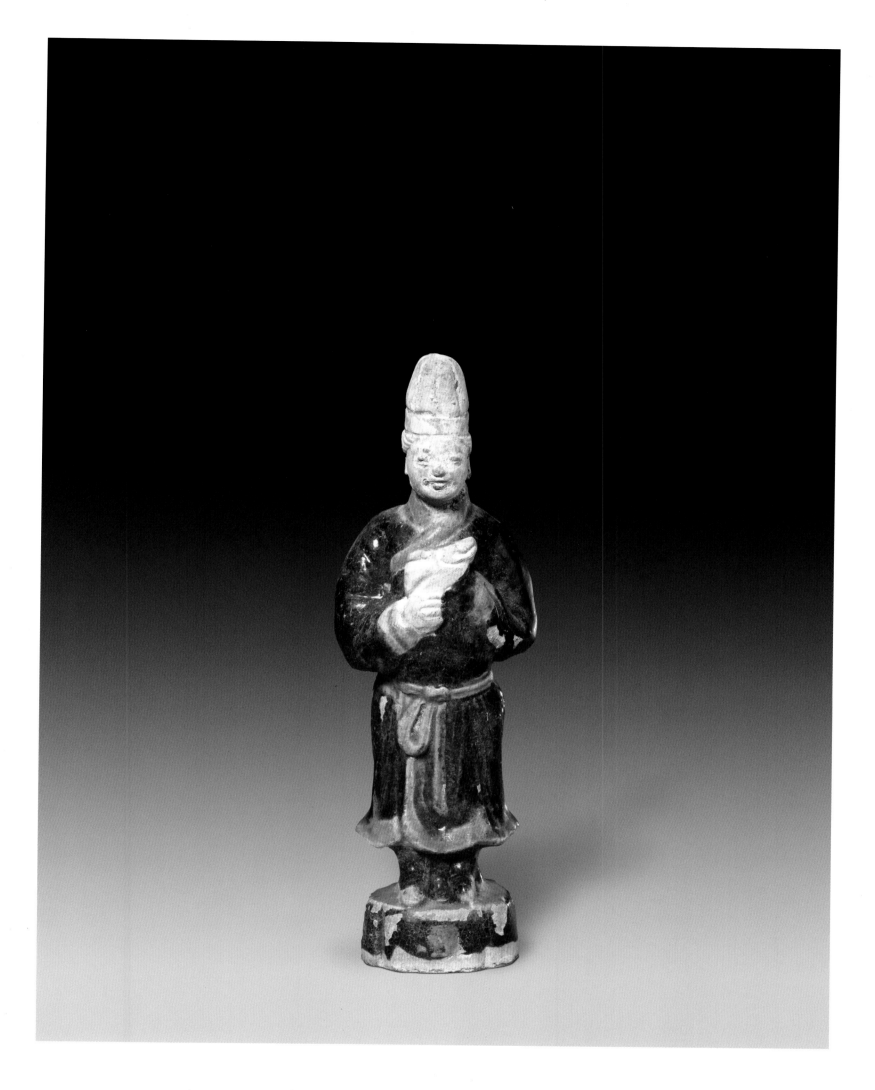

新128203
陶紫绿釉女俑
明

高17厘米 底宽4.3厘米

215

Xin 128203
Purple-green Glazed Pottery Female Figure
Ming Dynasty (1368-1644)
Height 17 cm
Bottom width 4.3 cm

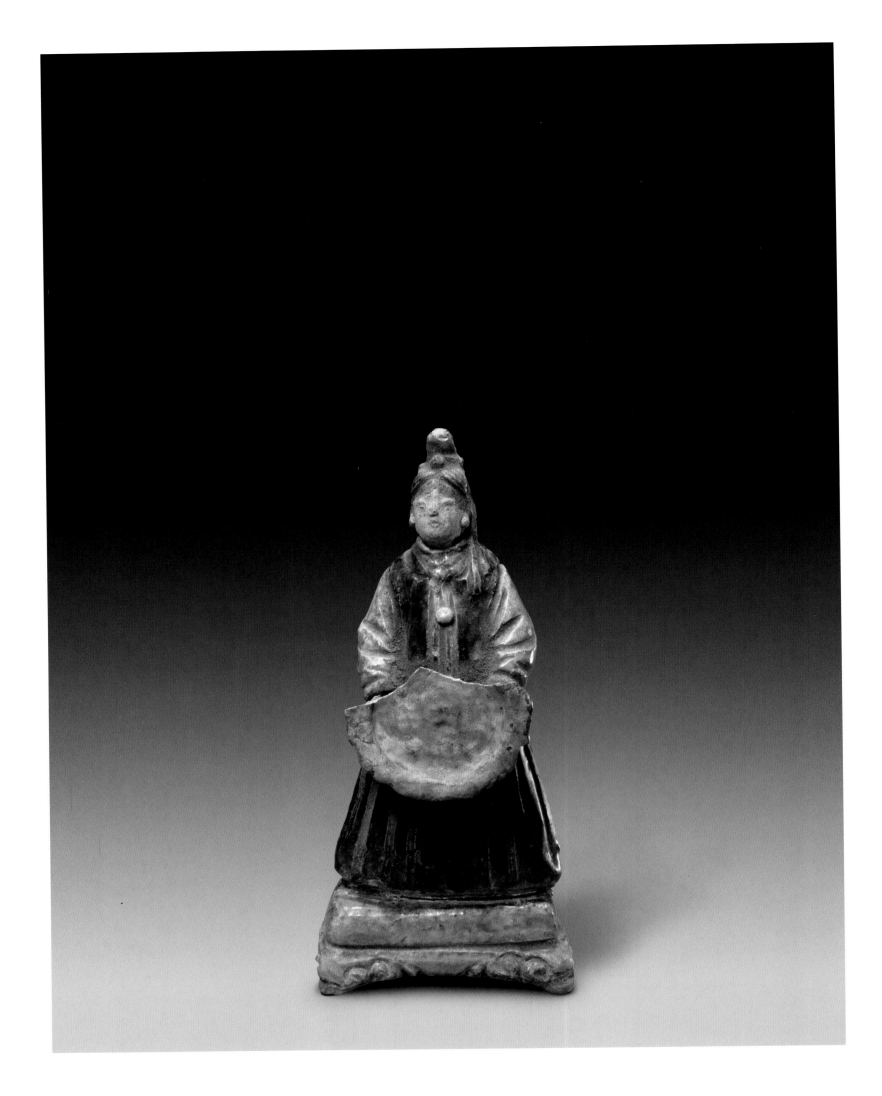

新143244

陶紫蓝釉女俑

明

高15.5厘米　底宽7厘米

216

Xin 143244

Purple-blue Glazed Pottery Female Figure

Ming Dynasty (1368-1644)

Height　15.5 cm

Bottom width　7 cm

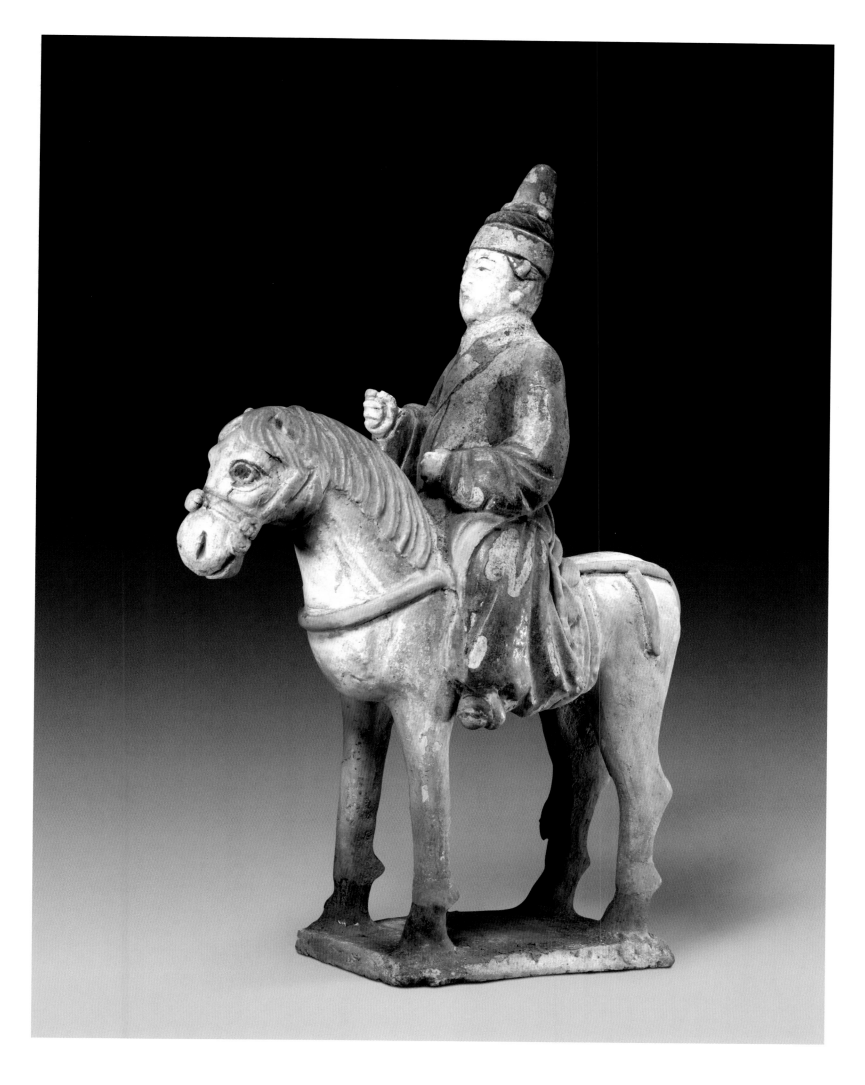

新43851
陶紫绿釉女骑俑
明

高33厘米 长22厘米

217

Xin 43851

Purple-green Glazed Pottery Female Figure on Horse
Ming Dynasty (1368-1644)
Height 33 cm
Length 22 cm

新105197

陶彩绘女骑俑

明

高37厘米 长21厘米

218

Xin 105197

Painted Pottery Female Figure on Horse

Ming Dynasty (1368-1644)

Height 37 cm

Length 21 cm

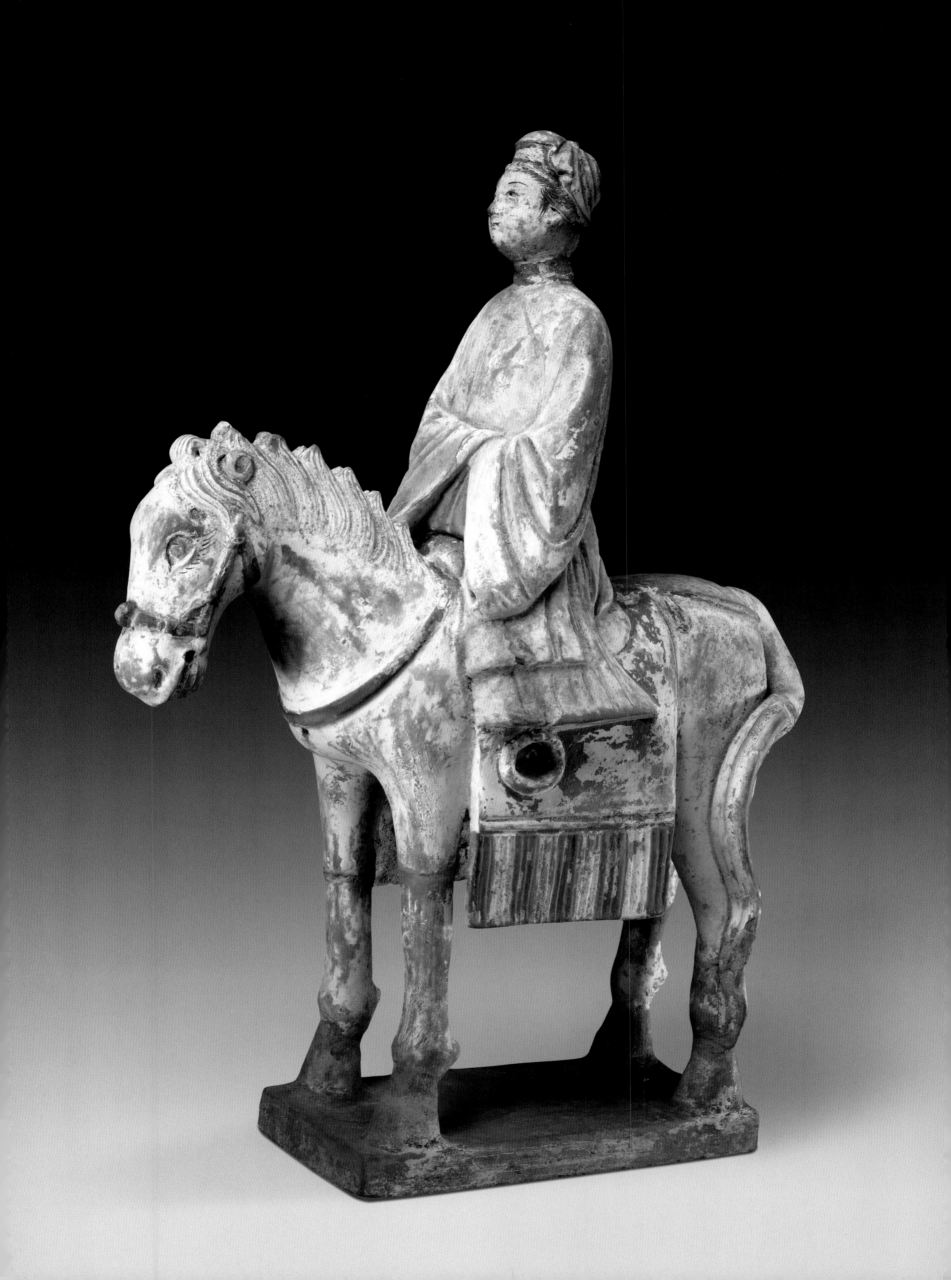

新105198
陶彩绘女骑俑
明

高36厘米 长21厘米

219

Xin 105198

Painted Pottery Female Figure on Horse
Ming Dynasty (1368-1644)
Height 36 cm
Length 21 cm

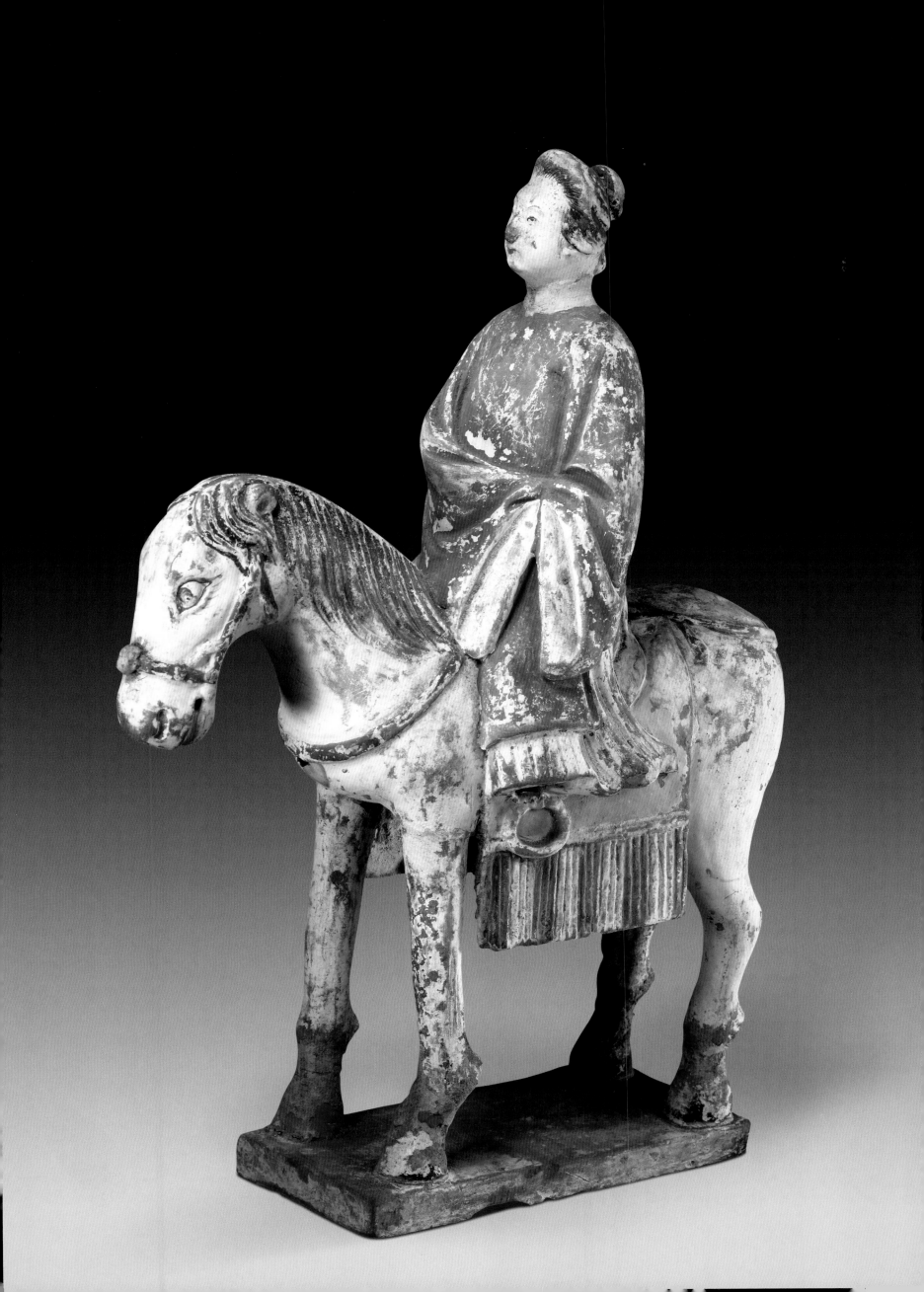

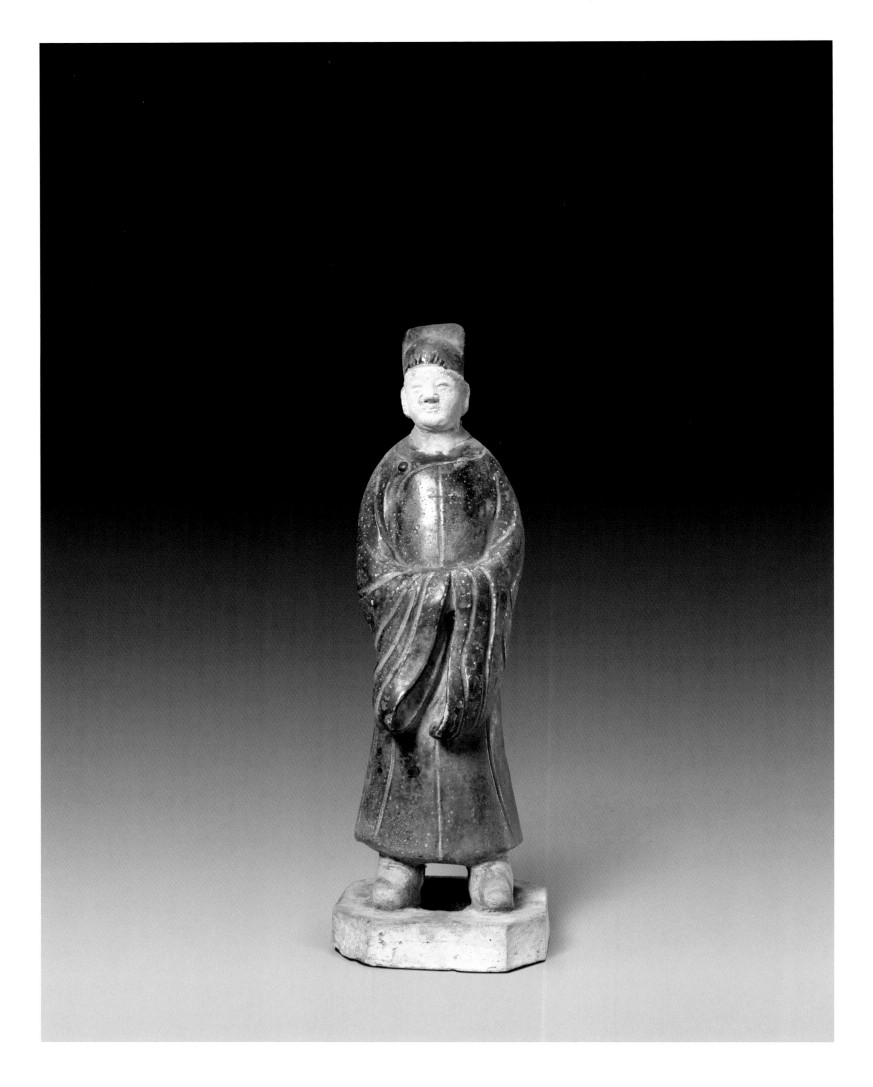

新121909
陶黑绿釉文吏俑
明

高29厘米 底宽9.5厘米

220

Xin 121909
Black-green Glazed Pottery Figure of an Official
Ming Dynasty (1368-1644)
Height 29 cm
Bottom width 9.5 cm

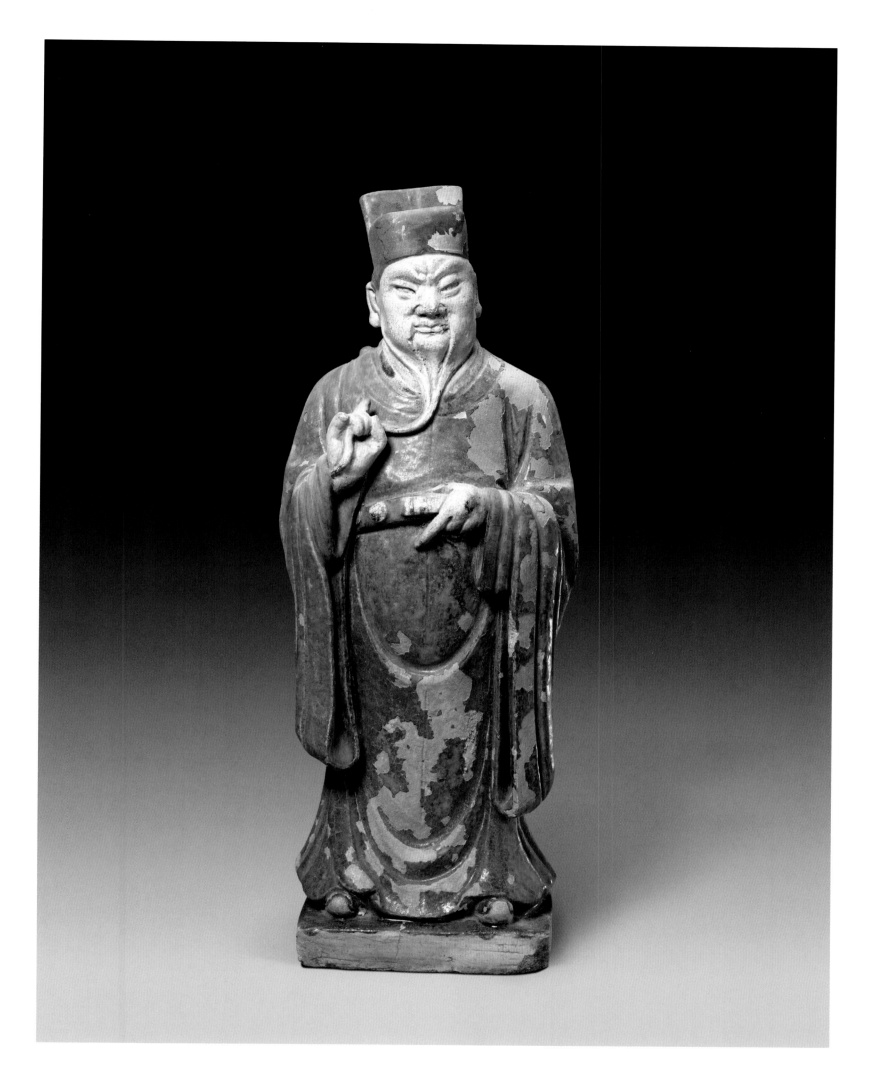

新60058

陶紫蓝釉文官俑

明

高38厘米 底宽12.8厘米

221

Xin 60058

Purple-blue Glazed Pottery Figure of an Official

Ming Dynasty (1368-1644)

Height 38 cm
Bottom width 12.8 cm

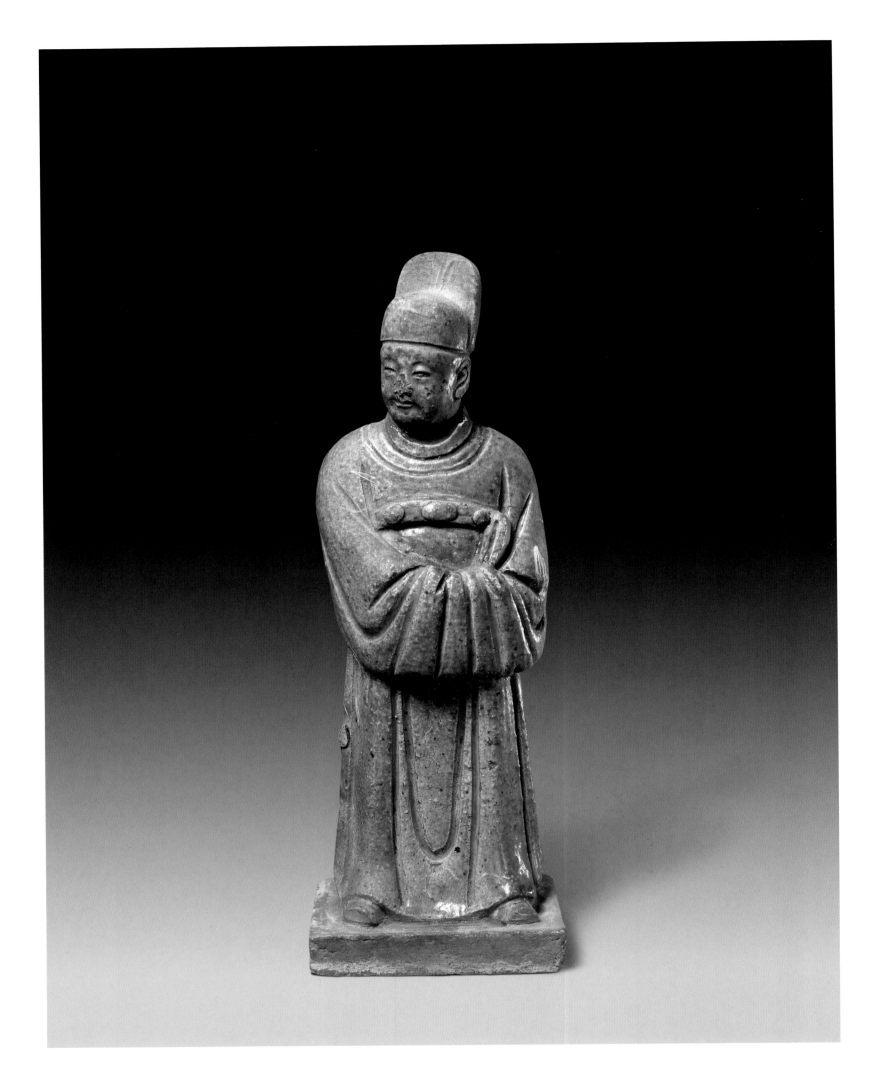

新60550

陶绿釉文官俑

明

高33厘米 底宽11.2厘米

222

Xin 60550

Green Glazed Pottery Figure of an Official

Ming Dynasty (1368-1644)

Height 33 cm
Bottom width 11.2 cm

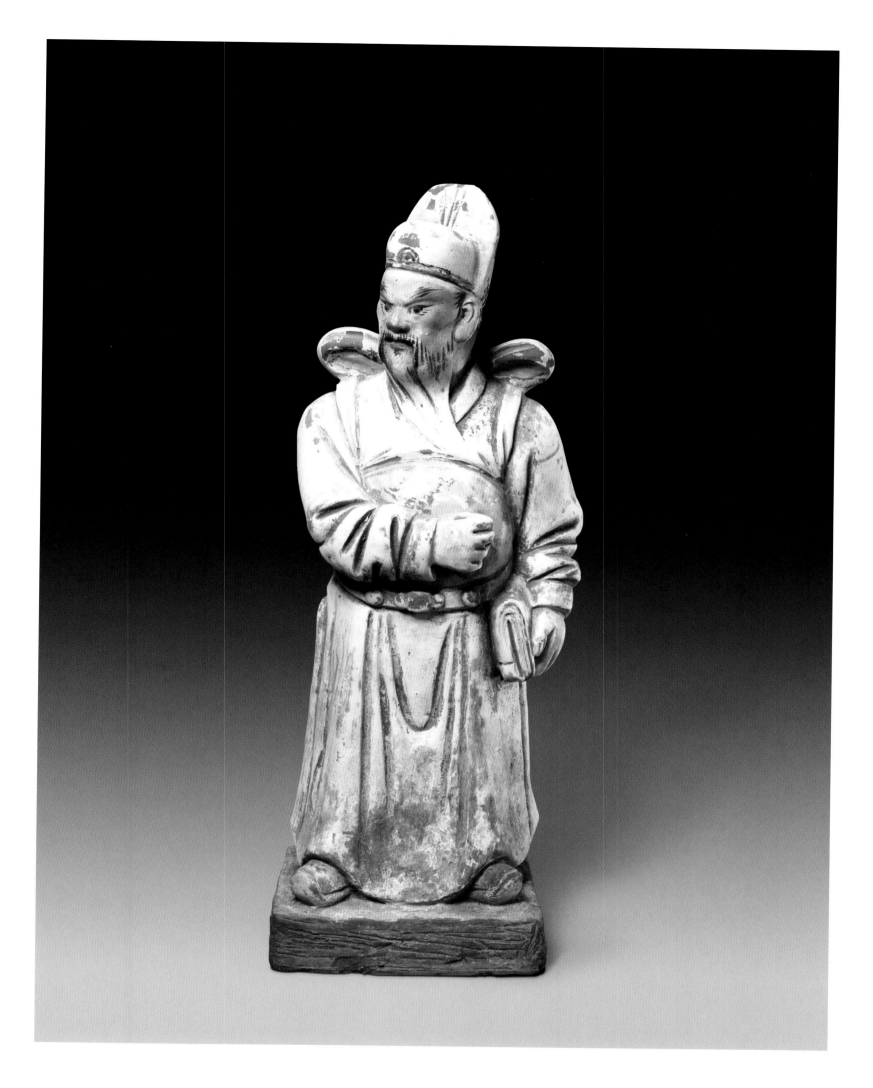

新62181
陶彩绘文官俑
明

高38厘米 底宽12.5厘米

223

Xin 62181
Painted Pottery Figure of an Official
Ming Dynasty (1368-1644)
Height 38 cm
Bottom width 12.5 cm

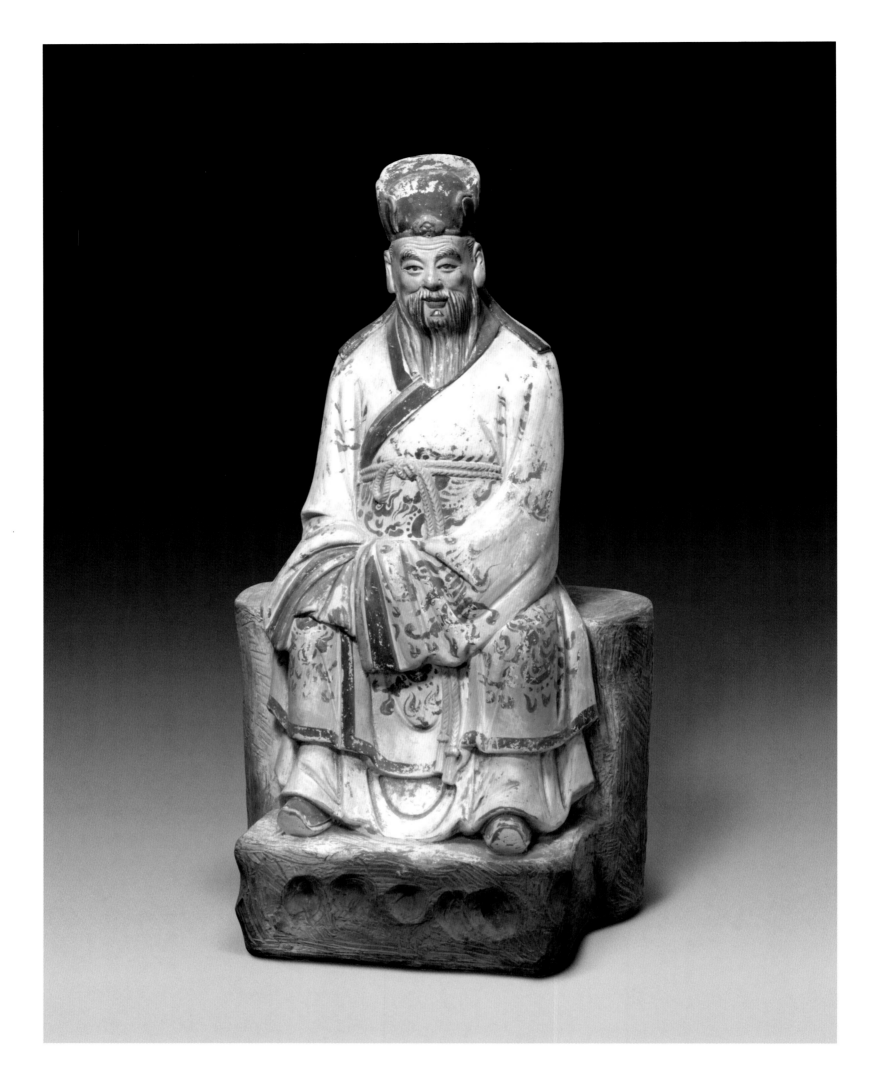

新60217

陶彩绘文官俑

明

高54厘米 底宽25厘米

224 | Xin 60217

Painted Pottery Figure of an Official
Ming Dynasty (1368-1644)
Height 54 cm
Bottom width 25 cm

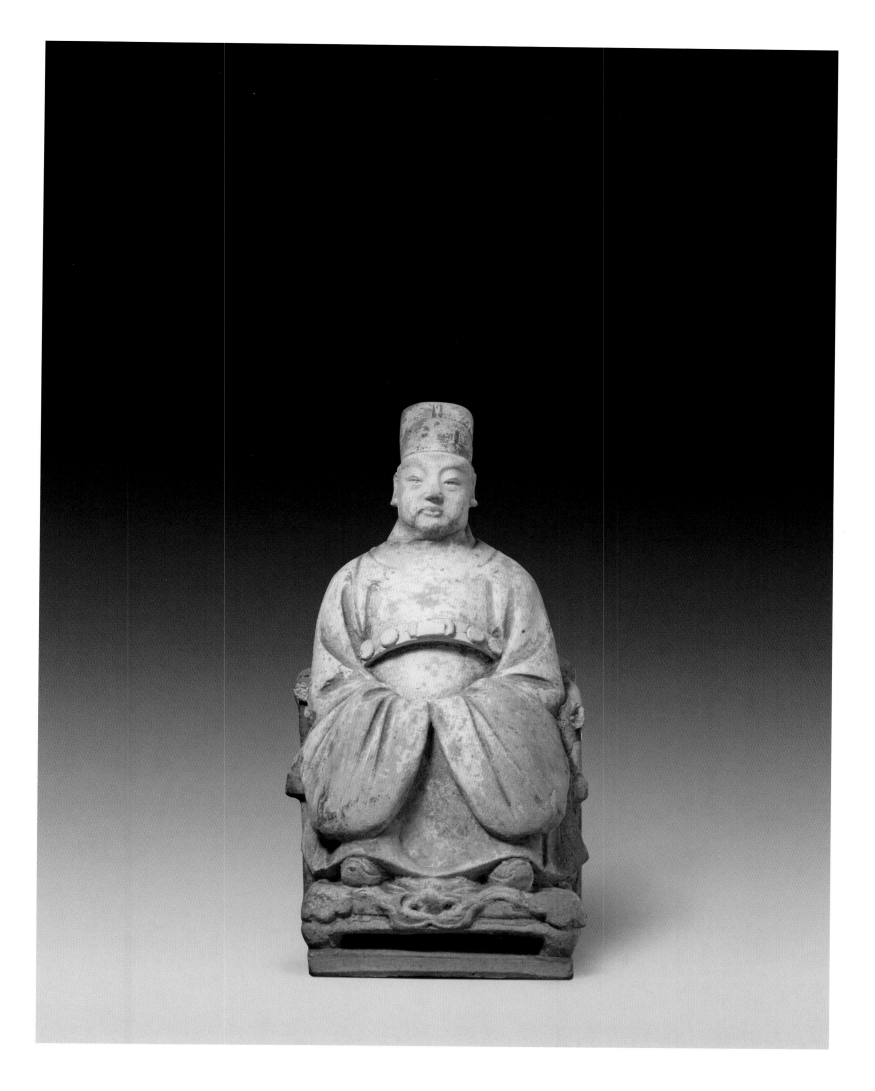

新122887

陶绿釉文官俑

明

高27厘米 底宽11厘米

Xin 122887

225

Green Glazed Pottery Figure of an Official
Ming Dynasty (1368-1644)
Height 27 cm
Bottom width 11 cm

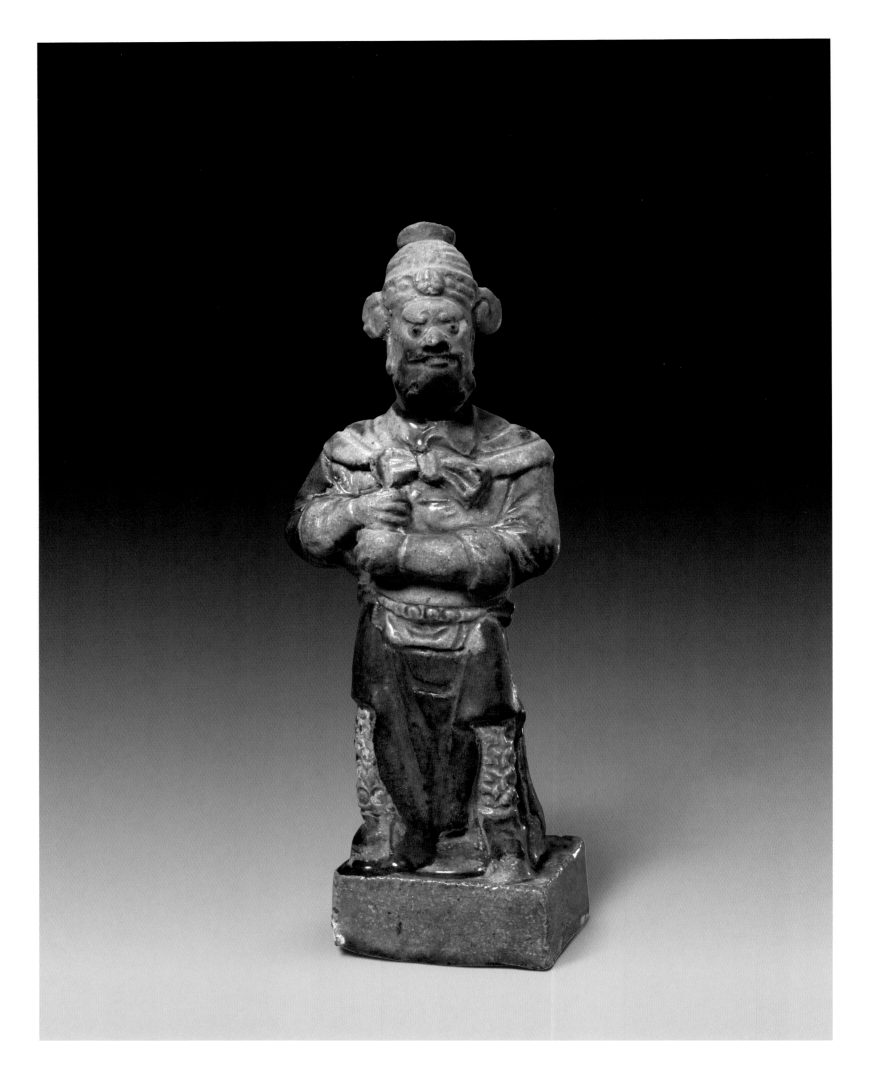

新60063

三彩武士俑

明

高21厘米　底宽6.5厘米

226

Xin 60063

Tricolor Figure of a Warrior

Ming Dynasty (1368-1644)

Height　21 cm

Bottom width　6.5 cm

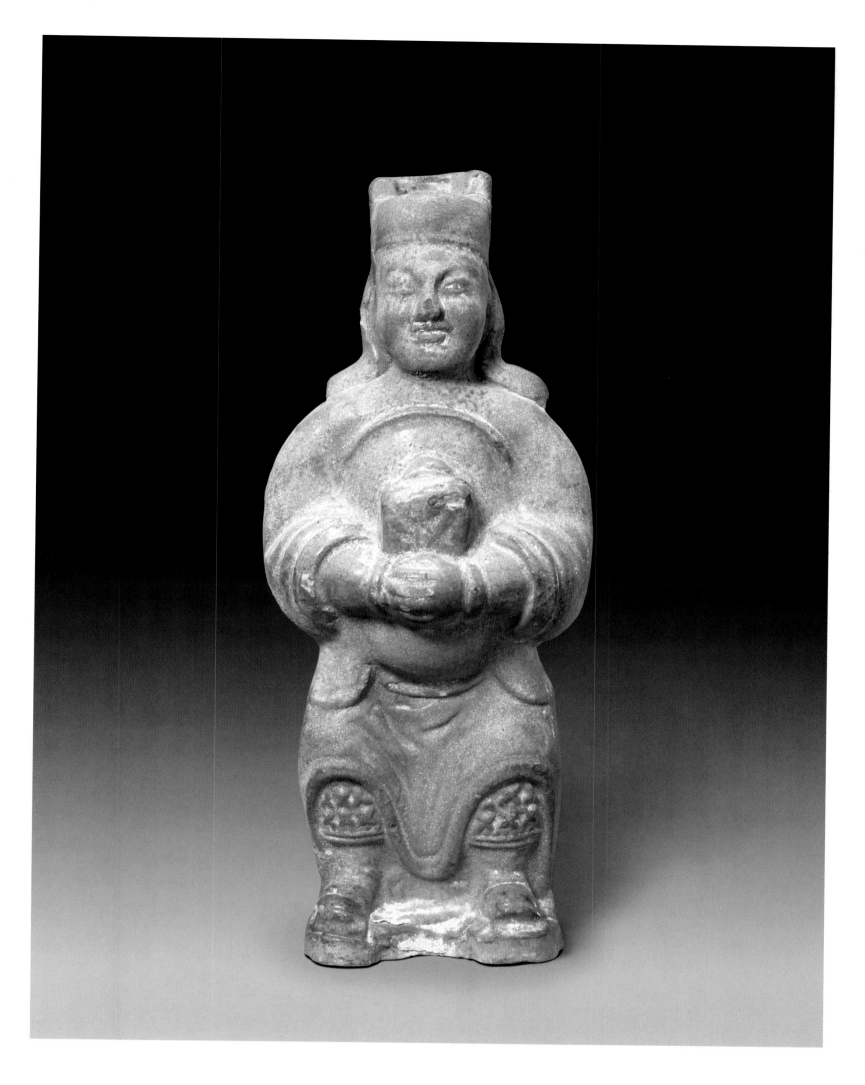

新125557

陶绿釉武士俑

明

高23.5厘米 底宽7厘米

227

Xin 125557

Green Glazed Pottery Figure of a Warrior

Ming Dynasty (1368-1644)

Height 23.5 cm

Bottom width 7 cm

新112467

陶紫绿釉坐轿俑

明

高30厘米　底宽12.5厘米

228

Xin 112467

Purple-green Glazed Pottery Figure Seated in a Sedan Chair

Ming Dynasty (1368-1644)

Height　30 cm

Bottom width　12.5 cm

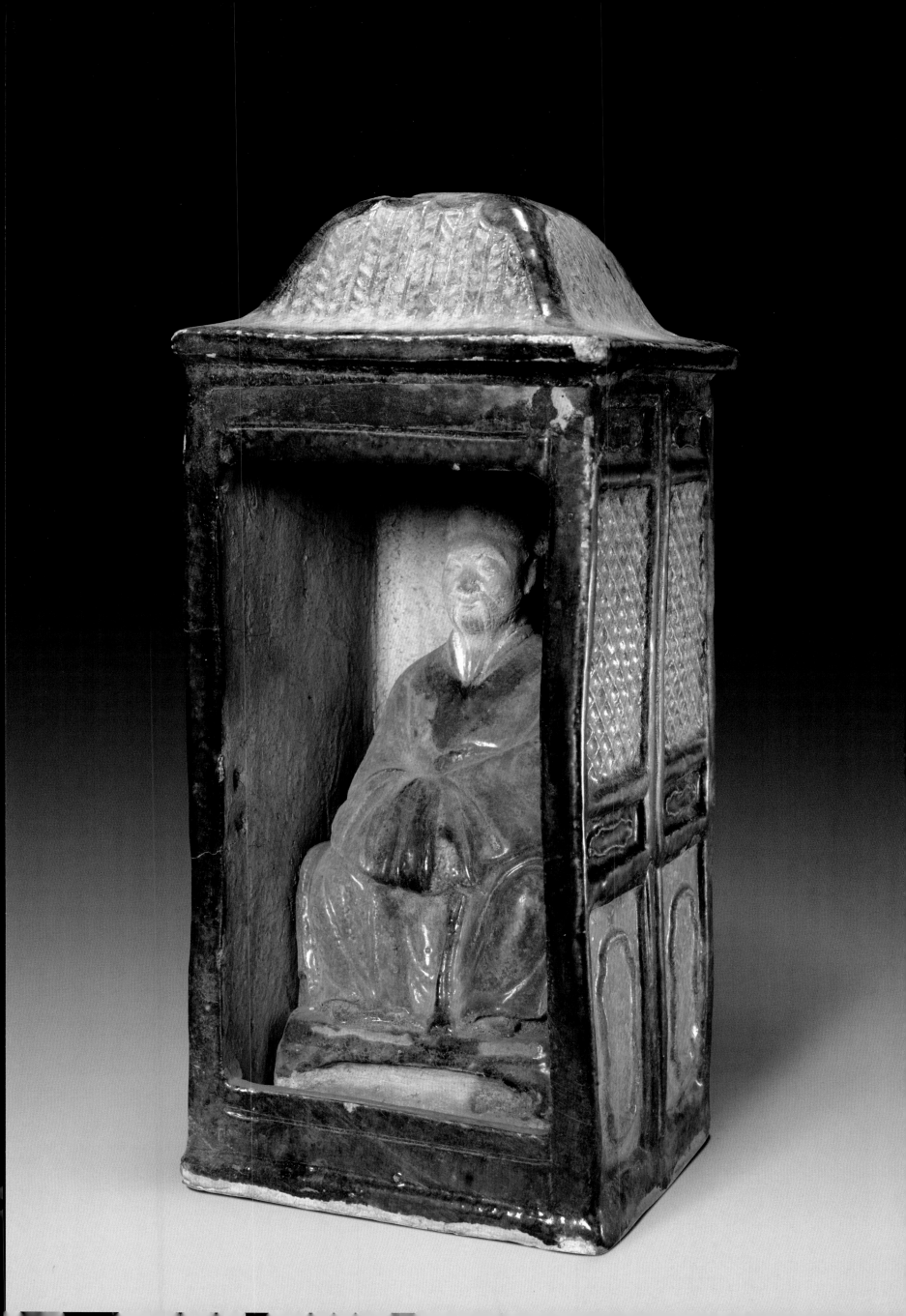

陶黄绿釉轿（侧面）
Yellow-green Glazed Pottery Sedan Chair（side）

新112468

陶黄绿釉轿

明

高24厘米 底宽12.8厘米

Xin 112468

Yellow-green Glazed Pottery Sedan Chair
Ming Dynasty (1368-1644)
Height 24 cm
Bottom width 12.8 cm

229

新143232

陶紫蓝釉轿

明

高30厘米 底宽14厘米

230

Xin 143232

Purple-blue Glazed Pottery Sedan Chair
Ming Dynasty (1368-1644)
Height 30 cm
Bottom width 14 cm

新60077

陶绿釉轿

明

高20.5厘米 底宽9.5厘米

231

Xin 60077

Green Glazed Pottery Sedan Chair

Ming Dynasty (1368-1644)

Height 20.5 cm

Bottom width 9.5 cm

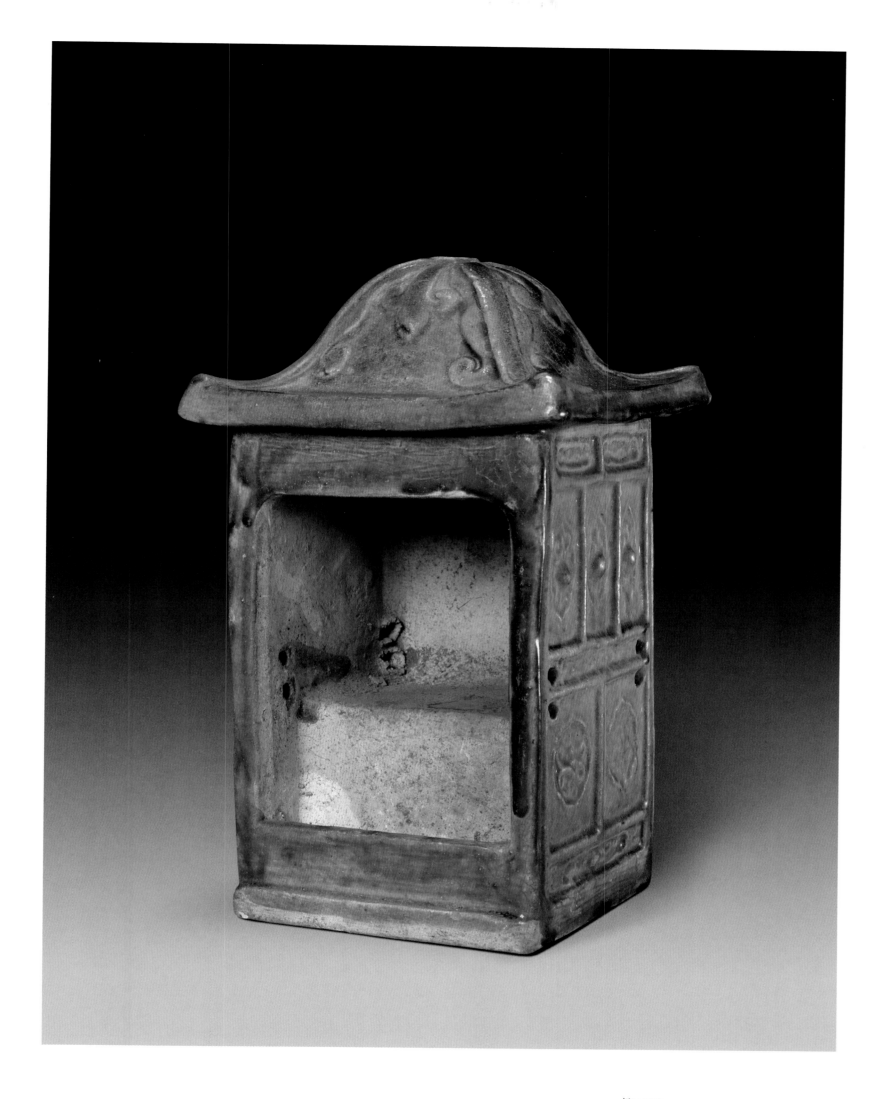

新144239
陶绿釉轿
明

高19厘米　底宽9.5厘米

232

Xin 144239

Green Glazed Pottery Sedan Chair
Ming Dynasty (1368-1644)
Height　19 cm
Bottom width　9.5 cm

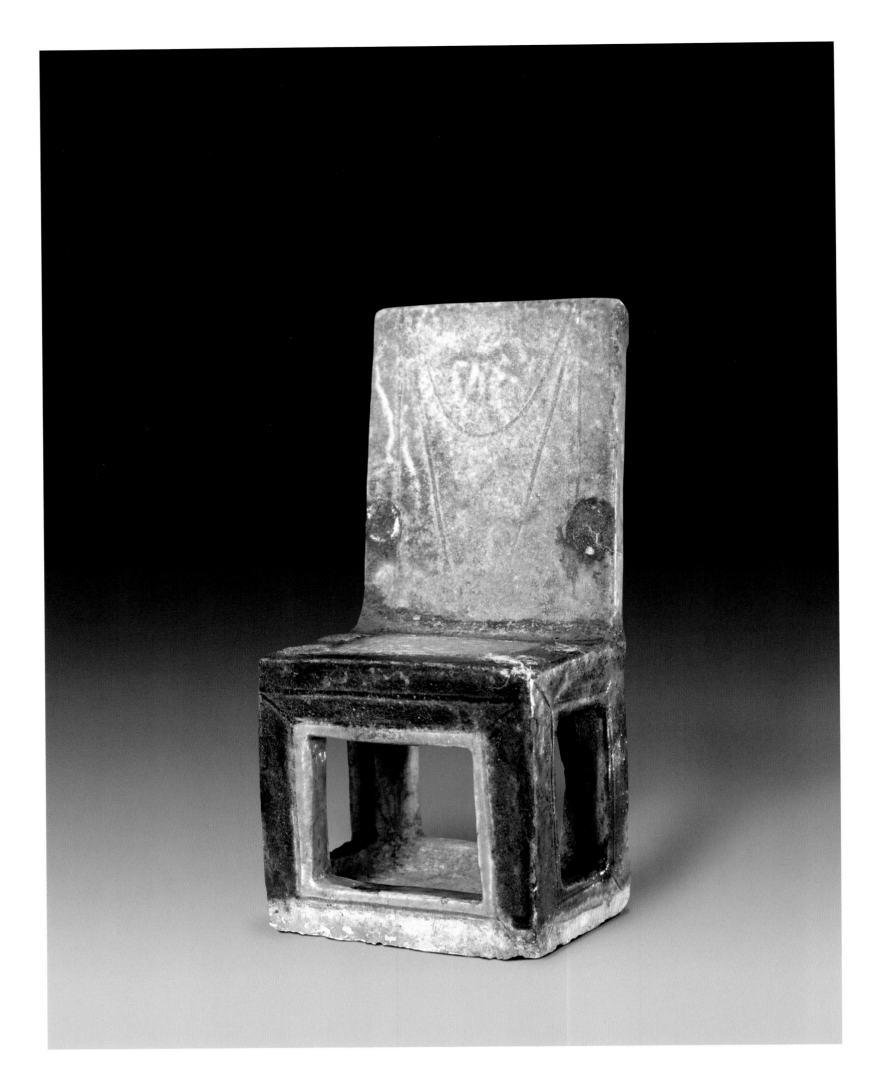

新43833

陶紫蓝釉椅

明

高18厘米 底宽8.5厘米

233 | Xin 43833

Purple-blue Glazed Pottery Chair

Ming Dynasty (1368-1644)

Height 18 cm

Bottom width 8.5 cm

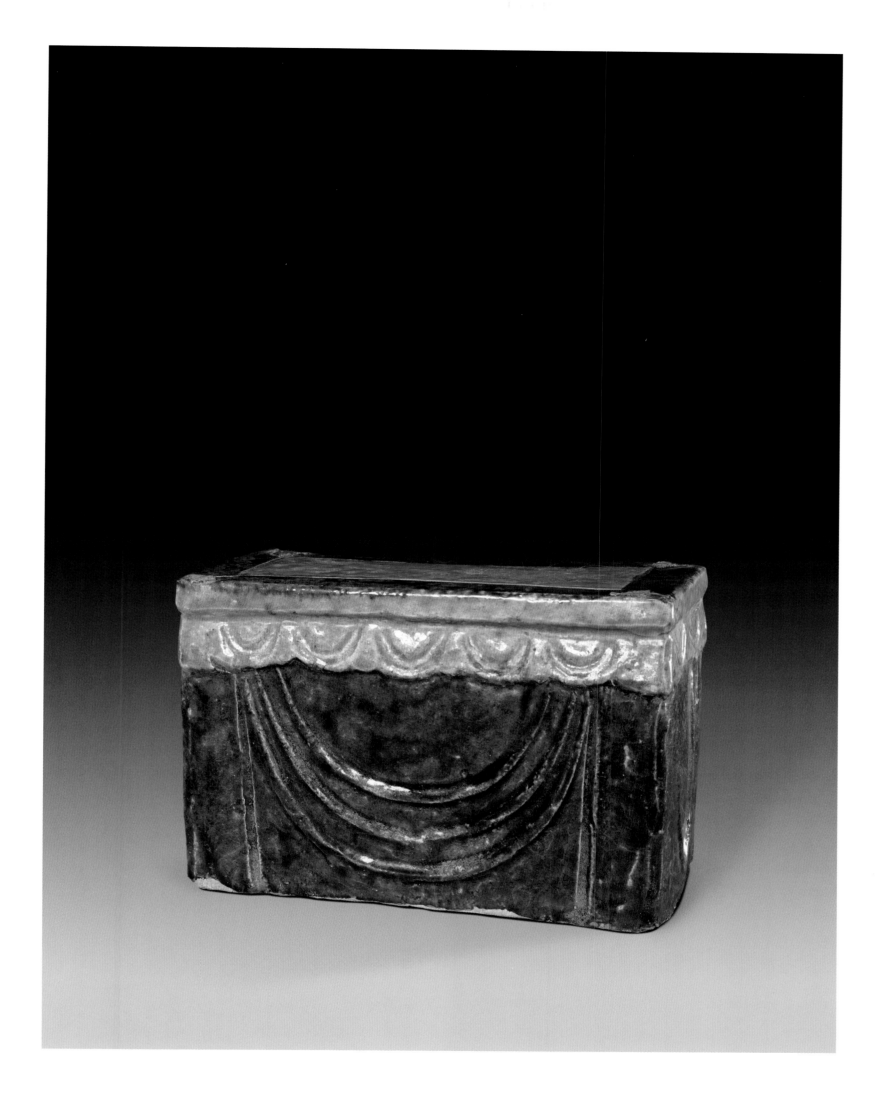

新125761

陶紫蓝釉供桌

明

高10.5厘米　底宽8厘米

234

Xin 125761

Purple-blue Glazed Pottery Table
Ming Dynasty (1368-1644)
Height 10.5 cm
Bottom width 8 cm

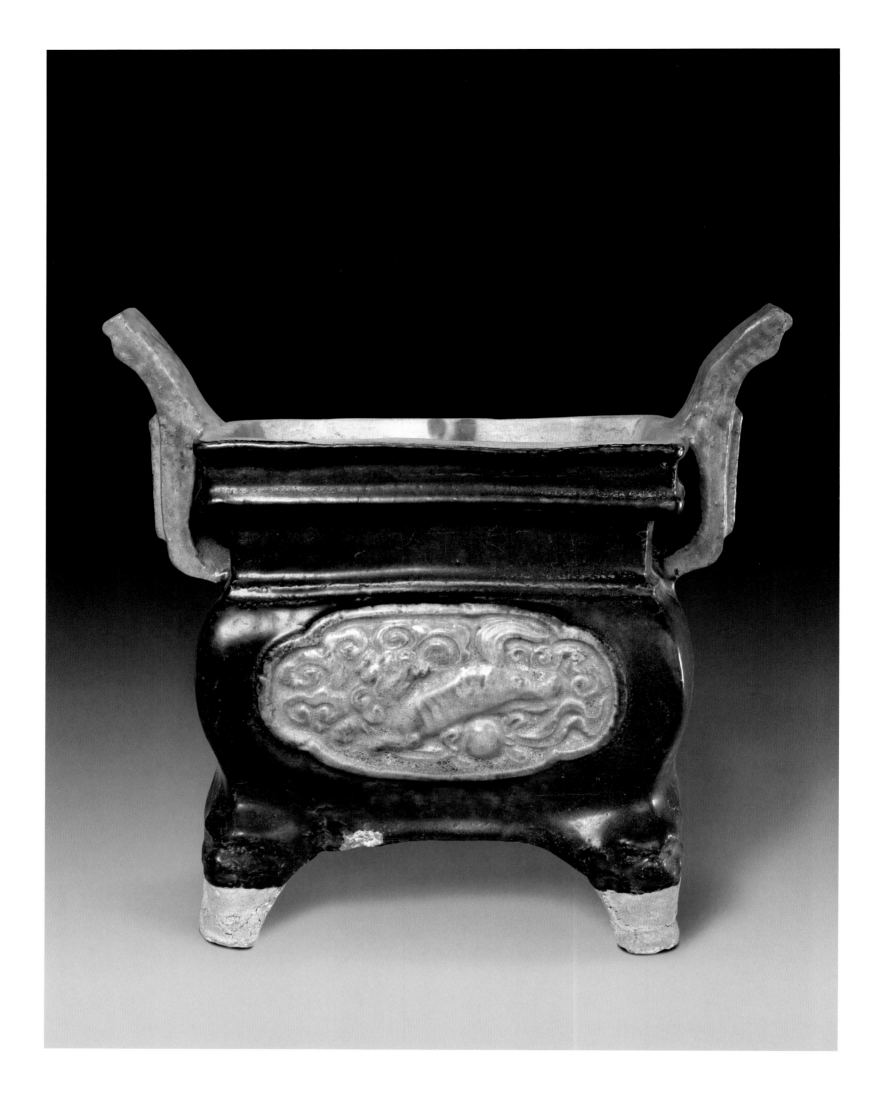

新43832

陶紫绿釉四足炉

明

高18厘米　底宽13厘米

235

Xin 43832

Purple-green Glazed Pottery Stove on Four Feet
Ming Dynasty (1368-1644)
Height　18 cm
Bottom width　13 cm

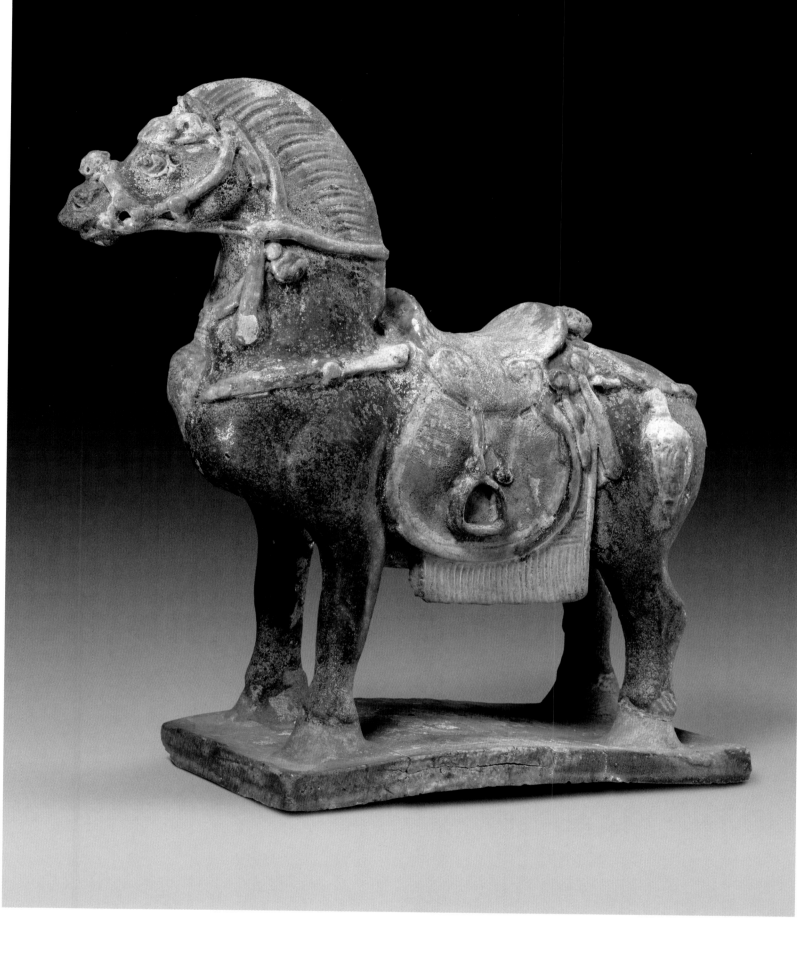

新104467

陶紫绿釉马

明

高25厘米 长27厘米

236

Xin 104467

Purple-green Glazed Pottery Horse

Ming Dynasty (1368-1644)

Height 25 cm

Length 27 cm

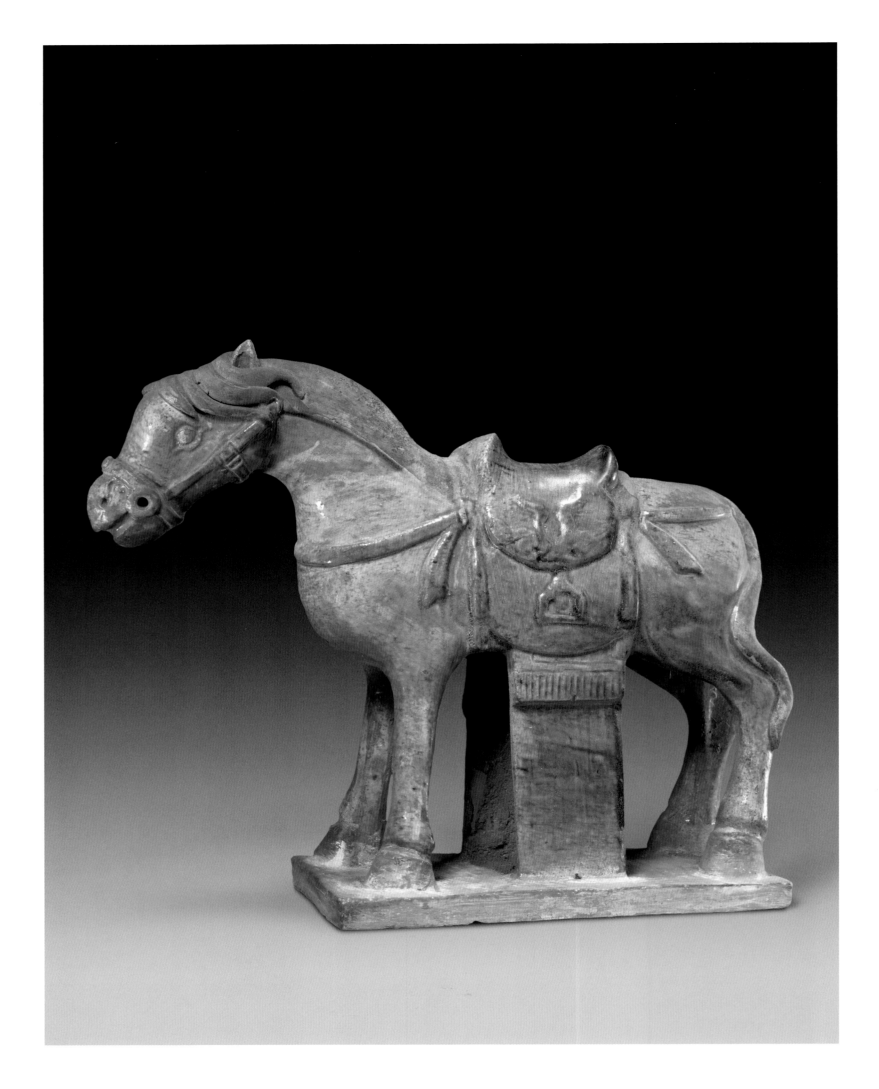

新62408
陶黄绿釉马
明
高25厘米 长30厘米

237 Xin 62408
Yellow-green Glazed Pottery Horse
Ming Dynasty (1368-1644)
Height 25 cm
Length 30 cm

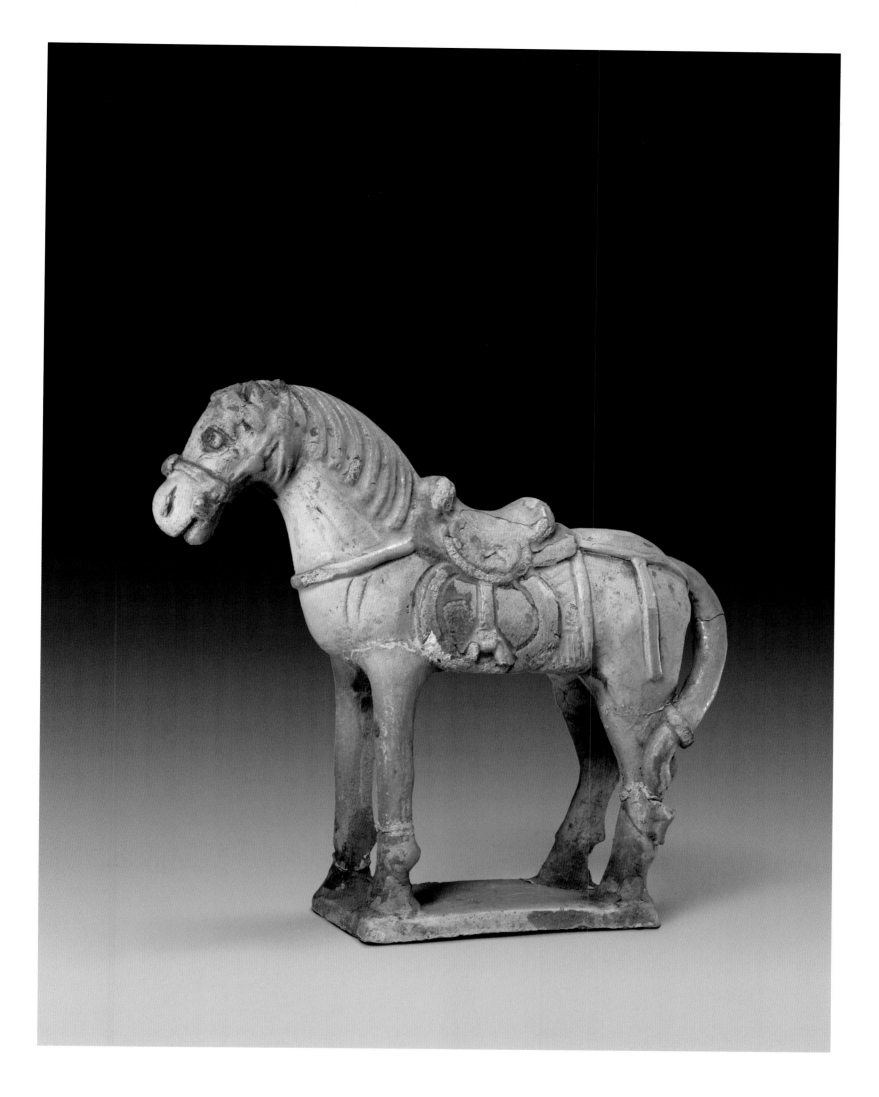

新43871
陶蓝釉马
明
高22厘米 长24厘米

238

Xin 43871
Blue Glazed Pottery Horse
Ming Dynasty (1368-1644)
Height 22 cm
Length 24 cm

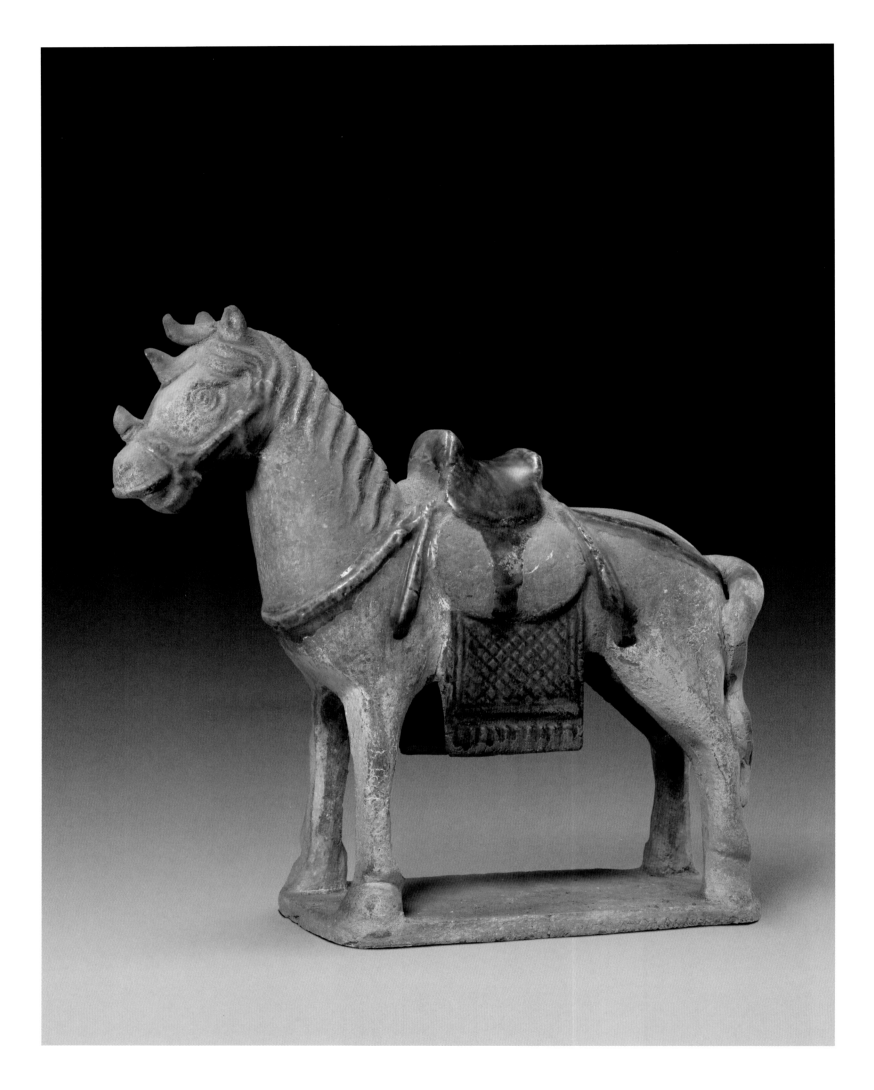

新58533

陶绿釉马

明

高23厘米 长25厘米

239

Xin 58533

Green Glazed Pottery Horse

Ming Dynasty (1368-1644)

Height 23 cm

Length 25 cm

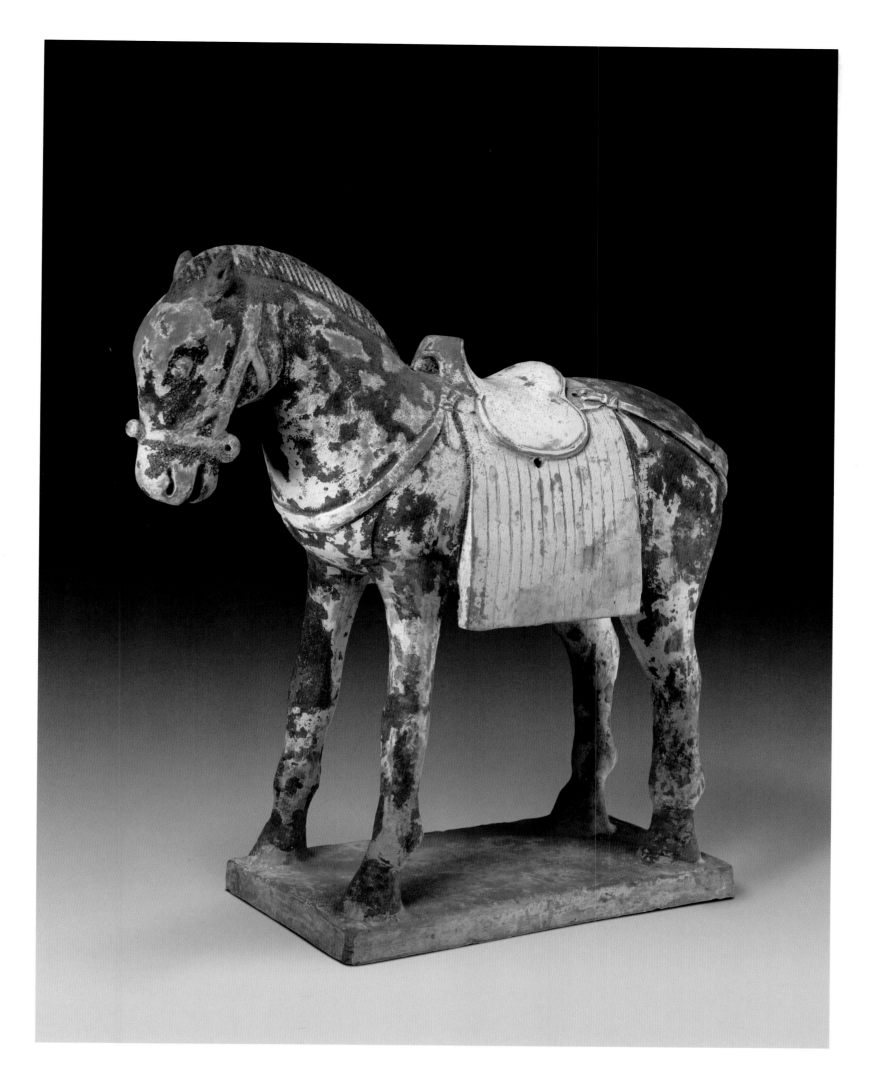

新51633

陶彩绘马

明

高29厘米 长30厘米

240

Xin 51633

Painted Pottery Horse
Ming Dynasty (1368-1644)
Height 29 cm
Length 30 cm

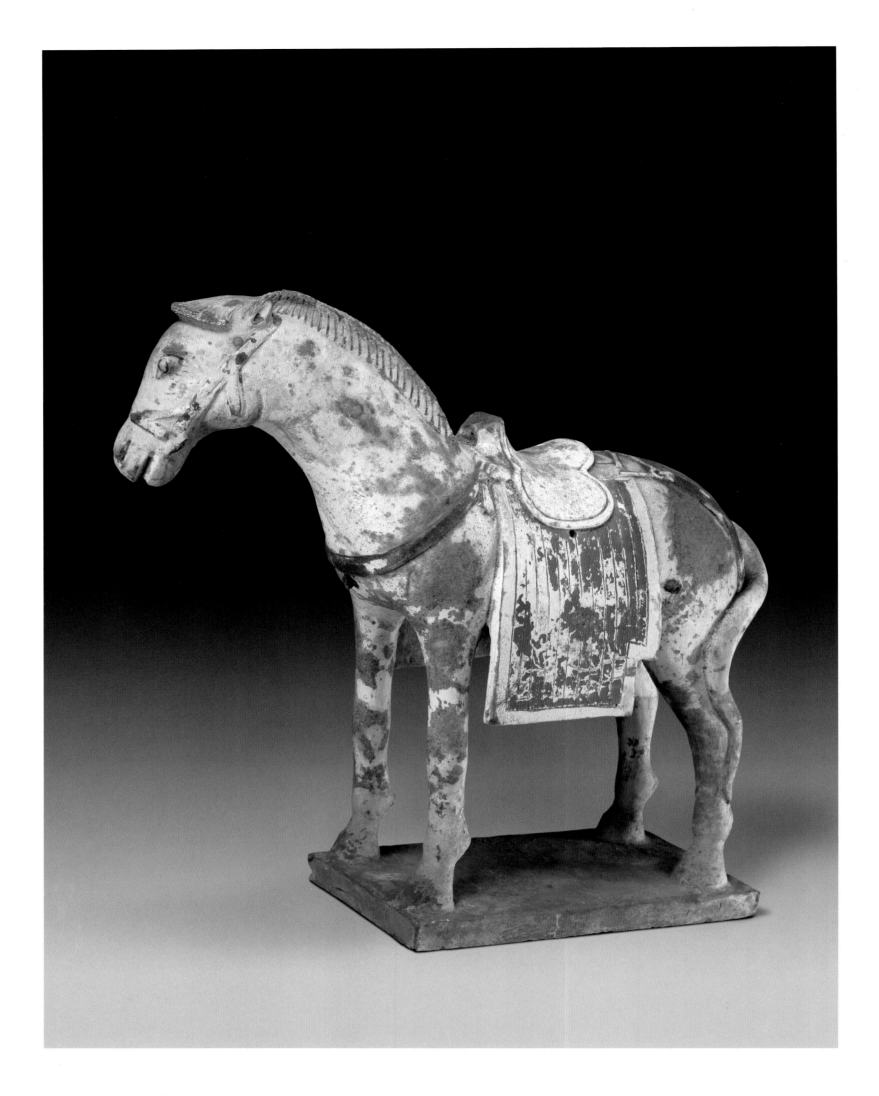

新51634

陶彩绘马

明

高30厘米 长36厘米

241

Xin 51634

Painted Pottery Horse

Ming Dynasty (1368-1644)

Height 30 cm

Length 36 cm

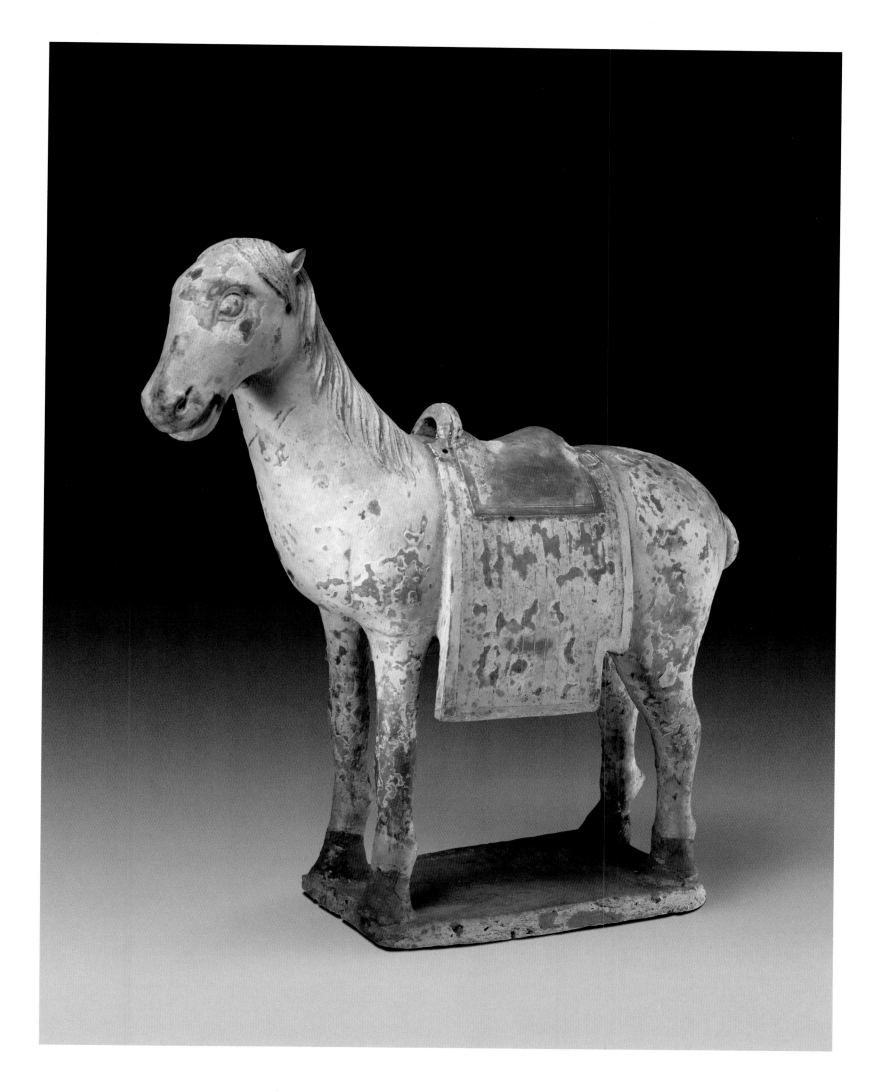

新51646

陶彩绘马

明

高32厘米 长32厘米

242

Xin 51646

Painted Pottery Horse

Ming Dynasty (1368-1644)

Height 32 cm
Length 32 cm

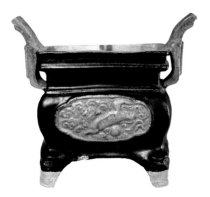

图版索引

Index

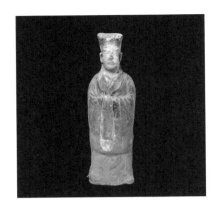

三彩男俑
1
Tricolor Male Figure

...19...

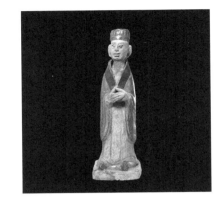

三彩男俑
6
Tricolor Male Figure

...25...

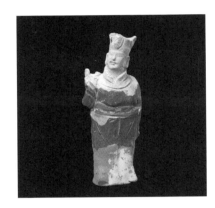

三彩男俑
2
Tricolor Male Figure

...21...

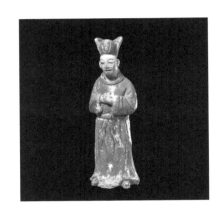

三彩男俑
7
Tricolor Male Figure

...26...

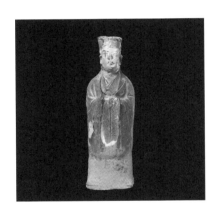

三彩男俑
3
Tricolor Male Figure

...22...

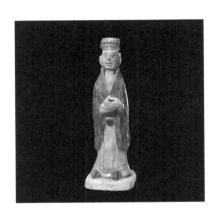

三彩男俑
8
Tricolor Male Figure

...27...

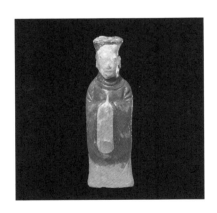

三彩男俑
4
Tricolor Male Figure

...23...

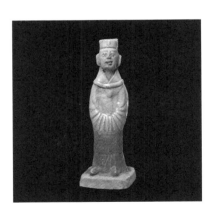

三彩男俑
9
Tricolor Male Figure

...28...

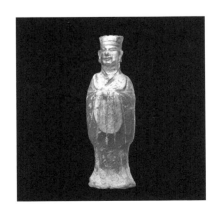

三彩男俑
5
Tricolor Male Figure

...24...

陶绿釉男俑
10
Green Glazed Pottery Male Figure

...29...

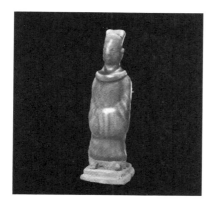

陶蓝釉男俑
11 Blue Glazed Pottery Male Figure
...30...

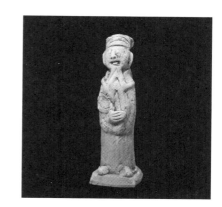

陶男俑
16 Pottery Male Figure
...37...

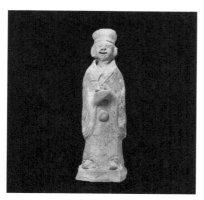

陶男俑
12 Pottery Male Figure
...31...

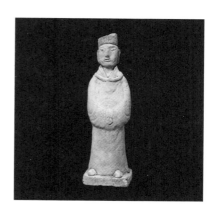

陶男俑
17 Pottery Male Figure
...38...

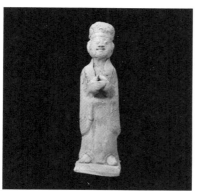

陶男俑
13 Pottery Male Figure
...32...

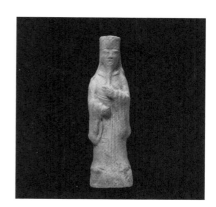

陶男俑
18 Pottery Male Figure
...39...

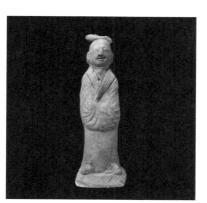

陶男俑
14 Pottery Male Figure
...33...

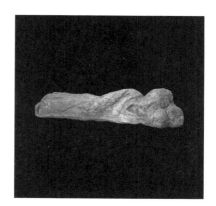

陶彩绘男俑
19 Painted Pottery Male Figure
...40...

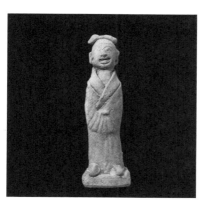

陶男俑
15 Pottery Male Figure
...35...

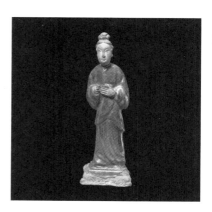

三彩女俑
20 Tricolor Female Figure
...41...

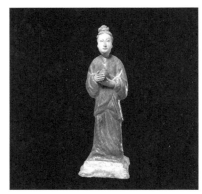

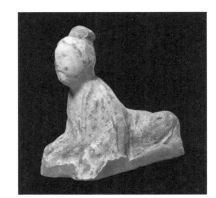

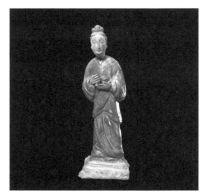

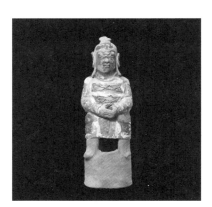

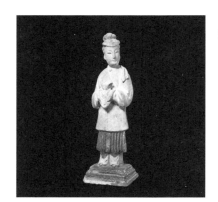

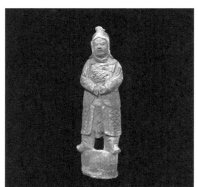

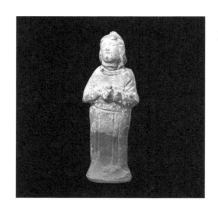

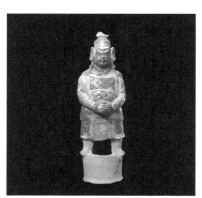

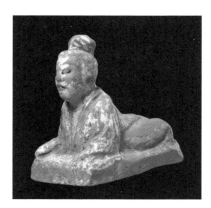

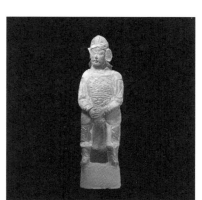

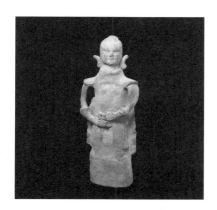

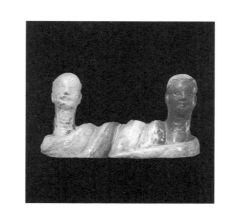

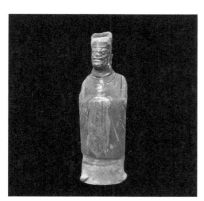

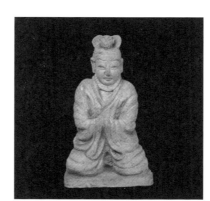

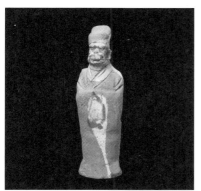

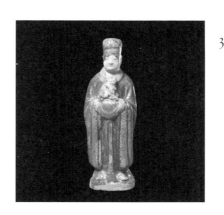

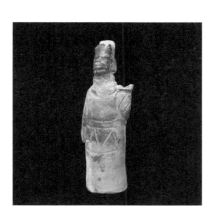

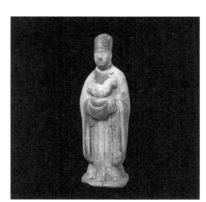

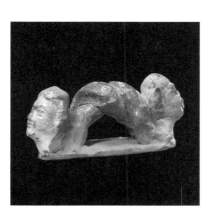

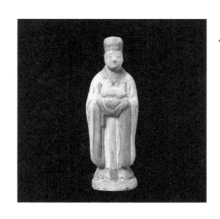

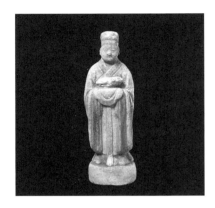

41 三彩生肖俑
Tricolor Figure with Animal Zodiac Sign
...65...

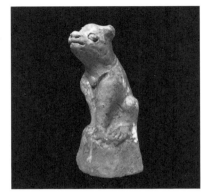

46 陶黄釉狗
Yellow Glazed Pottery Dog
...70...

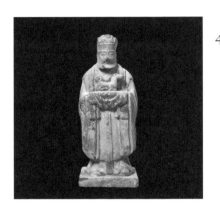

42 陶彩绘生肖俑
Painted Pottery Figure with
Animal Zodiac Sign
...66...

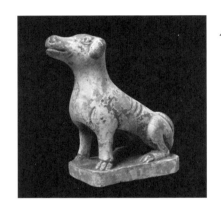

47 陶狗
Pottery Dog
...71...

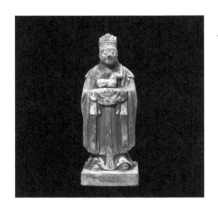

43 陶彩绘生肖俑
Painted Pottery Figure with
Animal Zodiac Sign
...67...

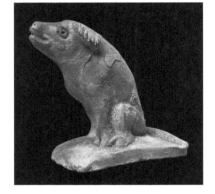

48 陶狗
Pottery Dog
...72...

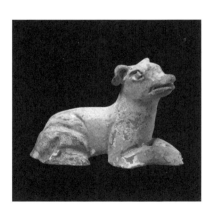

44 陶黄釉狗
Yellow Glazed Pottery Dog
...68...

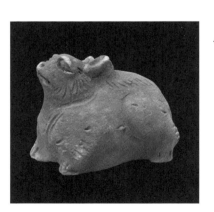

49 黑陶兔
Black Pottery Hare
...73...

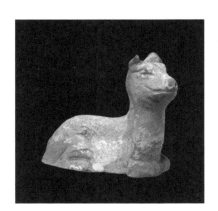

45 陶黄釉狗
Yellow Glazed Pottery Dog
...69...

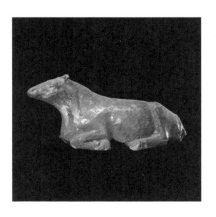

50 三彩牛
Tricolor Ox
...74...

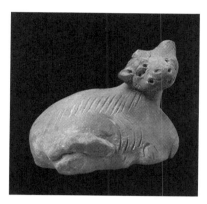

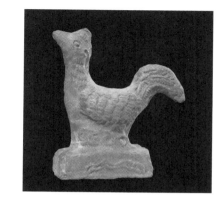

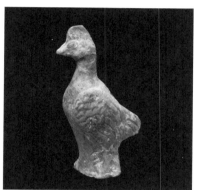

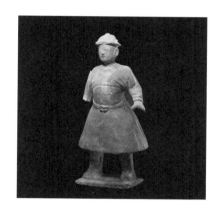

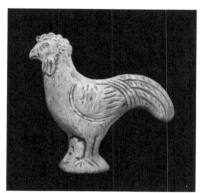

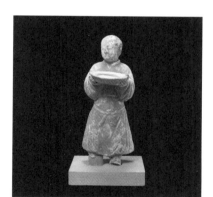

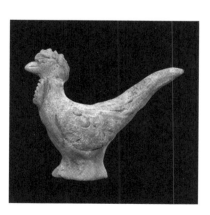

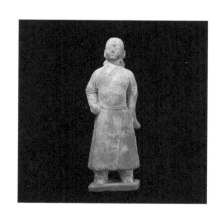

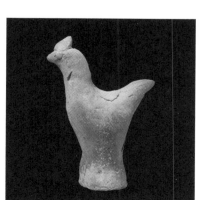

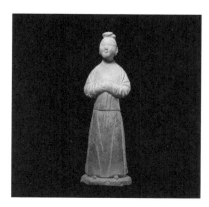

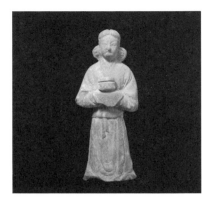

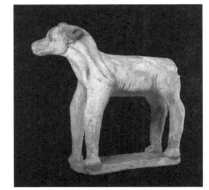

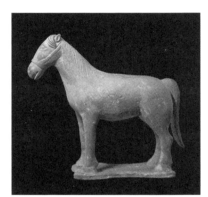

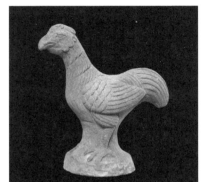

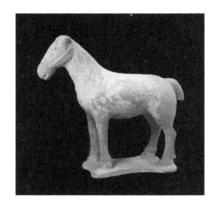

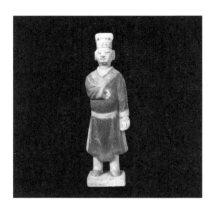

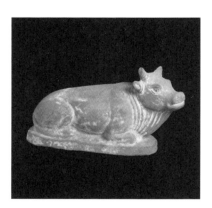

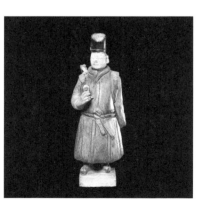

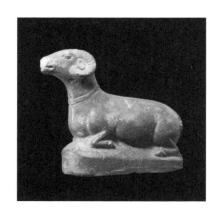

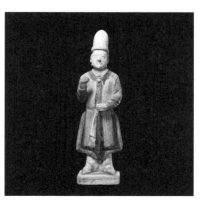

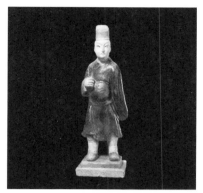

陶绿釉男俑

71 Green Glazed Pottery Male Figure

...95...

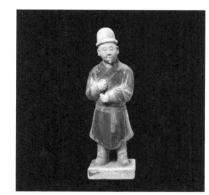

陶紫蓝釉男俑

76 Purple-blue Glazed Pottery Male Figure

...100...

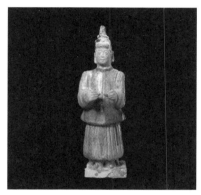

陶黄绿釉男俑

72 Yellow-green Glazed Pottery Male Figure

...96...

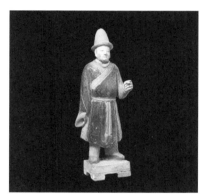

陶紫蓝釉男俑

77 Purple-blue Glazed Pottery Male Figure

...101...

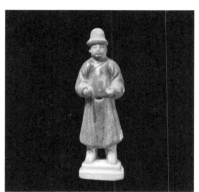

陶绿釉男俑

73 Green Glazed Pottery Male Figure

...97...

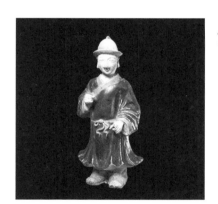

陶紫绿釉男俑

78 Purple-green Glazed Pottery Male Figure

...103...

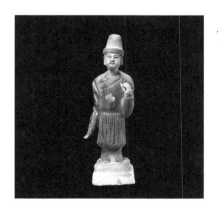

陶绿釉男俑

74 Green Glazed Pottery Male Figure

...98...

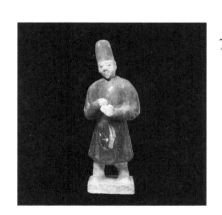

陶紫釉男俑

79 Purple Glazed Pottery Male Figure

...104...

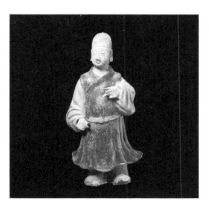

陶紫绿釉男俑

75 Purple-green Glazed Pottery Male Figure

...99...

陶紫蓝釉男俑

80 Purple-blue Glazed Pottery Male Figure

...105...

陶紫蓝釉男俑
81 ——————————
Purple-blue Glazed Pottery Male Figure
...107...

陶紫蓝釉男俑
86 ——————————
Purple-blue Glazed Pottery Male Figure
...112...

陶黑釉男俑
82 ——————————
Black Glazed Pottery Male Figure
...108...

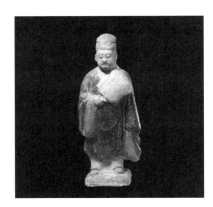

陶紫蓝釉男俑
87 ——————————
Purple-blue Glazed Pottery Male Figure
...113...

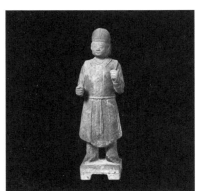

陶蓝釉男俑
83 ——————————
Blue Glazed Pottery Male Figure
...109...

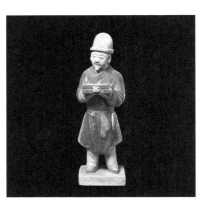

陶紫蓝釉男俑
88 ——————————
Purple-blue Glazed Pottery Male Figure
...114...

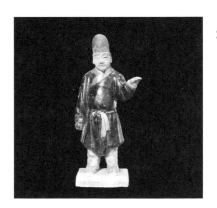

陶紫绿釉男俑
84 ——————————
Purple-green Glazed Pottery Male Figure
...110...

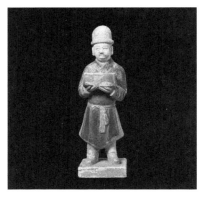

陶紫绿釉男俑
89 ——————————
Purple-green Glazed Pottery Male Figure
...115...

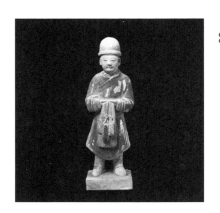

陶紫绿釉男俑
85 ——————————
Purple-green Glazed Pottery Male Figure
...111...

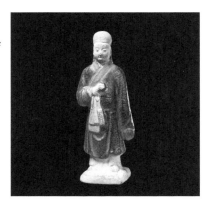

陶紫蓝釉男俑
90 ——————————
Purple-blue Glazed Pottery Male Figure
...116...

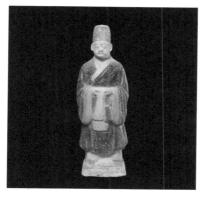

91 陶紫绿釉男俑
Purple-green Glazed Pottery Male Figure
...117...

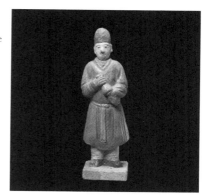

96 陶黄绿釉男俑
Yellow-green Glazed Pottery Male Figure
...123...

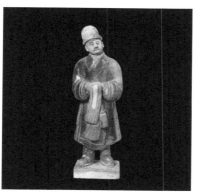

92 陶紫绿釉男俑
Purple-green Glazed Pottery Male Figure
...119...

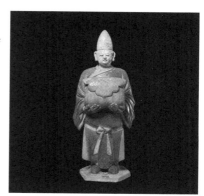

97 陶黄绿釉男俑
Yellow-green Glazed Pottery Male Figure
...125...

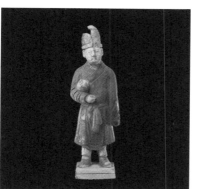

93 陶紫绿釉男俑
Purple-green Glazed Pottery Male Figure
...120...

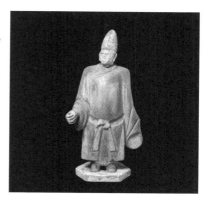

98 陶黄绿釉男俑
Yellow-green Glazed Pottery Male Figure
...126...

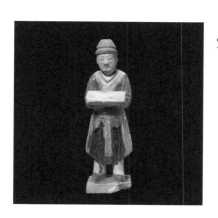

94 陶紫绿釉男俑
Purple-green Glazed Pottery Male Figure
...121...

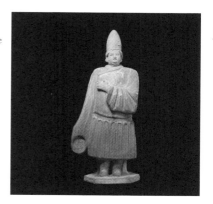

99 陶黄绿釉男俑
Yellow-green Glazed Pottery Male Figure
...127...

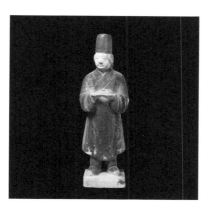

95 陶紫绿釉男俑
Purple-green Glazed Pottery Male Figure
...122...

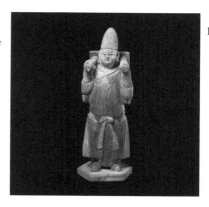

100 陶黄绿釉男俑
Yellow-green Glazed Pottery Male Figure
...129...

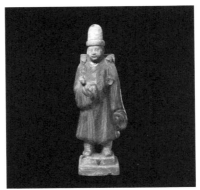

101 陶绿釉男俑

Green Glazed Pottery Male Figure

...130...

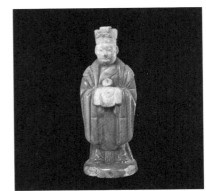

106 陶黄绿釉男俑

Yellow-green Glazed Pottery Male Figure

...136...

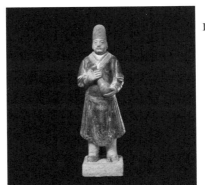

102 陶紫蓝釉男俑

Purple-blue Glazed Pottery Male Figure

...131...

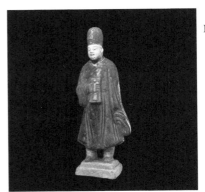

107 陶绿釉男俑

Green Glazed Pottery Male Figure

...137...

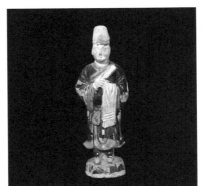

103 陶蓝绿釉男俑

Blue-green Glazed Pottery Male Figure

...132...

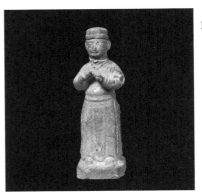

108 陶绿釉男俑

Green Glazed Pottery Male Figure

...138...

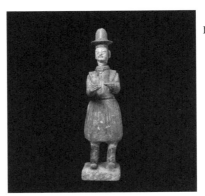

104 陶黄绿釉男俑

Yellow-green Glazed Pottery Male Figure

...133...

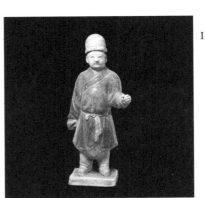

109 陶紫绿釉男俑

Purple-green Glazed Pottery Male Figure

...139...

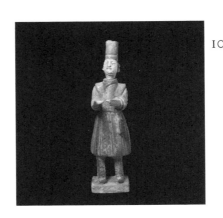

105 陶黄绿釉男俑

Yellow-green Glazed Pottery Male Figure

...135...

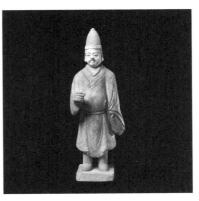

110 陶蓝釉男俑

Blue Glazed Pottery Male Figure

...140...

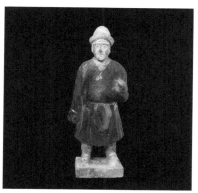

111 陶紫釉男俑
Purple Glazed Pottery Male Figure
...141...

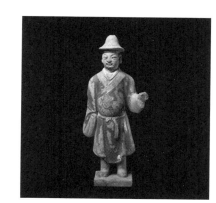

116 陶紫蓝釉男俑
Purple-blue Glazed Pottery Male Figure
...147...

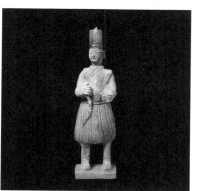

112 陶黄绿釉男俑
Yellow-green Glazed Pottery Male Figure
...143...

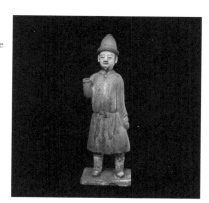

117 陶蓝釉男俑
Blue Glazed Pottery Male Figure
...148...

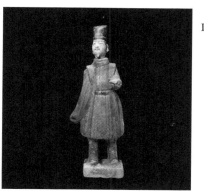

113 陶黄绿釉男俑
Yellow-green Glazed Pottery Male Figure
...144...

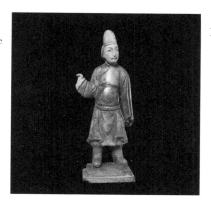

118 陶绿釉男俑
Green Glazed Pottery Male Figure
...149...

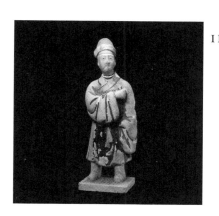

114 陶紫蓝釉男俑
Purple-blue Glazed Pottery Male Figure
...145...

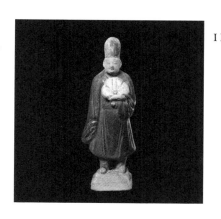

119 陶绿釉男俑
Green Glazed Pottery Male Figure
...150...

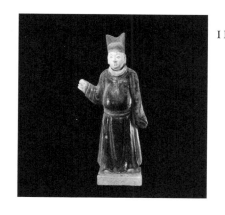

115 陶紫蓝釉男俑
Purple-blue Glazed Pottery Male Figure
...146...

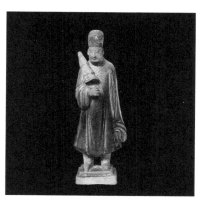

120 陶绿釉男俑
Green Glazed Pottery Male Figure
...151...

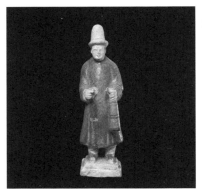

陶黄绿釉男俑
Yellow-green Glazed Pottery Male Figure
...152...

121

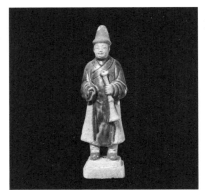

陶绿釉男俑
Green Glazed Pottery Male Figure
...157...

126

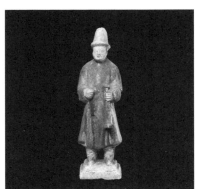

陶黄绿釉男俑
Yellow-green Glazed Pottery Male Figure
...153...

122

陶紫蓝釉男俑
Purple-blue Glazed Pottery Male Figure
...158...

127

陶黄绿釉男俑
Yellow-green Glazed Pottery Male Figure
...154...

123

陶绿釉男俑
Green Glazed Pottery Male Figure
...159...

128

陶绿釉男俑
Green Glazed Pottery Male Figure
...155...

124

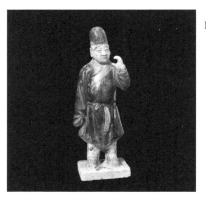

陶紫绿釉男俑
Purple-green Glazed Pottery Male Figure
...160...

129

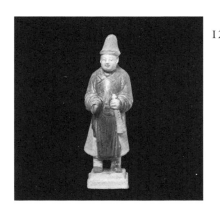

陶绿釉男俑
Green Glazed Pottery Male Figure
...156...

125

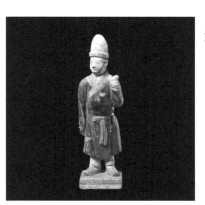

陶紫绿釉男俑
Purple-green Glazed Pottery Male Figure
...161...

130

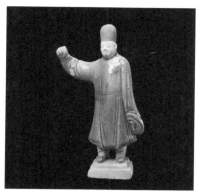

131 陶绿釉男俑
Green Glazed Pottery Male Figure
...162...

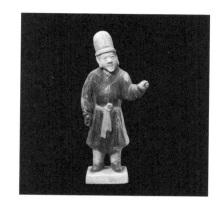

136 陶紫蓝釉男俑
Purple-blue Glazed Pottery Male Figure
...167...

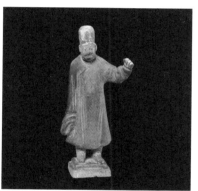

132 陶绿釉男俑
Green Glazed Pottery Male Figure
...163...

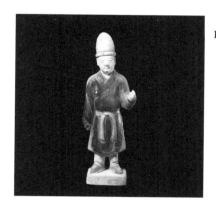

137 陶紫绿釉男俑
Purple-green Glazed Pottery Male Figure
...169...

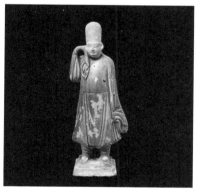

133 陶绿釉男俑
Green Glazed Pottery Male Figure
...164...

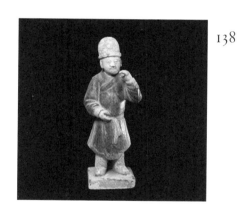

138 陶紫绿釉男俑
Purple-green Glazed Pottery Male Figure
...170...

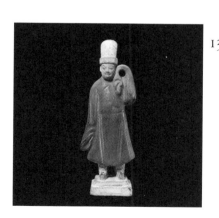

134 陶绿釉男俑
Green Glazed Pottery Male Figure
...165...

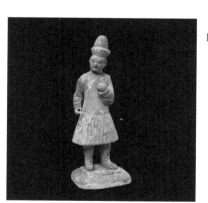

139 陶紫蓝釉男俑
Purple-blue Glazed Pottery Male Figure
...171...

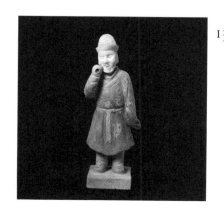

135 陶紫绿釉男俑
Purple-green Glazed Pottery Male Figure
...166...

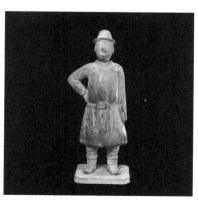

140 陶酱釉男俑
Soy-color Glazed Pottery Male Figure
...172...

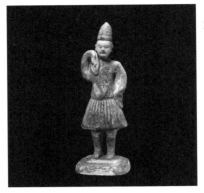

陶紫绿釉男俑
141 Purple-green Glazed Pottery Male Figure
...173...

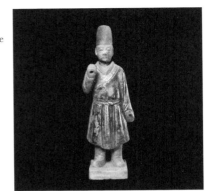

陶紫绿釉男俑
146 Purple-green Glazed Pottery Male Figure
...178...

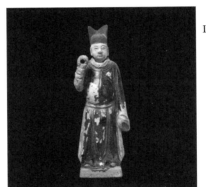

陶紫绿釉男俑
142 Purple-green Glazed Pottery Male Figure
...174...

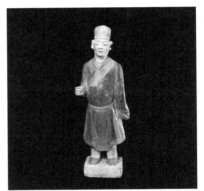

陶紫绿釉男俑
147 Purple-green Glazed Pottery Male Figure
...179...

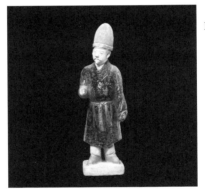

陶紫绿釉男俑
143 Purple-green Glazed Pottery Male Figure
...175...

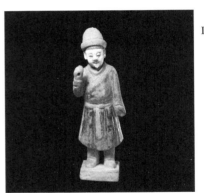

陶紫绿釉男俑
148 Purple-green Glazed Pottery Male Figure
...181...

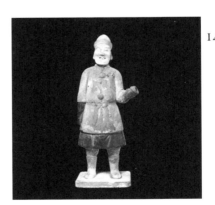

陶紫釉男俑
144 Purple Glazed Pottery Male Figure
...176...

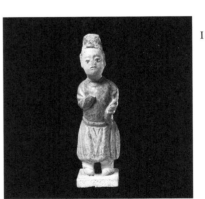

陶黄绿釉侏儒俑
149 Yellow-green Glazed Pottery Figure of a Dwarf
...182...

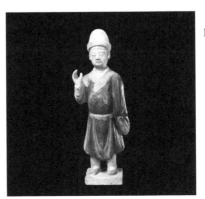

陶紫蓝釉男俑
145 Purple-blue Glazed Pottery Male Figure
...177...

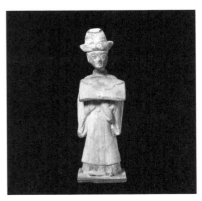

陶彩绘男俑
150 Painted Pottery Male Figure
...183...

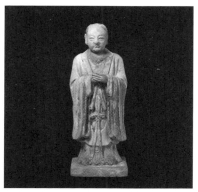

151 陶彩绘男俑
Painted Pottery Male Figure
...184...

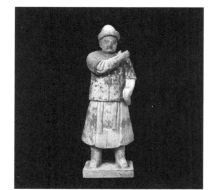

156 陶彩绘男俑
Painted Pottery Male Figure
...189...

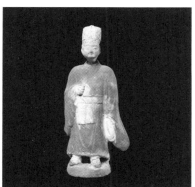

152 陶彩绘男俑
Painted Pottery Male Figure
...185...

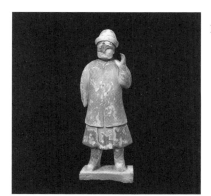

157 陶彩绘男俑
Painted Pottery Male Figure
...190...

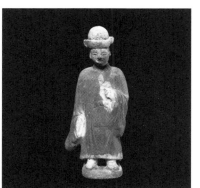

153 陶彩绘男俑
Painted Pottery Male Figure
...186...

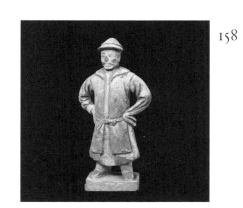

158 陶彩绘男俑
Painted Pottery Male Figure
...191...

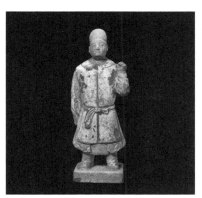

154 陶彩绘男俑
Painted Pottery Male Figure
...187...

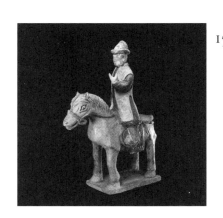

159 三彩男骑俑
Tricolor Figure of a Horseman
...192...

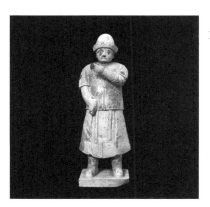

155 陶彩绘男俑
Painted Pottery Male Figure
...188...

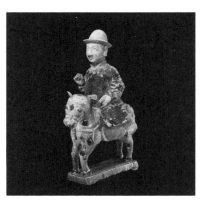

160 三彩男骑俑
Tricolor Figure of a Horseman
...193...

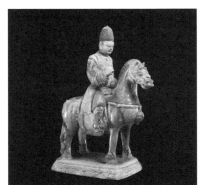

161 三彩男骑俑

Tricolor Figure of a Horseman

...194...

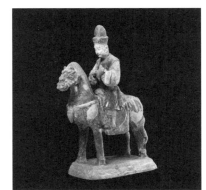

165 陶紫黄釉男骑俑

Purple-yellow Glazed Pottery Figure of a Horseman

...198...

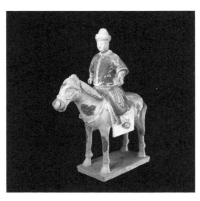

162 三彩男骑俑

Tricolor Figure of a Horseman

...195...

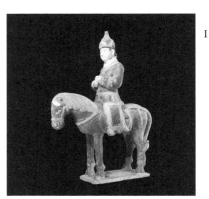

166 陶紫蓝釉男骑俑

Purple-blue Glazed Pottery Figure of a Horseman

...199...

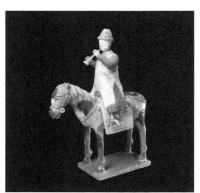

163 三彩男骑俑

Tricolor Figure of a Horseman

...196...

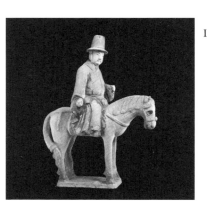

167 陶黄蓝釉男骑俑

Yellow-blue Glazed Pottery Figure of a Horseman

...201...

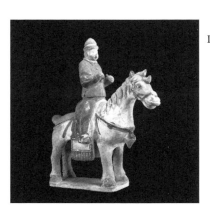

164 陶绿釉男骑俑

Green Glazed Pottery Figure of a Horseman

...197...

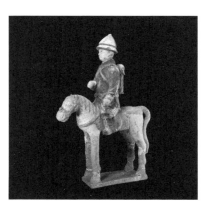

168 陶紫蓝釉男骑俑

Purple-blue Glazed Pottery Figure of a Horseman

...203...

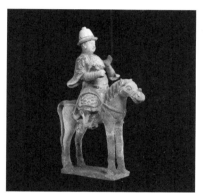

169 陶紫蓝釉男骑俑
Purple-blue Glazed Pottery Figure of a Horseman
...204...

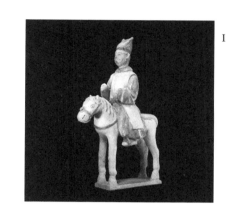

173 陶蓝釉男骑俑
Blue Glazed Pottery Figure of a Horseman
...208...

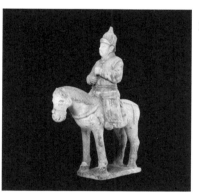

170 陶紫蓝釉男骑俑
Purple-blue Glazed Pottery Figure of a Horseman
...205...

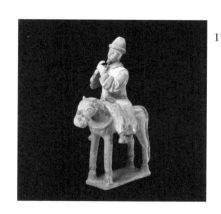

174 陶蓝釉男骑俑
Blue Glazed Pottery Figure of a Horseman
...209...

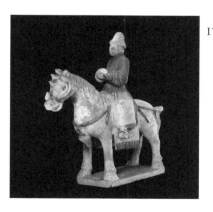

171 陶绿釉男骑俑
Green Glazed Pottery Figure of a Horseman
...206...

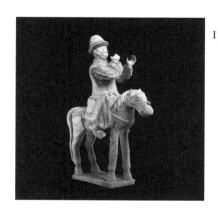

175 陶紫蓝釉男骑俑
Purple-blue Glazed Pottery Figure of a Horseman
...210...

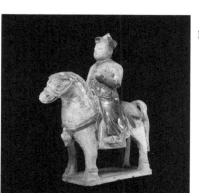

172 陶绿釉男骑俑
Green Glazed Pottery Figure of a Horseman
...207...

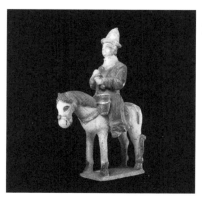

176 陶紫绿釉男骑俑
Purple-green Glazed Pottery Figure of a Horseman
...211...

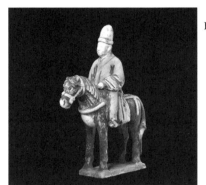

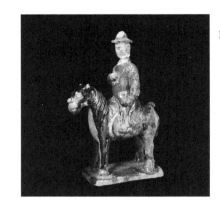

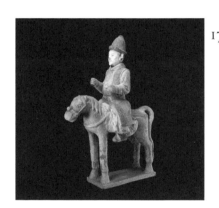

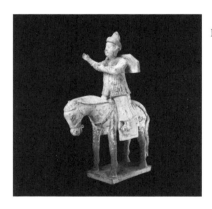

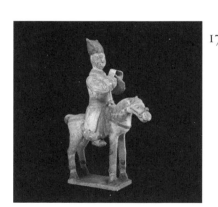

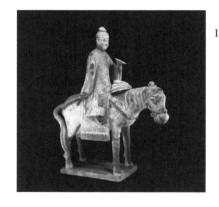

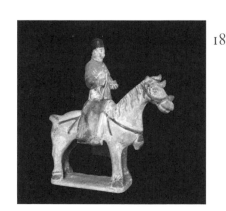

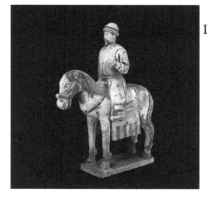

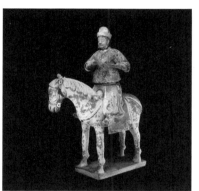

185 陶彩绘男骑俑
Painted Pottery Figure of a Horseman
...220...

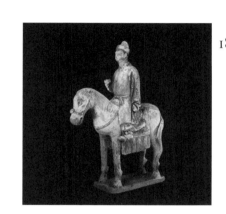

189 陶彩绘男骑俑
Painted Pottery Figure of a Horseman
...224...

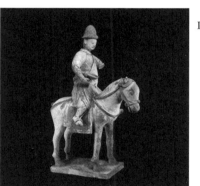

186 陶彩绘男骑俑
Painted Pottery Figure of a Horseman
...221...

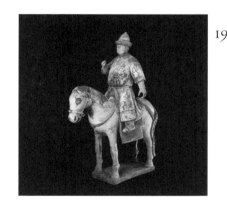

190 陶彩绘男骑俑
Painted Pottery Figure of a Horseman
...225...

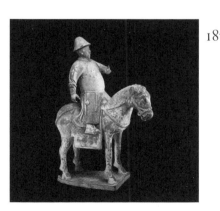

187 陶彩绘男骑俑
Painted Pottery Figure of a Horseman
...222...

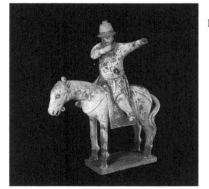

191 陶彩绘男骑俑
Painted Pottery Figure of a Horseman
...227...

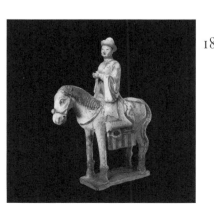

188 陶彩绘男骑俑
Painted Pottery Figure of a Horseman
...223...

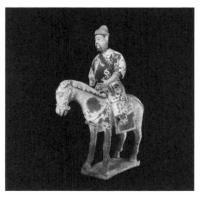

192 陶彩绘男骑俑
Painted Pottery Figure of a Horseman
...228...

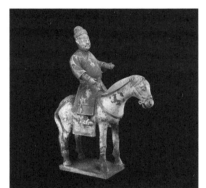

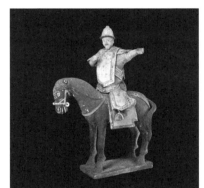

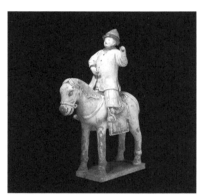

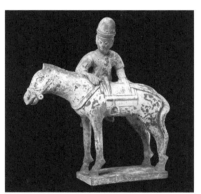

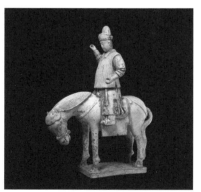

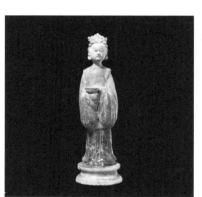

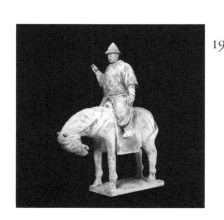

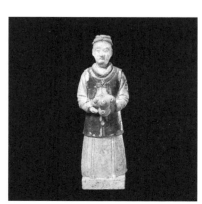

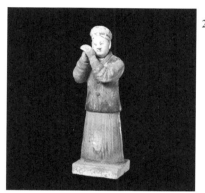

201 陶紫蓝釉女俑
Purple-blue Glazed Pottery Female Figure
...240...

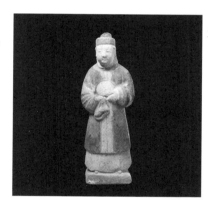

205 陶紫蓝釉女俑
Purple-blue Glazed Pottery Female Figure
...244...

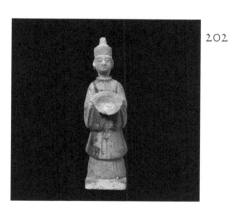

202 陶紫蓝釉女俑
Purple-blue Glazed Pottery Female Figure
...241...

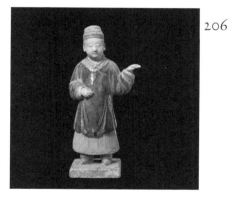

206 陶紫蓝釉女俑
Purple-blue Glazed Pottery Female Figure
...245...

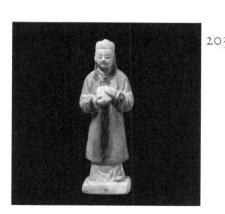

203 陶紫蓝釉女俑
Purple-blue Glazed Pottery Female Figure
...242...

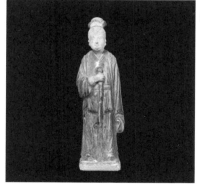

207 陶黄绿釉女俑
Yellow-green Glazed Pottery Female Figure
...246...

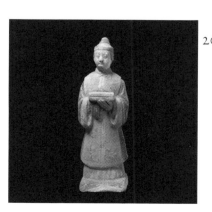

204 陶紫蓝釉女俑
Purple-blue Glazed Pottery Female Figure
...243...

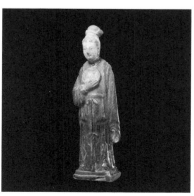

208 陶黄绿釉女俑
Yellow-green Glazed Pottery Female Figure
...247...

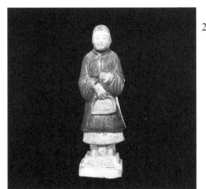

陶绿釉女俑
209 Green Glazed Pottery Female Figure
...248...

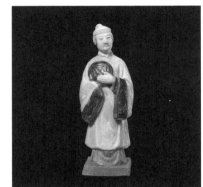

陶紫蓝釉女俑
213 Purple-blue Glazed Pottery Female Figure
...253...

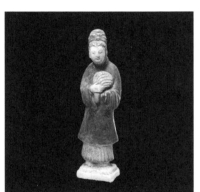

陶黄绿釉女俑
210 Yellow-green Glazed Pottery Female Figure
...249...

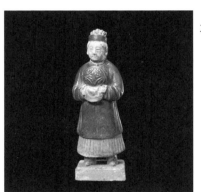

陶紫蓝釉女俑
214 Purple-blue Glazed Pottery Female Figure
...254...

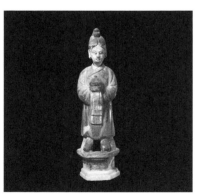

陶绿釉女俑
211 Green Glazed Pottery Female Figure
...251...

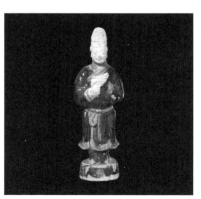

陶紫绿釉女俑
215 Purple-green Glazed Pottery Female Figure
...255...

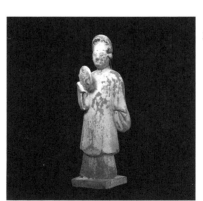

陶彩绘女俑
212 Painted Pottery Female Figure
...252...

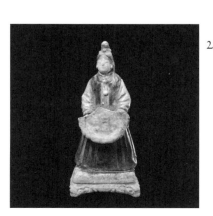

陶紫蓝釉女俑
216 Purple-blue Glazed Pottery Female Figure
...256...

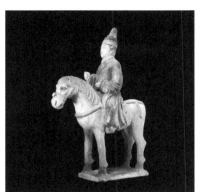

217 陶紫绿釉女骑俑

Purple-green Glazed Pottery
Female Figure on Horse

...257...

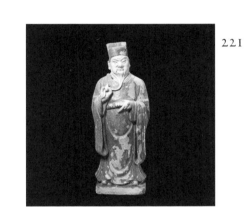

221 陶紫蓝釉文官俑

Purple-blue Glazed Pottery Figure of
an Official

...263...

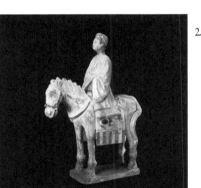

218 陶彩绘女骑俑

Painted Pottery Female Figure on Horse

...259...

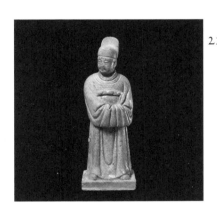

222 陶绿釉文官俑

Green Glazed Pottery Figure of an Official

...264...

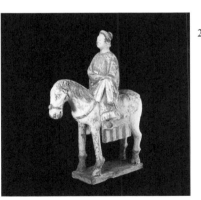

219 陶彩绘女骑俑

Painted Pottery Female Figure on Horse

...261...

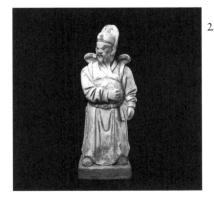

223 陶彩绘文官俑

Painted Pottery Figure of an Official

...265...

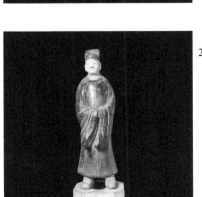

220 陶黑绿釉文吏俑

Black-green Glazed Pottery Figure of
an Official

...262...

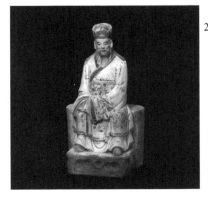

224 陶彩绘文官俑

Painted Pottery Figure of an Official

...266...

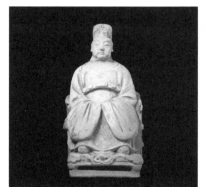

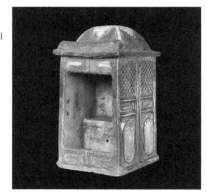

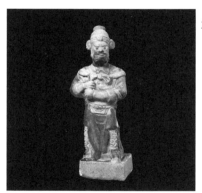

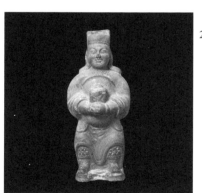

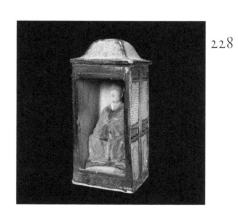

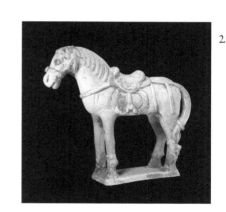

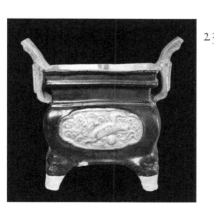

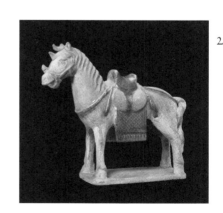

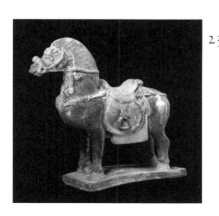

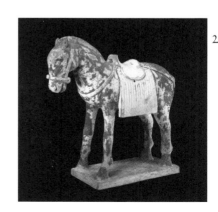

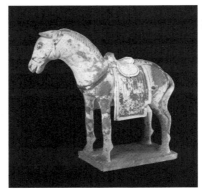

241 陶彩绘马
Painted Pottery Horse
...286...

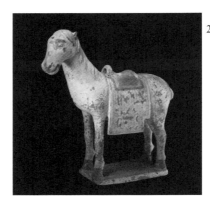

242 陶彩绘马
Painted Pottery Horse
...287...